THE SOUTHS IN HER

BLACK LIVES IN THE DIASPORA: PAST / PRESENT / FUTURE

BLACK LIVES IN THE DIASPORA: PAST / PRESENT / FUTURE

EDITORIAL BOARD

Howard University
Clarence Lusane, Rubin Patterson, Nikki Taylor, Amy Yeboah Quarkume

Columbia University
Farah Jasmine Griffin, Frank Guridy, Josef Sorett

Black Lives in the Diaspora: Past / Present / Future is a book series that focuses on Black lives in a global diasporic context. Published in partnership with Howard University's College of Arts and Sciences and Columbia University's African American and African Diaspora Studies Department, it builds on Columbia University Press's publishing programs in history, sociology, religion, philosophy, and literature as well as African American and African diaspora studies. The series showcases scholarship and writing that enrich our understanding of Black experiences in the past, present, and future with the goal of reaching beyond the academy to intervene in urgent national and international conversations about the experiences of people of African descent. The series anchors an exchange across two global educational institutions, both located in historical capitals of Black life and culture.

Jamall A. Calloway, *Imagining Eden: Black Theology and the Search for Paradise*

Wendell H. Marsh, *Textual Life: Islam, Africa, and the Fate of the Humanities*

Jarvis McInnis, *Afterlives of the Plantation:*
Plotting Agrarian Futures in the Global Black South

Lauren Coyle Rosen and Hannibal Lokumbe, *Hannibal Lokumbe:*
Spiritual Soundscapes of Music, Life, and Liberation

Laura E. Helton, *Scattered and Fugitive Things:*
How Black Collectors Created Archives and Remade History

Sarah Phillips Casteel, *Black Lives Under Nazism:*
Making History Visible in Literature and Art

Aïssatou Mbodj-Pouye, *An Address in Paris: Emplacement, Bureaucracy,*
and Belonging in Hostels for West African Migrants

Vivaldi Jean-Marie, *An Ethos of Blackness: Rastafari Cosmology, Culture, and Consciousness*

Imani D. Owens, *Turn the World Upside Down: Empire and Unruly Forms of*
Black Folk Culture in the U.S. and Caribbean

Gladys L. Mitchell-Walthour, *The Politics of Survival: Black Women*
Social Welfare Beneficiaries in Brazil and the United States

For a complete list of books in the series,
please see the Columbia University Press website.

THE SOUTHS IN HER

BLACK WOMEN WRITERS AND CHOREOGRAPHERS AND THE POETICS OF TRANSMUTATION

NICOLE M. MORRIS JOHNSON

Columbia University Press
New York

Columbia University Press
Publishers Since 1893
New York Chichester, West Sussex
cup.columbia.edu

Copyright © 2026 Columbia University Press
All rights reserved

Library of Congress Cataloging-in-Publication Data
Names: Morris Johnson, Nicole M. author
Title: The souths in her : black women writers and choreographers and the poetics of transmutation / Nicole M Morris Johnson.
Description: New York : Columbia University Press, 2025. | Includes bibliographical references and index.
Identifiers: LCCN 2025034638 | ISBN 9780231219679 hardback | ISBN 9780231219686 trade paperback | ISBN 9780231562843 EPUB | ISBN 9780231565035 PDF
Subjects: LCSH: American literature—African American authors—History and criticism | American literature—Women authors—History and criticism | American literature—20th century—American literature—20th century—History and criticism | Literature—Black authors—History and criticism | Literature, Modern—20th century—History and criticism | African American dance—20th century—History and criticism | African Americans—Intellectual life—20th century | Black people—Intellectual life—20th century | African diaspora | LCGFT: Literary criticism
Classification: LCC PS153.N5 J6455 2025
LC record available at https://lccn.loc.gov/2025034638

Cover design: Julia Kushnirsky
Cover image: Allison Janae Hamilton, *Floridawater II* (2019).
Courtesy of the artist and Marianne Boesky Gallery,
New York and Aspen. © Allison Janae Hamilton

GPSR Authorized Representative: Easy Access System Europe,
Mustamäe tee 50, 10621 Tallinn, Estonia, gpsr.requests@easproject.com

CONTENTS

INTRODUCTION
ON EMERGENCE: SOUNDING BEYOND
THE WOMB ABYSS 1

1. ON AUTHORITATIVE WANDERING:
 HURSTON AND DUNHAM 23

2. ON DYNAMIC SUGGESTION:
 HURSTON AND McINTYRE 65

3. ON UNINCORPORABLE STRANGE SOUND:
 CONDÉ AND SHANGE 107

4. ON AUTOFICTIONAL SUBJECTIVITY:
 CONDÉ AND KINCAID 147

CONCLUSION
ON MUCK HORIZONS 183

Acknowledgments 203
Notes 209
Bibliography 243
Index 253

THE SOUTHS IN HER

INTRODUCTION

ON EMERGENCE

Sounding Beyond the Womb Abyss

Now and then a black man has risen above the debased condition of his people. . . . But no such fortune fell to the lot of the plantation woman. The black woman of the South was left perpetually in a state of hereditary darkness and rudeness. . . . Her entire existence from the day when she first landed, a naked victim of the slave-trade, has been degradation in its extremest forms.

—ALEXANDER CRUMMELL, "THE BLACK WOMAN OF THE SOUTH:
HER NEGLECTS AND HER NEEDS"

The South in her, the land and salt-winds, moved her through Charleston's streets as if she were a mobile sapling, with the gait of a well-loved colored woman whose lover was the horizon in any direction. . . . She made herself, her world, from all that she came from. . . . she made up what she needed. What she thought the black people needed.

—NTOZAKE SHANGE, *SASSAFRASS, CYPRESS AND INDIGO*

In the March 27, 1926, entry for her *Pittsburgh Courier* column "A Woman Speaks" (later "Une Femme Dit"), Alice Dunbar Nelson lauds the ability of the visual artist Laura Wheeler Waring to capture "the sorrow-laden heart" of the Black race in her portrait of Annie Washington Derry.[1] By the mid-1920s, Waring had become widely known for her

portraits of influential African Americans as well as for her illustrations for the NAACP's *Crisis* magazine. Waring's oeuvre mainly features portraits of the Black middle class, but Dunbar Nelson is particularly enchanted by the painter's 1925 portrait of the working-class Derry. Whereas her column typically showcases the author's sharp wit, Dunbar Nelson's solemn tone in her profile of Waring's work aligns more closely with that of her short fiction. For Dunbar Nelson, Waring's subject is an "age-old sorrow-lined, calm-after-storm of the aged colored woman. An epitome of a race. Summing up in her weather-beaten countenance three centuries of making bricks without straw under the hissing coil of the whip-lash. Envisioning a future of a people out of bondage, but still wandering in the wilderness."[2] Although located in the US North and painted by a northerner, Derry is interpreted as being inextricably tethered to a degraded enslaved past that is generally associated with the antebellum plantation South. Dunbar Nelson's interpretation endows Derry with an ability to visualize a future beyond slavery and its afterlives, but, in a somewhat contradictory manner, she does not read the subject as possessing the ability to move toward it. While a movement into a more promising future may begin with her, it will not include her.

What is striking in Dunbar Nelson's focus on Derry's face is how Derry signifies metonymically as "an epitome of a race"—as being representative of Black womanhood as a whole through three centuries of slavery and into the contemporary moment. Even though Derry lived in Pennsylvania, her body bears the history of southern plantation labor through generations of toil within a brutal system of surveillance and violence. For Black middle-class women of a younger generation such as Dunbar Nelson, Derry represents a moment of recognition, an acknowledgment of a cultural inheritance linked to Black women's labor on the southern plantation. To acknowledge this inheritance was perhaps a difficult thing to do because Dunbar Nelson, who was born in Reconstruction Louisiana, was writing in the shadow of what Alexander Crummell described as Black women's shame, as representing the most debased condition of Black people in the South.

In his 1883 speech, "The Black Woman of the South: Her Neglects and Her Needs," Crummell casts Black rural women as obstacles to Black progress, as stuck in the past and unable to acquire the skills necessary to rise in the modern world.[3] Whereas many Black men had certain opportunities

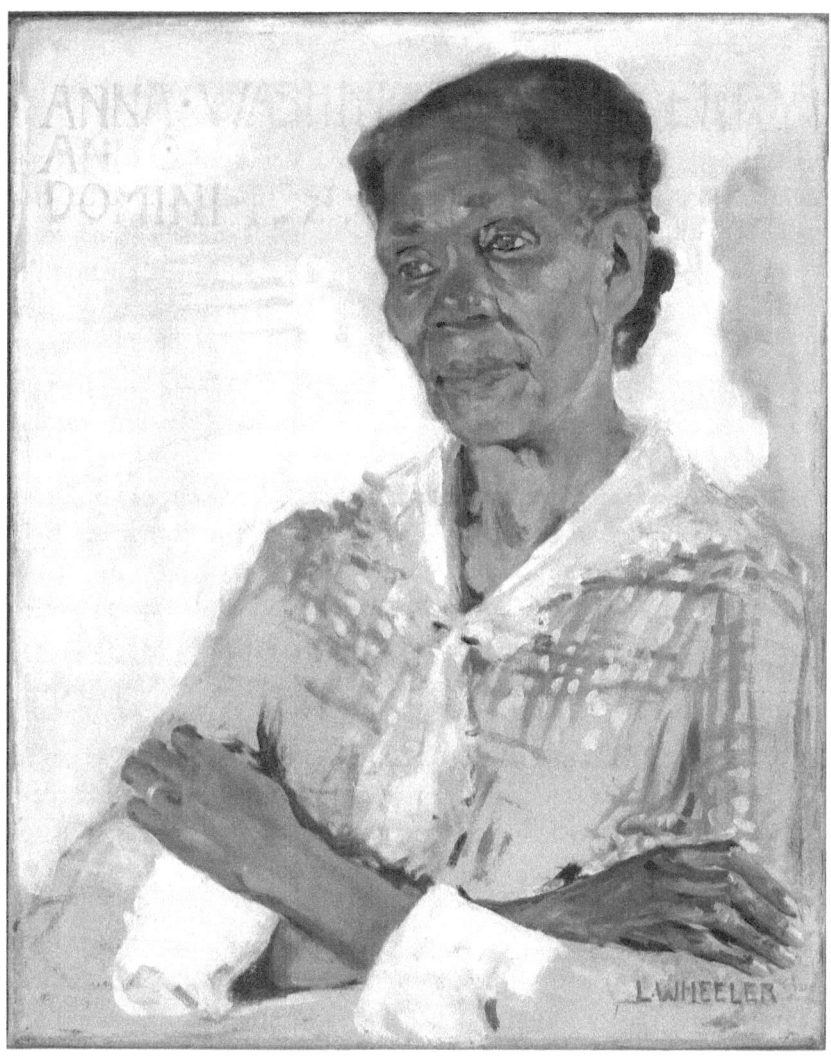

FIGURE 0.1 Laura Wheeler Waring, *Anna Washington Derry*, 1927, oil on canvas, 20 × 16 in. (50.8 × 40.5 cm).

Source: Smithsonian American Art Museum, Gift of the Harmon Foundation, 1967.91.1.

for education and mobility, Black women of the South "were left perpetually in a state of heredity darkness and rudeness." Black women, for Crummell, became the repository for all that was debased among the race; they alone carried the burden of primitivism in the age of uplift and modernity. Crummell's understanding of Black progress rests on a series of dualisms, such as men/women, civilized/primitive, city/country, and North/South. At the center of this dualistic understanding of progress is the juxtaposition of Black male development versus the primitivism and rudeness of Black women. Whereas one travels, the other is static, stuck in the past as well as on the land. By 1926, as the implied relationship between northern-based Derry and the South in Dunbar Nelson's review illustrates, the positioning of the Black woman as primitive appears to have extended beyond the geographical borders of the South. It is as if the notion of "hereditary darkness" that Crummell speaks of—a notion that has its origins in the Middle Passage and the plantation—ensures that Black women are perceived to be, as Dunbar Nelson suggests of Derry, "wandering in the wilderness" but unable to emerge and participate in the contemporary moment regardless of their location.[4]

However, a major shift transpires between the literary and artistic approaches shared by the formerly enslaved and first generations of emancipated southern Black women and those of their literary and creative progeny. Impressions such as those shared by Crummell that linked the South and the Black female body together as landscapes of abject primitivity—impressions shaped by what I call womb abyss framing—began to come under scrutiny as early as 1928, when Zora Neale Hurston shuns sentiments like Dunbar Nelson's celebration of the "sincere elevation of tragedy in the artistic life of the race" and the idea of sorrow being linked to the Black South in particular.[5] This shift continues fifty-six years after Dunbar Nelson's review, when the writer Ntozake Shange presents a contrasting portrait of the relationship between Black womanhood and the South. In a 1982 *Today* show interview, Jane Pauley poses the following question regarding characters in Shange's debut novel, *Sassafrass, Cypress and Indigo*: "One of your characters is a little girl who has quote 'too much south in her.' What's that mean?"[6] Pauley is referring to an exchange between a lovingly exasperated Hilda Effania and her youngest daughter, Indigo. Although perhaps made mildly nervous by the audacity of her daughter's generation, Hilda is not unfamiliar with the Black southern

women's heritage and is indeed largely responsible for teaching her girls about its power. Shange responds: "Oh, 'too much south in her.' It's like she is never losing contact with whatever it was that the slaves contributed to American culture. She's never lost sight of how we look in the sunset or how we cook or how gorgeous we are when we are being friendly with one another. If you think about what makes New Orleans gorgeous what makes Charleston beautiful or some sections of Paris even, it is . . . people of color and how strange we are in a European environment." As Shange explains, the phrase refers to Black girls and women who have maintained contact with African contributions to the cultures of the Americas.

Shange's South is a tool that enables mobility and that authorizes the defining of self and world, and it is Shange's notion of the "South in her" that inspires the title for this study. Shange's explanation of Black women's relationship to the South disrupts the logic of "hereditary darkness" that formerly linked the two. Taking up Shange's notion of both the South and the strange as representing not abjection but possibility, *The Souths in Her* tells the story of the writing and choreographic practices of twentieth-century Black women artists and the ways they move between artforms and geographies.[7] This study constitutes a diasporic genealogy that indexes key expressive shifts in the life writing, choreography, and fiction produced by, among others, Zora Neale Hurston, Katherine Dunham, Dianne McIntyre, Ntozake Shange, Maryse Condé, and Jamaica Kincaid. Hailing from diverse geographical and temporal locations, these artists share a history of confrontations with the multiple tensions that Souths as idiom present. Their varied positions enable an examination of the ways that these tensions play out between Black women artists and a number of intellectual and artistic movements, including the New Negro, Négritude, and Black Arts Movements. As their oeuvres show, each artist's movement across and encounters with various Africana southern cultures lead to significant transformations in her experimental relationship to artistic form. Each artist's shifts issue challenges to intellectual and expressive frameworks that understand modernity as determined by the symbols that emerged from the slave ship, the plantation, and masculinity, and they impel us to investigate the assumptions and narratives that inform these frames.

The Souths in Her illustrates the central role that Souths have played in the formation of a *poetics of transmutation* generated by Black women artists. I argue that this poetics represents the disruption and reconfiguration

of creative and cultural organizing principles informed by notions of "hereditary darkness and rudeness"—notions that emerge from a point of origin that I call the womb abyss—affixing the Black female to static notions of the South.[8] Through their travels across Black Souths, the authors and choreographers featured in this study encounter strange sounds, relationships to body and spirit, creation myths, relationships to inheritance, and modes of expression that catalyze this transmutation, and these encounters directly affect each artist's expressive horizons: their perceptions of the stories that can be told and their potential for telling them. Following these encounters, each artist casts new sites of emergence: The storytelling that follows the encounter with a strange South provides a model of expressive form and strategy undergirded by more expansive creative principles.

I analyze each artist's transformative negotiations with the narrative afterlives of the plantation by engaging both their writing and their choreography, since it is precisely at the nexus of the written word and the Black woman's moving body that plantation-based narratives of primitivity accrue, situating Black women as primitive sites of extraction that exist not to contribute to a broader cultural archive but rather to aid the formation of others' subjectivity. In locating this nexus, *The Souths in Her* makes key theoretical and methodological interventions: The Black female body becomes sutured to the word, and this union becomes codified in expressive forms. To understand the history of this fusion and Black women's maneuvers around it, we must examine written and embodied forms. Therefore, to most fully understand Black women's aesthetic maneuvers, we are required to examine the correspondence among movement, writing, and their formal innovations.

Southern encounters begin to disrupt the Middle Passage– and plantation-informed logics embedded in expressive forms and traditions. These encounters expose the writers and choreographers featured in this study to unfamiliar and differently organized principles through which they may define anew themselves and the world around them. The relationship between geography and the writing and choreography of Black women is dynamic: as Aimee Meredith Cox argues, "Choreography suggests that there is a map of movement or plan for how the body interacts with this environment, but it also suggests that by the body's placement in a space, the nature of that space changes," and for Shange, geography

and movement coalesce in a manner that enables her written expression.[9] The genealogy presented in this book does not lend itself to a teleological, linear story of progress; rather, it provides a snapshot of the recursive mappings full of irruption and shifts that collectively suggest another way of understanding Black women's poetics in relationship to the South.

WOMB ABYSS AND HEREDITARY DARKNESS

Informed by Black studies, decolonial studies, and feminist and queer theorists, *The Souths in Her* understands the issue of "hereditary darkness" as an inheritance passed down from the transatlantic slave trade with implications that exceed genetic transfer. Most urgent for this study are the ways this inheritance has become embedded and reinforced in our structures of thinking and the implications of this transfer for Black women's expression. As several theorists of African American and Caribbean studies have argued, the Middle Passage represents both a moment of unspeakable violent loss and a moment of emergence, with the latter true for the shaping of both Black culture and European modernity. Captive Africans' emergence from the violent sites of enclosure referred to as "holds"—from the warehouses of Cape Coast Castle to what Édouard Glissant in "The Open Boat" (1990) calls the "belly of the boat"—was understood as a kind of birth.[10] Following Stefano Harney and Fred Moten, Christina Sharpe explains that modernity "'is sutured by this hold.' The hold is the slave ship hold; is the hold of the so-called migrant ship; is the prison; is the womb that produces blackness."[11] This womb or belly into which Africans descended and were "dissolved," as Glissant describes, served as a site of suffering doubling as a womb that constituted one of three abysses that kidnapped Africans encountered and sometimes emerged from en route to the Americas.[12] He posits that "the unconscious memory of the abyss served as the alluvium" for the forging of new relation, or shared knowledge, from which new Afro-Creole cultures were born. If in this moment, as Glissant notes, captive Africans witness "language vanish, the word of the gods vanish, and the sealed image of even the most everyday object, of even the most familiar animal vanish," then as semiotics and forms of expression are reconfigured, they

are often crafted on a foundation that understands the Black woman as primitive origin of Black modernity—the site of memory that becomes the alluvium.[13] This imprinting precedes this moment when, before the crossing, the African female is met by the gaze of the European surgeon who plays an originating and authorizing role in defining "bodies that could be raped, chained, deported, or mutilated according to the wishes of the master."[14] It also exceeds the crossing and recursively shapes subsequent moments of Black expressive emergence, evinced by the recurring exclusion of Black women's active and recognized participation in those moments. While "language, world, and history" emerge from this original abyssal moment, it is to this location of primitivity that Black women remain semiotically and expressively tethered.[15] Black women become stubbornly framed by abyss and represent "the ejection, the abjection, by, on, through, which the system reimagines and reconstitutes itself."[16] The expectation that their bodies existed for labor—for providing pleasure for others and birthing the expected population of laborers and reproducers that would fuel the material and ideological economies of the New World—remained at the fore.

Over time, as Sharpe argues, the Black woman's womb is disfigured and becomes the site that produces "blackness as abjection much like the slave ship's hold and the prison, and turning the birth canal into another domestic Middle Passage with Black mothers, after the end of the legal hypodescent, still ushering their children into their condition; their non/status, their non/being-ness."[17] With this reality considered alongside Glissant's thesis on the potentials of relation, it becomes clear that the Black woman does not enjoy the full benefits of the rhizomatic identity.[18] So while Derek Walcott "forswears" an impossible "paternity" and Glissant "begins with maternity," what remains is a birthing or emergence from the womb abyss as a primal origin space that becomes sutured to the Black woman.[19] As such, she is not understood to move beyond it—instead, she becomes one with the site from which all other modern subjects emerge. Indeed, she becomes a palimpsestic body or perhaps represents a submerged location from which the aforementioned alluvium is continually drawn and reconfigured—a hole from which she cannot be heard or recognized as contributing to the relational knowledges and their resultant cultural outgrowth beyond this static role.

This predicament continues into the 1920s, where this study opens. By then, the notion of hereditary darkness and rudeness carried by Black women from its womb abyss origin has affected not only structures for thinking but also those governing the imagination, compromising the breadth of stories about Black life that can be told. Primitivism has long been deployed to seemingly contradictory ends: Antislavery crusaders in the early 1800s argued that "Negroes were a primitive people who were more highly endowed with emotions than with intellect and therefore . . . more religiously devout and artistic than white people." By the 1920s, participants in this discourse included members of movements who took as their focus the recognition and dignified treatment of contributions from artists and intellectuals of color, including those associated with the New Negro Movement, Negrismo, and Indigenismo.[20] The logics of primitivism were put to different uses among these groups, including the rationalization of gendered hierarchies. In the US context, many participants in the flourishing New Negro Movement were intently focused on the urban city center as the site of a new kind of origin. Black artists and scholars reveled in the possibilities of the migration away from what Alain Locke calls the "medieval" South to the modern North. Given the ways that an argument for a primitivism that associates Black and Brown people with greater emotional than intellectual strength runs counter to projects of Black modernism, it is not surprising that Black women find themselves most consistently associated with notions of the primitive. When the Chicago School urban sociologist and assimilation theorist Robert E. Park—after years of studying Black southern culture at Booker T. Washington's Tuskegee Institute—proclaims that the Negro is not naturally intellectual or introspective but is instead an art-making, expressive "lady among the races," one can imagine how such claims might motivate many Black male artists and thinkers to separate themselves from the South and from the notion of the "lady."[21] As the scholars Michelle A. Stephens, Henry Louis Gates Jr., and Gail Bederman note, Park's pronouncement coincided with a national obsession with manliness. Black men encountered Victorian notions of manhood that emphasized "strong character, a certain moral 'uprightness,' and sexual self-restraint" and a shift to "a more aggressive and virile form of American manhood captured in the increased use and developing meanings of the term 'masculinity' between

1890 and 1917."[22] It follows, then, that by the time Locke announces in 1925 that Black movement from the South to the North is synonymous with moving from "medieval America to modern[ity]," one finds not only a critique of the horrors of Jim Crow South in this statement but also a distancing from a gendered association with the South.[23] Although motivations for using the discourse of primitivism vary, as David Luis-Brown and Joanna Dee Das argue, even discussants who attempt to engage the discourse and simultaneously avoid racial essentialism fail in the encounter with the Black woman's moving body. Such an encounter releases "an outpouring of stereotypes about sexuality and thoughtless abandon to instinctive rhythmic and primal drives."[24] Thus framed, the Black female is perceived as ruled by emotion and sexuality and again emerges as the site of a primitive essence against which all others define their intellect and location in modernity. Conveniently, this is a reinforcement of extant mythology centered on the Black female body; it is imagined as static, in place, available for extraction, and rooted in the past. This imposed, intertwined relationship between the South and the Black female body is not what Ntozake Shange refers to as "in" her—a tool that a Black woman and girl can wield for world making as they see fit; rather, this frame places the Black female outside of the current moment. Viewed through this frame, Black women's creative and intellectual contributions are obstructed and denied, and they are positioned for extraction.

This understanding informs part of the work of *The Souths in Her*: a call for the reexamination of discursive and theoretical frameworks often applied to the study of Black people who are affected by both the transatlantic trade and the plantation and its afterlives. These frameworks are often undergirded by an organizing principle that tethers Black women artists to a space perceived to be outside of modernity or to a location "below"—whether this is the abyss below Paul Gilroy's male-filled ships traversing the Atlantic that make contact with and circulate within a Euro-African version of modernity or the auxiliary positions assigned via pronouncements issued by the architects of Négritude and later Créolité that submerge and render less conspicuous the contributions of thinkers such as Suzanne Césaire and Maryse Condé.[25] However unintentional, these theoretical approaches often reinforce a primitive and static frame around the expression of Black women and femmes that ultimately elevates the subjectivity of others. As they stand, prominent frameworks

applied to the study of Black women's expression threaten to limit our examinations of postplantation Black creative and political expression. The disruption of these frameworks is also part of the work of each artist in this book. Hurston, Dunham, McIntyre, Shange, Condé, and Kincaid each arrive at an intimate knowledge of and put forth their own theorization of cross-cultural exchange that appears promising for meeting Joan Anim-Addo's urgent call for a "fuller articulation of gendered creolisation at the theoretical level" and for enriching the male-centric discursive frameworks used for studying the histories and expression of the Black Americas.[26] This book's articulation of the womb abyss and its recurring frames provides a way to consider the full implication of capture and release that these artists represent.

DEFINING SOUTHS

To tell a fuller story of Black women and the South, we must consider the South expansively as both material and metaphor. Hence, in this study I refer to the Souths as a plural construct. These Souths include the US South, the Caribbean, and a postcolonial Guinea and Ghana. Additionally, this study uses the South as a construct that exceeds geographies. As Anne Garland Mahler reminds us, depending on one's subject position, a deterritorialized South implies a stubborn condition of subalternity.[27] This condition is experienced broadly by members of the Great Migration, as well as by waves of Black migrants traveling from the Caribbean to the United States and to current or former European metropoles.[28] As Deborah McDowell writes, in the United States context, "The black body was literally and materially a battleground throughout the segregated South," with this segregation "grounded in and on the body, anchored in the racialization of caste and class."[29] To consider the South in this study is to also consider the tension invoked by a term that is variably metaphor and metonym.[30] For example, whereas men become symbols for the freedom fight through numerous nationalist liberation movements, Black women become idiomized as South and by extension as (mother)land, plantation, and fecundity. "South" is thus taken up in embodied, historical, conceptual, geographical, temporal, narrative, and other aesthetic dimensions.

The Souths in Her defines the diverse terrain it engages along the lines of what Riché Richardson has named the Africana South, her theoretical framework that, in keeping with the new southern studies, is grounded in notions of the global and hemispheric South that "acknowledge the diasporic cultural flows that constitute black southern identities." In engaging and extending Richardson's framework, I focus on the ways that "Africa and its diasporas imprint black identities in the Americas, acknowledging their hemispheric and transnational dimensions, dislodging them from static and conventional southernist binary North-South regional epistemologies," while also acknowledging "the inherent migratory aspects embedded in black identities" in the urban North.[31] Although the Black Atlantic paradigm—from the European side, as Paul Gilroy highlights—helps explain the emergence of Crummell's ideas on racialized identities and their relationship to his time in Cambridge (including the ideas highlighted in this chapter's epigraph), it proves limited for indexing the shift in Black women's relationships with the numerous significations of Souths that include, but are not limited to, southern landscapes.[32] An Africana Souths framework privileges what is silenced on the ships: Black women's expressive maneuvers that are often reductively understood as primitive counterpoints to modern expressivity and dismissed.

This study highlights movement between material and metaphorical Souths in a manner similar to what Shange illustrates in the epigraph. As Katherine McKittrick and Clyde Woods write, "Human geographies—both real and imagined—are integral to black ways of life." Like Shange's protagonist, Indigo, the women in this study and their ability to craft new structures sturdy enough to support the transmission of their insights and creativity were affected by Black southern material and imaginative geographies. For example, whereas the choreographer Dianne McIntyre's encounters with Souths are in some cases mediated by texts, her experiences and even her speaking voice are shaped by the material geographies of her southern-born parents and their specific local histories that go on to inform their children's approaches to the worlds they traverse.[33] Katherine Dunham had to have her "consciousness . . . shaped by multiple histories and events, multiple geographies, multiple identifications"—namely, those emerging from a US southern geography—in order for her to better understand the ways that metaphorical Souths were imprinted upon her and the implications this influence held for her expressivity, despite her midwestern birthplace.[34] The importance of maintaining a nuanced

attention to movement between material and metaphorical engagement with Souths is further heightened when the artists in this study encounter unfamiliar or strange Souths. As McKittrick and Woods remind us, "environment[s] . . . racialized by contemporary demographic patterns as shaped by historic precedents" serve as "reminders of, but do not twin, other racialized spaces," even spaces that hold similar histories of colonization and/or slavery.[35] It is precisely this difference that makes the strange Africana southern encounter so powerful. This difference located across strange Souths inspires a different kind of mobility for each artist. For Hurston and Dunham, this is an encounter with unfamiliar Haitian Vodou cosmology; for McIntyre and Shange, textual and sonic elements constitute strange Souths. In the case of the Caribbean-born writers Maryse Condé and Jamaica Kincaid, their movement to the United States constitutes a movement to and through a strange South based not necessarily on their landing in the geographical South of the nation but rather on their encounter with a space where familiar social orientations to slavery and colonization were disrupted. Reflecting on her own movement across and between geographies, M. Jacqui Alexander acknowledges that she "couldn't live Caribbean feminism on American soil, and Caribbean soil had grown infertile to the manufacture of the needs of those to its north" and that, based on differences in anglophone Caribbean education, population, and political priorities, she transitioned from not knowing or feeling a Fanonian sense of double consciousness to "a daily awareness . . . of seeing myself as black—and equally important—[began] thinking about what white people were seeing/thinking as they saw me."[36] Condé's and Kincaid's sense of the new racial dynamics they are embroiled in similarly comes into clearer view, reflecting a sharpening awareness of the shared legacies of the Middle Passage and how these legacies imprint primitivities upon them. As is the case with Condé, Kincaid, and others featured in this study, the difference located across strange Souths mirrors the process of becoming strange experienced by each artist, at times motivating a unique physical and expressive mobility.

Although *The Souths in Her* is on one hand a deterritorial push against masculinist formulations of the Black Atlantic and diaspora, each artist's history with a specific material South and the kinds of movement that each affiliation allows evokes a set of tensions. Disjunctures emerge when one considers the specifics of where Black women are landed and their geographically determined estrangements. The artists do not simply

encounter unfamiliar cultural elements; they become strange themselves as they travel to new geographies. Depending on a woman's location, she may have more diminished access to travel than her counterpart holding a US passport, for example. As I note in chapter 1, Dunham is able to travel to Haiti and enjoy an access to male-oriented spaces and rituals that local women are denied. In the case of Condé and Kincaid, whom I discuss in chapter 4, this access may manifest as being seen and treated as the "accented, foreign, and . . . friendly" foil to the "'unjustifiably angry' black American."[37] This unevenness also extends to the circulation and amplification of artistic and theoretical contributions that depend on a convergence of factors beyond nationality, including sexuality. The so-called primitive woman in the United States is in this sense not the same as the Black primitive woman in West Africa, Martinique, or Haiti, and attention to both the connections and differences remains at stake.

The recognition of these tensions, the "several complexities [that] arise due to the continuing legacy of racial-sexual domination," or what Alexander calls "the confluence of different geographies of feminism," ultimately proves productive in a study of Black women's movement between metaphorical and material Souths because it highlights the capacity of Africana Souths to hold and allow for the processing of tensions. After all, as Marina Magloire notes is the case for Haitian Vodou, the unfamiliar cultural elements that the artists featured in this study locate across Africana Souths don't simply offer an easy way out; they "firmly inhabit life in the break of the Middle Passage and the enormity of the cultural loss even as [they] stand as [monuments] to the resiliency of the faith of enslaved Africans."[38] Although Black women's encounters with unfamiliar Souths are not without complication, these encounters prove vital for troubling and disrupting inherited "modes of thought" that give way to the crafting of new expressive approaches, allowing a more inclusive poetics to emerge.[39]

FROM AUTOPOIETIC TO POESIS

The artists featured in this study undergo transmutations that enable movement from submerged articulation to the casting of new expressive horizon in three stages. The first is the artist's recognition of the Middle

Passage–inaugurated autopoietic womb abyss frames that enclose them. My work here has been influenced by Sylvia Wynter, who explains that these narratively constructed frames are situated in the origin stories that shape our knowledge systems and definitions of the human.[40] Particularly relevant to this study is her insistence that we recognize that sites of rebirth as understood through these frames are of "the origin story rather than of the womb."[41] Although Wynter is not explicitly engaging a Glissantian womb abyss or a gendered body per se, her insistence on probing autopoietic myths clears an important theoretical path toward disrupting the organizing principles that affix limits to the Black female body and the expression that issues forth from it.

One such myth organizes our understanding of Black women's expression. Following emergence from the Middle Passage abyss and then the plantation, Black female utterance is positioned as the primal sound from which Black modern expression emerges. This scream or shriek exists outside the modern semiotics that emerge from the abyss, as is borne out in the foundational locus of the Black literary tradition of the Americas—the slave narrative. Saidiya Hartman, Fred Moten, and Meina Yates-Richard have all pointed to the prominent example of how Frederick Douglass uses his Aunt Hester's shrieks to serve as the abyss, so to speak, from which his own subjectivity springs forth.[42] And as Ifeoma Nwankwo illustrates, the slave narrative is interwoven with the emergence of a nineteenth-century transnational Black cosmopolitanism that also plays a silencing role in part because of the hegemonic and masculinist lens governing its construction.[43]

Glissant explains that at emancipation the body "follows the explosive scream."[44] The movement from the oral to the written is perceived to be one of improvement, "promotion or transcendence," and an immobilization of the body (for, as he explains, writing requires nonmovement and stillness), just as the ability to produce the written word represents control or possession of oneself. The scream itself, a necessary step in the progression from utterance to speech to the realization of a "liberated poetics," represents for Glissant a rediscovery of "the innocence of a primitive community." Black women's expression becomes a key site of this scream across the Africana southern world. For if "the oral is inseparable from the movement of the body" and the Black female body is already inscribed as dispossessed, the utterance that issues forth is primed to be perceived as the primitive alluvium that can be used as expressive liberation for

others.⁴⁵ Farah Jasmine Griffin explains how Black women's singing, a sound offered to readers from the pens of Black men, operates in this context in the United States. As Griffin argues, this thrice-removed sound (from the original context, from the experience of hearing it for oneself, and from receiving it from a man's pen), which "strikes some ancient cultural memory" in the men who encounter it, "situates a black woman's voice as the origin of black male literary and musical productivity and as the originary, founding sound of the New World Black Nation." As the author persuasively argues, the southern Black woman's voice serves as no less than "one mythical source of black modernity."⁴⁶

Whereas the first stage of transmutation often occurs before travel to a strange South, the second stage, beginning a process of formal and expressive poesis or creation, occurs in the encounter with the unfamiliar. It is in this moment that the Black women artists centered in *The Souths in Her* teach us that other, more generous principles structuring modes of relation and expression also emerged from the abyss moment but remain largely submerged. Omise'eke Natasha Tinsley centers one such mode in her discussion of the relations forged among unchained African women during the forced Middle Passage. As she explains, "unlike males, females were often packed onto slave ships unchained," leaving them susceptible to rape, yes, but also giving them "more mobility to interact in the holds and so to form *feeling* connections to each other—when, as chained property, they were not supposed to feel at all." Tinsley refers to these women as *mati* (following maroon oral histories as far back as the seventeenth century). Tinsley explains that *mati* is derived from the Dutch *maat* or mate, and that the term means "'mate' as in 'shipmate': she who survived forced transport and enslavement with me." As Tinsley notes further, *mati* is the most common name among several others for same-sex relationship patterns that signify a fluidity, a moving, and a "resisting [of] the commodification of their bought and sold bodies by *feeling* and *feeling for* their co-occupants on these ships."⁴⁷ Wynter's theorizing of the plantation or provision plot helps us understand how the organizing principles inaugurated by groups like the mati remain accessible across Africana Souths. As Carol Boyce Davies writes, Wynter views the provision plot as a location from which Africans renegotiate their connection with nature, moving away from the land-as-property (and by extension, human-as-property) relation. Wynter explains that

the provision grounds or plots upon which the enslaved grew their own sustenance are also where Indigenization took place: the "secretive process by which the dominated culture survives; and resists."[48] For Wynter, these plots formed the roots of Indigenous Black cultures.[49] Although systems such as mati relations become largely submerged, appearing strange when they surface partly because they exceed dominant semiotic patterns, they remain nonetheless, and the recognition of these structuring principles alongside others in sites of unique cultural emergence throughout the Africana southern world helps to explain the catalytic power of strange Souths.

In thinking through the ways that Black women artists engage with these sites, *The Souths in Her* is indebted to and extends conversations in Black and performance studies. Insights from these fields make clear, for example, that Black women artists' encounters with strange Souths are characterized by transfer rather than rooting. Given the brutal rupture that undergirds the invention and ongoing production of Blackness, Rinaldo Walcott extends Wynter's meditation on Indigenization with his argument that "understandings of land, place, indigeneity, and belonging" are troubled, making it perhaps necessary to consider Indigeneity "as more a flexible process of critique and resistance to modernity" than as "an organic identity."[50] The idea of a moving, resistant emergence is one that Alice Walker imagines her foremothers embracing when she notes that their metaphorical gardens constitute sites through which they intended to "han[d] on the creative spark, the seed of the flower they themselves never hoped to see; or . . . a sealed letter they could not plainly read."[51]

While Glissant similarly argues that the Africana cultures and poetics that emerge from the trauma of the Middle Passage and plantation are not rooted but rather rhizomatic, the women in this study, enclosed in a frame of "hereditary darkness," find that they are silenced by the fixed grammar of the informed structure that emerges, a structure informed by the dominant expressive and hierarchical womb abyss. They instead require access to an "overwhelming, messy," and at times "intangible" "performativity in flux"—a method of relation and practice of poesis that I call in the book's conclusion the muck horizon—which allows them to incorporate information and means of expressing that exceed the dominant poetics that follow the abyss.[52] As a methodological way forward, the muck horizon paradigm that emerges at the book's

end allows me to better identify and analyze the shock of the unfamiliar or strange across Africana Souths, the nonutopic grappling that ensues within the tense interstices at these sites prior to transmutation, and to appreciate the allure of the cloudiness that results from the earth being kicked up by the water's impact. Embraced, this cloudiness or opaqueness requires the artist to use the full battery of their senses to reimagine how to express their insights and thus expand the potentialities of storytelling. Movements across Africana Souths and encounters with strange disruptive elements—movements recalling those of mati during the Middle Passage—open possibilities for the formation of new "webs of affiliation," which offer promising "contexts for rethinking blackness" that center the "practice of exchange" with an understanding of diaspora emerging via written and embodied practices.[53] With the autopoietic spell of the abyss frame broken, Shange notes, for example, that she recognizes a need to fix her "tool" to fit her contemplative and expressive needs: "i have to take it apart to the bone / so that the malignancies / fall away / leaving us space to literally create our own image."[54] A central component of the work of each of the authors and choreographers profiled in this book is the reclamation and reorientation of both embodied and text-based tools for articulation. Performances in and of what Daphne Brooks calls spectacular opacity prove promising for the women in this study in part because of the layered, shifting, polyphonic nature of Black performance, enabling each artist to "confound and disrupt conventional constructions of the racialized and gendered body" that heretofore resulted in silencing.[55] This work leads to embodied expression of the kind that Cox refers to as choreography in its "most radical sense," the kind that "can disrupt and discredit normative reading practices that assess young Black women's bodies as undesirable, dangerous, captive, or out of place."[56] Shange begins to break abyss semiotics, for example, when, immersed in the collective opacity provided by women's collectives representing the hemispheric South, she realizes that she could "start a phrase with a word and end with a gesture."[57] From this point on, Shange's praxis is driven by a recognition that the expression issuing forth from her formerly denigrated body and her undervalued insights captured in writing did not operate on separate, differently valued planes. Merged, they constitute a powerful tool that allows a new story to be told.

POETICS OF TRANSMUTATION

As the case studies that follow illuminate, Black women writers' and choreographers' encounters with unfamiliar expressive elements within and across Africana Souths make plain the limitations of imposed frames—framing that necessitates a negotiation with both the written archive and the performed repertoire. Each chapter of *The Souths in Her* considers the ways that two artists uniquely move away from a shared framing predicament and toward what will become the third stage of transmutation—the emergence of a collectively crafted poetics (if a mosaic of individual contributions). Chapters 1 and 3 focus heavily on how movement through and negotiations within unfamiliar Africana Souths have affected the formation of new expressive processes, and chapters 2 and 4 focus more intently on the ways that each artist's travels and new poetics play out in their formal written and choreographed innovation. I necessarily engage archival texts and/or life writing in each chapter to examine how geographical, cultural, generic, and/or formal border crossings and encounters with the southern unfamiliar have affected each artist's expression. This focus informs my approach to each author's and choreographer's work, as well as my recognition that new creative principles directly informed by Souths undergird the poetics of transmutation that emerges.

Chapter 1, "On Authoritative Wandering: Hurston and Dunham," asks: Who has the authority to tell individual and collective stories of Black life? Both Zora Neale Hurston and Katherine Dunham encounter extractive challenges based on what their bodies are believed to provide special access to, but neither is considered authorized to tell the stories of what she finds. Through an engagement with the unfamiliar religious and expressive elements they encounter in the United States and Haiti—travel they access as anthropologists—both artists develop innovative methods of telling the stories of themselves and their communities. Engagement with Haitian Vodou in particular grants Hurston and Dunham tools for piercing autopoietic frames embedded in anthropology, religion, and expressive genres. Each artist, empowered by southern cultural elements and Vodou cosmology, creates models that enable the Black woman to "say" herself.

Chapter 2, "On Dynamic Suggestion: Hurston and McIntyre," takes seriously Glissant's suggestion that folk expression introduces hopeful if

challenging possibilities for communities that look to avoid being subsumed by hierarchies that locate them outside the contemporary moment. This chapter considers how folk expression operates as an important creative site of origin for what will become the Black archive and repertoire, and it asks what happens when the possibility to participate in these ongoing creative processes proves elusive for Black women. As a Black southerner, Hurston unsettles the notion of telos; writing against her New Negro contemporaries, she does not understand a linear movement from the North to the South (whether her own or the ways that southern folklore moves) as any kind of progress. Instead, for her the crosscurrents of community are continuously under investigation and revision. However, she finds that both in the North and South, Black women lack a platform through which to contribute to the innovative folklore that is impacting creative activity in both spaces. Continuing the discussion of Hurston's expanded expressive framework in chapter 1, this chapter first examines her development of dynamic suggestion as a method of preservation by which she embeds Black women's insights into the folk archives and repertoires of Black life. I then consider how Hurston's embedding of dynamic suggestion into her writing enables her to craft a text-based strange South with the novel *Their Eyes Were Watching God* (1937). Nearly fifty years later, Dianne McIntyre inherits and extends the work that Hurston started with *Their Eyes Were Watching God: An Adventure in Southern Blues*. I argue that through the deployment of *Their Eyes* as a site of narrative preservation and reflection, Hurston and McIntyre extend a nonhierarchical poetics that consists of cycles of dynamic suggestion and porous absorption: cycles located at the meeting of observer and art maker and of artist and audience, in which artists promote audience participation by "gripping the beholder[s]" and compelling them to "finish the action the performer suggests," while the audience, locating its own expression, meets, completes, and passes a merged expression forward.[58] In so doing, Hurston and McIntyre intercept prominent loci of the exclusion of Black women and enact a poetics of transmutation by embedding their voices and experiences into the source texts and performances that constitute the archive and repertoire of Black expression that inform the broader Black imaginary.

In the second half of *The Souths in Her*, the artists featured have shifted from seeking methods of incorporation to leveraging the potentials of difference. In chapter 3, "On Unincorporable Strange Sound: Condé and

Shange," I am especially attentive to the implications that the continued building of masculinist subjectivity upon women's silence (carried out by participants in Black radical traditions who see the slave narrative as one origin of the traditions) has upon the relationship between sound, articulation, and meaning-making negotiations in the life writing of Ntozake Shange and Maryse Condé. Condé encounters communication barricades in several African nations from the late 1950s to 1968, and Shange is met with sonic challenges that issue forth from US-based artistic and political movements. Both artists become determined to make their expressive language(s) "strange," a process inspired for both by encounters with unfamiliar sonic Souths. Analysis of Condé's *What Is Africa to Me?*, Shange's *lost in language & sound: or how I found my way to the arts*, and archival documents and interviews is key to deciphering the sonic initiations that both artists undergo and that help them locate slippages at the nexus of languages and genres and perform what Urayoán Noel calls the "un/incorporable." As this chapter demonstrates, the embrace and cultivation of illegible or strange sound help both authors break language, or at least transmute the hold that it and the aesthetic rules governing its use have on their ability to actively negotiate relation and meaning with their audiences.

Chapter 4, "On Autofictional Subjectivity: Condé and Kincaid," extends issues raised in the preceding chapters by examining the opportunities and limitations of the semiotics of the Black mother. This chapter asks, How should we approach and interrogate our mother's gardens and provision plots—particularly when they've been narratively encoded as sites of loss and disavowal? What emerges is a multifaceted presentation of autofictional subjectivity as an essential site of emergence that allows for the maintenance of a Black women's poetics of refusal and living. Condé (*Windward Heights, Desirada*) and Kincaid (*The Autobiography of My Mother, See Now Then*) present the problem of monstrous inheritance for the Caribbean woman, and they draw attention to its impact on the semiotics of the Black mother—or what the Black woman vis-à-vis the monstrous Black mother's inheritances "means" when inheritances bared and transmitted from mother to child reflect the afterlives of *partus sequitur ventrem*.

In their movement from the Caribbean to the United States as a strange South, Condé and Kincaid leverage what Carole Boyce Davies calls a "slipperiness, elsewhereness" that allows for a "path of movement outside the terms of dominant discourses." As they meld formal elements of fiction

with the conventions of autobiography, they craft an approach that allows for an extension of the aforementioned slipperiness to the expressive, literary space, enabling a movement beyond the monstrous inheritance and toward a new way of telling the Black female Caribbean self. I argue that by leveraging autofictional subjectivities, Condé and Kincaid create distinct yet related narrative worlds that illustrate the promise of rerouted (relational and internal) relations.

The book concludes with "On Muck Horizons," a brief chapter that examines how artists such as the US-based visual artist Allison Janae Hamilton (*Floridawater II* [2019]), the dance collective Urban Bush Women (*Haint Blu*), and the Nigerian-born Igbo and Tamil writer Akwaeki Emezi (*Dear Senthuran*) engage and extend the poetics set into motion by Hurston, Dunham, McIntyre, Shange, Kincaid, and Condé. Each contemporary artist's physical and imaginative engagement with multiple Souths presents a new set of questions that extend the work of *The Souths in Her*. The concluding chapter synthesizes the book's findings and implications and suggests new directions for future inquiries.

The catalyzing Africana Souths that the artists in this study encounter—like Wynter's provision plots—obscure and provide shelter for what is unknowable in Western systems, making them apt spaces for preserving southern-forged information on expansive worlding and expressing. Abyss framing also follows women to these spaces, challenging their ability to participate in or to be recognized as co-crafters of these worlds. But as Alice Walker's mother's gardens (a reference to the mundane, often-overlooked sites that reveal that the creativity of centuries of "our mothers and grandmothers, *ourselves*" has not "perished in the wilderness") illustrate, they also encompass "wild and unlikely places" that nourish and preserve this creativity.[59] In following the mati Middle Passage relations to Wynter's provision plots to Walker's mothers' gardens, another Africana southern genealogy emerges. *The Souths in Her* details Black women artists' crafting of a poetics informed by strange Souths that ultimately expands the stories of Black life that can be imagined and told.

1

ON AUTHORITATIVE WANDERING

Hurston and Dunham

In order to create a movement, we have to be conscious of what makes that movement move or makes it static, makes it give forth this energy. We have to know.

—KATHERINE DUNHAM

The filmmaker and multidisciplinary artist Ja'Tovia Gary's 2015 film *An Ecstatic Experience* explores historical narratives through animation. By the time Gary takes up the formerly enslaved Fannie Moore's account of her mother Rachel's transcendental story, it has passed through numerous frames. Both Fannie's and, by extension, her mother Rachel Moore's stories have survived the well-documented limitations of the WPA slave narrative project, during which they were subject to manipulation influenced by racial bias and were mediated by the pens and typewriters of their interviewers.[1] The actor and filmmaker Ossie Davis also revisits Fannie's narrative in his 1965 television miniseries focused on the history of Black life in the United States, in which the actress Ruby Dee portrays Moore. Emblematic of the shifting points of view through which the Moore women's stories have passed, Gary, building on Ossie Davis's live action revision of Fannie's story, uses 16-millimeter direct animation and hand-etches each frame to portray Fannie Moore's face being surrounded by an ever-shifting frame.[2]

This is potent work in which the powerful center of the account is Rachel Moore's frame-shifting moment when she transcends her immediate circumstances, imagines a world beyond the confines of the plantation that encloses her, and reclaims her voice as she transmutes her scream.[3] Like her family and friends who are forced to toil in subjection, Rachel Moore longs for a means to move herself and her children away from the Moore Plantation in Moore, South Carolina. As on many plantations, enslavers desire to control not only the expression of the enslaved but also their relationship to the divine. As Fannie Moore explains, these relationships were heavily mediated: The enslaved in her community were to sit in the back of White churches and worship a God framed for them by their enslavers. However, Moore reveals a clandestine practice that allowed for an unmediated relationship with the divine: prayer meetings in the woods.

This direct contact with the divine in a secret location within the Africana southern tradition—a space deeply rooted in African spiritual practices adapted by enslaved people—likely catalyzes Rachel Moore's puncturing of the plantation-enforced cosmological frame. As Fannie recounts, one day her mother begins singing, shouting, and "whoopin' an' a hollowin,'" an outburst that is met with a vicious rebuke upon her return home that evening. Interviewer Marjorie Jones writes that the plantation owner's mother, "ole granny Moore," approaches Rachel and demands: "What all dat goin' on in de fiel? Yo' think we sen' you out there jes to whoop and yell? No siree, we put you out there to work and you sho' bettah work, else we git de overseeah to cowhide you ole black back. "[4] In response to the lashes, Rachel withholds the scream that confirms the power dynamic between the enslaved and enslaver. She explains that she will be free, and she redirects her voice to her own uses: cathartic singing. While ole granny Moore verbally and physically reinforces Rachel's position as a less-than-human, unrefined foil to White ladyhood, Rachel's response reveals a striking shift in her ability to discern possibilities and to speak an alternative reality that exceeds the plantation frame. Suddenly, Moore's voice becomes more than just an expression of pain; it becomes a powerful act of self-reclamation.

Gary's animation also explores both the limitations and possibilities of these frames. For example, she conveys a sense of enclosure by surrounding the speaking Moore's (played by Dee) face with several lines suggesting a box. This effect becomes particularly pronounced when Moore discusses

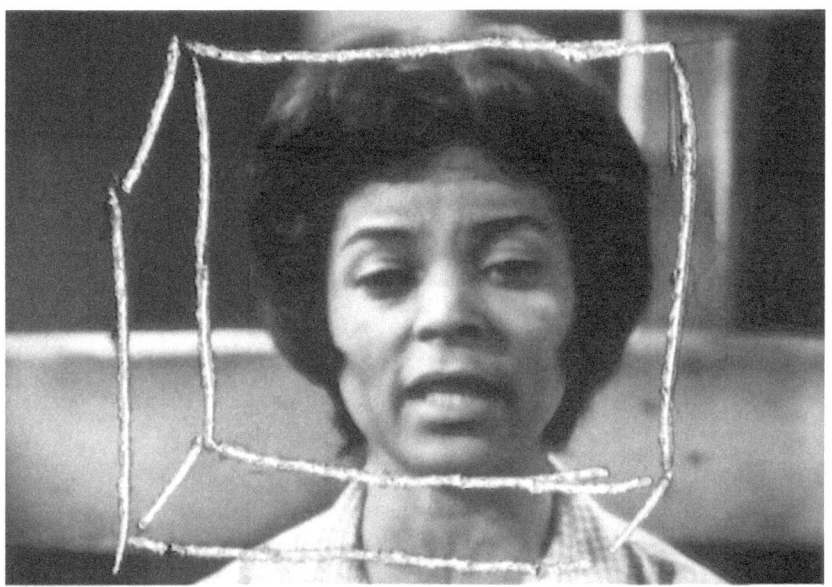
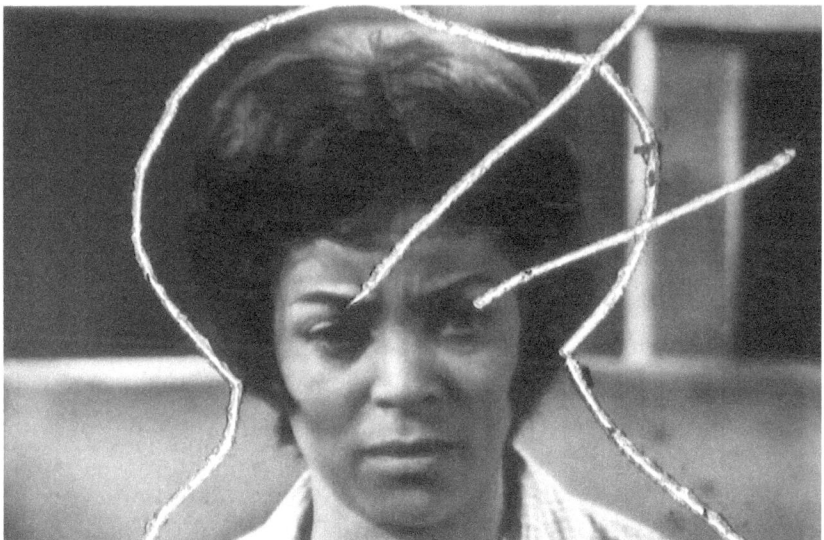

FIGURE 1.1 Two stills from Ja'Tovia Gary, *An Ecstatic Experience*, 2015, single-channel, digitized 16-mm film, 6 minutes, looped, color/black & white.

Source: Courtesy of Ja'Tovia Gary and Paula Cooper Gallery.

the strictures of the plantation. Alternately, when she describes her mother's ecstatic experience, Fannie Moore is surrounded by a curved line that suggests expanded vision. As Fannie recalls Rachel's assured response, lines emerge from her eyes, indicating a shift in focus and a transfer of an expanded vision to others. When the camera pans out, three adult listeners come into view, and the audience is made aware that Fannie is speaking to the others while etched lines bore from their eyes into her, further suggesting a transfer of her experience and expanded vision to the community. Gary's animated frames and lines, combined with the placement of Fannie Moore's narrative amid contemporary videos that document ongoing racism, force the audience to confront the dominant conceptual frames that emerge from the womb abyss, a metaphor for the deep-seated, inherited societal frames that continue to restrict our understanding of Black women's subjectivity, enclosing them within limiting and often dehumanizing narratives.[5] Black women become stubbornly framed by this abyss and represent "the ejection, the abjection, by, on, through, which the system reimagines and reconstitutes itself."[6] This frame affects both our understanding of Black women's expression and their creative processes.

With Gary's 2015 treatment, Fannie Moore's—and by extension, her mother Rachel's—story restores some authority and agency for both figures: Their stories return most closely to a saying of the self. Gary, born and raised in Texas, notes that her own southernness, central to her performance-influenced approach to interrogating the afterlives of slavery, means that her practice is grounded in an "ethic of care." She considers what it means, for example, to engage the text for an extended duration: how the time spent hand-etching the footage allows for a deep consideration of the context and archives it emerges from. She approaches narratives such as Fannie Moore's with a probing interest in power differentials: Who, she asks, gets to classify, aggregate, film, and photograph which stories eventually constitute the archive? In other words, Gary asks us to consider who is authorized to tell the stories that will be passed on. In Gary's hands, the footage, focused primarily on the moment that Rachel Moore claimed this right for herself, becomes a "refusal of the original condition," a "constant making and remaking" of the material that, following the work of Ruby Dee, moves the narrative ever closer to the Black woman's perspective that it emerged from.[7]

Moore's narrative is recorded in 1937, a year that coincides with the frame-transcending experiences of the anthropologist-writer Zora Neale Hurston and the anthropologist-choreographer Katherine Dunham. Though born after emancipation and generations younger, Hurston and Dunham encounter challenges to their intellectual and artistic authority that resonate closely with Fannie's and Rachel's experiences. Like Rachel, Hurston and Dunham also experience a cosmological shift that disrupts and ultimately expands their perceptions of their authority. These experiences shape their engagement with the field of anthropology and with the expressive worlds of the folk, literature, and dance, which lead them to pose questions like those raised by Gary about who is authorized to chronicle and participate in crafting a culture's story.

In this chapter, I examine how Hurston's and Dunham's personal engagement with anthropology and southern folk culture helps them to move beyond challenges encountered by earlier generations of Black women artists to form new storytelling frameworks. I illuminate their proto-Black feminist narrative innovations by examining each artist's biographical information alongside her writing and choreography. This approach allows me to emphasize how their respective intellectual and spiritual journeys led both women to rethink the transcendent potential of their bodies. Embracing corporeality as a vehicle for divine experience, they embarked on a journey of transmutation in which the notion of their primitivity and thus stasis and "hereditary darkness" was disrupted. By working through troubling racist and sexist narratives that associated Black women with these notions of "hereditary darkness," Hurston and Dunham approach a transcendence of the disempowering framing reinforced in their anthropological training and social educations—stories told by others that limited how they were perceived and where they imagined creative and intellectual authority was located. Hurston's and Dunham's journeys provide insight into how Africana Souths might function in the work of Black dance and literary artists to enable a poetics of transmutation, where the abject can be converted to the role of creator. This transmutation requires a deep engagement with the unfamiliar religious and expressive elements they encounter while wandering across Africana Souths, and it is on this basis that they develop innovative methods of saying themselves and their communities.

I argue that through direct engagement with Africana southern folk and religious cultures in the United States and Haiti, where each artist encounters worldview-shifting practices that persist alongside and despite the trauma and subjection of the plantation and the afterlives of slavery, Hurston and Dunham disrupt and reconfigure creative and cultural organizing principles informed by the womb abyss as they are embedded in and shape anthropology, religion, and expressive genres. Their experiences with unfamiliar cosmologies enable them to pierce autopoietic frames, which in turn enables each artist to counter the limited cultural representations of Black women. By redefining the narratives around Black womanhood, Hurston and Dunham reclaim the power to narrate their own experiences, thereby establishing renewed and empowered storytelling. Furthermore, by adapting the tools of anthropology to meet their needs, they create expressive frameworks for embedding Black American women's insights and expression into recordings of African American folk narratives, modern dance vocabularies, and Africana expressive culture more broadly. Empowered by Black southern cultural elements and inclusive Haitian Vodou cosmology, Hurston and Dunham disrupt—if at times imperfectly—the practice of Black women being represented by others, and they replace this practice with models of the Black woman saying herself. Rather than remaining the primitive subject of others' framing, Hurston and Dunham craft frame-shifting strategies for becoming central agents in storytelling.

WANDERING AND SELF-RECLAMATION

WPA narratives, such as Marjorie Jones's recording of Moore's story, can be understood as part of a longer tradition of written representation of the "other" that includes written accounts such as the colonial travelogues and anthropological writings that have historically framed non-Western cultures as primitive and limited. These documents set the terms for, as Audra Simpson discusses in the Indigenous context, "a story that is always being told," illustrating how a people is "not only comprehended but *apprehended* in these literatures."[8] Such storytelling affects not only the development of racial and gendered hierarchies but also the impression

of who is authorized to speak.⁹ This practice is in full swing in the 1930s, when participants in the flourishing New Negro Movement, Southern Renaissance writers, Boasian anthropologists, and writers involved in representing the so-called New South in the Southern Renaissance Literature Movement all have their own mythmaking projects well under way.

In the early twentieth century, social scientists trained and influenced by Franz Boas contested evolutionist views on human origin, race, and culture. During this period, the field of anthropology flourished, and its practitioners were deeply interested in preserving so-called primitive cultures, which they considered at risk of extinction. Although progressive in challenging racial hierarchies, these figures still held underlying anxieties about cultural evolution that subtly reinforced the notion that these cultures were temporally and developmentally behind Western civilization. Even with Boas's (and his students') revolutionary approaches to the study of Black and Brown cultures—they took care, for example, to avoid hierarchical thinking through his directive "to strip the idea of primitive society of its pejorative descriptors and define it simply as a society without a written language"—they continue to undergird the notion of progression and proximity to the current moment versus the past given the continued privileging of the written word and its elevated value.¹⁰ Wealthy patrons were invested in gathering Black southern folk material because they, like anthropologists, were anxious that the advent of modernity would eradicate this expression, which they believed was endowed with a special power. In the early nineteenth century, antislavery crusaders often argued that "Negroes were a primitive people who were more highly endowed with emotions than with intellect and therefore . . . more religiously devout and artistic than white people," a notion that resonates with views held by figures like Charlotte Osgood Mason, a wealthy heiress and patron of several Harlem Renaissance artists, who believed that rural Black culture contained a necessary essence for combating the ills of modernity.¹¹ However, patrons such as Mason looked to maintain power over the dissemination of the artists' expression. In her work with Zora Neale Hurston, for example, Mason placed strict contractual limitations that gave her control over how the material Hurston collected would be presented to the public, thereby restricting Hurston's ability to freely use her work in her publications.

As Zora Neale Hurston reminds us, Black southern folk culture is not a thing of the past but of modernity: It is ever in the making.¹² However,

during this period, artists, theorists, anthropologists, and many White southern writers are all concurrently publishing work that suggests otherwise. As such, southern Black folk and religious expression generated in the United States and beyond—including that produced in Haiti—continues to be perceived as occupying the space of the primitive against which the aforementioned groups, despite their varied stances, define themselves as new or modern. Both Black US southern cultures and Haiti have been subjected to colonialist and racist narratives and have borne simplistic, reductive labels that mark their inhabitants as static and primitive. As Imani Owens and Mary Renda note, a continued proliferation of writing about "the other" in the form of travel writing follows the US occupation of Haiti. These works "contained lurid accounts of Vodou rites, offensive illustrations, and other content that emphasized the primitivism of Haitian culture." They also set the stage for the proliferation of myths about the Haitian people and their folk practices. As Owens notes, these works also, notably, "'stimulated the dramatic turn' to Haiti in U.S. anthropology," a turn that prompted American anthropologists to resort to a new genre. The ethnography—a genre that centered participant observation—enabled these anthropologists to "distanc[e] themselves from these sensationalist accounts."[13] Both Hurston and Dunham challenge these reductive views and reclaim these Souths as active, living sites of cultural production and resistance rather than static, primitive backdrops.

Zora Neale Hurston and Katherine Dunham began their anthropological studies during this period of heightened interest in telling stories of "the other." Both have noted that they were motivated to join the field partly to push back against what Édouard Glissant describes as "folklorization": a process in which an elite group perceived as socially superior to the culture they are representing "'go into' the countryside" to observe a culture's expressions and rituals, and in turn present them prominently in the name of tourism, for example, while their creators are silenced. When folk expression is thus emptied of dignity and context, it becomes viewed as belonging to the past and not the present.[14] Hurston's and Dunham's engagement with anthropology and their written and embodied representations of themselves and of Africana southern culture that follow, though at times notably riddled with missteps, begin to strikes an important blow against these multiple extractive modes of representing "the other" in the United States and the Caribbean.

As both are aware, folklorization occurs across the multiple communities they traverse, manifesting in both familiar and unfamiliar guises, and these guises have significant implications for reinforcing the "womb abyss" framing that is tied to static representations of Black women's bodily autonomy. The concept of the "womb abyss" captures the encompassing framing of Black women as sites of cultural extraction, where their bodies and expressions are confined to narratives of otherness and primitivism. While the anthropologists, patrons, and other interested parties that Hurston and Dunham encounter during their respective journeys appear to celebrate the silenced groups, they are in fact using these groups' expression in the service of their own goals and subjectivities, including but not limited to using Black women's bodies to gain unprecedented access into Black national and international communities. However, both Black women and Africana southern Black culture writ large are discussed as needing mending and preserving from without, and as such, Black women are not endowed with the same level of authority granted to their White or male counterparts to tell the stories of Black people. The nuance of Black women's lives and experiences continues to be written out of the histories of Africana Souths.

By the 1930s, despite the pioneering work of women like Anna Julia Cooper, US and broader Africana southern geographies and their perceived primitivity are frequently aligned with Black womanhood. These stereotypes are often reinforced by cultural narratives that portray Black women as existing outside of modernity. Myths affixed to female participants in the Great Migration illustrate this alignment. Many residents of the Black urban North and Midwest believe that Black women migrants needed not only protection from new predators but also reform—that they had to learn to perform a presumably new sexual chasteness. As such, womb abyss framing and its attendant assumptions follow Black women from the American South to their new metropolitan locations. For many—White or Black, from the North or South—Black women are often perceived in the same way as their enslaved ancestors. Whether drawing on stereotypes of the loyal degraded servant or the hypersexualized primitive, this perception informs how Black women were represented and how various groups used these portrayals for their own purposes.

This representation makes Hurston's and Dunham's leveraging of the tools of anthropology in their own spiritual and intellectual wandering

even more critical. For Hurston and Dunham, wandering transcends physical movement; it is a recovery of hidden and suppressed narratives that connect Black women across the diaspora. As Marina Magloire notes, "Black feminism has, from its seedlings, been activated by travel and its productive tensions."[15] Although at times imperfect, Hurston's and Dunham's purposeful wandering enables them to begin to disrupt these stories of Black women's movement and replace them with insights from a moving Black woman.

However, Hurston and Dunham encounter additional limiting myths while wandering with anthropology. Race- and gender-based biases are evident in the writings of the field's leading scholars. A letter from the American anthropologist Melville Herskovits to the German ethnologist Erich von Hornbostel illustrates how this racism becomes relevant in relation to Hurston. During a period when his views about African cultural "survivals" begin to shift, a shift that coincides with Hurston's arrival at a similar position, instead of defending his new views by engaging Hurston's work and thoughts, Herskovits chooses to hyperfocus on her physical attributes. In the letter, he presents his observations of Hurston's motor behavior and gestures as support for his burgeoning argument. He characterizes Hurston as something of a "'technical' Negro," a person who in skin color and behavior cannot be distinguished from White people at a glance, and he shares that she is indeed representative of the African "as far as her manner of speech, her expressions,—in short, her motor behavior—are concerned."[16] As Herskovits makes clear, the body of the Black woman is consistently understood as representing primitivity. No matter what her level of educational or artistic achievement is, Hurston slips nimbly into the embodied symbol of what exists outside of modernity. This characterization has important implications for Black women's ability to participate in—or to be perceived as participants in—contemporary creative or intellectual discourse. As Herskovits makes clear in his letter, whether in the field or in the ivory tower, Black women are believed to provide a privileged access to what is considered primitive, and anthropologists like himself claim the authority to define their meaning at will. As the southern-born Hurston and midwestern-born Dunham wander across the United States and the Caribbean, as well as through northern academic and creative circles, they are regularly reminded that their bodies are made to speak before they have the chance to speak for themselves.

Nonetheless, with movement across the United States and Haiti made possible in large part through their engagement with anthropology, Hurston and Dunham experience unmediated access to unfamiliar folk and religious cultural elements that help them recognize and dislodge the autopoietic elements embedded in the religious, academic, and cultural stories they've been told about themselves. As they journey through these "Souths," both literally and metaphorically, they confront and challenge the limited frameworks that confine Black women's cultural and artistic expressions to the margins, allowing them to reclaim and redefine their identities. This work is key for disrupting the power that these entrenched stories and stereotypes hold, for, as Sylvia Wynter argues, humans are a hybrid storytelling species, both bios (referring to biological genetic codes) and mythoi (referring to nongenetically chartered origin myths and stories), and taken collectively, this "hybrid sociogenic" programming, embedded in stories, plays a central role in the human consciousness and in the cosmologies that govern our perceptions of what is possible. These story-influenced cosmologies become stubborn frames that undergird hierarchies that determine who, for example, counts as human and who is an insider or outsider. The stories that govern our understanding and defining of the human, and of the hierarchies and communities we imagine ourselves as being part of, are the same stories that, reinforced by systems of religion, learning, and economic status, bolster the oppression projected onto people who find themselves on the subhuman portion of the scale. This oppression, of course, has a direct impact on who can even consider themselves endowed with the authority to tell their own story.

Applying Wynter's insights to a study on women that find it necessary to probe the nexus of Africana southern myth and anthropology helps to illuminate an additional limitation: Like those of the anthropologists, artists, and sponsors they encounter, Black women's imaginaries are also affected, making all the more urgent Wynter's call for the "climbing out" of autopoietic frames to allow for an imagining beyond.[17] Initially as each artist breaks convention in her own wandering through a number of Souths, literally and figuratively, Hurston and Dunham remain ensnared in narratives of primitivity. It takes an encounter with Haitian Vodou—an unfamiliar Africana southern cosmology—and its associated collective narrative creation practice for both to most fully disrupt the constructed seams of their enclosure and embrace their authority.

Leveraging the tools of anthropology, writing, and dance, Hurston's and Dunham's direct access to Africana southern cultural elements disrupts their interest in meeting expectations that they serve as access points for others' exploration into Africana southern culture. This disruption, in turn, enables them to claim their authority to both chronicle and express their own stories, as well as those of Africana southern culture more broadly. The creation of an expressive mode that combines insights gained from their wandering, from methodologies of anthropology, and from transcorporeal Vodou cosmology—itself a mode of wandering involving the body, soul, divine, and community—allows them to embed their insights into narratives about themselves and the broader Africana South. It also allows for the saying of themselves.[18]

HURSTON'S SOUTHS

Although Hurston is often accused of contradicting herself, she remains resolute on at least one point: The persistent alignment of Africana Souths with sorrow is worrisome and does not align with her experiences. In 1928 she declares, "I am not tragically colored. There is no great sorrow dammed up in my soul, nor lurking behind my eyes." In the essay "Art and Such" (1938), Hurston laments the expectations placed on the Black artist to "weave something in his particular art form about the Race problem": expectations that she believes perpetuate the problem.[19] She points to an early expressive tradition that Lindsey Stewart calls "neo-abolitionism," in which the Black body is ventriloquized for White liberal aims.[20] Both Hurston and Stewart locate Frederick Douglass as a key example. Hurston calls him the legitimate "original pattern" that the troublesome "Race Champions," spreading the gospel of the "race problem," follow.[21] Stewart illustrates the issues Douglass encounters in establishing the pattern, noting that "in his *My Bondage and My Freedom*, Frederick Douglass is explicit about the racism he faced within the abolitionist movement. Douglass tells us that white abolitionists insisted that he continue to play 'the slave,' even after his successful escape. Instead of being encouraged to tell his own story, Douglass's scarred Black body was used by white abolitionists as a 'text' to confirm the 'truth' of their cause."[22] In "What

White Publishers Won't Print," published nearer the end of her career (*Negro Digest*, 1950), Hurston airs a continued irritation around these stories "always being told" that reinforce stereotypes about Black people. She argues that instead, and "for the national welfare, it is urgent to realize that the minorities do think, and think about something other than the race problem," and that an apt disruption of this story cycle would be a shift to featuring "the average, struggling, non-morbid Negro" who for her is "the best-kept secret in America."[23] As Hurston would go on to argue throughout her career, such impositions left no room for entire groups of Black people to speak for themselves—namely, Black southerners who had long been aligned with sorrow or portrayed as "objects of pity." Growing up in Eatonville, Florida—one of the oldest Black-incorporated (in 1887) municipalities in the United States—would have imparted a unique sense of southern Black autonomy and joy to Hurston. It is in Eatonville that she received her earliest lessons on storytelling and its potentials and limitations. The porch of Joe Clark, the Eatonville cofounder and store owner, was central to this formation. For Hurston, Clark's porch was the "heart and spring of the town" and the site where she would learn "the primary language of her own literature, the vital force of her life as a storyteller."[24] The porch was the primary site for the communal working through and explaining of the towns' residents' world and the stage for the forging and sharing of folklore and songs that gave language to these findings. It is also in Eatonville that Hurton's comes to understand how Black women could navigate and participate in the world—where the frame governing her imaginary was shaped—for better or worse. As Hurston recalls, "There was open kindness, anger, hate, love, envy and its kinfolks, but all emotions were naked and nakedly arrived at," including men's "brag[ging] about beating their wives."[25] Hurston was enamored by what for her was the creation and sharing of storytelling genius that played out in the primarily male homosocial space. Her observations of the discussions on Clark's front porch—filled with the exchange of folklore, lively games of the dozens, and also open misogyny dictating the boundaries of women's lives—would figure prominently in her creative output.

While Clark's porch teaches Hurston that women can only occasionally engage in its collective narrative worldmaking, these lessons are reinforced by the activities playing out on the different stages she is exposed to during her youth. For example, Hurston gains an intimate view of the

power of the pulpit via her father, a Baptist preacher. Not only does John and his fellow preachers bring stories about "God, the Devil, animals and natural elements" to the Hurstons' front porch, but as a preacher, John Hurston enjoys a great deal of mobility—geographically and sexually—a mobility that is not extended to her mother Lucy Potts.[26] As the author will later famously recall in *Mules and Men*, Eatonville also taught her about what she will call "feather-bed resistance": the methods that Black people used to navigate "nosy (white) anthropologists. . . . Anthropologists who had their own stories about the people they were studying. . . . stories [that] prophesied . . . (southern) racial tragedy for African Americans." By smiling and "tell[ing] him or her something that satisfies the white person because, knowing so little about us, he doesn't know what he is missing," as Hurston illustrates, Black southerners "maintain some sense of sovereignty over their representations" by crafting what Audra Simpson calls an "ethnographic limit."[27]

Taken collectively, lessons from Clark's porch on the power of (and exclusions from) the crafting of Black folklore, mythology, and the potentials of religion coalesce to inform Hurston's eventual development as a storyteller. Although Eatonville could partly be understood as akin to a more contemporary version of Sylvia Wynter's provision plot, it is also clear that womb abyss framing has invaded this space. However, the provision plot maintains its status as a site of potential transformation. Indeed, Hurston's ability to both challenge and navigate abyss framing allows her to begin redefining Black women's place within the broader tapestry of Africana southern culture. While Hurston marvels at the ability of the folktale spinner or the preacher to weave worlds, she also receives lessons on the limitations of participating in these spaces for Black women. However, despite their exclusionary challenges, Hurston recognizes something compelling in each of these storytelling practices.

WANDERING AND PERSONAL MYTHMAKING

The death of Hurston's mother inaugurates a period of what she describes as "wanderings" that occur "not so much in geography, but in time. Then not so much in time as in spirit."[28] This was undoubtedly a painful loss

as, after all, Lucy Potts Hurston supported her daughter's precocious creativity and expressive exuberance, even as her father and grandmother worked to quell these qualities. It also brought on unexpected hardship because her father relinquished financial responsibility immediately after he remarried. However, Hurston's geographical movement begins here as well—movement that initially exposes her to new confrontations with racial and gender politics.[29] Her exhaustion with these experiences will lead Hurston to recognize the potentials that meet at the intersection of mythmaking and embodiment.

As Hurston learns from observing her traveling father and ever-present mother, wandering was the prerogative of men. A young Hurston would often gaze at the horizon and along the road in front of her home, yearning for the kind of freedom and mobility that her father enjoyed. Later, Hurston's use of the word "wandering" to label her movement in the 1910s is provocative and suggestive of gendered subversion. In the context of the Great Migration, which was well under way, this language is used to describe the movement patterns of male migrants—either from rural to urban Souths or from the South to the North—while Black women migrants are generally described as having a clear, predetermined destination, often the home of a family member or family friend, or an "uplift" organization like Victoria Earle Matthews's White Rose Mission. In this way, mobility for Black women is carefully circumscribed as they move directly from point A to point B, and this movement illustrates both their vulnerability and the abbreviated perception of their frame of movement.[30] In 1916, Hurston takes a chance on personal mythmaking that results in purposeful travel. She has grown tired of navigating false starts and the varied politics of other folks' households, where she is forced to fend off unwanted sexual advances while working as domestic help. She is also frustrated by having missed out on decent employment opportunities because of her youth. During an interview for a job as a performer's maid with a Gilbert & Sullivan light opera touring troupe, Hurston portrays herself as older to secure the position. In this way, Hurston's personal mythmaking creates a mode of transportation that enables her to wander through the country with the troupe, and, through an early storytelling innovation using a scrapbook and the call board, she experiments with melding her Black, female, southern voice into a larger collaborative storytelling structure. This effort marks her earliest experiments with a

collective mythmaking structure that she observed but was barred from participating in on Joe Clark's porch.

After her time with the troupe, Hurston disembarks in Baltimore, and once again she alters her age so that she can attend Morgan Academy and Howard University. At these institutions, she encounters what Imani Perry calls HBCU Souths: "the tight network of Black life that Black colleges and universities make" and that constitute "a southern thing, even if it's not always precisely happening in the South. These institutions built up from the striving and hoping of freedpeople, under the constant threat of . . . violence, training against the odds of doors ever opening, are home places."[31] For Hurston, Morgan and Howard provide diverse Black communities reminiscent of those in her home state of Florida. Despite facing continued challenges like harassment at her places of employment, Hurston thrives in the intellectual and artistic environments that these HBCUs provide.[32]

These institutions also give Hurston access to what W. E. B. Du Bois calls the talented tenth: solidly middle-class, classically educated Black people and their children (for Du Bois—more specifically their sons) that he argues will lead and uplift the less fortunate Black masses. Hurston has important intellectual exchanges with classmates and professors from this class. For example, she immediately aligns herself with the writing and theater communities on campus, including the staff of the campus literary magazine *Stylus* (founded by Alain Locke), and she becomes a fixture at Georgia Douglass Johnson's literary salons, where she joins the likes of Du Bois, May Miller, Sterling Brown, and James Weldon Johnson, a group that call themselves the Saturday Nighters. However, instead of being compelled to conform to the wealthy students from elite families that she is now encountering, Hurston embraces her southern, working-class background and her southern folk knowledge. Some of her earliest writing from this period includes the short story "John Redding Goes to Sea," published in 1921, which centers on southern Black life and folkways. In "John Redding," she elaborates on the lessons she learned early on about race, gender, and mobility. However, somewhat oddly, her own youthful desire to wander is now embodied by the protagonist John, and his supporter is his father—a double gender swap that perhaps reflects an ambivalence about women and mobility.[33]

Eventually, concerns with gender become more pronounced in her writing. For example, Hurston's 1924 short story "Drenched in Light" features a young girl named Isis who, like the young Hurston, woos wealthy White visitors with her performances; this character highlights Hurston's prescient focus on Black female expression, censure, and White consumption. Her writing from this period also reveals that she is considering the geographical reach of women's expressive limitations.[34] Hurston begins to develop critiques of Black masculinist theories and stances on the representation of the race. For example, although Hurston publishes some of her earliest work in his *Negro World* magazine in 1922, she satirizes Marcus Garvey in her unpublished 1925 essay "The Emperor Effaces Himself" and in her unstaged musical *Meet the Momma*.[35] Notably, while *Meet the Momma* features movement from the United States to a fictionalized African nation, the Black women characters remain removed from any serious decision-making, are mocked without recourse, and are highly sexualized. Unlike Hurston's own experience, the women remain background actors while the men determine the direction of the action and the national stages on which it will take place.[36]

THE SPYGLASS OF ANTHROPOLOGY

Hurston's concern with Black southerners' ability to speak for themselves intensifies upon her arrival in New York. Here, she moves at the nexus of two communities: the New Negro Movement, which is seeking to escape association with the so-called primitive, and the anthropologists, who are actively seeking the "primitive." As Alice Gambrell notes, "It is possible to map the northwest quadrant of Manhattan, circa 1925, as an intellectual battleground where two competing discourses—anthropological representation of African-American culture, and African-American literary self-representation—had it out, in muted but intensely seriously ways, for a decade or so."[37] Despite being among the most thoroughly conversant of her peers in both worlds, Hurston is left out of many important cross-fertilizing discussions; for example, letters reveal ongoing collaborations between Franz Boas and W. E. B. Du Bois and between Melville

Herskovits and Alain Locke. Instead of being included in these mutually influential discussions that framed approaches to Black culture and art, Hurston is regarded as a mentee and as such is largely excluded from their co-creative, co-theorizing discourse.

Nonetheless, Hurston leverages resources from each group to gather and deeply probe an archive with a particular focus on the intersection between religion and southern folk life and lore. She spends the years 1927–1931 collecting folklore, with her focus increasingly trained on the relationship between performance and religious expression. Her growing concern with religion is registered in her prolific output of short fiction published between 1921 and 1934—particularly in her experiments with the possibilities and limits of biblical language and Africana belief systems. This work is perhaps best showcased in the 1934 publication "Characteristics of Negro Expression," *Jonah's Gourd Vine* (her first novel, 1934), and her first book-length ethnographic study, *Mules and Men* (1935), focused on both folklore and New Orleanian Hoodoo.[38] However, Hurston's epistolary discussions with both Langston Hughes and Franz Boas in 1929 illustrate a depth to her religious investigation that perhaps rivals what we eventually receive in both "Characteristics" and *Mules*. Recently returned to Florida from New Orleans and organizing her notes, she shares observations that illustrate a deep probing and collapsing of religious and social hierarchies. In both letters she discusses, for example, the relationship between baptism and water worship, the relationship between the use of candles in the Catholic Church and fire worship, and other connections between organized religion, nature worship, and oral or literary mythology. Her impulse to comparatively probe these practices is perhaps catalyzed when she witnesses the immediate repercussions of religious hierarchies, such as the criminalization of Africana religious practices in both New Orleans and the Bahamas. On several occasions, her fieldwork is interrupted when practitioners go into hiding to avoid prosecution.

Hurston also begins experimenting with filmmaking during this period, and interestingly, the movement of her camera lens provides a frame that exceeds that of her writing. Autumn Womack suggests that "Characteristics of Negro Expression" could double as a script for the footage she takes from 1927 to 1930. Additionally, I recognize that

Hurston's use of film captures aspects of Black womanhood that go beyond what she explores in her written work. In "Characteristics," the major actors featured in both the "Folklore" and "Culture Heroes" sections are all male, illustrating Mary Helen Washington's point about "an interesting dilemma" that Hurston faced: "The female presence was inherently a critique of the male-dominated folk culture and therefore could not be its heroic representative."[39] Womack discusses, by contrast, footage of a social gathering where, despite the "practiced choreography" and "impressive dance stunts" of a male saxophonist, Hurston's filmic gaze finds a solitary dancing woman more compelling. Similar to another film Hurston recorded in Florida in which her camera lens lingers on a woman lounging joyfully on a porch, the woman pulls the filmmaker's focus and, by directly engaging with the camera, tells her own story. In both instances, the women take center stage and disrupt the idea that Black women are static and primitive. The women in her films move and are very much part of the contemporary moment as they co-create with the filmmaker.

During this period, film is a "nascent ethnographic strategy." It is unfamiliar to Hurston and her colleagues in anthropology and as such comes with no "extant ideology" or clear grammar to follow. This lack of precedent may partly explain Hurston's inability at this point to transfer this frame to her writing, though it also allows for film's potential to "explod[e] and reconstitut[e] the ideological architecture structuring racial knowledge" and to influence her theory of Black expressive practice.[40] Taken together with the car that helps transport her to the communities and practices that she will record, the camera and the disruptive Black feminist uses of the hardware of modernity provide additional challenges to figures like Du Bois, Locke, and others who will find her presentation of the folk as showing a return to a past that they believe should be left behind. Even in this early stage of her own expressive transmutation, Hurston's intellectual and imaginative practice disrupts categories that become fundamental to how we think about the unfolding of Black life and challenges perceptions of the folk—who they are, what they do, and what they represent—while rejecting northern frames shaped by middle-class values. Her film work offers an early glimpse of the broader perspective she would later bring to her writing.[41]

THE AFRICANA SOUTHERN DIVINE

In her early writings, Hurston attempted to imagine how the Black woman would fare in a collective worldmaking venture beyond the borders of the United States, and a 1936 Guggenheim fellowship enabled her to deepen the broader Africana southern immersion she started a few years before with short trips to the Bahamas. In *Tell My Horse* (1938), the author reflects on experiences in Jamaica and Haiti that reveal continued challenges not only with misogyny but also with her own unfamiliarity or strangeness: her qualities that make it difficult for the people she encounters to "place" her because of her nationality, race, gender, and mobility. As Hurston notes, this illegibility enables her entry into a curry goat feed ceremony in St. Mary's Parish, something she claims "has never been done for another woman."[42] On the other hand, she is barred from obtaining knowledge on the "three-legged-horse celebration" because she's a woman, and assumptions about US "career" women and gender politics gain her a berating by a disgusted young man.[43] Although it remains unclear whether her report is sincere or dripping with sarcasm, she uses this distance from home to compare the challenges that are met by women in the Caribbean and the United States. For better or worse, Hurston's illegibility as a Black woman from the United States and the access it provides, even if at times that access simply reveals a "different same," begin to chip away at the deeply embedded autopoietic idea of Black woman's "place" that continues to appear in the author's writing.

In promotional material for *Tell My Horse*, however, the tensions born of cultural difference and the complications it presents are diminished if not outright ignored. Instead, as Imani Owens details, the advertisements highlight the chance to experience "VOODOO as no WHITE PERSON ever saw it!" by way of Hurston's Black female body.[44] Demands continue to be placed on Hurston to provide access for White audiences to "witness secret ceremonies seemingly incredible in these modern times," illustrating a continued alignment of the Black women with primitivity, no matter how far or under what circumstances she travels. Nonetheless, Hurston resists reinforcing the stories told about Haitian Vodou and Africana southern religions. In *Tell My Horse*, for example, she notes that the sensitivity that members of the Haitian elite exhibit when Vodou is referenced is, "in a way," justified "because the people who have written

about it [excepting Herskovits] have not known the first thing about it."[45] This critique is similar to those she's offered in personal letters and published texts with regard to the representations of folk culture and Africana southern religious practices in the United States. She also illustrates her continued interest in disrupting hierarchical rankings of religion when she writes, "Voodoo is a religion of creation and life. It is the worship of the sun, the water and other natural forces, but the symbolism is no better understood than that of other religions and consequently is taken too literally."[46] This statement echoes her observations shared years earlier in letters to Boas and Hughes, making clear Hurston's investment in shifting the prevalent narratives told about Africana religions that perpetuate notions that they are uncivilized.

But, as scholars including Daphne Lamothe and more recently Imani Owens and Marina Magloire have noted, in *Tell My Horse* this resistance at times suggests a tone of ethnocentrism. Indeed, as Owens suggests, even Hurston's use of the title *Tell My Horse* "invokes the signature utterance of an authoritative and subversive spiritual figure—a *lwa* named Papa Gede." The author argues that by taking up this title, Hurston's "invocation announces the fundamental truth of the pages therein." For Owens, "Hurston melds folk authenticity with scientific authority to craft a redemptive narrative of the U.S. occupation."[47] Hurston certainly challenges readers to form a more nuanced reading of Haitian spiritual practices in *Tell My Horse*, and this challenge may be partly a result of the challenges she herself faces during this period. As Magloire writes, "Hurston's Haitian fieldwork was marked by crises of authority where funders and mentors questioned everything from her ability to speak Creole to her deservingness of funding. . . . There was little room for Hurston to admit mistakes, incomprehension, or anti-American sentiment if her text was to be published as an authoritative account of Haitian Vodou."[48] And yet the notion of the Black woman's place in the world, which Hurston inherited and repeatedly encountered, faces perhaps its most substantial challenge when she engages Haitian Vodou.

The inclusive Vodou origin myth, as Hurston informs us, positions women as, if not the most essential element, at least equal to men in the crafting of the world. Hurston is exposed to rituals and a cosmology that venerate women and the "bi-sexual concept of the Creator."[49] Opening the "Voodoo" section of *Tell My Horse*, Hurston informs the reader that,

according to Dr. Holly, "in the beginning God and His woman went into the bedroom together to commence creation. That was the beginning of everything." Then, according to her account, Dr. Holly asks her "What is the truth?" and provides the answer through a Mambo priestess, who throws "back her veil and reveals her sex organs."[50] However, as Daphne Lamothe observes, here "Hurston represents Haitian women as representing the source of knowledge, truth, and life; and yet the image is troubling because it simultaneously depicts Black femininity as sexually available."[51] Instead of an uncomplicated victory for women, this scene provides an example of Hurston's "narrative dissonance," which Lamothe defines as a textual "asymmetry": "abrupt and unexpected changes" characterized by "Hurston's movement from ethnocentric travel narrative, to naïve political commentary to respectful and complex rendering of Vodou ritual," with the end result largely being an inconclusiveness.[52] Whereas on the one hand "this moment admittedly traffics in stereotype," it also "introduces a belief system that equates women with the sacred and natural world, providing one avenue for empowerment that is otherwise unavailable to them."[53] I acknowledge that Hurston's "narrative dissonance" and sporadic shifting sometimes lead to challenging moments in the text. Particularly as the shifts pertain to point of view, they are also evidence that the extractive demands placed on her body have been disrupted. I read the shift in perspective that occurs between the "Hoodoo" section of *Mules and Men* and her depiction of Haitian Vodou-related trance possession in *Tell My Horse* as evidence that Hurston is now more comfortable with asserting her authority using her body and her voice.

In a continuation of the work that she begins in the US South, as, indeed, she understands Haitian Vodou to be part of an Africana southern religious continuum spanning from Louisiana to Haiti, Hurston undergoes a Vodou initiation. Haitian Vodou appears to most legibly disrupt the impact of imposed notions of primitivity upon her writing—namely, her ability to most fully view herself as her primary authority when speaking her individual and collective Africana southern selves. This disruption is discernible in part through her intensified embrace of the opacity of trance possession rites. These rites, which, as Roberto Strongman explains, lead to a state of transcorporeality, allow for a "commingling of the human and the divine" that "produces subjectivities whose gender is not dictated by biological sex."[54] This Africana southern encounter with

the divine is, in a manner similar to Rachel Moore's generations before, a clandestine one because, just prior to Hurston's arrival and in keeping with her experiences in the United States and the Bahamas, the Haitian president passed a law declaring the practice illegal.[55] Crucially, trance possession serves as a form of shared storytelling, which is vital for establishing authority for both personal and diasporic stories.

Through her initiation, Hurston joins a complex conversation that includes diasporic ancestors and an Afro-Creole pantheon of spirits—including feminine spirits that far exceed the circumscribed domestic ideals of the time.[56] The body in trance becomes a vital part of this conversation, as a portion of the spirit (the *gwobonanj*) moves to allow the *loa* or divinities to speak through the possessed to the community in which they are situated. Because this removal causes a loss of consciousness for the possessed individual, onlookers must recount what the inhabiting loa communicated when they awaken. In this way, everyone involved, regardless of gender, has a key role in the creation of an ever-shifting, unpredictable, collectively composed narrative.

While participating in Hoodoo rituals that include a trance component, Hurston struggles with embracing the requisite opacity inherent to practicing the rituals, as is illustrated in her recollections in *Mules and Men*. One such instance is the Black Cat Bone episode in the book, where she displays great frustration at not being able to label and catalogue specific aspects of her experience. Unable to fully unpack or make sense of what she has experienced, Hurston writes: "Maybe I went off in a trance. Great beast-like creatures thundered up to the circle from all sides. Indescribable noises, sights, feelings. Death was at hand! Seemed unavoidable! I don't know. Many times I have thought and felt, but I always have to say the same thing. I don't know. I don't know." This frustration is consistent with the anthropological framework in which Hurston has been trained and through which she approaches her initiations. As an anthropologist, Hurston is to analyze such moments in an attempt to provide a so-called rational description. However, both Hoodoo and Vodou cosmologies prove resistant to such probing, leaving Hurston only with "I don't know" in the final analysis. In *Dust Tracks*, Hurston writes, "The most terrifying was going to a lonely glade in the swamp to get the Black cat bone. . . . Strange and terrible monsters seemed to thunder up to that ring while this was going on. It took months for me to doubt it afterwards."[57] Hurston's

need to "doubt" what she experienced in this episode further reveals her struggle with rationalizing what cannot be explained.

Hurston's tone switch signals a recognition of the ongoing opacity of Vodou cosmology and through this recognition a growing familiarity, if not comfort, with ongoing change. Glissant argues that opacity, or the right to difference, is disruptive to social hierarchies such as those that anthropologists reinforce with their need to name and catalogue.[58] Hurston's growing acceptance of opacity suggests that she is more clearly able to recognize the limitations of the tools of anthropology and is perhaps outgrowing them. Additionally, as Barbara Ladd highlights, Hurston's voice often seems displaced in *Tell My Horse*, resulting in the appearance of a distancing from her initiation or possession experiences as opposed to their representation in *Mules and Men*. In *Tell My Horse*, it appears that Hurston completely steps away from discussing details of her own initiations and instead, as Ladd suggests, focuses on several second-hand and third-hand accounts. When discussing the Canzo initiation, one that she herself performed in Haiti, she shares such an account at a remove and later simply describes her own initiation as "both beautiful and terrifying."[59]

As a letter to Henry Allen Moe dated January 6, 1937, reveals, Hurston had already begun outlining *Tell My Horse* during her first trip to Haiti, and the final text is executed very closely to her plan.[60] As the outline makes clear, Hurston never intended for *Tell My Horse* to include the personal details of her own initiation as provided in *Mules and Men*.[61] One way to understand this shift is to read it as a departure from ethnographic convention. The need for authorization or validation from the anthropological arm of the academy, registered in her opening line of *Mules and Men* when she notes, "I was glad when somebody told me, 'You may go and collect Negro folk-lore,'" has been displaced by the invitation to co-create and contribute to a narrative via Vodou cosmology, and as such the need to scientifically catalogue and explain her personal experiences falls away. All the while, however, Hurston reminds us that she is present and on the scene. For example, she becomes aware of a possession at Dieu Donnez's Hounfort, a ceremonial sacred space, because she hears "odd noises from a human throat somewhere in the crowd behind me" and shares the sensation of fear with the others in the crowd of observers. Of note here is Hurston's movement between first and third person. The horror moves from a place behind her to permeate everyone present.

Fear spreads rapidly as participants witness a man losing control with odd noises escaping his throat, his face "los[ing] itself in a horrible mask," and "a menace that could not be recognized by ordinary human fears" sweeps the atmosphere. The man's possession begins just as Hurston switches to a third-person description that increasingly becomes a description of the collective's point of view. Third person allows Hurston to occupy the position of the anthropologist, offering a "safe" distance of detachment at a time when she is frightened by her proximity to the inexplicable. "Transcendence" here is not beautiful but terrifying, as is reflected in her description of the "horrible mask."

However, unlike in the Black Cat episode, Hurston's expression of horror gives way to a recognition that she must balance her horror with respect for the role that the community of Dieu Donnez's compound plays. In a gradual return to a third-person description, she states:

> And the remarkable thing was that everybody seemed to feel it simultaneously and recoiled from the bearer of it like a wheat field before a wind. . . . The fear was so humid you could smell it and feel it on your tongue. But the amazing thing was that the people did not take refuge in flight. They pressed nearer Dieu Donnez and at last he prevailed. The man fell. His body relaxed and his features untangled themselves and became a face again. They wiped his face and head with a red handkerchief and put him on a natte where he went to sleep soundly and woke up after a long while with a weary look in his eyes.[62]

While Hurston's account of this episode on the surface reads like a shift between first and third person, I understand this to be a moment when she realizes something else—a complicated "we" that sutures the narrative together. Once she begins to insert herself early on in the passage, it is clear that she is part of the community, and this switch between first and third person registers the failure of either point of view to encompass her new position.

The emergence of this shift is significant because it signals the moment when she no longer needs the tools or authorization of anthropology. Hurston has successfully found and embraced her authority within both this Africana southern community that has most fully catalyzed this change for her and the other communities that she has engaged along the

way. However, this underlying "we" reserves space for the individual as well, in a manner similar to the way the possessed individual is of great importance to the larger storytelling group. In the modular understanding of the body and movement that the Vodou possession model presents, the possessed is the site and source of information being transferred from the spirit world to the community. With no intervention from a powerful mediator necessary, Hurston—or in another tradition an ecstatic Rachel Moore—can become the vital sources of disruption that will reverberate through the community. In this instance of narrative dissonance in which Hurston appears to weave between differing points of view, I ultimately read her unstable "we" as a demand to dislodge the notion of a singular site of truth or authenticity. It is a statement that she, a Black woman, and also any of the participants are qualified to represent (or are qualified to decline to represent) themselves in the story. This is also a recognition, if implicit, of the necessity of embracing the opacity of the other—even if the text doesn't bear this necessity out more broadly. In locating the underlying "we," Hurston has not only disrupted the extractive demands long placed on her body but has also become clear about the limited ability of social science to translate the mystical experiences of the other. Hurston has crafted a new relation with her representation of herself and the community.

DUNHAM'S SOUTHS

Whereas Hurston's aim to disrupt narratives of sorrow power her development of a methodology to reclaim and restore alternative stories about herself, her community, and the Africana South, Katherine Dunham's motivations are more personal and distanced. As Dunham is shuffled between Glen Ellyn, Chicago's South Side, and Joliet following her mother's early death, her early movements mean exposure to different worlds—the tenement world of her beloved father's sister, the class- and color-conscious world of her older half-siblings, and the mostly White world of Joliet where she spent most of her upbringing with her father and stepmother. In each setting, Dunham is exposed to stories told about Black southerners that encourage her to position herself in opposition to

them even though she is curious and feels drawn to their expression, and she develops an insider/outsider anxiety that she will spend years negotiating. From childhood, Dunham is inculcated by her father and other adult family members with the admonition that she must avoid public emotional and physical expression in order to evade an alignment with primitive-coded Black southern women migrants. However, Dunham longs for what she calls the "abandon and naked joy and fullness of meaning" that she reads in the expression of southern migrants. Leveraging the transportation and tools made available through her engagement with anthropology, Dunham dissolves her insider/outsider anxiety and crafts a new dance vocabulary that allows her to tell stories of US and Africana Souths from a different angle. The relationship that she locates between dance and the divine ultimately gets her there.

Although Katherine Dunham's early contact with the US South was geographically removed, its cultural resonance did not fail to make an impact on her life. As a child, Dunham delighted in learning the defiant stories of Br'er Rabbit and other Black southern folktales from her father, who was from Tennessee. It is perhaps because of her early exposure to these stories that she bristles at encountering racist folk expression from a high school music teacher who, also from the South, teaches songs that reinforce racial stereotypes. In perhaps her earliest openly rebellious acts against being coerced to support others' reductive narratives about Black culture, Dunham refuses to sing the demeaning songs, disrupting "the teacher's satisfaction at her discomfort." In expressing her defiance, Dunham asserts her agency against reductive narratives and lays the groundwork for her broader resistance to societal constraints. For example, she is not deterred from pursuing a career in dance even after she faces barriers to getting training due to racial segregation.

However, the insider/outsider dynamics that would plague her for years are not so easily shrugged off. Growing up primarily in the Midwest, Dunham comes into direct contact with southern participants in the Great Migration. Her move to Chicago's South Side to live with her Aunt Lulu following her mother's death coincides with a rapid influx of Black southerners to the area. The racial tensions and prejudices usually ascribed to the South are also deeply entrenched in Chicago. Here, a young Dunham witnesses her aunt suffer humiliation when she loses her lunchtime privileges at a segregated cafeteria that shares a building with her beauty salon,

and she learns an early lesson about Black mobility: "What had been a slow infiltration of dark blood became an unforeseen, unwanted transfusion; and this mass exodus of Negroes from south to north had disturbing and permanent consequences on the relationship of the races, profoundly affecting the treatment of dark-skinned citizens by white." In other words, the moving, migrating Black southerners are to blame for the new unjust restrictions her family members are now subjected to, not the people imposing the heretofore unfamiliar regulations upon them. These migrating Black southerners represent the primitive, and the perception of this primitivity is rubbing off on their new northern neighbors.

This lesson is reinforced during a trip to St. Louis with her stepmother Annette and her friend Agatha Carrington, and it would have lasting implications for her work. As the three drive past what for a young Dunham becomes the fascinating theater of Chouteau Street, her stepmother Annette, by contrast, cringes at the site of the newly arrived southern Black people populating the streets and what she might describe as their proud, loud culture. Dunham, by contrast, is taken by the sounds of laughter, the proud, bright sartorial expression, and the music, which she describes as initiating "a possession by the blues, a total immersion in the baptismal font of the Race." Although she is aware that her mother's friend's vehicle—a conservatively colored new Nash—signals their outsider status, she imagines that there was a recognition that the three of them "belonged to [the migrants] in a way though they didn't belong *here*," and she feels that the "rhythm and feel" of the people have entered her body and "ensured a kinship."[63] However, consistent with her stepmother's response to the southern migrants, at home Dunham faces demands to keep "quiet and without excitement," to "conceal wounds and hurts and fears and bitterness."[64] She learns that the dancing Black woman's body is unwelcome in the church. Years later, Dunham approaches the dance world carrying the burden of these lessons. Black movement, particularly when associated with the American South, carries a negative value. Black expressive movement is considered distinct and separate from ballet and modern dance. She confronts the belief that Black people are naturally endowed with dancing ability and that any evidence that disrupts this belief signals inauthenticity. She is also taught that Black women's movement reveals an overly sexual nature that lies in wait just beneath any carefully cultivated surface. These ideas—that the Black moving body is distinct from the

dancer that has undergone extensive training and negative ideas affixed to Black women's movement broadly conceived (migration, etc.)—all paint the Black dancer as primitive. Because of these lessons she learned as a child, Dunham initially adopts an uplift ideology that reinforces the narratives imposed by others about Black movement.[65] This perspective is evident in her early work, as seen in an article with the early collaborator Mark Turbyfill in which "Dunham . . . bluntly stated that black dance did not yet exist as an art form. She admitted that some of the magazine's African American readers would voice 'objection' to her assertion but went on to say that civilization draws a sharp distinction between an uncurbed, purely racial expression, governed solely by rhythm and emotion, and the crystalline symphony of the traditional ballet."[66] It is perhaps the impact of this early ideology permeating her approach to Black dance that leads Carmencita Romero, a southern migrant and early Dunham dancer, to later recall the pre- and post-Haiti difference in Dunham's work. Remembering negative experiences with early performances, she remarks: "This was before Dunham went to Haiti and we had no self-esteem."[67] However, Dunham's eventual entry into the dance world is heavily motivated by a desire to disprove the erroneous story that, as she tells Frederick L. Orme in 1938, "the Negro is a natural-born performer and needs no training."[68] Once she begins dancing, she is met with criticism when this notion is disrupted by evidence of training and performance technique. If Black concert dancers "staged themes perceived as Africanist, then White critics considered them 'natural performers' rather than 'creative artists.' On the other hand, if black concert dancers staged themes perceived as Eurocentric, then white critics considered them 'derivative' rather than 'original artists.'"[69] As I note elsewhere in this book, the attempts of several prominent discourse communities to salvage the language of the primitive fail when confronted with the Black woman's dancing body. Dunham's failure to appease both the more conservative faction of the New Negro Movement and the White and Black critics in the press is evinced in what the *New York Times* critic John Martin aptly refers to as "Dunham Schizophrenia."[70] As David F. Garcia explains, reviewers for Black and White publications oscillate between referring to Dunham as "a scientific researcher of primitive dance" and "a sultry dancer of film and the Broadway stage" whose shows are "flashy, undulating, highly sexed, and orgiastic" or "interpretive or authentic"; depending on where a given

show was perceived to fall within this frame, it was characterized as a "frenzied jubilee of uninhibited tropical passions" or, more negatively, "jive."[71] Anthropology enables movement that will lead to an encounter in Haitian Vodou that will disrupt Dunham's relationship to these demands.

DANCE ANTHROPOLOGY

In 1928, Dunham enrolls in the University of Chicago. She deepens her study of anthropology while intensifying her focus on challenging the stories told about and Black dancers and the barriers they face in her first dance company, Ballet Nègre. Like Hurston, although Katherine Dunham's engagement with anthropology supports her movement in several aspects, it also serves as a site of extraction with its own demands for the kinds of access her body stands to provide. Dunham is drawn to the formal methods that the field offers for probing Black diasporic cultures. For example, her interest in social form and function, a tool that would structure her approach to ritual dances in Haiti, reveals the distinctive theoretical imprint of the University of Chicago and the work of the social anthropologist A. R. Radcliffe-Brown. Her affiliation with the University of Chicago gives her the capital to secure a Rosenwald fellowship to support her travel to Martinique and Haiti, an award that confirms for Dunham that she is not "just another woman" but "an actual creator." Yet, although she secures these honors, her mentor Robert Redfield, part of the Boas school, later writes in a letter of recommendation, "She is a better-than-average student, but with her handicaps of sex and race one would certainly hesitate to encourage her to make a career as a teacher and research worker in anthropology," betraying a telling lack of faith in her potential as an academic and a continued limitation in the ways that Black women were understood and framed.[72] However, anthropologists find Dunham promising because as a Black woman she can permeate spaces that they are denied access to.

While carrying out her Rosenwald-funded research in Martinique and Haiti in 1935–1936, Dunham is both insider and outsider—in the dual subject/object position that researchers such as Herskovits find so promising. In encountering colorism similar to the kind she faced during her childhood, Dunham finds that she is sometimes granted access to

communities because of her African ancestry and connection to Nan Guinée and that Haitians are often confused about where she resides on the color hierarchy—an issue further exacerbated by her nationality. As Dunham recalls, she is strange and at times confusing: "Of my kind I was a first—a lone young woman easy to place in the clean-cut American dichotomy of color, harder to place in the complexity of Caribbean color classifications; a mulatto when occasion called for, an in-between, or 'griffon' actually, I suppose; most of the time an unplaceable, which I prefer to think of as 'noir'—not exactly the color black, but the quality of belonging with or being at ease with black people when in the hills or plains or anywhere and scrambling through daily life along with them."[73] Her letters of introduction from Herskovits align her with elite communities, but her interest in and fellowship with Vodou practitioners in some ways signal a dismissal of the cosmopolitan project and frustrate her hosts and acquaintances. Although her personal concern with her insider/outsider status becomes a source of mild obsession in her reflections, the difficulty those who encounter Dunham face in classifying her works is in many ways to Dunham's advantage.

One benefit of Dunham's strangeness is the access it affords to spaces from which women are otherwise barred. For example, she secures entry to the male-centered Martiniquan *ag'ya* rituals that later capture her imagination and become central to one of her earliest and most oeuvre-shaping works, *L'Ag'Ya*. In this instance, her relative illegibility grants her visual access beyond the gendered frame, even as she, like Hurston, laments the restrictions placed on Caribbean women.[74] This access, along with what for her are also strange encounters, prompts broader questioning of gendered frames. As Das observes, within the safe space of her unpublished field notes, Dunham speaks frankly about the impact that Kanaval (Carnival) has upon her conceptions of gender and sexuality. Carnival is broadly understood as a period of class subversion, and Dunham is particularly taken by the transgression of sexual scripts. Describing the dancing as "pure & simple sex" shared across and within genders, she is impressed by the dissolution of gendered and sexual social norms, and she questions whether "basically there is no male & female sex."[75] This questioning illuminates a disruption of earlier learned (and recursively encountered) lessons that as a female she should move within and inhabit her body differently. It would follow, then, that restrictions around accessing expressive catharsis should also be disrupted. We begin to see Dunham probe

this issue in her production of *L'Ag'Ya*, where, by placing herself within the male-only ritual space, she raises questions around gendered embodiment and access to cathartic movement. Dunham thus recognizes a connection between gendered and sexual transgressions (of what she comes to identify as human-constructed boundaries) and transcorporeal ecstatic states.

The experience most transformative for Dunham's understanding of gendered restrictions to creativity and expression is her encounter with the Vodou creation myth. Like Hurston, Dunham is introduced to an expansive notion of women's creative power. She notes, for example, that Damballa, the loa she is personally dedicated to, and his mistress Erzulie "together . . . inhabit the sky and do more to determine the destiny of man . . . that any of the many other gods of this possessed and obsessed island."[76] Similarly, in the glossary to her published master's thesis, she defines the Vodou priestess, or mambo, as "equal in power to the *houngan*," the male priest.[77] However, while undergoing initiation, Dunham is plagued by what she calls a "split in attitude," referring to the ways that science and embodied ritual experience conflict for her, and with "being an outsider within," which she now experiences as an obsession with the conflict between her relationship with the *houngfor* (or parish) community and her position as a US-based academic. Such crises are likely unanticipated by a field that is giddy with expectation over what her Black female embodiment means for providing new levels of access to Black Caribbean communities. Furthermore, while methodologies created without a person with her embodiment in mind allow Boasian anthropologists, for example, to take up ironizing Whiteness as a central strategy with the goal of prompting White audiences to "reflect upon their own ignorance," a move that allows them to deploy what Clifford Geertz (and later Alice Gambrell) describe as "self-nativising," whereby anthropologists such as Boas and Herskovits defamiliarize Whiteness by "adopting the voice of one who is not quite white, by performing a complicated kind of cross-cultural ventriloquism" in order to provide a portrait of North American culture from an external, alienated position, such poses are unavailable to Black women social scientists such as Hurston and Dunham. The theoretical position of Blackness taken up by White social scientists cannot be claimed by those that occupy this subject position.[78] Instead, Black anthropologists risk being dropped into crises of belonging as they encounter new Africana southern cultures.

While she strives to apply the neutral distance of the scientist, Dunham is simultaneously anxious for acceptance and approval from her community of initiates, and she understands trance possession (which she both fears and desires) as a mark of legitimacy. Dunham's growing anxiety about not undergoing trance possession partly causes her to initially overlook the ways that dance and the divine are bound together. After all, dance is a phenomenon to be observed and described for anthropologists, not the portal for transcorporeal connection that it ultimately becomes for Dunham. However, through Dunham's recollections of the later danced portions of her initiation, the connections between movement and ecstatic release that will become so important to her creative expression begin to come into view. Just before a public portion of the ceremony, Dunham reveals that she and the other initiates "danced, not as a people dance . . . with the stress of possession or the escapism of hypnosis or for catharsis, but as I imagine dance must have been executed when body and being were more united, when form and flow and personal ecstasy became an exaltation of a superior state of things, not necessarily a ritual to any one superior being."[79] During this dance, the insider and outsider binary dissolves for Dunham, and she is able to probe her experience through her body in a way that sharply differs from her earlier recollections. Here, Dunham shifts from earlier attempts to gain legitimacy in the academy or from other legitimizing bodies that ultimately render her primitive or an outsider. She and her fellow initiates perform the 'zepaules, which Dunham describes as "the pure dance part of the Arada-Dahomey ceremony which serves to purify the air and prepare the body for the reception of the loa," and a "dance of religious ecstasy." They follow this dance with the *yonvalou*, the dance that becomes her gateway to transcorporeality and to a reconciliation between religion and dance. The yonvalou, with its fluid, snakelike undulations, is for Dunham the "signature" of Vodou, and she calls it "prayer in its deepest sense."[80] Dunham describes this dance, which becomes central to her technique and much of her choreographic work, as characterized by a complete lack of tension and "constant circulatory flux which acts as a psycho-narcotic and catharsis of the nervous system," indicating an enhanced fluidity of the psyche and body. Whereas the 'zepaules begins to prepare the body for possession, with a performance of the yonvalou "the dancer is left in a state of complete submission and receptivity," completely ready for possession.[81] Although Dunham

claims that she was not possessed, and in fact felt "sublimely free because I was experiencing the ecstasy without being taken over, 'mounted,' or possessed," she mentions lapses of consciousness that suggest a transition from an ego-driven focus on the self as individual to a new corporeal openness and understanding of connection that exceeds what's available to Black women in Western autopoietic myths.[82] Here, although Dunham remains convinced that she has not experienced possession, she reveals an understanding of having experienced a transcorporeal ecstasy marked by a disruption of the unitary, static self. Instead, the performance of the 'zepaules and then yonvalou has transmuted this relationship. Her body and the expression that issues forth are characterized by movement and multiplicity, and as such are ever of the present moment.

Sacred dances such as the yanvalou and the 'zepaules form the support for the creative framework that Dunham eventually constructs. They provide access to the ecstatic states that in turn provide a route to emotional release and psychological unity for Dunham. They also speak to an escape, if momentarily, from the pains caused by the afterlives of plantation slavery. Transcorporeal expansion disrupts notions of static primitivity, and it begins to transmute Dunham's limited ideas of herself as a storyteller. During her early experimental years following her work in Haiti, Dunham confronts challenges tied to physical movement in several forms, not least of which the narratives attached to the Black woman's dancing body. The Africana southern framework through which she pursues this work provides the generous space required to illuminate threats of enclosure.

CONSOLIDATING FRAMES, RENEGOTIATING SOUTHS

As her early work illustrates, Dunham emerges from the Caribbean with a changed relationship to and understanding of the Black woman's moving body and its expressive potential. Indeed, in some of her earliest work, including *Christophe*, a ballet she conceives while still in Haiti, she illustrates a concern with recentering women's participation in the Haitian Revolution—a story that has been represented in the diaspora as one of male might.[83] This work continues upon her return to the United States, where Dunham enters a period of intense experimentation and

comparative exploration—work that will facilitate the development of an enduring movement-based theory and methodology for conceptualizing Black women's expression beyond womb abyss frames. The impact of the new worldview she was exposed to via her transnational contact is immediately evident in her 1937 shows *Tropics: Impressions and Realities* and *The Negro Dance Evening*, her earliest work with her newly established dance company.

Tropics, in which Dunham most fully begins to come into her own as a dancer and choreographer, is a meditation on the form and function of Caribbean dance, especially religious and Carnival dances. Remarkably varied in content, the show includes Ruth Page's *La Guiablesse*, Haitian ceremonial dances, a dance based on Homer's *Odyssey*, and Carnival, fire, and Moorish dances. In reprising Page's ballet, Dunham makes a change in point of view. Having never herself traveled to Martinique, Page relied on Lafcadio Hearn's *Two Years in the West Indies*, a travelogue replete with the "exoticized, romanticized language of all Caribbean travelogues of this period."[84] Although not Martinican herself, Dunham, recently returned from the island, contributes, per the show's title, a new impression of the Martinican folktales that undergird the show. In a departure from her performance of Page's work prior to traveling, this time the show is told from a Black woman's point of view—one enriched from time on the island and among its people.

Although the performance showcases a newfound confidence in telling the stories of Africana Souths by drawing on the cultural elements of African, Caribbean, and southern US traditions, there is also evidence that Dunham continues to grapple with issues of authority. The copious notes in the program hint at Dunham's continued desire that the academy acknowledge her scientific rigor. Additionally, although Dunham addresses lynching in the United States with the inclusion of the "Swamp" section of the show, including the dances "Tropic Death" and "Blues," and although "Tropic Death" features a fugitive escaping a lynch mob and "Blues" meditates on Black pain, Dunham's presentation of her connection to the South feels a bit forced and tenuous, as if the insider/outsider anxiety has resurfaced and she is at pains to prove her authority to tell the story. In the unpublished manuscript for the memoir "Minefield," Dunham recalls meeting Kokomo in a barbecue shack in Chicago that for her evoked "the black ghettos of the South." Kokomo was from Indiana.

Program

1—PRELUDE—DANCE OF THE PORTERESSES and LOVE DANCE FROM "LA GUIABLESSE".

Ballet by Ruth Page to Music by William Grant Still.

Lovers: YZARE ..Katherine Dunham
ADOU ..Jordis McCoo

Porteresses: Armour, Williams, Washington and Foulkes.

2—HAITIAN CEREMONIAL DANCES

a Congo Paillette

Danced chiefly in the spring, the Congo Paillette is one of a series of ritual dances whose form remains constant, but whose significance has been lost to the Haitian peasant. Originally a fertility rite, it is now danced only for pleasure. The dance continues thus for hours, unbroken, new dancers replacing those who become exhausted after incredibly long periods.

b 'Zepaules, or shoulder-dances

Introductory to a vodun (voodoo) ceremony of the Rada-Dahomey sect. The "Mombo" leads the dance with the sacred bell and rattle, her "hounci" or the initiated joining. Both drums and drummers are very important items. The "feint", or broken crashes of the drum announce the arrival of the god who is being invoked. A "hounci" becomes possessed.

c Yonvalou, dance sacred to Damballa, high god of the Rada-Dahomey cult.

Damballa is represented as a serpent, and this same symbolism is expressed in the dance. Two priests dance the sword dance, the significance of which is known only to the initiated; two "hounci" salute each other in the dance Damballa.

Mombo ..Margaret Brooks
Hounci ..Dorothy Brooks
Priests ..John Carlis and Lester Harris
Damballa "hounci"Talley Beatty, Roberta McLaurin and group

3—PIANO SELECTIONS

Jeanne Fletcher

4—TANGO MOTIF ON A THEME BY SHULHOFF

Katherine Dunham
with
Jackson, McLaurin, Armour, Foulkes, Washington, Beatty, Sebree, Carlis, McCoo, Harris

10 MINUTE INTERMISSION

FIGURE 1.2 Program for Katherine Dunham's *Tropics*, 1938.

Source: Fisk University, John Hope and Aurelia E. Franklin Library, Special Collections, Rosenwald Collection, Box 409, Folder 10.

5.—LOTUS EATERS .. DEBUSSY

"They went and found themselves among the Lotus-Eaters soon, who . . . gave into their hands the lotus plant to taste. Whoever tasted once of that sweet food wished not to see his native country more, nor give his friends knowledge of his fate."—Homer's Odyssey.

Katherine Dunham
with
Brooks, Johnson, Brooks

6.—RITUAL FIRE DANCE ..DE FALLA

Talley Beatty
with
McLaurin, Armour, Brooks, Jackson, Brooks

7—MOORISH DANCE ... YON

Katherine Dunham

10 MINUTE INTERMISSION

8—SWAMP

 a Tropic Death

 Fugitive ..Talley Beatty
 Mob..Johnson, Armour, Washington, Carlis Sebree, McCoo
 Friends and Relatives................Brooks, McLaurin, Jackson, Brooks, McCoo, Harris

 b Blues

 The DancersBrooks, Jackson, McLaurin, Brooks, Harris, Beatty
 The Woman ..Katherine Dunham
 The Singer ...Kokimo

9—PIANO SELECTIONS

Jeanne Fletcher

10—BIGUINE—BIGUINE

A little "porteuse", arrayed in head-dress and grande robe of the Empress Josephine period is on her way to Fort-de-France where she will meet her lover at the "bal dou-dou" (dou-dou, creole equivalent for "honey" or "sugar"). Someone in a wayside hut is playing a popular biguine, and unable to resist the temptation she stops to dance a few steps as she will tonight. Then she moves on, carrying her shoes because shoes are for the "bal dou-dou", not the dusty mountain roads.

11—CARNIVAL DANCES

The carnival, or mardi-gras, is the big event of the year in Haiti for both peasant and elite. The peasants gather in huge bands behind favorite leaders and roam the country, challenging other bands to dances in competition. The elaborately dressed leaders compete in the intricate "cis-seaux" and "danse du ventre", while their sycophants alternately cheer them and join in the dance. Money may be lost or won betting on the favorite "major-domo", or carnival king, or the losing band may simply treat the other band to a round of white rum. The dance over, each band continues on its way to seek another competitor.

Accompanist, Mildred Nielson Lighting, Ruth Fantus
Costumes designed by Katherine Dunham and executed by Marjorie Arrington
Masks by John Carlis
Management, Richard Gilruth Michell

West Indian dances based on research by Miss Dunham while on a Julius Rosenwald travel fellowship. Ceremonial drums and headdresses from Haiti. Properties for "La Guiablesse" loaned through the courtesy of Ruth Page.

FIGURE 1.3 Program for Katherine Dunham's *Tropics*, 1938, page 2.

Source: Fisk University, John Hope and Aurelia E. Franklin Library, Special Collections, Rosenwald Collection, Box 409, Folder 10.

She recalls: "Kokomo played the guitar and sang the blues as I never heard the blues played or sung. The pain in him came from a deeper source than the violence of Indiana." However, Indiana was a violent site of deep racial strife, and, if not at the rate and frequency of the Deep South, lynchings occurred in Indiana and even in her native Illinois. Thus, if not with the comfort she will soon exhibit, "Swamp" is an early example of her attention toward the South and its plantation legacies, and it reveals an awareness of an alignment between the pain shared among Africana Souths due to a shared legacy—a pain that she now attributes, not to the victims as she was taught as a child, but to the perpetrators. Dunham's intense focus on presenting the form and function of the dances also reveals an ongoing dedication to correcting erroneous stories about Haitian Vodou and culture.

If *Tropics* reveals a recognition of the shared conditions of Black Americans, then *The Negro Dance Evening* (March 1937) finds Dunham's choreographic vocabulary placed into direct conversation with Black southern expressive culture. For example, for the first time, Dunham's post-Haiti work is placed in a narrative space with the cakewalk, the ring shout, and women dancing to Black spirituals. This connection leaves a lasting imprint on the ways she imagines her work—and her access to Black southern expression—going forward. However, it is with *L'Ag'Ya*, Dunham's first full-length ballet performed under the auspices of the Works Progress Administration's Chicago Federal Theater in 1938, that the full impact of the artist's frame-shifting Haitian Vodou experience on her expressive vocabulary becomes apparent. As she reflects in her unpublished memoir, she was also experiencing this impact personally: "These were my most impressionable years, and whole new vistas were opening at such a great rate that anthropology receded much of the time into the background, diminished by the stirrings of a desire to create something new and wonderful, to include myself in it, and to make of it something permanent."[85] This creative impulse is reflected in both the absence of copious explanatory notes on form and function and in her taking up the role as narrator of a traditionally male-centered movement space. As several critics have observed, the evolutions in form that Dunham presents in *L'Ag'Ya* represent perhaps the earliest presentation of what will eventually become codified as the Dunham Technique, satisfying her goal of creating something enduring. But perhaps most striking is the continued evolution of Dunham's presentation of a movement vocabulary related to

the ecstatic state—here via a generalized Africana southern ecstatic ritual movement—and the untold story of the Black woman's relationship to it.

Dunham's *L'Ag'Ya*, a reimagining of the competitive ag'ya ceremonies she witnessed in Martinique, is set in an eighteenth-century fishing village, and the plantation remains just beyond view. The show focuses on a battle between Alcide and Julot for Loulouse's affection. Composed of five parts (Overture, Market Scene, Pas de Deux, Zombie Scene, Festival Scene), the show is couched in the mundane, everyday actions of life in the village. I follow Stephanie Batiste in understanding the ballet as broken into three acts and their corresponding modes of living—work life, the sacred, and holidays—and her argument that the repetition and modification of movements interwoven throughout these three sections provide a circularity that "allows the ballet to depart from an overarching Western linearity of the narrative" while also "undermin[ing] the traditional effects of exoticism in performance."[86] The ballet stands as one of the first complex examples of cultural mixing in Dunham's post-Haiti repertoire. While the show ends with performances of the *mazouk* and ag'ya specific to Martinique, the zombie scene includes additional creolized dances such as the *myal* from the Maroons in Jamaica and the habanera from Cuba. These dances continue a key shift for Dunham: After extensive research in the Caribbean, she is no longer fearful of misrepresenting a culture because of lack of exposure to it. Instead, she has located a comfort in the idea of diasporic reimagining, drawing connections between her own experiences and those in other postplantation spaces. Similar to VèVè Clark's understanding of Dunham's oeuvre as a *lieu de mémoire*, I also recognize the reappearance of ideas differently framed. *L'Ag'ya* is often understood as a key origin point for Dunham's use of repetition and circularity. Similar to the movement inherent to trance possession in which via circular movement an element of the self (*gwobonanj*) departs to open space for inhabitation by a loa or another element and then the formerly inhabited returns to full consciousness with a difference (catalyzing a difference in the movement of the overall group narrative), Dunham removes and then returns to Africana southern elements in ballets that advance her concerns with collective narrative creation—and the inclusion of her own evolving choreographic voice.

Although in *Christophe* Dunham tells a fuller and more inclusive culturally specific story of Haitian Vodou and the central role that it, with women included, played in the Haitian liberation struggle, her inclusion

of Africana religious expression in this ballet shows that she is critiquing both the colonial imagination and its internalization. Dunham highlights the ways that diasporic rituals previously presented as full of possibility have been permeated with Western hierarchical structures. And with her inclusion of diasporic dances in this scene—the Jamaican myal and the Cuban habanera—her observation is extended across the Caribbean. In a play on her prior observations on the misrepresentation of Vodou culture, here Dunham presents a diasporic example of hierarchical perversion. If in *Christophe* Vodou stands out as a space of communal potential and power against Christophe's individualism, in *L'Ag'ya* it is the colonial structure permeating Black spiritual and religious culture, not the Africanist belief system, that makes things frightening.

After extolling the dangers that the entire community faces in Act 2, the ballet ends with a reappearance of the Black woman demanding an extended meditation on Black pain. Julot, newly empowered, has returned to the village with a *cambois* or love charm, and in a scene now in heavy circulation on social media, he interrupts a carnival celebration (that, as Batiste notes, is notable for the freedom it represents "from the strictures of colonial rule and mandated labor"), and he uses a charm to enchant Loulouse.[87] Possessed, Loulouse begins to dance the Brazilian majumba and remove her clothes. Alcide intervenes, breaks the spell, and he and Julot begin the ag'ya fight. While Alcide emerges victorious, an enraged Julot kills Alcide and flees. The ballet closes on Loulouse holding her dead lover's body in the mundane sunlight, with everything around her returning to the usual daily rhythms. Here, Batiste's observation that a focus on the mundane disrupts notions of the "native" or the primitive only makes Loulouse's final placement and predicament all the more striking. The woman is left alone to return to her daily movements with no cathartic ag'ya to turn to herself. Instead, she becomes the permanent holder of this pain, and without Dunham's intervention, is likely excised from the narrative altogether. Through *L'Ag'ya*, then, Dunham demands that we turn our attention to the dangers inherent in denying Black women expressive release. Loulouse is entrapped in a world governed by stories about the Black oversexualized moving female body, and yet with no access to movement that would induce access to a transcendent ecstatic state or catharsis, she remains in a static abyss of pain.

The turn represented in *L'Ag'ya* continues to intensify in the ensuing years. While in the *Negro Dance Evening* Dunham's movement vocabulary

has a direct encounter with that of the Black US South, her integration of a transcorporeally influenced structure in *L'Ag'ya* represents a modular framework illustrating Dunham's understanding of the US and Caribbean Souths as a circuit of unique movement forms with specific functions connected by the afterlives of the Middle Passage and the plantation. This framework allows her, for example, to recognize the Charleston in the Haitian dance La Martinique as well as in the movements of storefront church attendees while in a trance.[88] It is the case that by 1941, when she drafts "The Negro Dance," Dunham understands that cultural expressive traditions are connected in form and function, with a key function of the dance being tension release throughout the diaspora. And by the 1950s, Dunham issues in her show *Southland* her most direct creative indictment of the system that denies Black women storytelling authority, illustrating through the ballet that the shame and destruction narratively imposed on Black people is actually associated with the architects of the plantation, and that it against them and not Black people that this "living, present" shame should be directed.[89] In the 1950s she also fully claims her body as a direct tool to speak new stories of Black life, further inciting critics' "Dunham schizophrenia" when, for example, she uses her body as a tool of protest against segregation and thereby denies it to White audiences as a form of entertainment.[90] In these ways, Dunham locates sources of stories that demand that Black women remain still and silent for the benefit of others and disrupts them in her performances. No longer anxious about locating authority from any specific group, Dunham claims the authority to tell her own story of an Africana southern self and of "we," endowing her point of view and creative insights with the authority to guide her reinterpretations and representations of herself and her communities. With the crafting of the Dunham Technique, she enshrines this expanded story of the Black woman's moving body and extends a new method of storytelling to others.

As Both Hurston and Dunham teach us, a culture's stories and myths—whether folk, religious, or otherwise—tell a larger story about the community that creates them, including which voices are sacrificed for their maintenance. Because of the expressive hierarchies that emerged from the Middle Passage and the plantation, it has often been the case that Black women's voices have been central among those sacrificed. Like Rachel

Moore years before, Hurston and Dunham locate powerful Africana southern spaces akin to those that Wynter calls provision plots: spaces that obscure and shelter African-descended structures of thinking and expressing that appear illegible or opaque in dominant Western systems such as anthropology, dance, and literature. Through their respective wanderings, Hurston and Dunham are introduced to folk traditions, religious practices, and cosmologies that catalyze a new orientation to their own storytelling authority. This is particularly true in the case of their encounters with the Haitian Vodou cosmology that reorients Hurston's relationship to illegibility and the need to catalogue and that helps to dissolve Dunham's lifelong insider/outsider tension. Following these transcorporeal encounters, both artists begin to see beyond the creative and cultural organizing principles embedded in anthropological and dominant storytelling structures that affix the Black female and even the Black South to notions of primitivity, and they reconfigure their own approaches to the oppressive stories told of their bodies and communities. Guided by the reclamation of their own rich voices and complicated truths, they craft key foundations for Black feminist storytelling that do not require intervention from powerful mediators. Instead, Hurston embraces the position of a complicated and unstable "we" that demands that the belief in a singular site of truth or authenticity be dislodged, while Dunham, by recognizing the union between dance and the divine, embraces and incorporates her experiences of repetition, circularity, and modes of bodily movement that allow Black women access to catharsis and release. Through both artists, a collective ethos emerges that joins their voices to the larger Black narratives emerging across Africana Souths, and like Moore's narrative, Hurston and Dunham locate modes of expression that continue to inform the stories told about Black southern cultures. Through their transcorporeal and Africana southern-informed work of silencing womb abyss frames, Hurston and Dunham amplify the diversity and complexity of the stories told of Africana Souths. In the chapter that follows, I consider how Hurston continues to refine the lessons learned from her wandering by examining its influence on her innovative approach to the novel—an approach that I argue has implications for the Black expressive archive and repertoire.

2

ON DYNAMIC SUGGESTION

Hurston and McIntyre

Women often attempt to embody an archive or to be it. They are willing to make the body a vehicle; courage and recklessness are required to be a host of history.
—SAIDIYA HARTMAN, "FUGITIVE DREAMS OF DIASPORA"

So whilst Ah was tendin' you of nights Ah said Ah'd save de text for you.
—ZORA NEALE HURSTON, *THEIR EYES WERE WATCHING GOD*

When Toni Morrison's formerly enslaved Baby Suggs in the novel *Beloved* (1987) mounts her pulpit, she attempts to transfer insights—those hard earned from years of slavery and others realized upon crossing into freedom—to inspire communal healing.[1] After years of enslavement "busted her legs, back, head, eyes, hands, kidneys, womb and tongue," a newly liberated Suggs delights in discovering her "heart that started beating the minute she crossed the Ohio River," and she uses her pulpit to guide her community to a similar discovery and reflection on its implications. Children, men, and then women respond to Suggs's suggestions to laugh, dance, and cry and to love their flesh—especially their hearts. Yet despite the heart-led healing that Suggs delivers, her wisdom and power prove too much for the community she seeks to uplift. After a particularly generous celebration, joy and admiration

turn to envy as her community determines that what she so openly shared "were His powers"—those of a male messiah, not for the use of a formerly enslaved woman. This rejection leads to the alienation, heartbreak, and partial erasure that ultimately kill Baby Suggs.[2] Although she moves across the Mason-Dixon line and from the plantation to freedom, Suggs's insights remain repressed. Her expression fails to be broadly embraced and preserved despite her attempts at crafting a communal expressive space in the Ohio wilderness.

In many respects, Suggs—with her pulpit and congregation—represents the realization of the dream held by Nanny, the disappointed formerly enslaved character of Zora Neale Hurston's *Their Eyes Were Watching God* (1937). Nanny longs to "preach a great sermon about colored women sittin' on high, but they wasn't no pulpit for me. Freedom found me wid a baby daughter in my arms, so Ah said Ah'd take a broom and a cookpot and throw up a highway through de wilderness for her. She would expound what Ah felt." After her daughter Leafy is raped and impregnated by her schoolteacher, Leafy leaves her own daughter Janie to be raised by Nanny, and Nanny determines she'll now save the "text" for her. Nanny recognizes that, since she is the "mule uh de world," positioned at the bottom of the social hierarchy, no communal space exists that is open for her participation.[3] Instead, she decides to preserve her "text" for her female progeny in the hope that it proves beneficial for them.

Despite their differences (and the fifty years between the publication of each text), both protagonists recognize the value of preserving Black women's insights. Imparting this knowledge to her community proves impossible for Baby Suggs because not only is she not a male messianic figure, but she also represents a plantation past, as her neighbors' criticisms make clear. Much like Black southern folk expression is treated by Black northern artists and intellectuals as something that is useful but in want of cultivation, Suggs's community determines that she is an improper leader whose voice needs to be stripped of its power. As is illustrated in both Morrison's and Hurston's novels, the exclusion of Suggs's and Nanny's insights means that the collectively conceived narrative base from which Black futures are imagined—and thus the worldbuilding potential of the communities in which each woman is embedded—is deprived.

While both Suggs's and Nanny's approaches fail to transform their communities' alienation of Black women, Janie's response to her grandmother's

text inaugurates the appearance (in print and then in formal performance culture) of a system capable of mobilizing and preserving Nanny's "text" and Suggs's evocation of the physical and emotional sensorium. After two failed attempts, Janie locates a heretofore unfamiliar southern community that is willing to include her insights in a space of possibility that, in its constant renewal, vigorously refuses the imposition of hierarchy, allowing her shocking emergence as a folk heroine. Janie's story becomes Hurston's textual representation of a technique that—in its constant movement between expressive modes—ensures that the insights, "longings and aspirations" of Black women are incorporated into Black expressive culture more broadly through a fusion of ethnographic, literary, and performance methods.[4] She names this practice—the transfer between observation, repertoire, and archive—dynamic suggestion. This practice will prove useful for Hurston personally, and by embedding it in *Their Eyes Were Watching God*, she inaugurates a metaphorical Africana South that both preserves and activates Black women's expression throughout the twentieth century, as is illustrated in the work of dancer and choreographer Dianne McIntyre in the 1980s.

This chapter extends my discussion of Hurston's framework expansion in chapter 1 by examining how she develops dynamic suggestion and discusses it in her formative treatise on Black performance, "Characteristics of Negro Expression" (1934). In reading "Characteristics" alongside her correspondence, her novel *Their Eyes Were Watching God*, and Dianne McIntyre's *Their Eyes Were Watching God: A Dance Adventure in Southern Blues* (1986), what emerges are collaborative methods of recording and then extending Black women's expressive vocabularies and insights that resist extraction and erasure. I argue that by using *Their Eyes* as a site of narrative preservation and reflection, Hurston and McIntyre extend a nonhierarchical poetics that consists of cycles of dynamic suggestion and porous absorption: cycles located at the meeting of observer and art maker, and of artist and audience, in which artists mobilize audience participation by "gripping the beholders" and compelling them to "finish the action the performer suggests" while the audience, locating its own expression, meets, completes, and passes a merged expression forward.[5] In so doing, Hurston and McIntyre intercept prominent loci of the exclusion of Black women, exclusion informed by hierarchical creative and cultural organizing principles that bear the imprint of womb abyss framing. Each artist

enacts a poetics of transmutation by embedding her voice and experiences into the source texts and performances that constitute the archive and repertoire of Black expression that inform the broader Black imaginary.

PRESERVING, TRANSFERRING, REFLECTING

Folk expression informs a sizable share of what constitutes Africana southern archives and repertoires. In his essay "Theater, Consciousness of the People," published in 1973 in his journal *Acoma*, the Martinican theorist Édouard Glissant presents a compelling argument for both the potentials of folk expression and the forces that prevent the realization of this potential. He explains that this potential is realized in the movement from folklore to theater, an effective vehicle for a culture to represent itself and reflect on its identity.[6] This process helps transform rich traditions of rituals, ceremonies, dances, and folktales into collective knowledge and cultural consciousness. When reflected on collectively, theater becomes a powerful tool for worldbuilding and for maintaining the integrity of a culture's own archive and repertoire of stories and rituals as sites of knowledge, as opposed to having them cultivated by an elite that feels empowered to speak for them. Along with histories of violent acts of colonization and slavery that have "obliterate[d] a sense of a shared past," this elite that "takes charge of the function of representation" prevents Black cultures from realizing the full potential of folk expression.[7] Speaking specifically about the Martinican community, Glissant argues that the aforementioned challenges have prevented his culture from "develop[ing] a common vision," a failure that Hurston seems to anticipate in the US context. Though commonly understood as a recognition of its dynamism in contrast to anthropological anxieties about its disappearance, her famous assertion that Black "folklore is not a thing of the past" but "still in the making" could also be read as a more complicated acknowledgment of an unfinished project.[8] During the first quarter of the twentieth century, a Black educated elite in the urban North began to dominate Black cultural expression. The members of this elite positioned themselves as the drafters of both the aims of Black expression writ large and the terms of its critique. They viewed southern folk expression as a primitive but

inspiring base that required revision to move Black art into a space of modernity. The creators of this Black expression—likewise viewed in need of alteration—were largely absent from these deliberations.

While considered primitive by urban northerners, Black southern cultures based their own hierarchies governing creative inclusion and preservation on notions of modernity and primitivity. Although these often-rural cultures have a thriving folk expression, Black women are not often recognized as (or allowed as) co-contributors to it. Glissant repeatedly stresses the importance of collective participation in creating, critiquing (through internal challenge and refutation), and providing transitions in this process.[9] However, as Mary Helen Washington writes in the foreword to the 1998 print edition of *Their Eyes Were Watching God*, the very presence of a female "was inherently a critique of the male-dominated folk culture."[10] Here, Washington identifies a deeply entrenched tension governing the omission of women that Hurston confirms when she reflects on the expressive creation she witnessed as a child and the exclusions that show up in her collected folklore. McIntyre extends this witnessing much later in the century to other sites of expressive rebirth and possibility, including jazz jam sessions and improvised collaborations with musicians. Positioned as not co-creators but rather as an alluvium from which to form jokes, folktales, and modern subjectivities, Black women's insights and creative contributions are submerged in a location I metaphorically describe as the womb abyss. Taken together, Hurston's and McIntyre's work reveals a long arc of evidence extending from the 1930s through at least the 1980s that suggests that Black women's ongoing framing by this abyss compromises the potential of Black expression. Akin to Glissant's theater, Black expressive sites of becoming that hold larger implications for the emergence of collective consciousness and worldmaking have failed to meet their promise.

In her work as a folklorist, Hurston uniquely encounters this exclusion both in masculinist sites of folklore creation in the South and with an urban elite (Black and White) in New York. While each group appears to celebrate the silenced groups (women, creators of southern folk expression), they are in fact using these groups' expression to promote their own goals and subjectivities. Both Black women and southern Black culture writ large are discussed as needing mending and uplift, and the expression of each group is manipulated to meet the aims of the elite. Black women,

then, are written out of history twice: They face erasure from both the broader national history and local cultural histories. Thus, Black expression moves through several hierarchical cycles of interpretation and presentation that reinforce the original silencing of Black women's creative insights, making necessary frameworks like those crafted by Hurston and McIntyre that emphasize Black women's complexity. It is the case that, in addition to the ways these exclusions affect Black expressive possibilities more broadly, women lose out on communal preservation of their experiences and as such locations from which to reflect, create, and revise.

A discussion about the exclusion of Black women's insights from sites of emergence and preservation is ultimately a conversation about the deficiencies of the logics and operations of the archive and repertoire as repositories of Black life. These logics, as Achille Mbembe and Diana Taylor make plain, have theoretical and material implications. Insofar as "the archive is primarily the product of a judgement, the result of the exercise of a specific power and authority" that grants privileged "status" to items that have been selected discriminately, archival logics extend to the selection processes that New Negro intellectuals were undertaking.[11] In this way the archive also works as an "instituting imaginary," one that ultimately controls, beyond what is "catalogued, embalmed, and sealed away in a box of files and folios," the kinds of stories that can be told—the stories that are possible.[12] The repertoire also holds this power, particularly in its operation as a series of scenarios. In turning our attention to the scenario as meaning-making paradigm, Taylor explains that these "sketch[es] or outline[s] of the plot . . . giving particulars of the scenes, situations, etc." constitute a "portable framework" that, by "promoting certain views while helping to disappear others," works to "structur[e] our understanding" and perspective.[13] Additionally, in looking to the repertoire and away from the often written documents that we generally associate with archives, we run the heightened risk of encountering the stories affixed to the materiality of the body that similarly impact our imaginaries, the stories that can be told, and ultimately, who is allowed to create stories that can lead to a collective transcendent consciousness.

This chapter considers how Hurston and McIntyre craft a unique methodology for enacting the technologies of both embodied and archival memory and placing each into relationship with Black women's expression in a manner that challenges and expands the inclusive capacity of

each mode of preservation.[14] During the formative years of their careers, both artists encounter sites of silencing reinforced by hierarchical perceptions of both their embodied realities and the expressive forms they engage. In the epigraph that begins this chapter, Saidiya Hartman explains that one approach Black women have taken to addressing the gendered character of scholarship and writing in spaces of absence has involved embodied attempts at "host[ing]" the excluded histories. As Hartman explains, she has addressed questions of the repertoire pertaining to what has gone unpreserved ("What are the social texts and the historical texts that articulate those longings and aspirations, that take forms commensurate or productively incommensurate to the experience described?") by combining the physical, the autobiographical, and the imagined.[15] She applies this method, which she named *critical fabulation*, for addressing the silences. In Hurston's and McIntyre's methodology, their insights are embedded in ethnographically informed embodied and written expression that cycles between archive and repertoire.

If a history is successfully "hosted" through Black female embodiment, whether textually or in live performance, the prominent creative and cultural organizing principles that emerge from the womb abyss—principles informed by the notion that the Black female body represents "hereditary darkness and rudeness" and often reinforced in the hierarchies that submerge Black women's voices and insights—must on some level become disrupted. In her approach, which is characterized by movement between oral traditions, writing, and performance, Hurston anticipates the work of the performance studies scholar Richard Schechner, who, in his collaboration with the anthropologist Victor Turner, was particularly interested in the transfer of what he calls performance knowledge, which he argues belongs to oral traditions and is a strong basis for exchange among theater practitioners and anthropologists. Performance knowledge includes and exceeds dramatic written texts; indeed, Schechner defines the performance text as "all that happens during a performance both onstage and off including audience participation." On the transmission of performance knowledge, especially as it pertains to cross-cultural engagement, Schechner argues that "what's important about these contacts is . . . the direct manipulation of the body as a means of transmitting performance knowledge; respect for 'body learning' as distinct from 'head learning'; also, a regard for the performance text as a braiding of various performance

'languages,' none of which can always claim primacy."[16] Here, Schechner points to the broadly conceived hierarchical divisions between body, mind, and their affiliated modes of expression that Hurston and McIntyre must negotiate at various sites of expressive creation.

Embodied expression is crucial in transmitting and preserving performance knowledge, and, as Hurston's and McIntyre's personal experiences and creative expression illustrate, it also disrupts hierarchical frames. Theorists such as Peggy Phelan may disagree with my former assertion; Phelan posits that performance is ephemeral and cannot be saved. However, Rebecca Schneider, Diana Taylor, Dorota Sajewska, and Dorota Sosnowska have challenged this notion, questioning, for example, the ways that thinking of performance "as the antithesis of 'saving'" limits us "to an understanding of performance predetermined by cultural habituation to the patrilineal, west-identified (arguably White-cultural) logic of the Archive."[17] Sajewska and Sosnowska argue that "there is nothing ephemeral in performance" and that "performance is a medium of memory that transfers and actualizes in the body that [which] official and institutionalized archives reject." Counted among the rejections is "memory that exists outside a text, document, or tangible trace." These theorists "assum[e] a different point of view—non-Western, marginalized, peripheral or defined by race"—in what they call the body-archive, or the understanding of the body as a site of history and a presence that recognizes the ever-present "residue" of pasts intertwined in the present and performing body in action, and in theater.[18] And of course Diana Taylor's delineation of the preserving roles of both the archive and the repertoire illustrates a recognition that embodied memory (gestures, movement, and so on) is important in "learning, storing, transmitting," and challenging knowledge.[19]

Soyica Diggs Colbert highlights a complication that embodied modes of creating and transferring knowledge present for the progeny of the enslaved: "The legacy of slavery, as communicated through racial hierarchies, reduces black people to materiality—walking archives—reflecting the assumption that at one point the ancestor of a black person was literally property." She suggests that African American drama is "the perfect medium to untangle this snarled web of racial inheritances" because it allows for "the symbolic reordering of the social and political hierarchy."[20] Extending and complicating Taylor's observation on what she presents as a somewhat dichotomous relationship between the archive and the

repertoire, Diggs Colbert argues that this relationship is "actually more malleable in African American theater through repetition/reproduction."[21] While Taylor writes that "written documents have repeatedly announced the disappearance of the performance practices involved in mnemonic transmission. . . . [s]erv[ing] as a strategy for repudiating and foreclosing the very embodiedness it claims to describe," Diggs Colbert asks that, in addition to archives and material evidence that are "supported by or [work] in the furtherance of the state," we consider the physical apparatus of the theater in recognition that this space calls additional archives into being "which undermin[e] the stability of all material evidence, including the body. As such, the archive itself is set in motion."[22] Like Diggs Colbert, I recognize a unique, malleable relationship at play between archive and repertoire in Black cultural expression and knowledge transmission. However, in studying Hurston's case in particular, I am led to ask: What happens when the stage of the southern store front or the northern theater proves unhospitable to Black women as participants in what becomes preserved and transferred? This very refusal is evidence that from the street corner to Broadway, and even in Black-centered spaces, instead of co-creators, Black women's bodies continue to stubbornly represent the excluded primitive as dictated by womb abyss framing.

In their movement between archive and repertoire, Hurston and McIntyre create alternative methods of transferring and preserving their stories via a praxis that exceeds the hierarchical frames that efface them. They craft and extend a methodology that, in moving between text and stage, allows for an intervention at the level of the repeating story being passed and its embedded exclusion of their insights. Leveraging the unique possibilities of each mode of preservation, each artist issues a direct challenge to the limits that excluded insights have long held on the stories that can be told by inviting audience members to co-create new possibilities for understanding Black women's expressive role and its value alongside their work.

Through a process of continual reiteration with a difference, the repository of *Their Eyes* that Hurston crafts and McIntyre extends features a built-in critique that works against the stagnation and elevation of any one story or mode of expression over others. Rather than operate as an echo chamber, it provides opportunities for rigorous reflection, and, uniquely based on the histories of Black women, it catalyzes revision and new possibilities for lives being lived. In what follows, I examine Hurston's

development of this dynamic system, including its necessary engagement with utterance, gesture, and writing, and the ways that the novel and a later iteration, the choreographer Dianne McIntyre's 1986 *Their Eyes Were Watching God: A Dance Adventure in Southern Blues*, exemplify a multimodal expressive approach that extends Glissant's vision of the possibilities of conscious reflection.

HURSTON'S NEW NEGRO (ART) THEATER

When Zora Neale Hurston writes to Langston Hughes from Maitland, Florida, in April 1928, she enthusiastically shares her ideas on "the new, the *real* Negro art theatre (emphasis added)" that she plans to present. As she explains to Hughes, she has recently formed five general laws on Black performance and has made one signal discovery that will set her apart from several of her contemporaries: "Negro folk-lore is still in the making."[23] Hurston's academic and artistic colleagues who ponder questions about the role that Black folk expression should play in Black aesthetics broadly tend to view folklore—particularly from the South—as "a remnant or survival of the past" that often needs editing and adjustment to establish a modern Black group identity.[24] Hurston's "discovery" reveals that she, uniquely of the folk that she studies, instead views Black folklore as a dynamic contemporary creation that should take center stage. Furthermore, her understanding of Black folklore as dynamic means that it is still possible to participate in the crafting of the "new kind" that is emerging.[25]

Indeed, when Hurston writes in 1928, she has been considering the formation of a new approach to Black theater and performance for nearly three years. Hurston is involved with a bourgeoning Black theater movement as a playwright and director from the mid-1920s through the early 1940s, with most of her theatrical work taking place in the 1930s. Her engagement with New Negro performance likely originates in her involvement with the student theater at Howard University, and by 1925 Hurston's plays are garnering attention: her play *Color Struck* wins second place for drama, and *Spears* receives honorable mention, in a writing competition for the National Urban League's *Opportunity: A Journal of Negro Life*. In a letter to Alain Locke the same year (also the year she

moves to New York City), she excitedly mentions a leadership role in a forthcoming "New Negro play company."[26] The understanding of Black aesthetics that undergirds Hurston's dynamic suggestion methodology finds its roots in these years as she thinks and creates among artists and researchers who "wondered at the efficacy and impact of black expression as they produced plays, visual art works, dances, and musical compositions" and who determined that "black performance styles and sensibilities were not merely verbal or aural, but also included visual symbolic codes that communicated and commented in-group."[27]

However, having grown up in awe of the virtuosity on display in masculinist sites of southern creativity—and having witnessed Black women's exclusion from it— Hurston finds herself at odds with the way folk expression is taken up by northern Black artists and intellectuals. As Deborah Plant writes, "The Harlem Renaissance leaders looked to the folk for inspiration and artistic material, but they deracinated and 'refined' these materials, purifying them of their 'barbarisms,' presenting them in a manner that would reflect the 'cultured' sensibilities of the Black intelligentsia, that is, in a manner they considered acceptable and palatable to whites, while safeguarding their elitist image of the New Negro."[28] Hurston now experiences a doubled exclusion in the North when she becomes involved with W. E. B. Du Bois's Krigwa Players—part of the Little Theatre Movement happening in major US cities. As a child that delighted in the theater of Joe Clark's store porch in Eatonville but couldn't participate, Hurston is likely thrilled and hopeful when she becomes a member of the "Cabinet" for the company. However, although she was an early establishing member, there is no space for her to contribute as a playwright.[29] Du Bois does not approve of her scripts: he rejects *The Lilac Bush* outright and suggests that she revise a play titled *The First One* (based on the biblical story on the curse of the son of Ham), citing his concern with the characters' understanding (and projection of the idea) of Blackness as a curse.[30] As Jean Lee Cole and Charles Mitchell note, though "Hurston put her own spin on the story, Du Bois 'believed that theater should depict the best of black society—his vaunted 'Talented Tenth'—as exemplary figures for whites and role models for other blacks.'"[31]

Hurston objects to what she views as Du Bois's insistence upon propagandistic theater. She, like Glissant, recognizes unfiltered Black folk expression as a particularly powerful and transformative site. She also

KRIGWA PLAYERS
LITTLE NEGRO THEATRE

AN attempt to establish in High Harlem, New York City, a Little Theatre which shall be primarily a center where Negro actors before Negro audiences interpret Negro life as depicted by Negro artists; but which shall also always have a welcome for all artists of all races and for all sympathetic comers and for all beautiful ideas.

Season of 1926

Repertoire "Compromise" by Willis Richardson, 5 players
"The Church Fight" by Ruth A. Gaines-Shelton, 10 players
"The Broken Banjo" by Willis Richardson, 5 players

Performances Mondays, May 3, 10 and 17, 1926, at 8:30 P. M.

Playhouse 135th Street Branch, New York Public Library.

Tickets for the three performances are now on sale at 50 cents each and are limited to 200 for each performance. No tickets will be sold at the door. For information address

THE CABINET
W. E. B. DuBois, Chairman, 69 Fifth Avenue, New York
Charles Burroughs Frank L. Horne
Zora Neale Hurston Louise Latimer

FIGURE 2.1 Handbill for Krigwa Players Little Negro Theater.

Source: W. E. B. Du Bois Papers, Robert S. Cox Special Collections and University Archives Research Center, UMass Amherst Libraries.

increasingly differs in both method and theory from Du Bois's approach to Black theater and what he views as its potentials. In an article focused on the Krigwa Players and his vision for "a new Negro theatre" published in *Crisis* in July 1926, Du Bois shares the major impediments, as he sees them, to the development of "a real folk-play movement of American Negroes." Among these are the hindering influence of the "Negro church" (which, for Du Bois, is Baptist and Methodist in composition) and its disdain for drama and theater, the skewing impact of a primarily White audience (who, he explains, expect a limited range of characters to include the "minstrel, comedian, singer and lay figure of all sorts" and exclude the "ordinary human being with everyday reactions"), and a limited range of plays written by Black authors.[32] As evinced in an earlier *Crisis* column, Du Bois is also keenly concerned with the Black audience, and he views this issue as acutely intertwined with that of the actor. In 1916, he writes: "The colored audience as I have seen it recently in the colored theatres of large cities is not above reproach. We are an appreciative people certainly, but our appreciation need not take the form of loud ejaculations and guffaws of laughter. . . . Is this state of affairs due to ignorance or thoughtlessness? To a combination of both, I fancy. . . . Our actors must be encouraged and not put on a level with mountebanks whose slightest gesture is the signal for laughter. There is no truer encouragement than an intelligent appreciation."[33] In his call for guiding lights from a northern-based, middle-class background to take the charge on refining Black theatrical expression and reception, Du Bois aligns less with Hurston's celebration of Black, working-class folk expression, especially that emerging from the South, and more with the elite class that Glissant discusses. It is likely against Du Bois's vision, at least in part, that Hurston conceives of "the new, the *real* Negro art theatre (italics added)" that she aims to create.[34] In tension here is their understanding of "real" and the "ordinary human being with everyday reactions." For Du Bois this refers to a movement toward what he saw as a theatrical "legitimacy" and away from the image-challenging legacy of minstrelsy and its stereotypes that he in part associates with the Black southern folk. For Hurston, increasingly frustrated with what she saw as lackluster representations of Black folk expression, it speaks to what she would refer to as "let[ting] the people sing"—an unfiltered celebration of Black creativity.[35]

SAVING THE TEXT FOR HER

From 1927—the year of Hurston's first folklore-collecting expedition in Florida—through 1933, Hurston's focus turns sharply from writing fiction and toward immersion in southern folk life, with a particular focus on its stage potential. A great deal of Hurston's financial support during this period comes from Charlotte Osgood Mason or "Godmother," a wealthy philanthropist whose contract both supports Hurston's work and silences her expression. With her anthropological training, Hurston likely appears a fitting candidate to satiate Mason's desires for unique access to what she imagines is an undiluted Black culture. While Mason's financial support allows Hurston's work at preserving folk expression to flourish, it also presents her with an increasingly urgent challenge: In an extension of the limitations for women's participation in Black expressive creation in the South and for Black southern women's participation in the northern theater scene, Mason curtails Hurston's ability to join into conversation with the folk creatively or to freely publish her insights on her findings. Hurston is contracted to turn her research over to Mason and is beholden to Mason for permission to publish anything. She is progressively convinced that she is uniquely positioned to present her findings creatively, and her challenge during this period is to "save the text" or integrity of Black southern folk expression, along with her unique point of view, from Mason and others that demand her silence.

If, while growing up in the South, Hurston observed the limitations that Black women faced in participating in folk creation, and if in New York she was exposed to the ways that this expression was deemed primitive and in need of curation and intervention, then with Mason, Hurston faces a challenge of the archive. The folklorist's collected findings become archived by Mason, and Hurston's access to this archive is dictated by Mason's sensibilities. For example, when Mason is convinced that Hurston's plans for the theatrical presentation of her collected folklore will lead to what she determines is proper Black artistic expression, she "gave Zora access to the Fire Dance films she'd shot in the Bahamas, footage that was technically Mason's property." Later, Mason forces Hurston to remove her interpretation of a southern conjure ceremony from her concert *The Great Day* out of fear that "someone would try to steal the ritual and exploit it for commercial gain," and she drafts a legally

binding addendum to the contract reinforcing her control of the material and encouraging the use of the material for books, which for her were, unlike scholarly articles or commercial theater ventures, "lasting monument[s]."[36] So positioned, Mason exercises archival power and authority: It is she who holds the final power of "coding, classification and distribution," she who "grant[s] . . . privileged status" to the written documents presented by Hurston that she deems worthy, and as such, she who determines the "story" that this archive "makes possible."[37] Hurston's physical distance from Mason during this period helps her mitigate Mason's potential to dilute the power that Hurston as a Black southern woman folklorist holds for disrupting extraction and silencing. The folklorist returns to the South having intimately witnessed the ways that the New Negro is being crafted against the assumed primitivity of the Black South writ large even as southern folk expression continues to inspire its cultural production. A return to the South for Hurston is a return to an immersion in what she views as a comparatively superior expressive vibrancy. Hurston's distance also allows for an alternative mode of communication with her Harlem colleagues that grants her a measure of control over extraction. Through her epistolary engagement, Hurston exhibits a savvy sense regarding how much she shares and with whom, illustrating a selectivity about whom she takes into her confidence. As she writes to Langston Hughes on April 12, 1928, she is discussing her nascent ideas on Black performance solely with him, not with "Godmother or Locke until I have them worked out. Locke would hustle out a volume right away."[38] Here, while concerned with preventing uncredited extraction of her ideas, Hurston is still able to share ideas and findings and receive feedback.

Hurston's letter writing also constitutes the creation of a counterarchive documenting the development of her theories and methods. While she appears to be largely absent from the contentious discourse concerning Black aesthetics that is playing out in major journals and other visible forums between Langston Hughes, George Schuyler, Du Bois, and Alain Locke among others, Hurston establishes her own private forum for engaging with several of the more prominent participants in her letters. For example, Hurston discusses with multiple correspondents her growing frustration with the lackluster representations of Black southern folk expression being put forth in both print and the theater.[39] It is in her letters from this period that we find her critiquing how Black folk

expression is presented by White folklorists such as Howard Odum and Guy Johnson, regarding which she notes, "I certainly would like to see an honest criticism of the work published, but we couldn't do it lest we be accused of jealousy."[40] Turning what appears to be a heightened attention toward the methodologies of southern folk creators following her experiences witnessing the extractions taking place in New York, Hurston's letters reflect her formation of a prototheory on a creative exchange practice she is observing that will inform her inclusive, cross-generic expressive framework. She initially mentions this concept to Hughes in a letter from Florida in April 1928, describing it as a performance of restraint by a Black person via music, dancing, or gesture that produces a catalytic response in an onlooker.[41] She reflects on her application of this idea in July 1928, when she recalls the response she receives to sharing Hughes's poetry while conducting fieldwork. Hurston explains that she begins storytelling contests throughout the South by reading Hughes's poems. Members of her audience absorb his poetry, "making it so much a part of themselves they go to improvising on it," and, in a "strang[e] and most thrilling" way, they turn the poems into songs via a call-and-response performance reminiscent of a Black church service.[42] This reflection also reveals the author's early experiments with expressive frames.[43] Through this practice, as she illustrates in this example, written poetry becomes live utterance that transforms into song, and co-creators are not confined to a single expressive or hierarchical mode.

Perhaps as a result of these early observations and reflections on the exchange between performer and audience and on the intimate and intricate relationship between Black southern folk song, dance, gesture, and utterance, Hurston becomes convinced that the stage is the most capable venue for sharing Black folk expression. After she returns to New York City in 1930, she focuses with growing intensity on staging concerts that use each of the aforementioned elements of expression.[44] After several collaborations and after her work is staged by groups such as the Gilpin Players in Cleveland, Hurston's large-scale revue *The Great Day* premieres on Broadway on January 10, 1932. Although it garners glowing reviews, the show fails to attract a producer, and Hurston's frustration with locating a space to express her insights continues. Later that year, she returns south with her vision for Black theater, working first with Rollins College and then less successfully with Bethune-Cookman College in Florida.

BLACK EXPRESSION:
THEORIZING, PRESERVING, AND PARTICIPATING

Despite her continued difficulties with the stage, Hurston's 1934 "Characteristics of Negro Expression" makes clear that she is still focusing on the mechanics of what she argues is the most powerful Black art. Among a number of articles published in 1934 that reveal Hurston's public stances on Black aesthetics, "Characteristics" was perhaps the most quietly presented, published in Nancy Cunard's *Negro* anthology. Nonetheless, at the time of publication, it was one of the most comprehensive analyses of Black aesthetics. Today, "Characteristics" is celebrated as a key site of origin from which the field of Black performance theory emerged. As Thomas DeFrantz and Anita Gonzalez write, in the article, Hurston "offered a taxonomy of African American performativity . . . that referenced sites, modes, and practices of performance," with "each section confirm[ing] Negro Expression as its own source and subject of possibility."[45]

After years of pondering Black expression from several angles, Hurston extends a case for discarding rubrics of appreciation and analysis that are influenced by dominant notions of excellence—including those that shape Black northerners' pursuit of modern subjectivity. On this point, Hurston differentiates between the "art-creating Negro" who understands Black expression as its own reference point for excellence and "the white producer," as well as the "Negro who takes his cue from the white," both of whom are governed by White-centered value rubrics. Aligning herself with the art creator, she foregrounds her distinctive ability to recognize the gulf between each type and the oversights of the latter two. In the section titled "Will to Adorn," Hurston declares that "we each have our standards of art," here contesting the idea that any group of individuals is bestowed with the privilege of determining and judging these criteria for others. Further challenging arguments for static prescription, Hurston explains that art writ large is characterized by "the exchange and re-exchange of ideas" between groups, anticipating Turner's and Schechner's pronouncements on the transmission of performance knowledge. And perhaps Hurston's most pointed rejoinder to the prominent framers of Black modern expression looking to refine Black southern expression appears in the "Jook" section, where the folklorist presents the southern "jook" as the "most important place in America." She writes, "To those who want to

institute the Negro theatre, let me say it is already established. . . . The real Negro theatre is in the Jooks and the cabarets. Self-conscious individuals may turn away the eye and say, 'Let us search elsewhere for our dramatic art.' Let 'em search. They certainly won't find it." It is in these "house[s] set apart on the public works where the men and women dance, drink and gamble"—the antithesis of respectability—that she locates what for her are key sites of not only the origin but also the ongoing creation of Black expression in the United States.[46] In "Characteristics," Hurston the folklorist compiles an archive that details the expression produced in numerous social "theaters" from the jook to the street corner. In creating such an archive, Hurston crafts a textual snapshot of a moment that allows for a unique reflection on the ways that, from Florida to New York, "black performance answers pressing aesthetic concerns of the communities that engage it."[47] However, if, as Glissant suggests, "folklore 'reveals' and theater 'reflects'" a more deeply rooted objective or intention that "at its origin [represents] the vestige of an intention (a becoming) whose manifestations (state, religion, language) are organized around a common objective," then the overwhelming exclusion of Black women from the archive that Hurston compiles proves alarming.[48] These exclusions can be traced back to the poetics that emerge from the womb abyss that I discuss in the introduction, and here they illustrate how the contemporary manifestations of this original moment of becoming—Black women's exclusion from participating in the creation of Black folk expression and from having their creative insights preserved—are revealed more broadly in Black expressive culture. As the geographical scope of Hurston's archive illustrates, these exclusions are not relegated to a postplantation South.

Substantial mention of meaningful integration of women's creativity is absent from much of the essay, most notably from the sections "Negro Folklore" and "Culture Heroes." These sections, supporting Hurston's argument that "the trickster-hero of West Africa has been transplanted to America," are dominated by the masculine folk imagination. This point is particularly significant because these are the aspects of Black southern folk culture that are taken up heavily by Black northerners. Though diffused and edited, the exclusion of Black women's insights is reflected in what is transferred, and Black women's (heavily curated) appearances further reinforce womb abyss framing and its attendant silencing. Black women are discussed in the section "The Jook," which for Hurston is the

ground zero for Black expression. The originality of the Black jook singer and dancer is celebrated, but the author makes clear how easily she is supplanted for a Whiter-appearing performer in the commercial theater. Here, Hurston also illustrates how the Black woman serves as material for the folk without herself becoming the creator of the folk—both in the male imaginary and as realized in folklore. She describes issues that surface in the commonly traded lore, such as the "scornful attitude towards black women" that determines their marriageability in the North and women's role in folk songs in the South, noting that "even on the works and in the Jooks the black man sings disparaging of black women. They say that she is evil. That she sleeps with her fists doubled up and ready for action. All over they are making a little drama of waking up a yaller wife and a black one."[49] While celebrating the "queen of the Jook," Hurston also highlights the pervasive perception of Black woman's subordinate role in folk expression.

Traces of the ways in which Hurston begins to confront and exceed this exclusion are introduced in the brief two paragraphs that appear in the "Dancing" section, which opens with the following words: "Negro dancing is dynamic suggestion."[50] Although she has approached it in letters with select correspondents, this is Hurston's public introduction of the framework that will ultimately open space for Black women's creative expression. On the surface, the section does not directly address Black women, but it does prompt powerful questions on the stories that bodies are forced to carry and the imposition of these narrative loads from without.

In her "Dancing" section, Hurston pointedly addresses the issue of stereotyped representations of Black culture around which the Black theater debates orbited. Notably, this is also where she publicly introduces her definition of dynamic suggestion. Opening the section with the declaration that "Negro dancing is dynamic suggestion," Hurston explains that White dancers attempt to express fully, while Black dancers "succee[d] in gripping the beholder by forcing him to finish the action the performer suggests," and in unequivocal terms, she crowns the Black dancer the superior artist because "no art can ever express all the variations conceivable." As she explains, Black dancers' flexed knees, "ferocious face masks," and upper body thrusts offer a "compelling insinuation" that draws the spectator in to "ad[d] the picture of ferocious assault, hea[r] the drums and fin[d] himself keeping time with the music and tensing himself for

the struggle." If, in keeping with her early explanation of this concept, Hurston continues to imagine the spectator as "the staid nordic," then she centers this spectator-as-performer in a key role in the performance, saying that they "finis[h] the action."[51] By illustrating this meeting of the dancer's and the spectator's imagination, Hurston directs our focus to the source of the racial stereotypes that continue to proliferate in popular culture in the mid-1930s, stereotypes suggesting that a primitive, coarse, and savage nature is inherent to the southern Black moving body.[52] Rather than reflecting a truth about southern Black culture, Hurston makes clear that these ideas are projected onto the dancing body and act as a foil within the imaginations of those who either already consider themselves modern and refined or aspire to be seen as such. Hurston's logic makes possible an examination of the Black woman's predicament with womb abyss framing and its imposed plantation-based silencing, meanings that reduce her to a specifically coded "walking archive."[53]

While "Characteristics" is often considered Hurston's fullest theorization of Black expression, after its publication she continues to observe southern folk creators and to develop her own methods of preservation and co-creative inclusion. In 1935, for example, she engages Gullah Geechee cultures in the Georgia Sea Islands and Black communities in Florida on a music-collecting expedition with the New York University professor Mary Elizabeth Barnicle and the student folk collector Alan Lomax. Later, during a recording session that features Hurston singing folk songs, her Federal Music Project colleague Herbert Halpert asks about her collecting methods. Hurston's answer reveals that her dynamic suggestion techniques have been sharpened. She explains that she learns "Halimuhfack" and other songs from crowds:

> I just get in the crowd with the people if they singing and I listen as best I can and I start to joining in with a phrase or two and then finally I get so I can sing a verse and then I keep on until I learn all the . . . verses. . . . Then I sing them back to the people until they tell me that I can sing em just like them. And then I take part and I try it out on different people who already know the song until they are quite satisfied that I know it. And then I carry it in my memory. . . . And then I can take it with me where ever I go.[54]

As this explanation reveals, Hurston has developed a potent method for enriching the Black expressive archive and repertoire that is facilitated by the tools of modernity (here, recording equipment) and informed by her observation and insights. The folklorist inserts herself as both a preservationist and a creative contributor through her presentation of "Halimuhfack." As she explains, her notes and her memory become the archive, disrupting the reduction to materiality or to an archive of imposed meaning. Instead, Hurston, an insider of the cultures that she is observing, takes on the power of the archivist by selecting key living artifacts to preserve. Notably, Hurston's answer illustrates a melding of absorption and dynamic suggestion that allows her to save the text and become its carrier and arguably its co-creator and co-performer. In becoming a carrier, Hurston inserts herself into the creative location that women are usually either wholly excluded from or included only in an extractive manner based on what they can contribute to the male storyteller's expression. Because she has strategically inserted herself in this way, Hurston is now clearly a contributor to what is "ever in the making," even if for some these contributions remain illegible.

Taken collectively, Hurston's "Characteristics" and her embedding practice illustrate that she has advanced in her analysis of Black expressive innovations and the ways that the written word can work alongside "the physical apparatus of the theater" in "undermin[ing] the stability of all material evidence, including the body," in part by setting "the archive" in motion.[55] From her written analysis of the gestures of the dancer and "strolling players" of the street corners as their utterances become the metaphor, simile, and blues that reconfigure the English language to her own movement between written archive and participant in folk repertoire, Hurston illustrates the potential of combining elements of other expressive modes with "words to create unexpected interpretive spaces [that] replicate the open structures of jazz, speech, and motion." For Thomas DeFrantz and Anita Gonzalez, with "Characteristics" Hurston provides an example of "performative writing": "rich portrayals of nuances of Negro form" that "might be the writing that Hurston refers to at the beginning of her essay, when she writes of the black performer that 'his very words are action words. His interpretation of the English language is in terms of pictures. One act described in terms of another.'"[56] Considered in these

terms, dynamic suggestion becomes a multisited catalyst that works in expressive and artistic forms that have the potential for not only a broad inclusivity but also, through the logic Hurston presents in "Characteristics," a contemplative element that encourages one to consider the ways that audiences, spectators, and anyone else's imposed frames reflect their own biases and not something intrinsic to their co-creators.

THEIR EYES: CATALYZING A STRANGE SOUTH AND INTRODUCING THE STRANGE FOLK HEROINE

By 1934, Hurston recognizes that drama and action permeate Black people's "interpretation of the English language," making a bridge between utterance, gesture, and writing perceivable.[57] In 1937, she gathers these elements together along with techniques for preserving the Black woman's creative insights and embeds them into the novel form. In perhaps her fullest expression of the possibilities of Black expression, Hurston's novel *Their Eyes Were Watching God* is endowed with the power of the strange (or unfamiliar) South: a disruptive catalyst for moving and expressing beyond the limitations of the womb abyss. This text invites readers to join a performance of dynamic suggestion that sets in motion inclusive modes of expression and preservation for Black women.

Published in 1937, the novel *Their Eyes Were Watching God* centers on the exchange of stories between the protagonist Janie and her friend Pheoby. This exchange primarily documents Janie's journey to self-empowerment. The novel ensures that the stories of Nanny (Janie's grandmother) and Leafy (Janie's mother), which represent the past, are also preserved in the reader's present. Because Janie tells her story to Pheoby, current and future readers also have access to Janie's and Pheoby's experiences and reflections. In a significant shift from the imposed and silencing notion of Black women's "hereditary darkness and rudeness," *Their Eyes Were Watching God* features a Black woman who ultimately shapes cultural expression and makes decisions regarding what is preserved. However, the novel also stands as a critique of how the legacy of slavery imposed on Black women often reverberates outward to exclude Black women's insights. For example, despite the townspeople's recognition that Janie is

a skilled orator, she is denied opportunities to participate in the creative spaces of Eatonville. As Hurston has taught in her earlier works, the creative expression generated at sites such as these is often taken up by intellectuals and artists in northern urban centers and presented on a broader stage. Returning to Glissant's observation that folklore reveals and theater reflects, *Their Eyes* ultimately intervenes in the archives and repertoires of Black folk expression that omit the insights of Black southern women.

With *Their Eyes*, Hurston powerfully disrupts the male-dominated position of the folk hero. Having herself recently encountered an unfamiliar South in Haitian Vodou, Hurston is exposed to a vast pantheon of loa or deities that explode the gendered limitations that previously governed her imaginary. The folklorist's conception of a Black woman folk hero as realized in Janie marks a discernible shift in Hurston's ability to imagine mobility for her women characters: Whereas in early works Hurston's women are "stuck" ideologically or geographically, Janie traverses physical geographies while overcoming limiting narratives in her quest toward liberation. The protagonist's extraordinary transformation following multiple silencing attempts by her husbands bears the imprint of Hurston's shift. Janie's first husband expects that the Black woman will serve as the "mule uh de world," her second husband demands her silence so that he can be seen as "I God" (meaning that the god that his community members' eyes are watching is unquestionably male), and Janie emerges from attempted murder by her third and increasingly insecure and possessive husband Tea Cake.[58] This final emergence allows Janie as folk hero to prevail; she has to return to Eatonville and Pheoby to transfer her story for preservation. For, as both "Characteristics" and the fictional Eatonville community illustrate, eyes focused on a male god are also focused on a male hero or masculine speaker of the race, leaving no room for noticing, much less notating, a Black woman's quest and transformation.

The novel begins with Janie's return from the final and most revelatory leg of her hero's journey, where she has been transformed by the strange South of the Everglades, or the muck. As Janie (via Pheoby) explains, the muck is a transient, transnational community where the "big and new" landscape, the ever-shifting population, and even her role as wife are somewhat unfamiliar. This strange set of relations (particularly the social atmosphere) sets the stage for her to initiate and participate in dynamic suggestion. In the muck, Janie's ability to share and preserve her insights

is transmuted; while "the men held big arguments here like they used to do on the store porch," here "she could listen and laugh and even talk some herself if she wanted to. She got so she could tell big stories herself from listening to the rest." Although by no means perfect, as illustrated when Tea Cake uses Janie's slapped face as motivation for the storytelling, "visions," and "dreams" of the community, the muck becomes superior to the Jook as explained in "Characteristics" as an inclusive site of Black art making, as Black women here also become creators.[59]

Janie returns from the muck not only with a shifted relationship to the value of her creative insights, but also with a heightened understanding of audiences and their ability (or lack thereof) to properly understand and preserve her story. When Janie places her "tongue" in her friend Pheoby's mouth, she disrupts notions of whose insights are passed or preserved, as well as who is empowered to determine what is valuable enough to pass or preserve and to whom it is transferred. In allowing Pheoby access to her "tongue," Janie endows Pheoby with the power not only to preserve what she finds useful but also to choose what and with whom she will share. The successful transfer and recording of a Black woman's folk journey that occur between Janie and Pheoby will remain inaccessible to the "tongueless, earless, eyeless" porch sitters if Pheoby decides to withhold the information or if, as Janie warns, their failure to probe and "find out about livin'" for themselves" renders her story inaccessible to them.[60] Diana Taylor proposes that this inaccessibility, or, as she addresses it, untranslatability, can actually be a positive problem if "we proceed from that premise—that we do not understand each other—and recognize that each effort in that direction needs to work against notions of easy access, decipherability, and translatability."[61] This recognition is registered when Janie reminds Pheoby that she too must "*go* there tuh *know* there," but unlike Pheoby, several of her neighbors cannot achieve this understanding because their oppression has rendered them dispossessed "lords of sounds and lesser things."

As was the case with the Muck's impact on Janie's transformed relationship to inclusion, physical space and audience remain important for the transfer and preservation of her insights. Pheoby notably bypasses Janie's front porch and instead enters her friend's "intimate gate" and joins her on her back porch, flattening the hierarchical symbolism of the front porch that Nanny aspired to and Janie abhors.[62] Like Hurston's manipulation

of the epistolatory space, this intimate and woman-centered space represents a careful selection of listeners. As Carla Kaplan writes, Janie has always had a voice, but as she demonstrates throughout the novel, she is impatient with wasting her breath.[63] And as Alice Walker argued against Robert Stepto at an MLA panel in 1979, through Janie, Hurston illustrates that women could "choose when and where they wish to speak because while many women *had* found their own voices, they also knew when it was better not to use it."[64] Janie's careful and selective use of her voice disrupts the extractive property relations set into motion upon contact with Black women's bodies and their imposed archives. Her strategic use of silence, for example, blocks her expression from being extracted and used to build others' subjectivities, be they creative, modern, or otherwise. Those present on the private back porch, which becomes the site of transfer, are capable of refusing demands for transparency and incorporation into the hierarchical frameworks that enclose their neighbors' thoughts. And yet the exchange that the back porch allows also impedes the womb abyss silencing that is perhaps best represented by Annie Tyler, another middle-aged woman who dares to disconnect from the crowd in pursuit of love and who becomes a ridiculed "tale told by others." Under the opaque cover that the back porch provides, Janie's and Pheoby's dynamic exchange instead allows for a movement beyond a framework that denies their agency. Although it is a static space geographically, the back porch becomes activated as a sort of stage upon which deep reflection and dynamic movement are welcomed.

The story transfer and preservation that occur on Janie's back porch are a layered performance. A gesture from Janie's audience of one mobilizes the process that enables the transfer and preservation of her story. After Janie enjoys the gift of food that Pheoby provides and the friends exchange a few pleasantries and acknowledge their prying neighbors, "They sat there in the fresh young darkness. . . . Pheoby eager to feel and do through Janie, but hating to show her zest for fear it might be thought mere curiosity. Janie full of that oldest human longing—self revelation. Pheoby held her tongue for a long time, but she couldn't help moving her feet. So Janie spoke." Under the cover of the night and on the back porch, Pheoby's earnest gesture compels Janie's utterance. Joining into conversation with the stories of her mother and grandmother, Janie shares her story. Here, Hurston captures in written form the impact of

dynamic suggestion (represented by Pheoby's gesture) and the sharing of a Black woman's narrative (intertwined with those of other Black women), processes informed and motivated by Janie's participation in the muck and mirroring the methods that the author has spent years observing and perfecting. Moreover, the narrative impact of Pheoby's gesture illustrates that between 1934 and 1937 Hurston's concept of dynamic suggestion has moved from operating partly as a text-based technique for issuing a critique of audiences and stereotypes and their impact on Black expression, to more fully encompassing the ways that the author has personally used dynamic suggestion to incorporate Black women's insights into folk expression. This change is symbolized when Janie welcomes Pheoby in to witness her experience under the condition that she will actively engage "with a good thought." In other words, Janie is inviting Pheoby in as co-creator. As Pheoby listens hungrily, Janie launches not only into her own story but also into those of her mother and grandmother, a transfer of collected, preserved stories that provide the "understandin' to go 'long wid" Janie's. In this textually presented practice of dynamic suggestion, Hurston and her protagonist radically relocate the masculinist foundations that undergird Black southern folk expression as well as the potentials of that expression as understood by the Black elite. And yet, this shift alone is not enough. In the framework that Hurston presents, Nanny's and Leafy's and even Janie's stories provide new starting points of dynamic suggestion, but they remain just that. With Janie's warning that "yo' papa and yo' mama and nobody else can't tell yuh and show yuh. . . . they got tuh find out about livin' fuh theyselves," Hurston reminds her audience that they must continue to preserve the broad range of insights that will enrich the archives and repertoires that stem from this and other sites of dynamic suggestion.[65] With Janie's and Pheoby's exchange and preservation, Hurston crafts a textual space for reflection and a creative springboard that anticipates the movement from folk expression to theater that Glissant calls for decades later. Furthermore, in embedding dynamic suggestion into a novel-cum-strange-South that uniquely situates a Black woman as folk hero, *Their Eyes* becomes an accessible springboard for a multisited poetics of transmutation that extends through the twentieth and into the twenty-first century.

"TONGUE IN MAH FRIEND'S MOUF": INHERITING *THEIR EYES*

Roughly fifty years separate the initial publication of Hurston's *Their Eyes Were Watching God* and the choreographer Dianne McIntyre's staging of *Their Eyes Were Watching God (A Dance Adventure in Southern Blues)*. In the intervening years, Hurston's novel receives mixed reviews, with some of the more negative among them making clear how unusual it is for rural and southern Black women's experiences and insights to occupy the narrative center. The novel is removed from print circulation in the late 1960s, is briefly printed again in 1971, at which point it has become an "underground phenomenon," and then goes out of print again in 1975 until the University of Illinois Press prints it in 1978.[66] When it is unavailable commercially, the literary critic Ann duCille recalls that the novel remains in heavy circulation as a communal text that is xeroxed and transferred "from sister to sister to daughter to neighbor to friend."[67] This alone is a testament to the resilience and effectiveness of Hurston's inclusive approach to cultural transmission and preservation. As Mary Helen Washington recalls, at a minority literature conference held at Yale in 1975, "the few copies of *Their Eyes* that were available were circulated for two hours at a time for conference participants, many of whom were reading the novel for the first time," and by 1979 "a novel that . . . just ten years earlier was unknown and unavailable had entered into critical acceptance as perhaps the most widely known and the most privileged text in the African-American literary canon."

The circulation history of the novel also speaks to Hurston's ability to embed elements of a strange or unfamiliar South (in this case strange because of the southern Black woman folk hero and the preservation of other women's stories as its center) into a format that can enjoy wide circulation, whether in a published book or on xeroxed pages. After all, whereas Hurston and McIntyre can take advantage of travel opportunities to directly encounter unfamiliar Souths, such opportunities remain unavailable for many others. As several Black women who have taught the text have attested, audiences throughout the United States had a "direct and personal" reaction to seeing "themselves so powerfully represented in a literary text," including Shirley Ann Williams's students from migrant

farming families, who saw "themselves in these characters and . . . their lives portrayed with joy" for the first time.[68] The ranging impact that Janie's (and Pheoby's and Nanny's and Leafy's) story and insights have on the book's readers complicates Kaplan's assertion that Hurston's "only ideal audience" is "a virtual mirror of Janie" and that through the author's framing of the narrative as an "overheard discussion," we "hear" Janie's story, but solely "in the form of a reminder that *we* are *not* its ideal audience, that it is not addressed to us, that we are not having a conversation with Janie and that we, unlike Pheoby (and apparently regardless of whoever 'we' in fact happen to be) do not have our tongue in either Janie's or Hurston's mouth."[69] Unreservedly, in contemplating the novel as one that aims to compel the creation of a more inclusive repository of folk expression, I understand Hurston to be speaking most directly to a diverse group of Black women. Within the world of the novel, Pheoby is far from a mirror of Janie, and with her liminal positioning between Janie and the townsfolk, Janie's insights thus preserved and transferred hold the potential to affect many people in the town, including some of the porch sitters. As the centrality of the culturally and even ideologically mixed strange South of the muck illustrates, Hurston is aware of and even celebrating a number of groups whose insights are similarly excluded from the broad archive and repertoire of folk expression, including the Bahaman workers and their fire dances and the Seminoles whose movement warns of the impending destruction that the hurricane will bring. These groups and the array of readers that connect with and are inspired by the novel illustrate that Hurston's imagined audience is by no means limited to "a virtual mirror of Janie."

McINTYRE'S SOUTHS

Dianne McIntyre is among the compelled—both by the repository of *Their Eyes* and by Hurston the folklorist and artist—to engage the strange South that is the *Their Eyes* repository. Although a midwesterner, McIntyre is perhaps drawn to what she, as the child of parents that participated in the Great Migration, finds familiar in the written representation of a Black southern sonic element in Hurston's work. Isabel Wilkerson

explains that the migrants "carried with them the accents of the South," a point that McIntyre confirms.⁷⁰

> Those of us who are from Detroit, Cleveland, maybe Pittsburgh, Chicago, a lot of our associates, their parents were from different parts of the South. In our area the people are from Georgia. On the East Coast the people are from North and South Carolina. In Chicago the people are from Mississippi and like that . . . they go straight up. . . . Those of us of next or other generations—often White people ask where from the South are we from because they think we have southern accents. I say this is the way Black people from my area . . . talk. I'm not from the South I'm not born in the South. . . . this is our way of speaking.⁷¹

However, it is not until she is undertaking research in the Library of Congress that McIntyre encounters Hurston's voice directly.⁷² It is instead the collaborator and drummer Steve Solder who directs the choreographer to the folklorist's work after recognizing how the artists similarly observe Africana southern folk expression and incorporate it into their own expressive vocabularies.

McIntyre begins to influence the dance world in 1970 when she relocates to New York following college. Her influence leads the dance scholar Veta Goler to argue that "chronologically, McIntyre follows Katherine Dunham and Pearl Primus as the next generation's most accomplished African American woman modern dance choreographer." Like Hurston, McIntyre faces challenges with creative hierarchies embedded in expressive forms, both in the broader dance world and in spaces where Black expressive creation occurs more specifically.⁷³ McIntyre inherits an atmosphere featuring increased racial representation in the dance world that occurs during the 1950s and 1960s, as well as the continued pressures that Black dancers and choreographers face "to represent the specifics of their raced and classed backgrounds, while white choreographers could continue to claim the project of radical exploration of the new."⁷⁴ Dancers and choreographers also deal with gender-related constraints, particularly when they are imagined to be creatively and intellectually inferior to musicians—a predicament that McIntyre would confront. As the journalist Marcia Siegel perceives in 1976, "virtually the entire contemporary black dance idiom has been shaped by men," and as Danielle Goldman

notes, midcentury "dance and music are analyzed consistently as distinct entities: one historically female, the other historically male; one of the body, the other of the mind; one seen, the other heard."[75] These binaries, persisting well beyond midcentury, are "inextricable from power relations, entrenched institutional biases, and historical circumstance . . . [and] affect how we understand and respond to bodies. They also shape people's freedom to move."[76] In addition to addressing racialized and gendered challenges with expression and representation, McIntyre aims to express the interior, emotional life.[77] Her work in this area dovetails with a burgeoning concern during the Black women's renaissance that occurred during the 1970s and 1980s.[78] The urgent need to address this issue and the way it is bound up in a plantation past is highlighted by Toni Morrison, for whom the denial of the inner life in the Black literary tradition originates in the slave narrative.[79] As was the case for Hurston, McIntyre faces intensified stakes around this issue. Additionally, because she is a Black woman who expresses primarily with her body, womb abyss framing intensely precedes her expression. In facing a public already primed to understand her creative contributions as of less worth than those of her male and/or White counterparts, she not only must develop methods that allow for the inclusion and preservation of her insights but must also combat a plantation-based erasure of Black interior worlds from expressive archives and repertoires that has endured for nearly a century.

In developing her methodology to address these issues, McIntyre illustrates a concern with inclusion and preservation that is consistent with that of Hurston years earlier. The choreographer refers to her own method of dynamic suggestion in terms of absorption. She acknowledges, for example, that she has "absorbed" all that Dunham has written and has also surveyed research on Vodou and the Haitian and Jamaican cultures in preparation for her travels. However, as a paradigm-shifting choreographer, she concedes that, in a tone reminiscent of Janie's, "nothing was like being there" participating in Haitian Vodou ceremonies to "absorb information and feeling" from frame-expanding gesture and movement vocabularies. Correspondingly, when McIntyre conducts research in the Sea Islands of South Carolina to "absorb the dances and the culture," she visits a Praise House, which she describes as a multidenominational "central community" that allows residents of the island to come together to participate in and continue rich sonic and movement traditions. Although

she is initially drawn to the site by a desire to hear the singing, what she witnesses leaves a strong impression on her: "In the tradition, they sing the songs, and they clap and they stomp.... So they clap and they stomp in that very... rhythmic way. And the praise house is... a smallish wooden structure... and [has] a strong wooden floor. So they feed against the floor."[80] McIntyre discovers a reverberating relationship between multiple expressive elements while in the Praise House: correspondence between the movement, the clapping, the singing, and the floor, with each in turn stimulating a response from the other. In some ways, this correspondence mirrors the possibilities that emerge from the intersection of sound, movement, and absorption. In a figurative sense, the experience could be understood as a symbolic representation of the method that she will develop to enter into an inclusive relationship with musicians that will disrupt the exclusionary womb abyss limitations projected onto her body.

SOUNDS IN MOTION

In New York, McIntyre quickly becomes enchanted by free jazz, or the new music, defined by William J. Harris as an abstract, experimental music that, "dissonant and seemingly chaotic... is based on no 'predetermined, underlying harmonic structure,'" is "rooted in the familiar sounds of Black music, especially the earthy and funky sounds of blues and gospel," and is "rooted in the African American audio past; that is, more specifically, it is rooted in the shouts of the Black church and the hollers of the field, sounds saturated with the history of slavery." In this way, free jazz operates as a repository of sonic Black folk expression. McIntyre sets out to absorb these sounds, and one of her earliest sites of experimentation is a day care center in Brooklyn where every week she joins a group of musicians called the Master Brotherhood. Working six hours against this sonic background, McIntyre sets out to put the instruments—the trumpet and the piano and the bass—into her body.[81] After long evenings of working to incorporate the sounds into her movement vocabulary, McIntyre's relation to the music "quickly went beyond mere emulation"—she "began to feel like another instrument, and she and the musicians developed a back-and-forth rapport where they influenced each other."[82] While

discussing her 1979 concert *Life's Force*, McIntyre more fully explains her philosophy on the relationship between music and dance: "My concept is that the dance is not accompaniment for the music. The dance and the music are all part of the same band, so that you can see the music through the dancers' bodies, and you can hear the dance in the musician's music. This piece captures my basic philosophy: Dance is music moving."[83]

When McIntyre stages an early concert titled *Sounds in Motion* (which later becomes the name of her company and school) that integrates several of the musicians from the Brotherhood, she ushers in a "radical understanding of embodied ensemble" via the "rapid, improvised exchanges that occurred between the musicians and dancers" in her company that would challenge the gendered relationship between music and dance as well as racialized perceptions in the modern dance world.[84] As McIntyre explains, the relationship between dancer and musician is one of simultaneous and recursive dynamic suggestion. She absorbs the music while the musician visually takes in her movement, and like the scene in the Praise House, the two meet and "something comes out" at the nexus, and they repeat the cycle.[85] Crucially, this cycle levels the hierarchy that values music more highly than embodied movement, with neither dance nor music emerging superior. Rather, a new unanticipated fusion always springs forth.

While working through these cycles characterized by absorption and dynamic suggestion, McIntyre develops a technique that troubles gendered binaries that code the Black woman's staged moving body as inferior to the male musician. The musician, seen as intellectually superior, is endowed with the (at times extractive) power of the archivist. McIntyre's model challenges the hierarchy nested in the dance/music binary and in so doing proves more hospitable to the expression and preservation of Black women's worlds.[86] However, this quality does not always shield the choreographer from musicians who decide to forcibly reinsert this divide. In an interview with Danielle Goldman, McIntyre recalls one such incident. The dancer spent hours rehearsing and developing a plan for a structured improvisation with a male drummer—a performance following the symbiotic dynamic suggestion relationship between sound and movement that would eventually characterize McIntyre's dance idiom. As Goldman relates, "the drummer adopted an intensity in performance that had been entirely absent in rehearsals. According to McIntyre, he didn't pay attention to anything she was doing; instead, he sat there, laughing as

he aggressively pounded upon his instrument. McIntyre recalled dancing with her back to the audience, screaming at the musician: 'What are you doing?' She explained that, at the time, they couldn't have had the same power. He was in charge. McIntyre exclaimed, 'it was like he was trying to beat me down.'"[87] Here, as McIntyre's painful recollection highlights, the drummer enacts a hierarchical script that demands the subordination of the Black woman's moving body to illustrate the drummer's (intellectual, physical) superiority. Perhaps he is somehow threatened by her collaborative, co-creative approach and aims to remind her of her "place." Although this incident illuminates the continued vulnerability inherent to McIntyre's approach, she also locates early collaborators (like the pianist Cecil Taylor) who respect the collective creative project, allowing her to continue to strengthen and evolve her danced and gestural vocabulary and ultimately gain a broad respect from the music community.[88]

While McIntyre strategically develops a method for co-creating with musicians in the avant-garde jazz scene in New York, it is through her work with one of her most enduring collaborators—the multi-instrumentalist, Mississippi-born, and fellow Hurston admirer Olu Dara—that she most fully develops the potential of her own southern-inflected expressive inheritance as a child of the Great Migration. Indeed, I don't believe it a stretch to suggest that for McIntyre, Dara symbolizes an inspiring encounter with a strange or unfamiliar South. Unlike the drummer who enacted the violent script with McIntyre, Dara welcomes the spirit of the exchange and rejects the hierarchical notions that structure relations between dancers and musicians. He notes, for example, that in his opinion, dancers "control the music more than [musicians] do. Because you're actually a servant for the dancers."[89] Like McIntyre, Dara prizes improvisation, and he also brings an Africana southern sensibility to his work. He has "go[ne] there tuh know there," having played with blues groups from the United States, the Caribbean, and Africa, and he contends that they all share a similar "country blues" sensibility.[90] As McIntyre explained to me, after spending some time in the avant-garde jazz scene, Dara underwent a "period where [he] made a shift and went back" to his Natchez, Mississippi, sonic roots—a shift evinced in the creation of his two bands, the Okra Orchestra and the Natchezippi Band, and in his co-creation of what he calls "plays with no scripts" with McIntyre.[91] Interestingly, Dara recalls his interludes satisfying audiences in midwestern

nightclubs specifically because "people didn't want to hear any jazz, they wanted to hear blues, and I would come out and sing the blues and get the people off of Art [Blakey]," speaking to the reality that not only southern accents, but also the taste for southern Black music, traveled along the Great Migration routes.[92] When Dara makes the transition from jazz gigs to the "dance-theater context," he moves closer to his Natchez-based understanding of how music connects with everything else. As he emphasizes to Daniel Cooper, "Theater has affected my life more than anything else. . . . More than bebop, more than avant-garde music, more than rhythm and blues. It's just the theater itself—basically, because it's a combination of everything."[93] Dara has a deep appreciation for McIntyre's

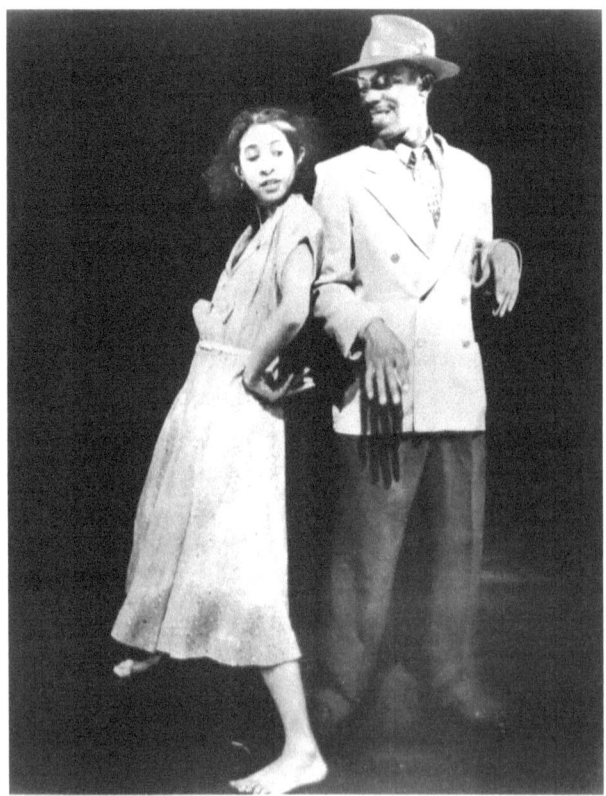

FIGURE 2.2 Dianne McIntyre and Olu Dara in *Mississippi Talks, Ohio Walks*.
Source: © Johan Elbers, 1985.

approach to music and dance. When asked by Tracie Morris to name a favorite person he's worked with, he answers, "Dianne McIntyre, she's my favorite of all time. She knows everything, more music than most musicians. I like her because we can fly. . . . She's the greatest artist I've ever worked with, period."[94] Through the creation of their collaborative and improvisatory "plays with no scripts," both artists allow their imaginations to fly beyond the confines of single traditions, genres, or exclusionary archives and repertoires.

While McIntyre credits Dara's music and ingenuity informed by his southern background as the basis for their co-created work, I posit that the fusion of his sound with her own deeply Atlantic southern-informed (by way of the Midwest) movement vocabulary uniquely inspires her to capture through movement the insights that reflect the interior life. Infusing the dynamic archive and repertoire of Black expression with a blues sensibility, the duo creates a folk-inflected improvisatory theater that more nearly aligns with Hurston's notion of the real Negro theater that emerges from southern Jooks than the "cool abstraction" happening in the free jazz and mainstream modern dance worlds.[95] Following Albert Murray's and Veta Goler's definition of the blues aesthetic, what McIntyre and Dara create enables the folk "vernacular imperative to process . . . the raw native materials, experiences, and the idiomatic particulars of everyday life into aesthetic (which is to say elegant) statements of universal relevance and appeal," and this imperative is undergirded by Black folk culture. Furthermore, via her collaboration with Dara, McIntyre locates a dynamically suggestive sonic and gestural vocabulary that allows for the integration and preservation of Black women's insights into a musical world that is in many respects hostile to such incorporation. Through her and Dara's co-creative fusion of the blues, modern dance, and theater, McIntyre taps into the same southern expressive archives and repertoires used by the avant-garde musician. And while she accesses the blues woman tradition, improvisation enables her to avoid the extractive demands and silencing that a number of those women encountered.

In a transfer from a written archive to the Black expressive repertoire (or from text to the stage), McIntyre's engagement with the strange South that is the *Their Eyes* repository further enhances the generative possibilities of her and Dara's fusion because it directly addresses a key element that is excluded from the aforementioned archives and repertoires of

Black expression. While her firmly established position as a "go-to person in the theater community" results from her "absorb[ing of] the history of the authenticity of our historic Black dances all the way from [the] slavery era . . . through modern times" and across several geographies, her engagement with the *Their Eyes* repository allows for a transmutation of the imposed archives of slavery bound up in the materiality of Black women's bodies.[96] McIntyre's transformative absorption of the repository means an absorption of the power of the folk heroine Janie, adding a powerful subversive, gendered element to her and Dara's performances of dynamic suggestion. If the dominant heroic representative as embedded in the blues is masculine, then the staging of Janie as subversive heroine allows for McIntyre to match it on equal grounds.

A DANCE ADVENTURE IN SOUTHERN BLUES

From its very beginnings, McIntyre's intervention in the *Their Eyes* repository has been focused on audience engagement and the power of movement between expressive modes. In the mid-1980s, the producer Woody King invites McIntyre to create a show based on a literary text with the belief that it will prove inviting to audiences that are hesitant to view modern dance, and in response she selects Hurston's *Their Eyes Were Watching God*. McIntyre's *Their Eyes Were Watching God: An Adventure in Southern Blues* opens in 1986 at Linda Goode Bryant's Just Above Midtown (JAM) gallery—itself a site of expressive experimentation. In several respects, Goode Bryant's experimental laboratory is the perfect location to host McIntyre's transfer from text to utterance and gesture because, like McIntyre's Sounds in Motion headquarters, JAM serves as a cross-disciplinary incubator of Black expression. Through collaborations with the musicians Olu Dara and Butch Morris, McIntyre's adaptation evokes a scenario for her audiences based on rural southern Black communities.

While space constraints prevent audiences from visually differentiating between the front and back porches as uniquely situated spaces of storytelling, transfer, and memory (the set, brilliantly designed by Felix Cochran, uses a shared "front porch" space for most communal exchanges), the show's set proves more than adequate for "conjur[ing] up the physical

location" of an early-twentieth-century Eatonville and the "muck," or the Everglades, and the male-centered folk expression that emanates from these locations. In turn, this particular scenario also threatens to evoke an intensified womb abyss framing around the women performing within it, as it is physically and temporally nearer to the plantation geographies that Black women's bodies are persistently aligned with. However, viewers unfamiliar with Hurston's text soon have their more familiar southern folk scenario challenged as, like Hurston, McIntyre invites audiences to participate in crafting a story with a woman as its heroic center. In so doing, McIntyre extends the disruptive work initiated by Hurston. As Taylor reminds us, "the repertoire, like the archive, is mediated. The process of selection, memorization or internalization, and transmission takes place within (and in turn helps constitute) specific systems of re-presentation." Scenarios, like the bodies of those who perform them, are governed by structures and codes. The choreographer's introduction of Janie as folk hero into the repertoire, then, disrupts the structures and codes embedded in the staged scenarios of Black southern folk life that Hurston herself witnessed being set into motion. Part of the conversation that McIntyre is inviting her audiences to join is one that challenges them to "wrestle with the social constructions" of Black female bodies both within the context of the Black folk South and, as northerners, within their imaginations. If, as Taylor notes, the "scenario places spectators within its frame, implicating us in its ethics and politics," then McIntyre's disruption of the expectations of the southern folk scenario brings these implications into sharp relief.[97]

The move from the textual archive to the staged repertoire further extends this work by making more immediate the collective texture of *Their Eyes*.[98] The staging emphasizes the accumulation of and possibilities present when multiple generations of women's vocabularies of joy and pain are available for reflection. Much like when the heft of a book or the act of turning pages reminds a reader of the weight of the archive, McIntyre positions Janie center stage so that audiences can watch Nanny's and Leafy's stories unfold before their eyes (while Janie's story is simultaneously being transmitted to Pheoby and the viewer). Through physical gestures such as the passing of Nanny's scarf from her own shoulders to those of her raped daughter and then her granddaughter, we watch the story both accumulate and shift to its newest contributor, and the scarf's movement to Janie's shoulders focuses the audience on the newest iteration

of the unfolding scenario. Each woman's unique movement vocabulary highlights her nuanced subjectivities. This vocabulary disrupts monolithic womb abyss framing that, through archive and repertoire exclusion, reinforces the idea of the Black woman as monolith while the accumulation tells a new narrative of the varied possibilities that Black women's inclusion introduces.

However, in the move from the page or words to the stage, where gesture, dance, and music are dominant, *Their Eyes* loses Hurston's innovative use of free indirect discourse—a merging of first- and third-person point of view—as a means of registering the appearance of Janie's "first language, the language of her own desire," and the subsequent ways that this language is submerged and resurfaced throughout her journey.[99] For this reason, the visual elements inherent to live performance, including representations of specific sites such as the porch and the muck that are populated with female characters melded with the potentials of dynamic suggestion, become essential for foregrounding the insights of the women characters. For McIntyre as for Hurston, this foregrounding occurs most notably in the presentation of Janie's and her foremothers' stories.

Live performance also activates a different register of dynamic suggestion by providing a heightened sense of the characters' interior lives. McIntyre refers to *Their Eyes* as "narrative light" in which she "interpret[s] in movement what is otherwise narrative." As she explains, "I give you the feeling, emotion, of what that moment was like. Not just for the person telling the story . . . but for anybody watching this and seeing what this experience is. (Because anybody watching this is a human being who has feelings and emotions and they can connect with it)."[100] McIntyre moves Hurston's rubric of dynamic suggestion as it pertains to dance (in "Characteristics") beyond a direct confrontation with racialized notions of aggressive moving Black bodies that approach the primitive and toward a focus on joint completion of expression born of a recognition of and reflection on Black women's emotional insights. Embodied expression allows for forms of expression to be transmitted that "are not reducible or posterior to language" and that allow for an enhanced sensual experience.[101] A gesture, cry, or sudden body movement may provide additional auditory and visual references to human emotions and may trigger an audience member's memory of other familiar scenarios in a way that exceeds textual capabilities. This memory can in turn expand

the imagined scenario so that an emotional insight that exists outside the Black southern folk and female scenario for the viewer now becomes newly intertwined as a possibility.

Visual and auditory elements further affect the stage's ability to foreground the materiality and sonority of the violent hierarchies in which Janie and her foremothers are enclosed. For example, McIntyre and her musical collaborators bookend Janie's narrative by indicating her chronic outsider predicament via sound and movement. At the opening of the show, as Janie returns to Eatonville from the muck, her isolation is amplified audibly. Janie's exclusion from the porch sitter community is lucidly illustrated in their harmonized "hahahaha haha." They repeat this—with Janie clearly the catalyst and the object of mockery—until she draws near, at which time they watch her in silence, and they commence singing when she exits. This situation is mirrored when Janie begins expressing her story to Pheoby. Recalling her childhood, a young Janie joins in with a group of children dancing and singing, "lalalala lala." Janie's movements and singing are not synchronized with the group. Before long, the children silently surround her in a circle (leaving her voice to trail off on its own) and scrutinize her before moving away en masse, leaving her isolated. The painful predicament of Janie's isolation is highlighted, and the viewer is also called upon to visit the emotional depths of loneliness felt by a woman who routinely faces no witness of her inner life or anyone with whom she can process her experiences and reach catharsis.

This sensory activation continues in McIntyre's presentation of the ventriloquism at play with Black women's bodies and expression. This ventriloquism is illustrated, for example, when Janie mirrors and absorbs her husbands' movements and when this joint movement is interrupted. At the start of each marriage, Janie's language of desire and hopefulness, illustrated by large sweeping arm motions gesturing toward the sky and far horizon, quickly segues into behavior that mirrors her husbands' movements, signifying the silencing and absorption of her expression into their own. For example, with her first husband Logan, Janie's initial movements (or lack thereof)—her still body, clasped hands, and slow glances around her new environment—express an air of defeat regarding the circumstances in which she's found herself. Initially reluctant to respond to Logan's eagerness to invite her in, Janie warms once her new husband lies at her feet and extends his hand upward toward hers. However, while

stirred to action, Janie's bourrée sequence with flowing arms carries her in the opposite direction from Logan. He joins her, mirroring her motions for a brief four seconds before turning his direction earthward to hoeing, digging, and movement generally suggestive of hard labor. Janie continues her hopeful expansive sequence, with her lower body now moving loosely, mirroring her arms. Although it initially appears that Logan rejoins Janie, it soon becomes clear that with hands firmly on her hips he is endeavoring to slow her spinning movement and to redirect her focus earthward. This is particularly apparent when he forcefully releases her in the direction of the ground. Once he succeeds, with Janie having absorbed (yet never fully accepting) Logan's movement vocabulary, Logan leaves Janie to the hard labor. When he reenters the scene confident that she remains in place, Logan has now taken on Janie's expansive skyward movement. With Janie installed in his former position as "mule of the world," Logan is—however short-lived—positioned to extract Janie's more liberated expression.

The perils of ventriloquism for both broader community expression and for Janie individually are thrown into sharp relief during Janie's marriage to her second husband Joe. Joe, in his driving ambition to be a "big voice," requires the silence of others, and he exacts this demand via a ventriloquism similar to that of Glissant's "elite." Janie is particularly important in this role because she operates as a silenced appendage that is used to amplify Joe's expression. Upon their first encounter, Joe approaches Janie with arms and legs outstretched and moving boldly, immediately commanding her attention. Fresh from her battle with Logan, Janie approaches Joe with lowered body but with arms still suggesting a vast horizon. Joe grabs Janie's hand and guides her body back skyward, and the two move in sync with soaring duets. Janie even enjoys space to express her own movement until the two encounter Joe's captive audience in Eatonville. In this setting, viewers witness Janie lose access to her body as a tool of communication as Joe co-opts it to expand the reach of his own voice. Joe forcefully interposes his body between Janie and a man as they converse, severing her contact with others and asserting his dominance. He then leaves her isolated on the sidelines to watch as he commandeers and eventually ventriloquizes other community members' movements, emptying them of their histories and accumulated meanings. When he acquires his general store and hangs his sign on the building, Janie takes a seat beside him and Joe never allows her to leave this apparently elevated, yet in fact isolated, position. When she gestures

toward joining the broader dancing community, Joe repeatedly restrains her from doing so. Joe remains intentionally isolated from the community because of his elevated position, and he basks in the separation because it illustrates his power. His role as puppet master of the town only shifts as death approaches and physically ventriloquizes a dying Joe.

If watching Janie lose her expression with her first two husbands is painful, audiences also join in the triumph when she regains it on the muck. With her marriage to Tea Cake, Janie immediately revels in lively, playful jumps and movements. Unlike her first two husbands, Tea Cake watches Janie's hopeful solo from a reclined, nonmanipulative, and noncompetitive position. Not long after the couple joins the community of the muck, Janie joins the workers in her overalls. Significantly, she

FIGURE 2.3 "Porch Image" featuring Janie and third husband Tea Cake (playing the guitar) from Dianne McIntyre's *Their Eyes*, with Phillip Bond, Malik Lewis, Laceine Wedderburn, Kevin Gaudin, Charles Wallace, Aziza, Dianne McIntyre, and Kathleen Sumler.
Source: © Johan Elbers, 1985.

initiates a movement phrase, and the other workers join in and amplify it, marking the first time that Janie's contributions are recognized and incorporated into the folk expression of the community. This unity is troubled after Janie's act of self-preservation leads to Tea Cake's death, but it is later restored following the group's reflection on the individuals involved. A community cohesion never realized in Eatonville, this restoration speaks to the reconciliation that is available when one's life and lore are meaningfully incorporated into the larger historical archive of the community. In her overalls and with her expression preserved, Janie returns to Eatonville and to her porch with this assured stance, and the audience is reminded that this voice is ultimately the one that frames the story just witnessed.

When Hurston originally develops and then embeds a dynamic suggestion paradigm in her novel *Their Eyes Were Watching God*, she sets in motion a basis for inclusion, reflection, and preservation that has enabled broad access to unfamiliar Souths and the creation of a flourishing Black women's poetic tradition. Moving between the textual archive and the Black expressive sonic and movement repertoire, the insertion of McIntyre's uniquely forged instrumental dance vocabulary informed by Dara's blues motifs expands the insights preserved in the *Their Eyes* repository as well as Hurston's methodology for preserving the stories of Black women's lives. By leveraging the strengths of the archive, the written word, and then live performance and the enactment of embodied and sensual memory, Hurston and McIntyre invite audiences to participate in performances of dynamic suggestion that transmute notions of Black women's absence from the archives and repertoires of Black expression and that challenge the womb abyss framing that precludes the participation and inclusion of Black women's insights at sites of Black folk creation.

Hurston's and McIntyre's interventions address the continued threat of hierarchical exclusionary structures, a ventriloquizing elite, and unexamined legacies of the plantation, and each artist illustrates how these perils silence the insights of Black women and thus the expression of Black people writ large. The following chapter extends this interrogation by probing the sonic demands that issue forth from the plantation and the ways they find expression in Black expressive movements spanning the diaspora from the 1960s to the 1980s.

3

ON UNINCORPORABLE STRANGE SOUND

Condé and Shange

Imagine those voices muzzled for life.
—ALICE WALKER, IN SEARCH OF OUR MOTHERS' GARDENS

In her meditation on Abbey Lincoln's piercing scream in *We Insist! Max Roach's Freedom Now Suite* (Candid Records, 1960), the poet and choreographer Harmony Holiday asks where the African-descended body begins. She questions if it begins "on the plantation, in the house, in the factory, before all that?" Holiday goes on to note that "to create a body founded before oppression we have to recall sensations anterior to our time here in this wasteland of values, and that harrowing remembering requires sound, a sound with its own senseless, untraceable, and ever retracing grammar."[1] The author ultimately determines that the body begins with the scream—a lesson that Lincoln's scream in "Triptych," the third of the five suites, teaches her.

Lincoln, Max Roach, the lyricist Oscar Brown Jr., the Nigerian drummer Michael Olatunji, and the tenor saxophonist Coleman Hawkins recorded *We Insist! Max Roach's Freedom Now Suite* in Paris in 1960. The five suites take the listener on a sonic tour of scenes of racial violence and subjection, from the "New World" plantation to South African apartheid and the struggle for civil rights in the United States. The album comments on these scenes through images (the cover art depicts three men at

a counter—connecting the album to the sit-ins that inspired it), through its subject matter, and through the broad creative insights represented by its creators. But Lincoln's scream, occurring near the center of the album, introduces a strange element into the ongoing conversation. Holiday writes:

> Abbey begins to scream. . . . Then in a loop, she sounds relieved to hear a human voice, even if it's her own. She likes the noise it makes, repeats it, is startled by herself like someone who has been caged and cut off from social contact. . . . She is a child just learning to speak and using the same wordless word for everything. By the third round of screams, we all know this is music landing in the crevice where hedonism meets struggle, where there is pleasure in announcing pain. The womb vibrates. . . . This is not a body trying to escape, rather one realizing itself, completing its helix, this is a body being built with sound, tearing itself apart and reconciling into a middle passage where the terror in the screaming is finally meant to terrorize.[2]

Lincoln's scream confronts dominant forms of womb abyss emergence that have depended on the extraction of the so-called primitive Black female sound to build others' subjectivities and expressive potentials. Sonically positioned between the past and present, and geographically between the plantation and the wrought afterlives of colonization, "each shriek evokes rape, witness, passage, horror, murder, protest, song."[3] Lincoln's scream enables the Black female expressive self to emerge in new forms.

The impact of her scream is doubled in 1980 when the choreographer Dianne McIntyre joins Roach and Lincoln in a performance of "Triptych: Prayer, Protest, Peace" during her *New Dance* concert at New York's Symphony Space. Two decades after the release of *Max Roach's Freedom Now Suite*, this collaboration makes clear that the stakes for the reclamation of the Black female scream are still high. The meeting of Lincoln, who "opened up an increasingly participatory role for the female vocalist within the male-dominated world of jazz ensemble" by regarding herself as "the instrument that speaks," and McIntyre, who, as discussed in chapter 2, developed a dance technique based around training her dancing body to become an instrument, meant the formation of a formidable pair that would collectively bend form and expression. McIntyre acknowledges

that joining the duo is not easy work—after all, joining into conversation with Lincoln's scream means that her body and the improvised movement it is producing must also take the trip to the site of emergence, meet up with her own sound in a loop, and then emerge anew. As the dance scholar Danielle Goldman notes, "The performance [also] indexed [McIntyre's] body's interior space as well as her capacity to scream."[4] Not only do the three form a strange trio with their two innovative embodied instruments joining Roach's drum, but McIntyre's collaboration with Lincoln and Roach also means that she learns and extends the "language" and "song" that Lincoln makes "out of guttural wordless howls."[5] And yet, even when they join together, each performer's contributions to the new language they are collectively forming remains distinct, none extracting from the other. "The three performers pushed with and against each other, screaming and moving in an articulation of protest that moves the gendered, sexualized, and racialized worlds of music and dance—perhaps toward a space where neither is bound behind the other."[6]

The challenge of confronting the long history of sonic extraction that Lincoln and McIntyre break with in order to locate their own strange sound is one faced by many Black women artists and activists working across expressive mediums in the latter half of the twentieth century, including Maryse Condé and Ntozake Shange. Although from two different lingual traditions and writing from different locations, both Condé and Shange make clear that locating one's unique artistic voice or sound and developing the field of subjectivity that defines it are greatly complicated for Black women by a long history of sonic extraction. This extraction continues to play out through a reoccurring set of expressive rules that, although drafted ostensibly in the service of broader Black liberation, is undergirded by creative and cultural organizing principles that circumscribe nonmasculine voices. Presented together, Condé's sonic travels through a newly postcolonial West Africa and Shange's travels through sonic third world Souths speak to the limits of juridical emancipation and legislative decolonization for Black women. Shange and Condé occupy moments that simultaneously offer tremendous promise and deep limitations informed by masculinist frames and interpretations of what liberation and possibility might be. Bringing Condé and Shange into dialogue also provides a useful way of thinking about how language works in relation to geography. Shange understands her own expression as being deeply informed by an

Africana South that far exceeds the borders of the United States, and she finds a continued engagement with Africana and so-called third world sound and languages necessary for most fully inhabiting her intertwined embodied and written expression. In her movement across West Africa, Condé locates both the alienation and sonic inspiration that would come to define her writing.

When I mention "strange sound" in this chapter, I am referring to both Condé's and Shange's literary voices or their movement toward what they might call their own languages, heavily informed by their own subjective points of view. In her 1979 essay "unrecovered losses/black theater traditions," Shange discusses the interdependent relationship between dance and gesture, music and sound, and writing. She presents this fusion as one characterized by an expansive Black "hearing." She says, "One of the bounties of black culture is our ability to 'hear' / if we were to throw this away in search of less (just language) we wd be damning ourselves," and she speaks to the long-standing integration of this tradition of hearing, noting, for example, that "in slave narratives there are numerous references to instruments / specifically violins, fifes, & flutes / 'talking' to the folks." "Hearing" and, following Shange, "sound" are then a multigeneric, multidisciplinary affair in which the artistic or literary voice is synonymous with "sound" insofar as what ultimately appears on the page is crucially informed by and in constant collaboration with Black expressive modes such as song, music, and movement. Indeed, Shange discusses with urgency the need to "listen" to Black poets, novelists, and playwrights in a manner similar to the way we approach musicians, and she argues that writers should be understood as having "a specificity that cannot be confused" and that their "language shd let you know who's talking" as opposed to operating in "a closed space" in which they are expected to "talk like an arena / . . . to be everywhere . . . to be the voice of everywhere we are not / as opposed to bein 'everything we are.'" She argues that we as audiences as well as writers need to refine our understanding of the writers' voice or sound (or, as she further notes, the writers' language) as one not "sequestered" in a monolith but rather reflecting a specific Black personal reality.[7] For it is in such sequestering, as I illustrate in this chapter, that Black women's subjectivities are silenced. The sound of the monolith reinforces the dominant creative and cultural principles that emerged from the Middle Passage womb abyss—principles that authorize the extraction of Black

womens' sound. This extracted sound continues to be used to amplify the point of view of the masculine teller of the race.[8]

Condé and Shange—in their confrontations with the silencing discursive frames that bridge their US, Caribbean, and West African experiences—use unfamiliar sound to develop their subjectivity. This chapter explores both artists' career-shaping sonic initiations—initiations prompted by forced negotiations with the rules of engagement regarding how Black narratives can be told. Sound is central to these negotiations, as each writer must contend with sonic enclosures around Black women that date back to the shrieks and screams of enslaved women in the Americas and the harnessing of these sounds in literature for the benefit of masculine subjectivity. Condé's and Shange's personal essays and published biographies enable us to examine the sonic initiations that shape each artist's expressive approach so that we might better understand the liberating impact that their relationships with Africana and broader southern sounds have on their development as artists. I argue that encounters with strange sound catalyze each artist's poetics of transmutation and disrupt the limited sonic dimensions they've been allotted. Each artist emerges from her southern sonic initiation with a transmuted relationship to difference. Rather than seeking to be validated or to blend in, Condé and Shange embrace unincorporable sound. Both authors reconfigure methods of artist and audience engagement via performance and literature through a sonic difference that is guided by deep listening and the contribution of individual, strange sounds to collective, ever-shifting harmonies.

FRAMING SONIC BLACK LIBERATION

Black women's ability to have their sound "heard" via the written word has long been compromised by the uses to which it has been put in Africana literary and philosophical traditions. To return to Shange's reference to the slave narrative as one key site where this tradition of expansive sounding and hearing is integrated is to confront, following Farah Jasmine Griffin, the situating of the Black woman's voice as a central origin point of a "black male literary and musical productivity and as the originary, founding sound of the New World Black Nation."[9] In the US context,

for example, as Saidiya Hartman, Fred Moten, Daphne Brooks, and Griffin, among others, argue, we need only look at how Frederick Douglass uses Black women's screaming and singing in his *Narrative* to powerfully build his own subjectivity, as well as the fact that "the only access we have to the sound is his written effort to describe it," to fully appreciate both the continued disconnection between Black women and their own sound and the static position in which such uses put Black women and, relatedly, an imagined Africa. Both of these uses, imagined as a still and in-place direct connection between an Africana southern woman and a primitive Africa and its sound, become a bridge to the expression of a modern Black male subjectivity. Jayna Brown probes this harmful melding of Black women's sounds and literature, as well as the lasting impact of what she calls "Douglass' ventriloquism" of Hester's shrieks or his many layers of mediation precluding any possibility of her subject formation.[10] Instead, as the aforementioned scholars have argued, Aunt Hester's voice is co-opted and becomes the basis of Douglass's own subjectivity, inaugurating him into the knowledge of his own enslavement.[11] As Meina Yates-Richard notes, once this task is completed, Aunt Hester's scream and other Black women's sounds become unnecessary.[12] Douglass's use of Aunt Hester's scream is one prominent example of the narrative disconnection of southern Black women from what Roland Barthes calls the grain or, as he defines it, "the very precise space (genre) of the encounter between a language and a voice," a space where the body directly informs the voice: "the body in the voice as it sings, the hand as it writes, the limb as it performs."[13] As a result of this dislocation, Black women's sounds come to occupy a center that Moten, citing Jacques Derrida, describes as a structure that allows all surrounding it to play while it itself must remain static.[14] Enclosed as such, the extracted Black woman's sound becomes a tool for the realization of male subjectivity and national catharsis.

This long history of extraction also results in an audience that is not trained to hear Black woman sounds. If, as Kamau Brathwaite writes of nation language (language that grew up around provision plots in Africana Souths in spite of being labeled inferior and forced into submergence), music and sound and an oral tradition form an intimate part of Black sonic expression, then certain expectations are placed on the audience: "The noise and sounds that the poet makes are responded to by the audience and are returned to him. Hence, we have the creation of a continuum

where the meaning truly resides."[15] Here, Brathwaite helps to highlight a problem: If Black women's sounds have long been extracted and disconnected from their bodies, then audiences have been ill-prepared to recognize them. These audiences include Black women. Abbey Lincoln, for example, was initially at a loss when asked to scream. As she shares with an interviewer, "I had never screamed before in my life. I never heard my mother scream or any of my sisters scream."[16] It is only in having her scream echo back to her that she is able to hear this unmanipulated Black woman sound. Locating unmanipulated sound of this kind also becomes part of the work that artists like Condé and Shange must confront.

The expressive rules that Condé and Shange encounter represent a continuation of this issue. Although Condé locates the social and political origins of a continuum of literary rules back to the declaration of a group of young Haitian intellectuals in a 1927 issue of the journal *La Trouée*, it is in the words of Aimé Césaire that she locates the enduring groundwork for an order that for her will span Négritude, Antillanité, and Créolité.[17] In having his mouth serve as "the mouth of those who have no mouth" and his voice "the voice of those who despair," Césaire prescribes a collectivist approach to poetic representation and warns that individualism and/or transgressions that interrupt or introduce disorder within the discourse governed by these rules will be shunned.[18] The reach and ubiquity of this one voice, collectivist ideology extends from the United States through the Caribbean and to newly decolonized nations in Africa.

Collectivist approaches influenced by and/or extended by Jean-Paul Sartre, Jacques Roumain, Césaire, Frantz Fanon, Sékou Touré, and Glissant, among others, coalesce notably in their insistence on the protection and celebration of a messianic Black male hero. While decolonization marks the start of a breakdown of "the dream of a united black world," this hero persists, becoming symbolic of the Black liberation and struggle that continue to dominate local literary production.[19] In allegiance to this symbol, in pan-Africanist or local iterations, the intellectuals who postulate the ideology undergirding the rules create a discursive frame or enclosure that denies women's, transgender people's, and nonbinary people's complexity, lingual and social change, and evolution, and, as Condé and Shange argue, creativity itself.

The many iterations of this metonymy and the accompanying demand to protect it and its imagined African motherlands directly affect Black

women's ability to participate in the loop that, as Brathwaite explains, is the continuum where meaning resides. Therefore, they affect their ability to be heard or to negotiate meaning. This has much to do with the positions allotted to Black women in these configurations. In her work on what she calls the "fantasy of return," Michelle Wright discusses the linear logic or "vertical synecdoche" that undergirds such collective approaches, noting that under these systems the discourses that emerge as dominant often "assume a heteropatriarchal model for this verticality; its leaders and workers are represented as overwhelmingly male."[20] The representative voice and the demands that emerge often focus on liberating men from the colonial-era codifications that ensnare them as premodern commodities while women remain firmly ensconced in their imagined role as willing auxiliary.[21] Wright argues that this focus has a direct bearing on both the imagined Africa posited by the representative Black male voice and on experiences (and the experiences illustrated in his literature) with projects of return. While men are free to form support networks and move through space—physically, politically, and imaginatively—with satisfactory ends, women are to attend to their roles as "mothers, daughters, or wives." These roles constitute the parameters of the static center within which they must remain enclosed. Any deviation from these clearly codified auxiliary spaces is met with the demand to either quickly conform to one of the three roles or become a rebukable, inconsequential, illegible other. Indeed, women's literary excursions into versions of this imaginary Africa often end with their women protagonist's fantasies of return being severely disappointed; unlike their male counterparts, who achieve the "diasporic goal . . . a spiritual (and often political, possibly cultural) 'return' to one's African roots," women's journeys often end in frustration and ambiguity.[22] Imagined Africas and other methods of sonic extraction, as Douglass's use of Hester's shrieks makes clear, mean that the sonic issues that Condé and Shange encounter are inextricably bound up with writing. Their shared desire to "break language" marks a recognition on some level that they must reclaim the scream in order to disrupt their position as the center around which all others realize subjectivity while they remain static and silenced. If, as Daphne Brooks explains in her articulation of sonic Black womanhood, sound is a "vital and innovative framework for art itself," then Black women must turn to sound to begin disrupting language and building a new syntax.[23] Both artists

must connect with their interiority as a step toward connecting with their "grained" sound, a location from which they may resist the co-option of their sound and its placement in narrative or otherwise service of other subjectivities. From this location, they cultivate their own strange sound and meet their shared goal of breaking language, or at least of disrupting the frame enclosing their ability to actively negotiate relation and meaning with their audiences.[24]

SONIC SOUTHS

Movement through strange sonic Souths enables this disruption of the frame. In engaging "Triptych" with their vocal and embodied instruments, Abbey Lincoln's and Dianne McIntyre's movement through time and geography to arrive at their own screams—from the plantation to civil rights and apartheid to their contemporary moment—is a movement through sonic Africana Souths. Ntozake Shange and Maryse Condé embark on a similar journey. Their encounters with unfamiliar or strange sonic Souths set into motion a confrontation with their bodies and subjectivities that leads them to their own strange sound. As they move across geographies, the unfamiliar sounds they encounter can be understood as related to what Brathwaite identifies as the common structures and semantic and stylistic forms of the languages that enslaved Africans brought to New World plantations. As Brathwaite explains, though forced to "submerge themselves," these "underground" languages were "constantly transforming . . . into new forms."[25] These sounds, stylistic forms, and structures that coalesce to form languages can be understood, then, as elements emerging from Wynter's provision plots, elements that would shift into distinct forms throughout the Africana South. In the case of the West African sonic Souths that Condé engages, these forms, though not transported through the Middle Passage, still bear its impact, ideologically and otherwise. Shange encounters a similar truth in her engagement with third world sonic Souths and how they echo a world order impacted by plantation and colonial pasts. Brathwaite and contemporary scholars such as Regina Bradley agree that these sonic Souths and the languages that emerge from them are intimately intertwined with the

sounds of landscape and lived experience: For Bradley, sound is "foundational to understanding southern life and culture" and captures the "plurality and multiple communities" of the Souths; for Brathwaite, these factors can mean the difference between an English utterance sounding like "a howl, or a shout, or a machine-gun, or the wind, or a wave. It is also like the blues."[26]

Each author finds that encounters with differently emerged sonic Souths reconnect people with self and subjectivity, which in turn allows them to craft their own strange sounds characterized by their embrace of difference. Each author's refusal to blend in with a collective where her unique sound will become effaced enables her to achieve these ends. Condé's relationship to sound is transmuted through the act of locating subjectivity through difference—in part through a refusal to render herself legible in several languages—while Shange finds that the differences accessible via multilingualism and translingualism are productive. Collaboration across genres also becomes central to Shange's sound. To this end, she develops a theory of listening based on a deep listening practice that illustrates "an acknowledgment that . . . noise is differentially experienced and lived."[27] Individual contributions, or noises, that come together to constitute a collective sound are not to be captured and consigned to a static center; rather, they are appreciated both for what they contribute to the choral whole and for their own individual difference. The emergence and performance of these sonic approaches, here also representative of an intellectual attitude that refuses to be framed, become central to Shange's sound, representing a broader shift in the writing of many Black women during the latter half of the century. In a manner similar to Condé, Shange learns to leverage difference to locate and share her integral sound through her reworked expressive tools.

In their encounters with sonic strange Souths, Condé and Shange complete sonic loops to reconnect with themselves and the sound that emanates from them. They disrupt creative and cultural organizing principles that render their sounds (written or otherwise expressed) silenced or affixed to real or imagined pasts. Instead they acquaint their audiences—and themselves—with insights that represent the scream or the reemergence of the connection between their bodies, their insights, and their sound by incorporating them into literary and performed conversations that center multiple languages, perspectives, and modes of expression.

MARYSE CONDÉ'S GRIOT LESSONS

In an interview in 2001, Condé notes that as opposed to créolité concerns over a Creole/French divide, "far more important for me as a writer is that the language one writes in must be forced open, subjected to a certain violence, made strange, so that it becomes the writer's own singular language [*une langue à lui*]."[28] Writing under a literary order that discourages individuality challenges Condé's stance, as does writing as a woman in an order structured by men. This challenge is deepened when, as one of the children of diaspora for whom "there are no easy shores to return," she travels to several West African nations in the late 1950s and 1960s. Often considered a renegade, she practices refusals that render her strange and illegible. However, it is in the particular challenges with difference that West Africa presents that Condé transmutes notions of the strange in relation to sonic poetics. Through this experience she embraces the power of the strange sound and develops the philosophy of writing that she espouses in the 2001 interview referenced previously that will become characteristic of her oeuvre.

To be rendered "strange"—under an Antillean literary "order," under Négritude more broadly, and in Condé's experiences in Africa—is to be rendered dismissible. It is excusable to fail to invite the strange outsider to engage in meaning-making processes. To be strange is to be disregarded and inaudible. To be strange is to be outside the order of the collective so central to Négritude, and it is to find oneself in Sékou Touré's "no place": "There is no place for the artist or for the intellectual who is not totally mobilized with the people in the great struggle of Africa and suffering mankind."[29] As Condé explains in "Order, Disorder, Freedom, and the West Indian Writer" (hereafter "Order"), this "no place" is for her a location of silence that is firmly established within Négritude (where Aime Césaire speaks for the supposedly audible masses), extends through Sartre's chastising of individualism, and continues with the créolistes and Édouard Glissant, who declares that it is the "we" who counts—the "I" is meaningless. As Condé writes, falling outside of this frame has silenced West Indian women writers such as Mayotte Capécia, Suzanne Lacascade, and Michèle Lacrosil, rendering them "incomprehensi[ble]" and silenced.[30]

Taking on these issues in "Order," Condé opens by reflecting on suggestions by Glissant, Raphaël Confiant, and Patrick Chamoiseau that there is

a breakdown in, or worse, a nonexistent connection between, West Indian authors and audiences. Although Condé agrees that a "crisis, a malaise" is afoot, she disagrees with the causes that the aforenamed authors set forth. Condé asserts that a connection between writer and audience does exist, and she suggests that it is in recognition of this connection that any real diagnosis of the issue may begin. In the essay, Condé examines this relationship while providing a sharp critique of the enclosure created by the ever-updated set of rules set forth by generations of male writers from Africa and the Caribbean. She argues that this enclosure has partly supplied the conditions under which "writer and reader implicitly agree about respecting a stereotypical portrayal of themselves and their society"—an agreement governed by perhaps the most restrictive and stubbornly recurring rule set forth by these writers: No one engaged in meaning-making negotiations must disturb the prevailing image of men or Africa. This rule closely guards an imagined Africa from which "any blemishes," including domestic conflict and "the subjugation of women," have been eradicated.[31] Although Condé argues that the latter transgression is a greater offense than the former, both result in a silencing of Black women's insights. When these women fail to align with demanded codifications or categorizations, they are rendered inert in fields of negotiation. Condé's essay contests the enclosures that this demanded order inscribes on nonmasculine and nonheteronormative expression and its location in meaning-making exchanges. However, Condé's relationship with Négritude is an evolving one, and her own frustrating experiences in Africa are colored first when she is led by Négritude's sonic and political precepts and then when she grapples with and finally transmutes them.

The publication of the memoir *What Is Africa to Me?* (2012, English translation 2017) grants readers insight into Condé's own reflections on the impact of her lived experiences as a Black West Indian woman in several West African locations, most notably Dakar, Sékou Touré's Guinea, and Kwame Nkrumah's Ghana. In the memoir's opening pages, Condé informs readers that the text will be devoted to figuring out "the considerable role Africa has played in my life and imagination. What was I looking for?"[32] This goal and guiding question place the writer into reflective company with Hartman, Sandra Richards, Maya Angelou, and others who write about their physical and theoretical traversing of real and imagined African geographies. The memoir also reveals a voice-shaping initiation

that, inspired in part by her difference, challenges the author's philosophical and theoretical relationship to Négritude, Africa, and pan-Africanism. This initiation directly informs the development of her strange sound and disruptive approach to and relationship with her audiences. In what follows, I examine the specific ways that strange sound replaces Négritude as Condé's guiding precept, and I then explore how this artistic and philosophical approach affects her oeuvre.

NEW WAYS OF HEARING: CHALLENGING THE SOUND OF NÉGRITUDE

In 1958, when Condé embarks on her journey to West Africa, she has recently left the Lycée Fénelon, has become newly politicized, and holds Africa past and present as her "sole preoccupation." While studying in France, the author was introduced to the aesthetic and philosophical movement that was responsible for her politicization and her understanding of the continent. As Condé writes, "All through my childhood I had been unwittingly integrated by my parents in French and Western values. It was not until I discovered Césaire and the Négritude movement that I learnt of my origins and began to distance myself from my colonial heritage."[33] What would become evident immediately upon her arrival, however, were Négritude's limitations as a sonic and social map to the continent. As Condé would learn, the revolutionary aesthetic tenets of thinkers such as Césaire did not prove capacious enough for the development of a woman's strange sound. Indeed, as her own writing will later suggest, this is the work of the individual artist.

While Condé notes that her philosophical shift was inspired by her encounter with Césaire, she reveals that her conception of the sonic landscape or "sound" of Négritude has been informed by Léopold Senghor. For Senghor, jazz is central to the sonic dimensions of Négritude. As he argued in an early speech given in Senegal in 1937, unlike language (which on its own was "not up to the task" of conveying Blackness), jazz singularly represented a sound that was large enough for representing the "whole [African] soul." Senghor's own conceptualization of sonic Blackness, as Tsitsi Jaji writes, is heavily informed by the writings of French musicologists

and the Africana southern (heavily African American) writings of New Negro artists such as Langston Hughes, Paul Laurence Dunbar, Claude McKay, and Sterling Brown, artists who "have made, of Negro American dialect, of the poor mumblings of deracinated slaves, a thing of beauty." Here, Senghor joins into conversation with Brathwaite's conceptualization of nation language and Wynter's provision plot. Interestingly, as Jaji notes, with the exception of one, the poems that constituted Senghor's archive as presented in the essay "Ce que l'homme noir apporte" ("What the Black man brings") were all published in Alain Locke's *The New Negro*, "a text so influential that one might claim Locke edited the textbook for Négritude musicology."[34] Although the volume represents a wide spectrum of ideas from a variety of perspectives (including those of Zora Neale Hurston and Alice Dunbar Nelson), it is introduced by Locke's own titular essay, in which ideas of the Souths as primitive—ideas that are firmly associated with Black women—are reinforced. The centrality, then, of the influence of Locke's volume on Senghor's conceptualization of Négritude's sonic qualities introduces the potential of a transfer or reiteration of creative and social organizing principles that reinscribe spatial and gendered hierarchies upon the rubrics used to assess the Africana southern sonic.

Condé's sonic allegiance to Senghor is immediately challenged upon her arrival in Africa.[35] When she reaches Dakar, her first port of call, Condé is "oblivious to [the] scents and colors" but is enchanted by what she hears. On her way back to the dock following a brief visit with the family of a childhood friend, Condé is struck by "the sounds of music—so strange and so harmonious"—wafting from behind a fence.[36] She follows the music and finds a group of musicians playing to a welcoming audience of women and children. Here she first sees and hears a griot and the kora and the balafon—instruments that she's only encountered in Léopold Senghor's poetry. And arguably, on a nascent level, it is perhaps here, with a sonic nudge, that Condé begins to more closely examine how the textures and integrity of each instrument are distinct from their use in Senghor's work. Although the author does not single out specific examples of Senghor's poems, hearing the instruments away from Senghor's filter—one that she later determines is politically motivated and perhaps centered on an artificial divide—is remarkable for her.[37] Here, Condé is also demonstrating an emerging sensitivity to what she will later call the subjective filter; she is aware that each individual's experience with

an artist's sounds is particular to that listener. Interestingly, as Jaji notes, Senghor's own experience with this exchange between the musician and the audience is mediated textually, likely further heightening Condé's recognition of the difference between Senghor's textual representation of the instruments and her live exchange with the artists.

This early example of nuanced listening is amplified alongside a close examination of Condé's relationship to sound, politics, and narrative throughout the memoir. Although Condé's first recollection of sound on the continent is an overwhelmingly positive one, it doesn't take long to find herself alienated, and even sonically "frighten[ing]." Condé intends to remain loyal to the precepts of Négritude as she journeys through Africa, but she is constantly reminded of her difference and inadequacies in aligning with the spaces allotted her—inadequacies that take a particularly sonic turn in her recollections. Condé's visual and lingual difference constantly frustrates attempts by the Africans and émigrés she encounters to locate her within preestablished categories. While the nations that Condé traverses celebrate their newly liberated statuses, colonial classifications stubbornly cling to Black women and their allotted spaces and conditions of movement. The extent of the expectations accompanying these roles is evident in the demand that accompanies the flippant expectation that Condé become polyglot and learn each language that she encounters. This expectation, usually posed as a benevolent suggestion, is voiced so often as to almost become the refrain of the book: "'Learn Malinké!' Said a Malinké. 'Learn Fulani!' said a Peul. 'Learn Soussou! Said a Soussou.'" Condé refuses these demands, and the consequences of what many consider a spectacular failure follow her from the Ivory Coast to Ghana. These consequences are perhaps best summed up in another response that she receives repeatedly, and notably from men: that her failure to conform to each local lingual and behavioral context renders her "frightening" or otherwise disagreeable. Although this response is often attributed to Condé's lingual illegibility, her recollection of the explanation she receives from "Harry," a fellow Antillean, provides more nuance: "It's because you frightened everyone. You were devilishly disagreeable. Nobody knew where you came from. Were you English-speaking? Were you French-speaking? You didn't have a husband but dragged around a flock of children of every colour."

Here, "Harry" highlights the complexity of the offenses that Condé represents: She cannot be immediately located nationally or otherwise, and

her lack of husband and her several children suggest a sexual freedom—all indicators of a woman who has ventured out of her allotted place. In her failure to immediately conform to and make herself legible in each local context, Condé finds herself in a complex condition of alienation, a condition that Michelle Wright argues Black women regularly encounter on their "return" journeys. This alienation dislocates Condé from the possibility of forming or joining "sisterhood" alignments with African women. This problem becomes particularly inconvenient when Condé realizes that no language acquisition is sufficient for overcoming the barrier of what she calls gendered "hemispheres," or a gender-based division of space, that she encounters. Although Condé experiences varying levels of alienation in Africa, she is not interested in pursuing superficial avenues of integration. Condé recognizes that learning new languages only offers opportunities to join the "we" and efface the "I" that she ultimately disagrees with. She fails to find alignment with fellow French Antilleans in Africa for similar reasons. Although integration into this group does not require the acquisition of a new language, it requires an unappealing separation from Africans. Condé observes that "for the Antilleans, Africa was a mysterious and incomprehensible landscape which, in the end, frightened them." Here, a striking echo can be discerned in the French Antillean response to the continent and to references to the author herself: Both are considered incomprehensible and frightening. This alignment is further solidified through Condé's own response to the continent when she notes that she, "on the contrary, was attracted to and intrigued by it." Here, beyond a surface intrigue, I locate an interest in genuine connection and exchange that will later emerge in Condé's thinking on audience connection. With this announcement, she repositions herself in relation to the "strange": She now welcomes it and is intrigued by its possibility.

FINDING HARMONIOUS BALANCE

This condition of strangeness or of being strange finds an analogue in the language that Condé uses to explain her first sonic experience upon arrival in Africa. It is striking that Condé uses this language, denoting the unfamiliar, the not-before-encountered, alongside the notion of the harmonious—or balanced, simultaneously occurring frequencies, notes,

or even narratives—to describe this overwhelmingly pleasurable experience. Also notable in a discussion focused on exchange between listener and audience is the fact that the harmonious, by definition, is determined by the ear. This harmonious exchange—between griot, accompanying musicians, the welcoming audience of women and children, and Condé—marks the author's first sonic experience that is counter to the estrangement she confronts on the continent.[38] Particularly notable in her recollection of this moment is the griot figure—a West African master of sound who is responsible for telling stories, playing music, and maintaining history.[39] The griot helps Condé to tune and center what she calls her "filter of subjectivity," or how her unique expressive and literary sound is shaped by her individuality as an artist. Interestingly, Condé's stance here is consistent with Senghor's. In his essay "Ce que l'homme noir apporte" ("What the Black man brings"), Senghor cites Hughes Panassié to support his view on the importance of an artist's subjective contribution to their expression: "It is, he adds, the expressivity, the accent which the performer imprints on each note, in which he transmits his entire personality."[40] However, Condé and Senghor differ somewhat in their relationship to the griot. An example of this difference appears in the poem "Joal" (1945), where, in presenting a sentimental portrait of his hometown, Senghor veers dangerously close to presenting the figure of the griot (as opposed to the figure of the contemporary "orphaned jazz") as someone belonging to a sentimental African past—a location that Black women and their expression are often aligned with.[41] For Condé, the griot is of the immediate moment; the griot's sound meets her active crafting of an innovative sonic stance and expressive approach. By strengthening her subjective filter, Condé moves toward an alternative approach to writing or enunciating in any form and audience—an approach that does not require an allegiance to a collective but instead centers on the unique perspective of the individual. The figure of the griot and its lessons on the strange and harmonious provide an audible map for deciphering Condé's method of forcing language open and making it strange. The griot helps the author navigate sonic discord and harmony on three registers that often overlap throughout the memoir: the political, the social, and the creative.

In Guinea, Condé witnesses both the harmonious and the compromised. Guinea is notable to Condé for being the only French-speaking nation to achieve a socialist revolution. Condé experiences some of the local implications of this revolution firsthand. Although a neutralization

of privilege is found in the cars driven by both the powerful and the average citizen, she also recalls the extreme shortages of food and provisions—shortages that are not endured collectively. She notes, "I could have borne the deprivations that cast a pall over our lives if they had involved the entire population in a collective effort to build a free nation. It could even have been elating. But it was obviously not the case. Every day the nation was divided more and more." In Guinea, Condé also develops a nuanced ear for griot sound as here she encounters a range of griot activity. Although this activity heightens her awareness of the privilege imbalance, she deeply appreciates the unique sounds she encounters.

Condé gains rare access to privileged sonic space when, with tickets secured by an elated Sékou Kaba, she borrows a boubou from Kaba's wife to cover her pregnant body and attends a concert at President Touré's palace. Although her impression of the hypocritical privilege imbalance deepens at the event, so does her appreciation of the distinctive sound. Here, Condé witnesses both the harmonious and the compromised. She is enchanted by Sory Kandia Kouyaté's distinctive voice and with the "other griots and over thirty musicians playing the kora, the balafon, the African guitar and the underarm drum," collectively presenting a "dazzling, unforgettable and incomparable" show. However, Condé also recalls observing Touré circulating among guests during an interval in the performance, and notes that as the president receives adulation from the crowd, she hears "the recitation of the griots, swelling now and then like the chorus in an opera" in the background. Here, in the shadow of a political leader, griots form a monolithic choral sound, the integrity of their individual contributions corroded.

Alternately, Condé's memories of her listening experiences at the People's National Theatre perhaps best epitomize the potential that the nuanced academy of the griot's sounds provides. The author draws the clearest distinction between the harmonious and disharmonious griot in her reflections of this space. The theater was formed by her husband with the support of, to Condé's disgust, the high-ranking official Keita Fodéba. Despite her political misgivings, Condé shares that she took great comfort in watching rehearsals. Discussing the new communicative vistas that were opening for her, she recalls: "I still hadn't learnt Malinké or any other language. But I managed to appreciate the words and music of the griots and the call-and-response rhythm of the sounds. Soon I was also

able to distinguish the sound of each instrument, not designed to accompany the human voice but, rather, to enthrall by their power and singular beauty.... The deafening cries of the griots that could be heard on the radio were a far perverted cry from this art of harmony." Here, Condé most fully expresses not only the powerful impression that the harmonious (versus discordant) sounds leave upon her, but also the discernible imprint that the griot as guide makes on her philosophical approach to communication. Despite the language barrier, Condé's ear becomes attuned to each sound in its full integrity, with none subordinate to any other. What she learns here confirms her earlier-stated suspicions on assimilation and superficial integration—that communication is possible without conforming or turning one's voice or "sound" over for representation by a singular entity standing in for a collective.

While in Guinea, Condé also learns the power of harmony in the face of alienation. Her most profound rejection occurs when her mother-in-law, Moussokoro, visits. Already ostracized for not assimilating linguistically and sartorially, Condé tries to become a more appealing daughter-in-law by wearing a skirt and learning the traditional Muslim greeting, *Assalamu alaykum*. However, her efforts are immediately rebuffed. Moussokoro, enjoying the privilege of the nonexile, doesn't speak and is never expected to learn French. Instead, Moussokoro converses joyfully in Malinké with her visitors while ignoring her daughter-in-law. Condé realizes that the gulf between them is not grounded in the loss of memory and culture that comes at the expense of the Middle Passage and slavery, but occurs because her mother-in-law sees her as an outsider—a gulf that no language acquisition can bridge. In this moment, the presence of the harmonious griot restores balance. As part of his exhaustive attempts to please his mother, Condé's husband invites griots to their home to perform. Seated on her terrace with neighbors, she finds that the sounds that the griots produce have a transformative impact on her. In a shift from her experience with the politically aligned griots that for her represented a monolith, Condé again identifies the individual sonic contributions of the singers, the kora, and the balafon.

In addition to attuning her ear to nuance, the sounds of the griots deliver the author from a state of isolated abjection. Whereas she is an estranged outcast prior to the concert, she recalls that while listening to the music, "all those I had loved and lost had come back to envelop me

and furnish my solitude. I was no longer alone. Rather, I was overjoyed by the presence of these invisible souls." Here, harmonious sound acts as a key element in space-making. By bringing Condé's attention back to the individual sonic contributions that constitute the whole, they invite the author to contemplate the intermingling of music, time of day, and landscape, with the combination creating a kind of canvas against which all three and the passing bats collide, "silhouetted as if in charcoal on large sheets of grey paper." This visual and sonic backdrop becomes the canvas upon which past and present and physical and spiritual realms become interwoven. Sound becomes a kind of transportation to an alternative relationship with space, moving Condé away from the exclusionary cacophony of the present to nurturing spiritual connections that restore and reground her ability to connect with others. Like the individual sounds that the griots contribute to create a collective harmony, Condé's multiple realities of both alienation and belonging (extended across time and space) coexist. The impact of the catalytic strange harmony that Condé witnesses at this home concert and the weaving it creates space for are later evinced in her polyphonic writing style, where she carefully attempts to capture the several seemingly divergent worlds and lived experiences occupying a single space.

Condé's lessons on nuance carry over into her distaste for and oft-repeated criticism of the politically manipulated "deafening cries of the griots" that issue from the radio. The radio initially represents discordant noise for Condé. Her recollections of the relationship between the political griot and radio often occur in close proximity to other sonically uncomfortable moments. For example, the author recalls a particularly miserable moment with her husband during their time at Sékou Kaba's compound in Guinea, a life that has become "devoid of any charm."[42] She shares that she would happily leave during school vacation months because her evenings are filled with "a hubbub of children crying, quarrels between wives, griots yessing on the radio and the cheering from a stadium close by. I had the choice of either staying to listen to incomprehensible programs in the national language while Gnalengbé and her buddies guffawed in the kitchen or spend the evening out with Condé and Sekou." She goes on to explain that because of her gender, the latter is a nonchoice and the former a miserable proposition due to communication barriers that result in her silencing.[43] This distaste for the radio continues upon her return to teach

a new term at Bellevue College, where she notes that her growing disdain for Guinea—a disdain that is destroying her ability to lose herself in books (her former reprieve)—necessitates ending her listening relationship with the radio, as she is "unable to bear the never-ending vociferations of the griots."[44] And, as I discussed earlier, Condé juxtaposes the instructive sounds of the griots at rehearsals for the People's National Theatre with the griots' yelling on the radio. This reaction contrasts sharply with her experiences with the Ghana Broadcasting Corporation.

ACHIEVING STRANGE HARMONY

Although the radio serves as a source of great annoyance for Condé during her travels, by the end it becomes an important route to the "strange" as she begins using it to transmit her own voice. This shifting relationship notably coincides with what Condé identifies as her beginnings as a writer, suggesting a direct relationship between the medium, the transition, and what she would eventually come to recognize as the work of "forc[ing] open" language or making it "strange." At the suggestion of a friend, Condé is hired to host a weekly show focused on women. She describes the unexpectedly transformative experience of being in the studio and likens it to being "wrapped in the protective embrace . . . [of] my mother's womb," suggesting that she experiences a kind of rebirth.[45] In the protective space of the radio studio where her own strange sound is becoming interwoven with those of the women that she interviews, Condé is not only beginning to recognize the power and potential reach of her own unique perspective, but she is also awakening to the audiences that exist beyond the masses associated with and dedicated to specific political and aesthetic ideologies—audiences that welcome engagement with her strange voice, even when they disagree. Although Condé shares that she was at times "upset" that her "opinions displeased and even shocked [her] audiences," she notes that this outcry "in no way deterred me from speaking my mind," and, armed with a resolute determination to remain in sonic integrity, she continues to draw curious audiences.[46] Through an unadorned, honest use of her voice, Condé accesses new possibilities for entering fields of meaning-making that spill over into her writing.

FIGURE 3.1 Maryse Condé with her colleagues at Bush House, BBC, London, 1967.
Source: Bibliothèque numérique Manioc—Collection privée.

HEREMAKHONON

Drafting *Heremakhonon*, Maryse Condé's debut novel, in Ghana marks a critical stage in Condé's sonic development. Guadeloupian-born Veronica Mercier, the protagonist of *Heremakhonon*, is in search of a language that allows her to speak herself. Veronica is a teacher from a bourgeois family who is undertaking a journey to an unnamed postcolonial West African nation in an attempt to "try and find out what was before" the Middle Passage and locate an alternative origin story. Along the way, we witness Veronica's recursive return to a set of imposed labels in which she seems hopelessly mired, and we see how they constantly reverberate from past and current encounters. This complex of appellations that "drif[t] into [her] flesh" takes center stage in her imagination and finds merged amplification through an event that occupies a prominent position in her

memory.⁴⁷ Veronica often ruminates on a disapproving group of West Indian youths wearing Black Panther–styled berets that she encounters years before while attending a Caribbean festival with her White beau. In pelting her with the appellation "Marilisse," these beret-wearing youths join Veronica's family and other characters in the novel by expressing their disapproval for her failure to remain in her proper place by labeling her a whore.⁴⁸ More pointedly, Veronica's persistent recollections of the incident with the beret-wearing youths reveals a major communicative roadblock: In each instance, she emphatically attempts—and fails—to communicate that her appearance with White and mixed-race men does not signify that she holds Whiteness as an aspiration. Because she fails to comply with social rules and stay in "place," Veronica is visually and sonically sorted into a space designated for the aberrant, and her voice is silenced by her accusers' deep contempt.

As Condé tells Françoise Pfaff, "the trap into which [Veronica] has fallen is that she seeks liberation through a man." I will take this one step further and suggest that although Veronica may find her engagements with the West Indians and her West African lover Ibrahima Sory a compelling alternative to her parents' bourgeois race politics, she remains entangled in an equally silencing field of rules and predetermined labels for Black women who dare to step out of "order." Through her emphatic attempts to correct the perceptions of the beret-wearing individuals—themselves representative of a transnational male freedom-fighting metonymy bridging multiple Souths—and in imagining her liberation in relation to Sory and his "ancestors," Veronica is striving to engage with a Négritude-influenced, masculine-centered field of ideological and sonic negotiation that echoes a struggle faced by many Black women artists and activists in the latter half of the twentieth century.

As Condé recalls, while writing the novel, "I was searching for something I was unable to find or name. Without being told or taught so, I sensed that the events of a story should be narrated through a field of subjectivity which was defined by the writer's sensitivity. Roughly speaking, despite the range of narratives, it remains the same, book after book. It is the unchanging voice of the author."⁴⁹ As a number of critics have noted, in *Heremakhonon* this quest results in what many consider a confusing narrative structure—a structure, I argue, that allows for an intense

interplay of sound and silence that reflects Condé's own sonic negotiation. Aspects that cause this confusion include Condé's use of interior monologue rather than an omniscient narrator and the unmediated access this monologue grants to the narrator's inner thoughts, the multiple points of view that constitute Veronica's interior monologue, the lack of clarity on when Veronica is "speaking aloud or thinking responses to comments addressed to her," and the question of whether the protagonist actually possesses a voice. As Forbes notes, the narrative is torn in what she calls a schizophrenic struggle in a "confused landscape of mind"—a reading that is indicative of Veronica's location—one that is moving toward, but has not yet arrived at, her own strange voice—in the process of realizing her subjectivity.[50] If the narrative structure, centering on Veronica's inner monologue, at first appears strange to the reader, it follows a harmonious if time-hopping logic in bouncing between her past and present experiences. Additionally, Veronica, like Condé, rejects demands to become polyglot. By divesting from attempts at incorporation, Veronica is instead investing in negotiations with herself through an inner dialogic process. Veronica is pursuing and cultivating internal and external spaces of quiet in the novel to facilitate the development of her filter of subjectivity. Condé's Veronica represents a rejection of the frames that silence women. Her intense interiority, a kind of quiet that can also be read as vulnerability, fails to align with the "pride and boldness, clarity of self and definitive resistance" commonly associated with nationalism.[51] In fact, through the foregrounding of her character's vulnerability and her focus on the intense inner life of a Black woman, Condé's arrival at strange sound is marked by the creation of Veronica.

The process that Condé goes through in Africa leaves a prominent mark on all her writing. Indeed, many of her characters undertake their own sound-defining journeys and are met with varying degrees of success. Condé's technique of polyphony, which focuses on multiple characters' subjective experiences, creates a textual harmony that challenges singular perspectives, troubling the single point of view or hegemonic sound. And yet, as Condé herself admits, locating her written sound is a lifelong endeavor—a process, not a destination. As she shares with Apter, "I'm still looking for the right form of the novel, the right voice. I'd like to create a 'Maryse Condé language.' I haven't found it yet; I'm still searching."[52]

NTOZAKE SHANGE'S BLACK GIRL SONG

In her essay "my pen is a machete," Ntozake Shange informs her audiences that "in order to think n communicate the thoughts n feelings i want to think and communicate / i haveta fix my tool to my needs / i have to take it apart to the bone / so that the malignancies / fall away / leaving us space to literally create our own image." This need to adjust her communicative tools, a large part of which is the sound that allows her to most accurately and meaningfully communicate with audiences and share in the process of meaning-making, firmly aligns Shange's project with that of Condé. As is also the case with Condé, for Shange this process is both necessitated and challenged by masculine-centered collectivist storytelling frameworks.

Drawing heavily on her immersion in Africana southern soundscapes as a child, Shange learns to leverage languages, music, and movement to locate a sound that is large enough to "sing a black girl's song." She recalls, "My house, my neighborhood, my soul was immersed as far as I can recall in the accents of Togo, Liberia, Trinidad, Costa Rica, Chicago, Lagos, New Orleans, Bombay, and Cape Town, not to minimize in any way drawls of the Mississippi, clipped consonants from Arkansas, or soprano-like chisme (gossip) of Kansas City," and she notes that these voices "made me want to have the sounds forever." These sounds are further amplified by the travels of her parents, who, returning from spaces such as Haiti and Cuba, "came back not only with instruments / but with new dances that apparently had ties to the colored people," and Shange credits this exposure as the early foundation of what she calls her "pan-afro-hemispheric consciousness."[53] These sounds and movement merge with the everyday notes that float through her childhood home: Her father loved Caribbean and African American jazz, and her mother was fond of reciting Black poets and writers. As such, from an early age, Shange is endowed with a notion of sound that mingles literature with music and dance—an expansive understanding of diasporic expression that deepens her fondness for its commonalities and nuances. This rich background informs the development of Shange's methods when she encounters expressive challenges in her artistic and political milieu.

The years that Shange recognizes as vital to locating her sound coincide with a moment when some artists and activists understand the Black

American struggle as intimately intertwined with the struggles of Africa. This period is also marked by many differences of opinion regarding how liberation, self-determination, and Black expression could and should be pursued. By 1968 Larry Neal marries several key tenets from these groups in his formative essay "The Black Arts Movement," a document that will light a path for many Black artists as they pursue the generally acknowledged worldmaking tasks they face. As Kevin Quashie notes, this "world-making instinct" is clear in part from the "the return to Négritude as an ideology of the black subject's 'being-in-the-world.'"[54] During a period encompassing the Black Panther Party's transition from a focus on militarism and national expansion, when they become a compelling presence in the popular imagination, through later phases where the focus returns to Oakland and is redirected toward providing service and populating elective offices, both Panthers and affiliated artists paid close attention to political and cultural developments within Négritude and in Africa.[55] According to Sonia Sanchez, James Smethurst, and John Bracey, activists and artists "were keenly aware of the political and cultural . . . debates between the adherents of Négritude [Senghor] and what might be thought of as the revolutionary nationalist Africanism of such independence leaders as Guinea's Sekou Toure and Ghana's Kwame Nkrumah. Many writers and artists . . . sided with the revolutionary activism of Toure and Nkrumah against what they saw as the depoliticized culturalism of Senghor and Négritude." The late 1960s also saw Maulana Karenga and his cultural nationalist US organization, with which Amiri Baraka and other artists and activists were affiliated, rise to prominence. As Baraka and others would later note, Karenga's neo-Africanist principles "posited women as 'complementary, not equal,'" and these principles would circulate within some artistic organizations and influence approaches to art and culture within both the political and artistic spheres.[56] Karenga's ideas would even find voice in Neal's manifesto, solidifying its centrality to the prominent aesthetic framework that many artists would adhere to.

Coming of age as an artist during and in the immediate aftermath of the confluence of Négritude-infused political and artistic movements, Shange, like Condé, finds herself at odds with the "rules." This challenge becomes particularly pronounced as her understanding of the relationship between politics and artistic expression shifts. "Politics and the arts were truly wed at the hip or thereabouts" during her years as

an undergraduate student in New York, a position reinforced when she witnesses the drummer Michael Babatunde Olatunji and his and Chuck Davis's dancers perform at the National Black Power Conference in Newark in 1967. A deeply inspired Shange emerges from these performances with the belief that "our commitment to the movement meant that all our resources intellectual as well as physical had to be dedicated to the liberation movement."[57] However, her understanding of what this liberation entailed would soon shift.

Shange's relationship to listening, sound, and meaning-making is informed by a moment that finds many artists of color grappling with and redefining their relationship to nation, canon, and sound in the United States, as evinced by the emergence of groups such as the Black and Chicano Arts Movements. Shange begins her undergraduate education in New York City in 1966, the same year that the Black Panther Party for Self-Defense is founded in Oakland, California. Amiri Baraka, one of Shange's major sonic influences who now identifies as a Black cultural nationalist, has been writing and organizing for several years. In "i talk to myself," a piece that Shange explains is "a conversation with all my selves," she notes: "around 1966 / abt the time I went to barnard I thot leroi jones (imamu baraka) waz my primary jumping-off point. that I cd learn from him how to make language sing & penetrate one's soul."[58] Many elements of Baraka's aesthetics become hallmarks of Shange's work; most discernible among these is the influence of music. Larry Neal expands on the influences on sound in his afterword to the anthology *Black Fire*, where he argues that "the cadences in Malcolm's speeches and sounds and methods of performer James Brown" were exemplary models for poets writing in this moment because their sound was particularly suited to interpreting and tapping into Black emotional history and contemporary reality in a way that unified the Black community.[59] The sonic representation of the interior life is recognized by influential figures such as Neal and Baraka as vital to the larger project of developing the revolutionary collective consciousness that can contemplate the Black freedom project. However, Shange finds that unless the expression of one's emotional life serves the larger goal of reconstructing Black manhood, reflections on women's interior lives are not particularly welcomed.[60] Although Shange enters this period (and always identifies as being) heavily influenced by Jones/Baraka, she soon finds

that his cadences and methods are not expansive enough to represent her experiences. The sonic models closely associated with Baraka and other leading voices are placed in the service of what many understood as a central expressive goal and focus of many artists: the restoration or creation of a new Black man. In much of the work of the period, "Black" and "man" become merged, and as a result "Blackness structures manhood and manhood becomes the desired end of blackness." When women poets are included in poetry collections, their work must reflect "the concerns male editors preferred to publish during this era: longing for Africa, motherhood, black history, rearing of children in blackness, understanding of black roots, [and/or a] rejection of whiteness."[61] Such a mandate restricts the full range of women's expression. As Margo Natalie Crawford notes, when the radical Black woman's interior "moves radically out of the endorsed frames, it is rendered pathological."[62] When Black women artists venture to "pull the so-called personal outta the realm of non-art," their projects are categorized as being against dominant Black aesthetic aims, and they are accused, as becomes the case for Shange and other women artists, of irrationality and/or of participating in Black male castration.[63]

In Shange's pursuit of a language capacious enough to "sing a Black girl's song," she embarks on a journey that entails encounters with strange sonic Souths via audience negotiation, encounters with third world feminism, and finally a confrontation with her own moving body.[64] As she begins her artistic career following her graduation from Barnard in 1970, Shange's understanding of sound, similar to other writers in her cohort, is informed by Black vernacular speech patterns and Black music—particularly free jazz and its rejection of traditional harmonic structures in favor of a more fluid (and disorienting) approach to atonal sound. These influences, along with her orientation to Africana southern sounds more broadly, will guide her to a literary "sound" that captures a multiplicity of voices, languages, and cultural forms and that is shaped by her own insights. By following this route from the late 1960s to 1975, Shange completes the loop that her early exposure to Africana southern sound began. Through a deep engagement with her body, her own strange translingual sound emerges, and this sound is foregrounded in her choreopoem *for colored girls*.

PORQUE TU NO M'ENTRENDE? MULTILINGUALISM AND AUDIENCE NEGOTIATION

During the early years of her journey to her strange sound, Shange takes on work that enables her to experiment with establishing direct relationships with diverse audiences. While in New York, one early site of this work was with the Young Lords Party. In a 1998 interview, Shange recalls that she decided to work with the Young Lords Party specifically because "they had an antisexist platform and a platform for bilingualism," platforms addressing the inclusion of women and Spanish speakers that the Black Panther Party had not yet established.[65] Although the Black Panther Party long influenced and affiliated with organizers across racial lines, the extent and form of this affiliation differed depending on chapter location.

In both politics and the arts, Shange encountered ideological challenges with dominant thought leaders on collectivity, monolingualism, and a focus on an imagined Black nation-state oriented toward Africa—a stance that for Shange overlooked the importance of the broader Africana Souths and threatened to limit the development of her unique sound.[66] Theorists like Larry Neal found the desire for individuality representative of a Western poison. He argued that the aim, rather, should be building a collective consciousness (and unconsciousness), with artists serving as the Black community's "voice and spirit," and, in discussing Jones/Baraka's theater, he notes that this work should be "inextricably linked to the Afro-American political dynamic."[67] Similar to Négritude, as Cheryl Clarke writes, "an idealized Africa, not unlike that which emerged during the New Negro Renaissance, haunted the poetry of Black Arts Movement practitioners. Africa is 'revolution,' 'lover,' 'progeny' as well as 'homeland,' 'mother/nation,' and 'ancestry.'"[68] This Africa has striking similarities with that of Négritude and similar movements with its preassigned auxiliary roles for Black women and its "female figure associated with Africa . . . resembling the long-standing trope of Mother Africa, linking black women and Africa with nature and procreation." Of note, however, is the complicated location of this particular version of Africa. As James Smethurst suggests, "the space is to be constituted or reconstituted in the United States, not Africa. There are few visions of a permanent physical return in Black Arts poetry and drama except for an imaginative return

to a prehistorical past."⁶⁹ Given its imagined domestic location, adherents to this vision of Africa and to the role of women as those who birth and support its messianic male heroes would likely find monolingual women, and, it could follow, women who stay "in place," a greater convenience.

For Black women such as Shange who are not interested in borders, including those of imagined nation-states, and who are interested in broad representation of women's realities, multilingualism presents an opportunity to evade border-bound silencing categories that demand that women work as helpmates toward the reconstruction of the Black male hero. Shange's conflict with what she viewed as a problematic and limiting monolingualism meant that she found the Young Lords Party's stance on multilingualism particularly attractive. Such a stance can represent a portal to a less easily controlled mode of Black women's expression, expression that can potentially slip beyond the impositions that an imagined Africa presents. As she later writes in the essay "Mr. Wrong," Shange shares that she has witnessed frustration in confrontations between monolingual men and multilingual Black women and that she finds a "commitment to African Americans in this hemisphere compelling as opposed to a direct ontological belief in the mother land which disturbs our men beyond comprehension."⁷⁰ The Young Lords Party's platform on multilingualism also aligns with Shange's broader interests in Black American liberation. She is able to remain committed to what she calls a hemispheric approach—an affinity for and collaboration with the broader Africana South—that illustrates her commitment to the cross-cultural sounds and accents of her childhood.

Given her gender expression, her local experience with and perception of the two parties, and her childhood immersion in cross-diasporic sounds and expression, her work with the Young Lords Party as a warm-up act for political speakers provides Shange with a more familiar starting point to begin examining the relationship between the artist and audience. As she fondly recalls, this work, taking place in parks, playgrounds, and community rooms, is "where [she] began to learn how to work a crowd."⁷¹ While her decision to align herself with the party presents an opportunity to hone her stage persona, it also reveals that she is carefully navigating the predicament that gave rise to Black women's liberation movements in the first place—the search for a platform for Black women's insights and experimentation that can lead to strange sound.

Although her writing does not yet take on what will become a heavily multilingual aspect, the impact of her experimentation within this atmosphere is evident in Shange's early exploration of gender-related issues. This exploration is evident in her poem "dark phases," where, as early as 1971, Shange calls for someone to "sing a blk girl's song." In her 1971 poem "Banjo," she also registers an awareness of a sonic strangeness through the repeated line "i am strange rhythms," the speaker's movement from a plantation (and even African) past to present, and a cycling between sonic Souths (references to ring shouts) and urban northern soundscapes (including a Harlem record store). Finally, in "sing her rhythms," also written during this period, Shange's speaker continues to explore the themes of "dark phases." Here, she goes as far as writing about a woman who "doesn't know the sound of her own voice," anticipating her forthcoming encounter with her own.[72]

By the time Shange graduates from Barnard in 1970 and relocates to Los Angeles for graduate school, she has developed a nuanced understanding not only of her affinities for communities that blend her artistic and political commitments, but also of the ways that sound threatens to interrupt her communication by preassigning what she "means," preceding and foreshortening her own ability to negotiate this meaning with her audiences. In Los Angeles, Shange continues to open for political acts, and she joins Ed Bereal's guerrilla theater group Bodacious Buggerilla.[73] Her sensitivity to the differences between New York City and Los Angeles audiences perhaps develops quite extensively while working with Bereal's group. Shange notes that this work exposes her to "some of the more intriguing neighborhoods of LA"—with the group's audiences including gang members and predominantly White Hollywood spectators. Street theater, as Ed Bereal states, is intimately intertwined with the audience, and during Buggerilla performances, characters interacted with these varied audiences, creating versions of an "improvisational political education class."[74] One could assume that these are not only sites of training for the audiences that the Buggerilla encounter; they are likely also, for Shange, vital moments of education on the audience/artist relationship and on the political and artistic tastes of LA's diverse audiences. Recalling her early days in southern California, Shange tells Savran that in facing the challenge of "making sense" to these new audiences, she is for the first time "challenged to find what I now consider to be my own voice and my own

way of interpreting language and music." She emerges from this challenge with a growing awareness of her own strange sound and a deep listening practice that directly informs it.[75] Working with Bereal and others, Shange develops an approach to the process of negotiation between artist and audience that centers her as a listener. In her growing recognition of the intimately intertwined relationship between performer and audience and the role that sound plays in it, Shange is aligned with the musicologist Nina Sun Eidsheim's insistence on the recognition of the collective and cultural nature of sound. Eidsheim argues that "voice is a manifestation of a shared vocal practice" that is created "just as much within the process of listening" as it is through the vocalizer, and that in fact "the listener ... embodies the category of the originator of meaning."[76] Los Angeles audiences present Shange with new challenges that move her to sharpen her relationship to and philosophy on both audience and sound. She is no longer surrounded by Puerto Ricans and finds a paucity of "black people who spoke more than one language," and she is faced with the challenge of making "sense to this audience"—making her artistic voice legible and identifying an entrée point into this meaning-making negotiation with her listeners.[77] To accomplish this, Shange finds that she must achieve a sonic separation from a dominant masculinist sound, an aesthetic that she finds too "male, too harsh, too rigid."[78] Although many artists look to the sound and cadences of Malcolm X and James Brown as models of how to express Black emotional history and contemporary reality in a way that unites, these models produce sounds that cannot render the full range of Black women's experiences. Shange later tells David Savran that her developing philosophy on audience engagement is at odds with such sonic associations and she has to carefully avoid them. She understands such performances to be "so condescending to the public in some instances. . . . everything was telescoped for the audience as opposed to allowing them to discover with us what we were going to experience. I didn't want to be a part of that." Here, she reveals a deep respect for the collective and ongoing meaning-making process between artist and audience.

In facing this set of challenges, Shange's burgeoning philosophy and practice meet, and she begins to significantly disrupt extractive frameworks. To escape becoming entangled in a method of audience engagement and a sonic semiotic system that are contrary to her aims, Shange avoids sonic elements that threaten to immediately both classify (and thus

extract) and curtail her ability to negotiate her own sound and "meaning." In considering musical collaborators, Shange explains, "I didn't want drums because that would invoke another aesthetic that I didn't want the Los Angelinos to think that I was part of," an aesthetic that she views as male, harsh, rigid, and possibly affixed to imagined Africas and her meaning within that rubric. In lieu of using masculine-coded "conga drummers," Shange tells Savran that she asks a Chicano guitar-playing neighbor to accompany her. She determines that in making such a choice they would enjoy "an open field," sonically and otherwise.[79] In thus sonically interrupting audience expectations, Shange is able to "disrupt the visual logic of race" and gender and introduce audiences to a wider field of meaning on her own, more expansive terms.[80]

In her strategic deployment of defamiliarizing strange sound, Shange reveals an alignment with what Urayoán Noel calls the unincorporable, a technique that emerges from the Nuyorican artistic community.[81] Noel's concept speaks to poets' ability to incorporate into canons or to be unincorporable. He also examines the psychological register of these questions, particularly in regard to questions of identity and an imagined Puerto Rican "homeland."[82] The distance from a strict allegiance to the Young Lords political movement grants Nuyorican artists the opportunity to play with slippage—primarily through sound and form. Whereas writers affiliated with the Black Arts Movement were directed to wield words that served a "concrete function," Nuyorican poets regularly weaponized the unincorporable, which Noel further defines as the remainder, or residue, that cannot be taken up in the order of language, that defies translation, and that ruptures the "fantasy" of incorporation and precludes assimilation.[83] It does not come as a surprise that Shange, who critiques fantasies of incorporation regarding imagined Africas, and who values multilingualism, Africana southern connections, and improvisatory meaning-making processes with audiences, would find the slippage of the unincorporable attractive. While in Los Angeles, her concerns with audience engagement, a threatened illegibility through an alignment with masculinist sound, and her desire to negotiate and create with audiences coalesce in her sonic solution. Given her early exposure to a vast selection of Africana southern sounds, Shange is aware of the slippages that occur between languages and cultures. She meets her communication challenges in Los Angeles by embracing the unincorporable differences

that emerge at the sites of such slippage through her decision to sonically complicate audience expectations based on visual cues (her Blackness and her presentation as a woman) and the dominant semiotic discourse. In this way, Shange's embrace of sonic strangeness clears space for the emergence of a Black girl's song.

INDIVIDUAL SOUND, COLLECTIVE HARMONIES: TRANSLINGUALISM AND THIRD WORLD WOMEN'S LESSONS

If Shange becomes clear on her political alignments in New York, and if Los Angeles is where she develops methods for disrupting frame silencing and defines the terms on which she prefers to engage audiences, then an early 1970s San Francisco is where Shange most fully attunes her sound to her daily realities as a Black woman. Shange arrives in the Bay Area as many shifts are occurring that will leave their mark on her work. As Black radical political action changes shape nationwide, the Black Panther Party, in what Vincent identifies as its third and final stage under the initial leadership of Elaine Brown, has turned its focus to developing infrastructure for Oakland's Black communities and has transitioned away from a masculine-dominant, confrontational sound.[84] The Bay Area has transitioned from being the "capital of West Coast bohemia," having hosted a robust leftist multiracial counterculture and Black avant-garde theater, to a vital poetry and arts space of "close interchange and interconnection" between Black, Asian American, Chicanx, Nuyorican, and White artists "unmatched elsewhere in the United States" that refer to themselves as "Third World."[85] Additionally, and perhaps most crucial to this stage of her process, Shange later recalls that "San Francisco waz inundated with women poets, women's readings, & a multi-lingual woman presence, new to all of us & desperately appreciated."[86] During this time, Shange joins the burgeoning multicultural women's movement in northern California and becomes most emphatically aligned with woman-centered expression.

Shange accesses this vibrant woman-centered scene through several entry points. She finds her teaching positions in the San Francisco and Berkeley public schools important sources of "inspiration & historical

continuity," and her time on the faculty in the women's studies program at Sonoma State College is "inextricably bound to the development of my sense of the world, myself, & the women's language."[87] She counts as contemporaries and colleagues the women behind Third World Communications, who publish the first women of color anthology, as well as those with Shameless Hussy Press (who will publish her first printing of *for colored girls* and *Sassafrass*) and the Oakland Women's Press Collective. Reflecting on the impact of this community, in 1991 Shange tells Serena Anderlini that the "collective effort was that of 20 to 30 feminist writers in the San Francisco Bay area, to remedy and explain, explicate and extrapolate our situation as women. . . . The stamina and the courage—if there is courage involved in it to tackle issues that might be painful or unattractive—comes from that collective effort."[88] In joining the women's collectives in the Bay Area, Shange enjoys a return to spaces where difference is respected. While this group of Asian American, Native American, African American, and Latinx women "gave each other the strength and the environment" and support to speak their truths, Shange notes that it is from this environment of collective support that each woman's individual sound, colored by her own experiences, is able to emerge.[89] Although dominant aesthetic movements of the moment address the role of the artist in relation to the collective versus the individual, including leaders such as Karenga who distinguish between the individual and personality, these considerations often do not take the woman's situation into account. In "i talk to myself," Shange writes, "i waz not able to establish the kind of environment i thot my work needed when i read with men all the time," and she notes that third world feminist spaces in the Bay Area serve as a sanctuary from ignorance about and refusal to engage with women's worlds. Readings with women's collectives prove to be "overwhelmingly intense & growing experiences" for Shange, both personally and as a poet.[90]

If third world women's collectives assist Shange in her "attempts to ferret out" the realities of being a woman, her experiences with Black dance help her to most fully negotiate and articulate her Blackness and woman-ness. Having seized opportunities to play in the unincorporable by interweaving variants of hispanophone sound into her work, during this period of intensive dance study Shange recognizes that words—in any language—are not capacious enough to sing a Black girl's song. Like her Nuyorican contemporary Maria Umpierre ("The Mar/Garita Poem," 1987), Shange finds that

she "must invent a language," and she learns to use dance and other modes of expression to this end.[91] She notes that although she cannot always find words to express what she wishes to communicate, she believes that "the body has a grammar for those constructs which are not beyond articulation, but of another terrain," and to this end she notes, "I'm becoming trans-lingual so that I may speak myself."[92] Working with Raymond Sawyer, Ed Mock, and Halifu Osumare, several of whom are "descendants of Dunham technique," Shange becomes immersed in the world of African American dance and learns that, for her, language, movement, and sound are interdependent.[93] And although, as Shange concedes, the combination of these elements is not new, the unlocking of a new dimension of knowledge and articulation that she experiences here is. As she notes in the essay "a history: for colored girls who have considered suicide," "Just as Women's Studies has rooted me to an articulated female heritage & imperative, so dance as explicated by Raymond Sawyer & Ed Mock insisted that everything African, everything halfway colloquial, a grimace, a strut, an arched back over a yawn, waz mine. I moved what waz my unconscious knowledge of being in a colored woman's body to my known everydayness." It is important to note that in referencing Africa here, Shange is not reaching toward a real or imagined exalted past. Rather, she is more likely engaging the trace of expressive emergence that traveled to what would become provision plots and take shape in different forms across Africana Souths, a fuller conception of what she calls "everything African." She participates in the choreographer Halifu Osumare's concert, which "depicted the history of black dance from its origins in Western Africa thru to the popular dances seen on our streets," and Raymond Sawyer's *Ananse*, "a dance exploring the Diaspora to contemporary Senegalese music, pulling ancient trampled spirits out of present-tense Afro-American dance." For Shange, learning "african-american dance / the same as afro-cuban / Haitian / or afro-brazilian dance" helps her to more deeply and clearly situate herself in her unique contribution to the "pan-afro-hemispheric consciousness" spanning multiple Souths that she began developing as a child.[94] Moving her body rigorously in this atmosphere leads to endorphin highs that direct her to new truths, including what she calls the "wealth of our bodies" and the recognition that embodied expression is an essential element of Black women's expressive vocabulary and sound.[95] As she recalls, "With the acceptance of the ethnicity of my thighs & backside came a clearer

understanding of my voice as a woman & as a poet."[96] This experience enables her to access and project elements of her sound that the politics and sonic structures of dominant movements could not accomodate.[97] If her acquisition of translingualism represents Shange's sonic transmutation, then her collective approach to engaging her audiences (to include fellow artists and spectators) reflects the lessons she's learned regarding listening, improvisation, and approaching her work as the creation of an ever-changing collective harmony. When discussing her growth experience inspired by her dance training in northern California, Shange notes that she learns she can demand of her "sweat a perfection that could continually be approached, though never known," and that this pursuit, where "mind & body" ellipse, becomes a "poem." This newly acquired understanding of always approaching, but never completing or reaching a perfection, through dance and movement can be seen throughout Shange's oeuvre. Her approach to presenting Black women's experiences through a carefully crafted sound is collaborative but also allows her to be heard individually. In this way, she avoids being silenced through the extraction of her sound or by preassigned meanings that precede her utterances and that inaccurately represent her fullness, her politics, or the varied lives of her characters. Shange can be understood to be Hurston's rhizomatic offspring in her approach; whereas Hurston embeds her invitation to extend her narratives in her solo-authored fiction, Shange's approach is more aggressive and overt and opens various entry points for collaboration.[98]

FOR COLORED GIRLS

Shange emerges from this leg of her journey with command of her sound, a reinforced affinity for improvisation and exchange, and an award-winning choreopoem that puts her sound to work. Perhaps her most famous urging of audiences to gather scattered half notes and sing a Black girl's song—a song that has long been interrupted, its performances unseen, its vibrations muffled into silence—occurs in her Grammy- and Tony-nominated *for colored girls*. Shange begins her earliest work on the show in 1974 while still in the Bay Area. *For colored girls* reveals a continued critique of the inability of a single language to carry the frequencies of a Black girl's song

in such a way that renders it successful in meaning-making negotiations with her audiences, a critique that the Lady in Yellow calls the "metaphysical dilemma" that a Black woman faces in expressing herself. The show also provides a fictional illustration of the power of Shange's negotiations with gender, race, sound, the unincorporable, and the translingual.

The show features seven characters named for seven colors of the rainbow, each endowed with their own strange sounds and monologues, but also part of a collective akin to the atmosphere Shange located in the Bay Area. Of particular interest is the role that translingualism plays in the identity negotiations of her character Lady in Blue. In the book and the 1976 Broadway cast recording featuring Laurie Carlos as the Lady in Blue, we learn that the character's "papa thot he was Puerto rican & we wda been" but they were just "reglar" Black Americans "wit hints of Spanish."[99] As Vanessa K. Valdés notes, the Lady in Blue "does not define what she means by 'reglar,' nor does she clarify what those 'hints of Spanish' are, only that they exist in her family line," and that the author "alters the Spanish language, as the Lady in Blue places the stress on the second syllable of 'hola' instead of on the first."[100] Nuyorican poets often similarly alter standard Spanish pronunciation in their negotiations "in and against [their] exclusion from Puerto Rico and the [US] mainstream." Noel points to the poet Tato Laviera's use of translanguage—specifically, his use of a distinctly Black sound that he describes as "'too black' to be 'trans*lated*,' to support his argument that the 'African side' of Nuyorican identity [is] the one hardest to assimilate."[101] The Lady in Blue, with the "hints of Spanish" in her background, may also be immediately recognizable audibly as Black in her own dialect, and in order to navigate this Blackness she opts to be a "mute cute colored puerto rican." It would appear, then, that she faces the dilemma of the song-less Black girl that the Lady in Brown speaks about in the opening monologue, closed in a requisite silence in order to connect with this portion of herself. Here, Shange's warning against the Black US failure to hear manifests psychologically in the Lady in Blue, as she appears to view her US and then her Puerto Rican Blackness as disparate and irreconcilable.

However, when she learns that Willie Colon, a Nuyorican and bridge figure between the island and the United States, is not attending the dance, the Lady in Blue drops being "a mute cute colored puerto rican" and becomes loud ("& i talked english loud"). We witness her move

sharply into a world of US Black sound and then settle into sharing a list of musicians that includes men and women from throughout the Africana southern world, teasingly warning that even with her admiration of them she loves something else more. I suggest that this highest love for her is dance—which becomes Blue's translingual bridge between the seemingly incompatible parts of her identity. Whereas Shange's inclusion of multilingualism (English and Spanish) makes apparent the influence of her time in the multilingual Young Lords atmosphere and the lingual slippage she was able to explore, dance provides an expanded space for strategic slippage. It is a tool that allows for communication and a sense of belonging when language fluency is not available, evident in Blue's line "wit my colored new jersey self / didn't know what anybody waz saying / cept if dancing waz proof of origin / I was jibarita herself that nite."[102] It also represents a moment in which the Lady in Blue becomes her own bridge when Colon cannot—dance assists her in closing the loop and reconnecting with self, her truth, and her own loud sound. It is a combination of Black US and Puerto Rican language, music, and dance that carries her into the most integrated expression of herself, allowing her and her audiences, like Shange, to most fully sing her song.

Condé and Shange provide two examples of mid- to late-twentieth-century Black women's performances of sonic refusal. When in "Order, Disorder, Freedom, and the West Indian Writer" Condé discusses the restrictive commands that she has to navigate, her citation of a pamphlet published by Amiri Baraka's Congress of African Peoples organization in 1975 provides a bridge from her own journey with West Indian and African soundscapes to those encountered by Shange. As Jeremy Glick notes, her footnote "triangulates Guinea, the West Indies, and Black radical Newark" and "reminds us that the fathers generate meaning via acts of framing and interpretation, the very acts that constitute literature and literary communities," framing acts that also directly impact Shange.[103] After all, Shange spends a portion of her childhood and adolescence a little over an hour away from Newark—in Trenton, New Jersey. Like Condé, Shange faces silencing by daring to move beyond the structures the "fathers" prescribe. She, too, with her belief in singular expression

furthered by collaboration, must negotiate the call for an art that reflects a collective consciousness in service to political ends that often silence the articulation of Black women's experiences.

Sounding through polyphonic structures crafted via movement through unfamiliar Africana southern soundscapes, both artists plot new routes to sonic mobility. Each artist cultivates strange, unincorporable sound. Both Condé's and Shange's transmutations of silencing, extractive frames are catalyzed by confrontations with and mark a deep attention to the unfamiliar that is emitted through language and music. Both artists emerge with a new relationship to subjectivity, and this subjectivity forms the basis for their written and performed strange sound. They each also disrupt expectations of audiences, and in sharing their strange sound, they challenge audiences to listen differently. In the next chapter, I continue to examine Condé's meditations on the benefits of being unincorporable, along with those of Jamaica Kincaid. Whereas chapter 2 considers the challenge of preserving the stories of Black women, chapter 4 considers womb abyss tethers passed from mother to daughter that require disrupting.

4

ON AUTOFICTIONAL SUBJECTIVITY

Condé and Kincaid

> *Crazy wild distension of belly belly*
> *And more belly*
>
> *Yet nothing wild here—*
> *Everything following*
> *Deep codes*
>
> —M. NOURBESE PHILIP, "DIS PLACE"

Kara Walker's monumental *Fons Americanus* (2019) visually foregrounds a history of the extractions demanded of the African-descended woman's body and her female offspring. The sculpture addresses an imperial origin point for the demands and definitions that the African-descended daughter and her mothers have inherited, and it highlights subsequent silencings, erasures, and manipulations of their representational potentialities. The featured "Daughter of the Waters" or Venus is perched atop and surrounded by sculptures that are smaller in scale, all looking to her for some form of extraction. These include "the Captain," an amalgamation of (or figure suggestive of) Toussaint L'Ouverture, Marcus Garvey, and the Emperor Jones. According to Walker, this figure represents "the cyclical nature of ideological *usurpation and*

cooptation by power-hungry leaders." The "Kneeling Man," a figure representing economic gain from enslaving Africans, kneels in a position of false modesty while offering "Capital and Promises and Religion," all representative of systems that render him innocent and Venus monstrous.[1] A laughing "Queen Vicky" is found in the rear, a nod to the Victorian Memorial and its representation of "the colonizing nation . . . [as] idealized flowing breast and giving hand."[2] Viewers can connect these characters with famous historical figures because of their lingering mythologies, which were all built on Venus's enforced sacrificial silence. Resting on the water at the very bottom is, among other things, a ship emblematic of those on which the daughter's, her mother's, and her progeny's relation to the world is forever changed (legally and otherwise). These changes include the imposition of monstrosity onto the Black girl or woman and the alignment of this girl or woman with what Walker calls the "Immaterial Void of the Abyss."[3] At the very top stands the daughter of the waters, representing those crosscurrents of subjection stemming from the transatlantic trade in Africans and the Middle Passage: legacies that bind Black female bodies and their female offspring throughout the Africana world.

Walker's sculpture makes clear that Venus's or the daughter's own story has undergone layers of silencing. Her precarious position at the top of a vertical structure symbolizes hierarchical control. Presented as herself a superabundant and hypervisible fount, the Venus is vulnerable to remaining enclosed in others' narratives. The Venus's blood/milk-become-water can be understood as representing the continuation of her subjection and silence. She cannot speak; her throat is slashed. Likewise, she cannot feed her daughters; the traumatic waters of the Atlantic, not nutrient-filled milk, flow from her breasts. Demands that she carry monstrosity to support the crafting of others' heroism or innocence persist and are inadvertently echoed when the exhibition visitors use her as a backdrop for selfies.[4] The water representing blood/milk also reminds us that her condition of entrapment, silencing, and extraction is passed on. Successive generations will inherit the myths of monstrosity that locate her at the bottom of social and political hierarchies. She and her progeny thus become the base on which the representatives of empire, nationalism, and mother nation surrounding her craft their myths of self.

This chapter extends the work of chapters 1 and 2, which focus on US-born women's disruptions of others' exploitation of and access to the

FIGURE 4.1 Kara Walker, *Fons Americanus*, 2019. Nontoxic acrylic and cement composite, recyclable cork, wood, and metal Main: 43 × 50 × 73.5 feet (13.2 × 15.2 × 22.4 meters) Grotto: 10.8 × 10.2 × 10.5 feet (3.3 × 3.1 × 3.2 meters) Installation view. Tate Modern, London, UK, 2019.

Source: © Kara Walker, courtesy of Sikkema Jenkins & Co. and Sprüth Magers. Photo: © Tate (Matt Greenwood).

Black female body. These chapters also analyze the role that the Caribbean as strange South played in catalyzing artists' newly crafted approaches to issues of authority and the story they tell of the self and the Africana southern community. Here, I consider the role that migration to the United States plays in the Caribbean-born novelists Maryse Condé's and Jamaica Kincaid's disruption of inherited structures that demand their submission. This chapter examines the expansions that arise from Condé's and Kincaid's encounter with a strange space in which they craft *autofictional subjectivities*—a meeting of autobiography and fiction informed by their migratory experiences that, in allowing for the crafting of emergent space, supports the transmutation of the silencing monstrous framing passed from mothers to daughters. If, as Carole Boyce Davies argues, migratory subjectivity suggests a "slipperiness, elsewhereness" of Black female subjectivity, allowing for a "path of movement outside the terms of dominant discourses," then an embrace of the autofictional for the migratory subject allows for an expressive slippage of this magnitude. Melding the formal elements of fiction with conventions of autobiography makes possible the crafting of a literary expressive approach that allows for narrative movement beyond expressive and social lineages and organizing principles that understand the Black female's body—and by extension, her expression—as beholden to these inheritances.

Condé's and Kincaid's crafting of autofictional subjectivities illuminates the urgency of turning our attention toward the "immaterial void of the abyss" that Black women across the diaspora have endured. Through literary performances of autofictional subjectivity, both authors privilege the individual consciousness, and in doing so, they model new ways of telling the Black female Caribbean self. Their formal approach enables investigations of self, truth, and imagination and illuminates the myths undergirding the recurring, extractive framing and its mechanics, allowing for an imagining beyond it. While Venus's slashed throat and nipples spray water in lieu of blood and milk, symbolizing a silenced history of subjugation that continues to play out at the site of Venus's body, disrupted and refused inheritances put in motion a rerouting that opens onto transmutation in Condé's *Windward Heights* (French 1995, English 1998) and *Desirada* (French 1997, English 2000) and in Kincaid's *The Autobiography of My Mother* (1996) and *See Now Then* (2013).

CODING BLACK FEMALE FERTILITY

Zadie Smith's contemplation of one of Kara Walker's early works provides insight into the range of constraining, extractive mythologies centered on the Africana southern female (and presumably, materially and metaphorically fertile) body that Condé and Kincaid inherit. Published in the *Fons Americanus* catalogue, Smith opens her essay with a meditation on Walker's 1994 drawing titled "what I want history to do to me." The drawing, depicting a barely dressed White woman and a naked Black woman (save a kerchief around her head) both struggling to be free of a rope connecting them by the waist, leads Smith to consider the differing ways the Black woman might be read. She writes, "To an American audience, I imagine, this black woman could easily read as 'Mammy.' To a viewer from the wider diaspora—to a black Briton, say—she is perhaps less likely to invoke the stereotypical placidity of 'Mammy,' hewing closer to the fury of her mythological opposite, the legendary Nanny of the Maroons: escaped slave, leader of peoples."[5] In this seemingly polar configuration, Smith places front and center the tangled complex of mothering mythology that undergirds Black women's maternal extraction. Although she presents what initially appears to be a positive and negative option, they both represent an intertwined, limited field of representation within which Black women are expected to locate themselves.

Christina Sharpe's discussion of the mammy figure in Kara Walker's silhouette work offers a parallel perspective that resonates with Smith's reading of Walker's drawing. Sharpe's analysis could easily apply to the depiction of the Black woman in "what I want history to do to me," which Smith interprets as a figuration of Nanny. Sharpe notes: "A house slave and then a domestic, but not fully domesticated, for the viewer she is an(other) indicator of desire and its absence, a placeholder, a cipher. With so much projected into and onto her figure, no wonder the mammy becomes large, superabundant, splits into more of herself. Impossible to contain her in one body, impossible not to see her, she circulates widely but remains invisible nonetheless."[6] Kincaid explores this issue of projection and physical superabundance in her protagonist Mrs. Sweet in the novel *See Now Then*. As the load of expectations thrust upon her grows from her husband's desire to "discover" something within her that would somehow "make him

free ... from all that bound him" to his and his children's ceaseless domestic demands and their thrusting of a monstrous primitivity upon her body, she notes that it grows strikingly large even as she becomes invisible.[7]

This is not unlike Walker's silenced "Daughter of the Waters" atop the *Fons Americanus*. Monumental in size, she is notably larger than those beneath her who continually extract from her to fulfill their aims. Sharpe cites Manthia Diawara, who notes that "the Mammy is the most powerful symbol of the South because she is the only one that is necessary and indispensable to the representation of the entire mythology of the South."[8] Sharpe writes, "The mammy is the mythic figure who forms the identity not only of the South; she comes to be a founding figure of the entire United States."[9] I, in turn, submit that this can be extended to European empire writ large (and, by extension, the Africana southern world) and to the social, religious, and educational structures that underwrite this relation and reinforce Black women's subaltern position within them.

Kimberly Juanita Brown also understands mammy mythology through this broader geographical scope. Brown identifies the mammy as an "another mother" archetype stemming from the enactment of *partus sequitur ventrem* and the plantation who represents "the ultimate vision of the slave nursemaid and disarticulated motherhood." Whereas Smith suggests that the narrative import of the mammy and Nanny of the Maroons is geographically determined, Brown understands the mammy as "carr[ying] the burden of mythmaking to the outer edges of the global imaginary," suggesting not only that this mythology far exceeds the borders enclosing the United States but also that the mammy archetype is situated as the extractive frame that underwrites relations between the Black female body and imperial power.[10] Thus situated, she remains relegated to a permanent state of subalternity, whether in the metropolitan capitals of empire representative of the North or in the Africana South.

If Brown extends the reach of the mammy archetype geographically, Patrick Chamoiseau inadvertently illustrates the powerful ways that mammy and Nanny mythology becomes aligned and represented in Caribbean cultural expression. Countering claims that his work is masculinist, Chamoiseau writes, "My novels are about Creole women, *matadoras*—women who ... have always had to fight, to develop strategies of survival and resistance. . . . There's also the figure of the maternal woman; she loves her children, she is deeply attached to her family, she will do

absolutely anything for her sons."[11] Chamoiseau is careful to explain that his work represents what he understands as the range of Antillean Creole womanhood. In so doing, he reveals the limitations undergirding Créolité thought: Within this framework, the Creole woman is either *matadora*—a freedom fighter laboring for Créolité nationalism in a manner similar to how Nanny mythology is often deployed—or a mother whose labors are especially directed toward her sons. In this formulation, the mother does not become the freedom fighter or vice versa; she must choose to be either one or the other, and in neither instance is the woman performing in a manner that centers her individual interests. Through this scope, the ideal performances for Creole women are sacrificial: They never exceed the needs of the family—domestic or national. Chamoiseau's careful delineation of the matadora versus the Western woman grounds the woman freedom fighter in place, as she otherwise loses recognition of her valor and is expelled from her Creoleness, and the mother and her daughter appear destined to disappear insofar as they exist outside the attachment to their sons. This limited scope of representation extends to Black women's expression. Artists such as Condé and Kincaid find that they, too, are expected to comply with the limitations of the matadora or mother, and thus their expression is governed by rules that demand that they reinscribe either the ideals of the sacrificial mother or the male-led nationalist imperatives. Both artists navigate and exceed these constraints by crafting migratory—and then autofictional—subjectivities.

DISRUPTING THE MONSTROUS FRAME

The principles that organize the limiting frames imposed on the Black female body are deeply embedded into widely held notions of the human and supported by an intertwining of origin myths and legal doctrine. My thinking on how this framing operates is indebted to Sylvia Wynter's theorizing on bios/mythoi and narratively encoded notions of the human. Wynter, joining into conversation with W. E. B. Du Bois and Frantz Fanon and engaging with Aimé Césaire's "new science of the word" (proposed during his talk "Poetry and Knowledge" given in 1946), discusses the importance of the creation myth to Black peoples' exclusion from the

Western category of Man. She recognizes humans as being programmed by "hybrid sociogenic codes," bios and mythoi, and finds that storytelling is central to human consciousness (and by extension, to human subjectivity).[12] If origin myths become contorted to meet the needs of empire, in part by expelling Black people from the category of the human, then such contortions meet with law in *partus sequitur ventrem*. As Hortense Spillers's seminal work teaches us, this civil law maxim, aligning the enslaved female with a "brute animalty," ensures that "the condition of the slave mother is 'forever entailed on all her remotest prosperity.'"[13] *Partus sequitur ventrem*, or what Jessica Marie Johnson calls "the ultimate logic of slavery," was adopted widely throughout the plantation Souths and ensured that enslaved women's children would remain ineligible to receive land, money, or freedom from their parents.[14] Instead, these children became the property of enslavers and the inheritances of their descendants. In other words, with the institution of *partus sequitur ventrem*, Black women's wombs became what the slave ship once was—the site of transformation from human to commodity.[15] The legal enforcement of the maxim throughout the Americas meant that African-descended women's lives were governed by a hegemonic worldview that encoded their wombs with the limitations inherent to sites of production and extraction.

The frame of less-than-human monstrosity, once associated with the perpetrators of imperial violence, was now transferred to those referred to by Jamaica Kincaid in *The Autobiography of My Mother* as the "vanquished," and to the Black female body in particular. This move absolved the imperialist "mother" countries of blame. Black women's bodies thus represented "site[s] of loss under slavery: birth, parentage, heredity, motherhood, fatherhood, sexual desire, and sexual consent are produced and denied through the terms of unfreedom."[16] Black women became representative of superabundant sites of reproduction, but they could never represent motherhood. Furthermore, they were expected to continue to serve as sites of emergence for the myths or stories of others' innocence or valor while remaining enshrouded in silence themselves. The relationship between the Black mother and Black daughter becomes weighted with the demands of this inheritance, and this transmission is taken up as a central topic of exploration in both Condé's and Kincaid's writing.

As scholars such as Carole Boyce Davies, Alys Weinbaum, and Meina Yates-Richard note, the silencing perception of the Black female body

that originated during the Middle Passage and colonization is reinforced by what some consider masculinist liberation discourse.[17] In her study of the impact of Black women's reverberating aesthetic of pain that "structures and haunts" Black nationalist texts, Yates-Richard argues that this original encoding is followed by "maternal disavowal" in the postcolonial period.[18] This disavowal, it follows, governs who is heard along gendered lines. The metaphorically disavowed womb becomes fundamental to the crafting of Black nationalist ideologies in the United States and, I add, postcolonial nationalist ideologies more broadly—obscuring the Black woman's vital ontological role in worldbuilding.[19] As noted in chapter 3, one instance illustrating how *partus sequitur ventrem* transcends the plantation and colony is when Frederick Douglass and other authors of the slave narrative enshrine the "indistinctness of the conditions of 'mother' and 'enslavement'" in what will become the Black literary tradition.[20] Through their novels, Condé and Kincaid illustrate that this indistinctness not only extends to the perception of who writes but in crucial ways also maps onto the conception of gendered distinctions in parenting, with mothers becoming invisible (and thus having their stories silenced) while fathers emerge as heroic. As Condé makes clear, this disavowal impacts the daily lives of Guadeloupians. In her essay "Order, Disorder, Freedom, and the West Indian Writer" (1993), Condé discusses how Guadeloupian women chronicle the erasure of the mother who, tethered in place, is working at the "forefront of the daily battle for survival," and how these narratives are silenced and supplanted with those focused on often-absent fathers who are portrayed as "messianic heroes coming back home to revolutionize their societies."[21] Whether theoretically, fictionally, or in lived reality, these valorized absences constitute an additional level of narrative inscription on the Black woman's body. This phenomenon equates the mother with enslavement and stasis, while the father is associated with the pursuit of freedom. Jamaica Kincaid provides an example in *The Autobiography of My Mother*, where the protagonist Xuela's father Alfred takes great pride in his absentee Scottish father, endowing him with possibility, whereas he barely registers his mother's presence. Alfred valorizes his father while separating himself from his African mother, who, although she raises him alone, "remain[s] to him without clear features, though she must have mended his clothes, cooked his food, tended his schoolboy wounds."[22] The increasing valorization of the father, depending on his

degree of removal from (and sexual proximity to) the Black womb, reveals the limits of Walker's imagined amniotic fluid flowing from the hole of the brave to the new world: On several levels (nation, colony/empire, gender), the potentials of these waters from the Black Atlantic flow through the Black woman for others but are not available to her.

The daughter inherits from the mother or othermother a list of expectations.[23] These expectations are akin to those that appear in Kincaid's short story "Girl" (1978) and M. NourbeSe Philip's "Dis Place: The Space Between" (1994).[24] These teachings guide the daughter to follow the mother: They ground the daughter to a stasis, ensuring that she is in her "place" and available for the demanded extractions that parallel those demanded of her foremothers. Kincaid suggests that in the "West Indies . . . one lives very much the lives of one's parents," and her fiction explores the implications of this fact.[25] She has also discussed how the British educational model that she was taught supplemented these imaginative restrictions, imparting lessons on Black inferiority to all that represents mother country (language, accent, skin color, ancestry, etc.). While women's bodies continue to serve as the vessels for continuing the lineage of the often-absent men repelled by their perceptions of their partners' proximity to bondage, restrictive demands are inadvertently indoctrinated into girls by the women who birth them and the othermothers who raise them. This narrative indoctrination perpetuates a destructive cycle across generations.

Understanding these historical and ideological contexts is crucial when examining the works of Maryse Condé and Jamaica Kincaid, who are part of the "second generation," a wave of transatlantic migration that, as Bénédicte Boisseron explains, occurred "in the late nineteenth and throughout the twentieth century, as black Africans migrated from south to north in North America and across the Western hemisphere—from Port au Prince to Montreal, from Kingston to London and elsewhere."[26] This generation is composed of what Condé calls cultural hybrids, people "born outside their parents' country of origin and incapable of identifying with it," and they are characterized as a "counterforce to the reterritorialization of the prior generation."[27] As Boisseron notes, members of this generation "write against new types of binarisms: neither the Caribbean nor Europe, neither the ex-colony nor the métropole, neither the periphery nor the center. . . . Rather, they have started producing within a Pan-American context for

themselves and about their individual selves."[28] As Condé and Kincaid interrogate monstrous mother/daughter transmissions, they themselves have moved "out of place," writing from the United States while exiled—by choice or force—from their natal islands.[29] This geographical shift draws attention to the deeply entrenched extractive demands faced by African-descended Caribbean women, demands made evident in their interviews and autobiographies as well as in the criticism they receive for embracing an outsider positionality.[30] As Boisseron writes, "The first-generation Caribbean diaspora as a location of primal residence, parental figure, and territorialization presents itself as the new center, the center to which diasporic writers need to talk back—like a defiant offspring insubordinately asserting his personality against authority; an expatriate who finally answers the native community's call after a deafening absence; or the immigrant writer desperately trying to reach back to a community that disowned her."[31] This precedent, already set by the generation that preceded them, prepares the critics at "home" to be on guard for further defection. In their embrace of the position of the outsider, Condé and Kincaid provoke these critics, but they draw an additional layer of offense because they embrace the expanded vision that exile and movement have allowed, an expansion that removes the womb, so to speak, from the service of both colonially imposed and contemporary extractive demands.

As scholars such as Lizabeth Paravisini-Gebert and Brooks Bouson have thoroughly argued, the focus on the mother-daughter relationship in Caribbean women's fiction functions as a critique of the relationship between the colonized and the colonial motherland—a critique likely made more nuanced with the benefit of distance and reflection.[32] But in the work of the second-generation authors Condé and Kincaid, this focus also highlights an acute awareness of the challenges and potentials inherent to developing migratory subjectivities when navigating the afterlives of *partus sequitur ventrem*.[33] Each writer investigates the terms of movement (often domestic work agreements placing them in caregiving positions), silencing, and encounters with monstrous intimacies that allow them to uniquely probe what is transmitted from mother to daughter. Their life writing and fiction make clear that the gender-specific demands affixed to what came to be coded as a monstrous womb do not simply dissipate in a move from a Caribbean South to what through their embodiment becomes a South in the North within the United States.

As their generation troubles the insider/outsider binaries more generally and as Condé and Kincaid navigate the social landscape of the United States, their encounters with the unfamiliar prompt shifts in their own expressive relationship with monstrous encoding. In their move to the United States, both authors become strange in a way that enables them to distance themselves from the transmissions they received from their mothers. They also encounter different social orientations to slavery and colonization. Although these orientations create tensions, they find themselves (if temporarily and sporadically) evading the frames that entrap local women, and through the space created and their embrace of difference they leverage and transmute the frames that formerly eluded them into new expressive possibilities.

Their textual interrogations of issues and ideas around truth and authenticity lead to the development of autofictional subjectivities, a concept informed by Boyce Davies's explanations of the potentials that both autobiography and migration hold for Black women's expression.[34] As Boyce Davies's formative work illustrates, the Black migratory subject disrupts symbolic representation, allowing Black women to craft what she calls autobiographical subjectivities: a method for Black women to articulate beyond the limits of the domestic space and to redefine geographies.[35] If migration becomes an idiom for illustrating one way that the Black female body becomes a shifting typology that disrupts what it represented symbolically within its original cultural context, Condé's and Kincaid's embrace of a condition of outsiderness—and even elements of monstrosity—pushes this disruption further. Through their embrace of a monstrosity that reflects a deviation from what had come to be viewed as the "natural or conventional order," each author sets into motion an expressive paradigm that allows for a break with origin myths, legal myths, and familial, national, and creative positionings of the Black female body that situate it as a site from which only the stories of others could emerge. As Spillers suggests, "claiming the monstrosity . . . which her culture imposes in blindness" could lead to the writing of "a radically different text for female empowerment"; as they meld the liberties they locate in autobiographical subjectivities with conventions of fiction (including, prominently, narrative point of view and time), Condé and Kincaid provide a model for having the Caribbean woman speak beyond silencing, extractive familial and national(ist) frames.[36]

MARYSE CONDÉ

In conversation with Kavita Singh in 2015, Maryse Condé, perhaps jokingly, shares that as early as her first novel *Heremakhonon*, "I have been writing autobiography. Because I believe the most interesting character is myself." Condé later reveals that until she began explicitly writing autobiography, she needed a "mask" to hide "my deeper feelings, my deeper self, the way I feel inside of me, and how I regard the rest of the world"— she had "to invent a way of protecting" herself.[37] I am interested in how these admissions help us understand how Condé interweaves elements of her own biography within her fiction, particularly in writing that features women's familial, national, and unfamiliar encounters with monstrosity. More specifically, I am attentive to how they inform her formal approach. During this period, the author's experimentation with a narrative point of view is especially foregrounded, and it prompts meditations on the nature of truth and the fiction or myths affixed to African-descended women in different registers across her novels. The intensification of the author's genre-bending development of autofictional subjectivity following major breaks or disruptions in her personal life suggests that an examination of novels produced during these periods is important for understanding the role that migration and an embrace of difference played in Condé's development of an expressive mode that allows for a disruption of dominant symbolic representations of the Black Caribbean female body and creates space for the emergence of new ways of telling the self. This subcategory of Condé's writing is intimately aligned with her own confrontations with shifting typologies and representative potentialities as she migrates and then moves between the United States and her natal home, and the shifts in her work alongside these personal encounters reveal an interdependent relationship between the author's personal movements, confrontations with family, nation, and mother country, and her evolving relationship with the monstrous.

As Condé shares in *What Is Africa to Me?*, "all through my childhood I had been unwittingly integrated by my parents in French and Western values."[38] As members of the elite community of Grands Nègres, she was raised to speak pristine French, and as Condé frequently recalls in interviews, her parents' fondness for Paris meant that they visited the city frequently when she was a child. Condé recalls, "During their stays in Paris,

my parents were particularly mortified when the *garcons de café* went into raptures over the way they spoke French. 'We're as much French as they are,' my father would sigh, sadly forgetting one important detail—his very blackness."[39] A young Condé did not share her father's stance. She was acutely aware of her race, and this awareness was heavily shaped by imperially imposed frames that dictated what her Blackness and femaleness meant. As Condé later tells Singh, she had low self-confidence as a child: "Because of my mother, I believed I was totally ugly. I was growing up in a place, Guadeloupe, where they liked people with fair skin. I was discarded by the boys because I was Black. So, I had the feeling when I was young, a child, an adolescent, that I had no value whatsoever."[40] Separation by class and language (Condé did not speak Creole growing up) only intensified the feelings of alienation. This lingual rift is later cited as justification for the attempted silencing of her contributions and as evidence of her separation from the broader Creole imagination.[41]

For Condé, a move to France to continue her education was simply a deeper movement into the monstrous frames forged during the Middle Passage, solidified on the French Caribbean plantation, and continued through others' expectations of and demands upon the Black female body. It is during this period that the author receives a crash course in the history of the Middle Passage and African subjection that links Guadeloupe and France, leading to a break in her perceived relationship with her "colonial heritage" and colonial mother country.[42] As Condé writes in 2020, the father of a close friend from the Lycée Fénelon was a well-known and patient history professor at the Sorbonne who taught her about "the evils of colonialism and placed the Africa my parents never told me about squarely in the history of my people. Thanks to him, I came to understand the displacement that had populated the West Indies with black people. I learned the meaning of the terms 'slave ship,' 'forced baptism' and 'imposed language.'"[43] However, the discourse around Black liberation that led to her enlightenment also paved the way for her confrontation with an imposed monstrosity. Convinced that Frantz Fanon "understood absolutely nothing about the French Antilles" based on what she read as his "crude, macho and malicious" accusations hurled at the Martinican novelist Mayotte Capécia, Condé penned an impassioned letter to Jean-Marie Domenach, then-editor of the journal *L'Esprit* in which Fanon's analysis appeared. Much to her surprise, Domenach invited her to

his office to discuss her position. Condé recalls Domenach "talk[ing] the whole time without letting me get a word in." Condé had also raised her concerns about Fanon's text with her professor. Although her interaction with the professor over her reading of Fanon was more respectful than her conversation with Domenach, both men point out a wrongness situated in both Condé's thinking and her body—a wrongness that, though imposed by colonialism, is now being carried by the author. In the case of the professor, Condé notes that with "sweetness and tact" he "convinced me that I hadn't understood a word of *Black Skin, White Masks*. . . . Colonialism not only affects the mind and soul but can be perceived in the slightest posture; it impacts our bodies and behavior. Apparently, I still had to liberate myself physically as well as mentally."[44] Despite their conflicting opinions, Condé and Domenach soon engage in a physical and intellectual affair. Condé becomes pregnant with her first son, and although Domenach is initially pleased, exclaiming, "this time it'll be a little mulatto boy!," he abruptly packs up and leaves for Haiti the next day.[45] As Condé recalls, "Jean Dominique flew off and never even sent me a postcard. I remained alone in Paris, abandoned during my pregnancy. . . . As a mulatto, Jean Dominique had treated me with the contempt and thoughtlessness of the so-called elite."[46] Here, much like in her childhood episodes, Condé is reminded of the perceived taint she carries in her body, with the exception that now both she and her offspring are being rejected. This is, of course, not the explanation that Domenach provides Condé. He explains that a significant political threat is looming over Haiti, and the underlying subtext is that he must leave right away and play a heroic role in resolving it.[47] For Condé, this episode confirms her alignment with monstrosity: Following conception, her Blackness means an abjection that her mixed-raced child's father flees. She is positioned as the monstrous African-descended mother who is representative of a static, primitive past; Domenach, on the other hand, is essential to the freedom fight and must leave for work that will help the race continue to charge into modernity. She never hears from Domenach again.

Condé's confrontations with monstrosity in Paris provide a useful context for understanding her careful approach to expression and self-preservation and her need to develop a method of speaking the Caribbean woman self beyond the myths of monstrosity perpetuated and reinforced by family, mother country, and nationalist discourse. Her confrontations

with this implied monstrosity, both subtle and overt, anticipate her push against male-centric rules for Caribbean expression as illustrated in "Order, Disorder, Freedom, and the West Indian Writer" (1993), and this period has an evident impact on the methods and content she develops that most aggressively address these concerns.

Condé's move to the United States is a movement into an unfamiliar South that allows her to experience an unfamiliar relationship with established typologies of the Black female body. She enacts productive breaks with a familiar imposed monstrosity by embracing this difference. Condé comes to view New York, one of her adopted cities, as "the hybrid city par excellence. . . . The city of the Fugees, Danticat, Diaz and Garcia, in other words, a generation of artists who are living proof that the Caribbean imagination invades, transgresses and remodels cultural canons as it pleases. . . . It dies in one shape only to be reborn in another."[48] Like her second-generation peers, Condé is interested in "a conception of creativity in motion" that captures a spirit of "renewal."[49] As she melds the conventions of autobiography and fiction, she leverages the potentials that both forms offer with a particular attention to the renewals possible in using narrative point of view as a tool. For example, she is able to take advantage of the autobiographical "I" to center Black Caribbean women's voices and perspectives under the protective cover of fiction. What follows is an examination of both *Windward Heights* and *Desirada*, novels that feature Condé's experiments with narrative point of view to tell a story about truth, fiction, and the potentials that an embrace of monstrosity holds for transmuting narrative legacies of *partus sequitur ventrem* and telling a different story of the Black Caribbean woman self.

WINDWARD HEIGHTS

Caught between Mammy and Nanny, Cathy I, the protagonist of Condé's *Windward Heights*, faces several demands to sustain the multiple fictions that her partially African-descended female body supports. She experiences her position as one of being split into "two Cathys"—"one Cathy who's come straight from Africa, vices and all. The other Cathy, who is the very image of her White ancestor, pure, dutiful, fond of order and

moderation." Cathy understands herself as the embodiment of the binary that governs the myths structuring the society she lives in. This split entices her childhood friend and lover Razyé, representing the Black masculinist iteration of Black mother narrative extraction, and her husband Aymeric, representing the iteration deeply rooted in the plantation economy, to pursue her and integrate her into their respective fictions. Razyé, with no past or roots, questions why he lacks "a maman like all the other human beings" and laments that "even the slaves in the depths of their hell knew the womb that carried them." Brought to l'Envoulgent as a young orphan chiefly for Cathy's father Hubert and his children's entertainment, Razyé and a wild and relatively free young Cathy quickly forge an inseparable bond. For Razyé, Cathy represents "a papa, a maman and a sister to him. Her body had protected him. . . . Curled up against her he found the softness of the breast and the womb he had never known." Aymeric de Linsseuil becomes captivated by Cathy at the sight of her blood. After her brother imposes new household rules that restrict her youthful freedom, Cathy becomes acquainted with Aymeric's sister. Aymeric and Cathy meet at the precise moment when Cathy, working clumsily at a tapestry, pricks herself with a needle. Cathy arouses Aymeric's desire as she is "casting looks around her like a trapped mongoose," highlighting Aymeric's blindness to his own complicity in the plantation economy. The sight of her blood sows "in [Ayermic's] heart for the first time the desire to conquer," and Cathy becomes a tool for continuing his lineage and power and a means for reinforcing his innocence.[50] Convinced of his goodness and the sturdiness of his moral compass, he determines to improve the lives of the African-descended people in his employ but believes the best way to do so is to provide them with an education that effaces their pasts. In this, and in his hypocritical educating of Cathy, Aymeric uses education and religion to reinforce the controlling social myth that he attempts to meld to his uses and point of view.

While certainly worthy of serving as the center of its novel, Condé doesn't stop with Cathy's story. Indeed, the novel's power as a model of the potential of autofictional subjectivity is the breadth of perspectives that it can include—perspectives that disrupt the myths of origin that dictate what is carried by and passed between mother and daughter. Condé's *Windward Heights*, published in French in 1995 (English translation 1998) and set in Guadeloupe and Cuba at the turn of the century,

presents a remarkable multigenerational portrait of the imposition of horror on the bodies of Black women and girls. Published two years after Condé's "Order, Disorder, Freedom, and the West Indian Writer," the novel reveals a deepened concern with the impact that gender and class exact upon expression. In the novel, women's narratives are inextricably tied to those of slavery, and characters such as the Linsseuils—the White Creole representatives of power—are much invested in silencing them. Although the action is set after the abolition of slavery, a similar political and social structure endures, and these systems continue to benefit from an extractive relation with the Black female body. As several wet nurses attest, Black and lower-class women occupy a subjugated position like those they or their forebears inhabited in the plantation economy. Positioned at the bottom of the social hierarchy, African-descended and poor women physically nourish the children who stand to inherit the wealth generated by their own children's toils.[51] In the world of the novel, *partus sequitur ventrem* is upheld and neither women nor their children inherit the wealth or power that their expended sweat, blood, and milk create. Their place in this hierarchy is further enforced by the historical and religious origin narratives that order their lives.

Although the racial categorization system is not as rigid as that in the United States, there is still a suspicion of the monstrosity believed to be transferred in African blood, and thus, African-descended mothers—even if of mixed race—are viewed with suspicion. However, in the world of the novel, daughters are routinely denied access to their mothers, who die in childbirth. While this death severs their connections to their mothers' perspectives, it opens an alternative abyss space that allows for attempts to embrace strange paths, upon which the daughters experience empowering and unfamiliar encounters. Such is the case for the three central characters representing three generations of disconnection: the mixed-race Cathy I, her daughter Cathy II, and her granddaughter Anthuria. By melding the tools of fiction with those of autobiography, Condé crafts a polyphonic novel that not only disrupts the origin myths that continue to shape the representative potentials of Black women and their female progeny but also weakens the perception that they represent firm truths.

Cathy I ultimately rejects both Ayermic's and Razye's attempted uses of her body to craft mythologies of self. This refusal issues a direct strike against a lineage of fictions extending from the Middle Passage

to contemporary origin myths, fictions informed by organizing principles that locate the Black female body as existing "perpetually in a state of hereditary darkness and rudeness."[52] Initially, her embrace of Aymeric and the movement up the power hierarchy he represents spells a rejection of Razyé, disrupting her role as the Black womb from which he could be reborn. This rejection ultimately leads Razyé to contemplate a watery suicide in the sea, "rolled up in a ball like a foetus in its element." His fantasy operates as a recognition of the continued connection of African-descended women to the Middle Passage: When Cathy refuses to allow extraction that would enable a rebirth, Razyé imagines moving to a narrative fetus parallel to hers. And although Cathy I marries and procreates with Ayermic, she ultimately humiliates him and rejects her place in his narrative as well. The lure of Whiteness and its accoutrements—a noble name, land, and "a centre pew at church"—do not ultimately prove enough to hold her captive. Despite his careful inculcation, Cathy ultimately rejects Aymeric's lessons on Christianity and troubles the evil/good binary on which it is transposed. Indeed, it is the case that Cathy stuns her caretaker Lucinda when, claiming her African heritage aloud for the first time, she shares that she's long "wondered whether the Christian religion is not a white folks' religion made for white folks" and that she dreams "of an afterlife where we can express all the emotions and desires we have had to stifle. . . . Where we would be free at last to be ourselves." Cathy's (and her daughters') ability to refuse such impositions is enabled in part by the absence of a mother from which to receive the material or physical and metaphorical interpretive frames transferred via *partus sequitur ventrem* (PSV), but more crucially, Condé's insertion of these breaks allows for a rerouting of relationships that opens opportunities for strange paths and empowering encounters. The novel is populated, for example, with a number of *mabos* or nannies that serve as stand-in mother figures for Cathy and her progeny. This rerouted pairing of women and girls from various backgrounds and with various experiences into an intimate relation provides an opportunity for the sharing of varied and unexpected perspectives. One powerful example of this sharing is Cathy's daughter Cathy II's encounter with Ada the Fishwife, who becomes "like a maman" to Cathy. Ada early on acknowledges that their paths were not meant to cross but that it is precisely because of her uniqueness that she is drawn to Cathy rather than repulsed or shocked by her. Ada finds Cathy grieving her

pregnancy and newly abject state, introduces her to her daughter Patience who teaches her to weave, and provides a second home where Cathy can ponder her thoughts. Their relationship is mutually beneficial: Ada cares for and provides community for Cathy, and Cathy, via her careful and consistent journaling, teaches Ada the importance of tending to one's interior life. Importantly, it is in Ada—a woman who is disinvested from the patrilineal, declaring that she doesn't need men, a woman who built her own house, a woman who embraces other cosmologies and origin myths, and a woman that has a healthy relationship with her children—that Cathy II is able to arrive at her own conception of a good mother.

Through their rerouted relations caused by disrupted mother-daughter transmission, Cathy's and her progeny's encounters with othermothers catalyze a collective disruption and revision of origin myths. In one prominent example that perhaps extends from the revelation that Cathy I shares with her regarding her views of religion, Lucinda Lucious contributes a creation myth that centers her foremother's narrative. Displacing Belles-Feuilles, "the jail of my life," as her origin, she shares a tale that extends "as far back as Fankora, my Bambara ancestor, who was captured by some 'mad dogs in the bush' outside the walls of Segu while she was returning from washing her clothes as white as cotton in the waters of the Joliba. Her wedding with a nobleman from the house of Diarra was to be held three months later. Instead of which she found herself captive, a wooden collar around her neck, being forced to march to the tip of Cap-Vert." Detailing Fankora's entry into the Black mothering economy of the New World, Lucinda goes on to discuss Fankora's violation by a sailor on the ship that brought her to Guadeloupe, and the little girl the "color of curdled milk" that she gives birth to on the plantation.[53] By doing so, she highlights the beginning of a long cycle of the women in her family holding such a position. Her mother is noble—Bambara—with the sailor paling in comparison. Here, the sailor is not cast as a god or king but instead as the first in a long line of New World rapists. Significantly, Lucinda's tale, like that of the Indian housekeeper Sanjita, intervenes to highlight the struggles women have faced while silenced by prevailing origin myths. In authoring a family history that interrupts the binary that equates the Black female body with monstrosity, Lucinda is also crafting an empowering autofictional subjectivity for herself and an empowering inheritance for her

progeny.[54] Although Condé's autofictional writing allows for a play with various points of view not available to the autobiographer, a move that enhances her ability to present an elaborately textured story, I submit that her innovation with expressive form is not simply an aesthetic matter. Of note here is the author's presentation of the stories of several mabos, not to other characters but rather, in a manner borrowed from autobiography, directly to the reader. In this way, beyond providing an entertaining story, the author also challenges her readers. This challenge comes through perhaps most directly in the story of the mabo Julie, a seventy-two-year-old woman who recalls enduring fifty years of bondage. We learn that Julie adores the children of her former enslaver. We also learn that Julie has been raped and has had to deny her children the "nourishing, frothy milk" from her breasts and folk songs from her ancestors. The two men she loved were murdered: One was hanged and the other killed by a fatal strike from a foreman.[55] In return for this labor and largely invisible pain, Julie has had silver medals pinned to her breast and her name mentioned by the priest from the pulpit. These celebratory acts absorb and stifle her full story and align her with the mammy narrative.

Perhaps because they do not receive the intimate, privileged view that we as readers receive, Julie has become a postemancipation symbol of slavery in the eyes of her own children and in those of the Black men that she encounters. For example, when the men of the La Pointe politician and socialist Jean-Hilaire Endomius arrive at Razyé's home to recruit him to their cause, Julie opens the door to their sneering disavowal. Energized by their task of organizing the setting of fire to plantations to secure their own power, these men recognize Julie's pain, which, framed within a monstrous archetype, also becomes the thing they "must leave behind in order to claim a future" for themselves.[56] When they exclaim, "I thought they didn't make them as ugly as this since the abolition of slavery," they attempt to disconnect themselves from what they perceive as a threat to their own myths of power. The inclusion of mabo Julie's tale represents both Black women's narrative subjection and the deep threat that internalizing myths will become interwoven into these women's own conceptions of the world. When discussing Aymeric's sister Irmine's troubles, Julie could just as well be describing her own when she reflects that "some wounds can never be lanced and dressed. The pus and purulence build up

inside the flesh and gangrene the whole body." While Julie acknowledges holding "mourning, hatred, and resentment," she attributes her troubles to a "fate that has inflicted my color on me and Condemned me to hell." Here, Julie seems to concede that an otherworldly being is to blame for her fallen position. Julie's embrace of this origin myth may begin to explain why she preserves her enslavers' children's hair and teeth alongside the governor's silver medal and a picture of the Sacred Heart blessed by the bishop as "treasures." And despite her own daughters' reminder of her advanced age, perhaps it also explains why she decides to return to labor for a distressed Irmine, noting that "slavery isn't over for someone like me. I suppose I'll always remain a slave to white folks."[57] Julie's own malnourished sense of worth and understanding of her place in the world are deeply entwined with the narratives that sustain the power structure on the island. She appears unable to perceive a reality beyond these narratives in which she might access any alternative notion of self, and she settles into a kind of stasis.

Discussing the representation of this conundrum in Faulkner's work, Valérie Loichot reminds us that ordering narratives undergirded by "fertile" and "lethal" myths rooted in the hold of slave ships are recalled by "mother-love or mother-food," connecting this source of nourishment "to the excremental, produc[ing] only decaying matter."[58] So, although characters such as Cathy, her daughter Cathy II, and her granddaughter Anthuria may feel disinherited as a result of the denial of what they perceive to be vital transmissions from their departed mothers, this severance can also be read as a gift. Insofar as characters such as Julie and the Cathys internalize ideas of their own monstrosity and then transfer this monstrosity to their daughters, the loss of direct transmission means that they have a chance at severing the roots that tether them both to the plantation and to the hierarchy that holds them and their bodies hostage, and at embracing a new mother-daughter relation that disrupts the transmission of calcifying myths and leads to new, ever-renewing origins. Although troubled, the presence of narratives such as mabo Julie's are important because they evince an archive that represents Black women's silenced truths. The introduction of these silenced stories disrupts the autopoietic reproduction of the notion of Black woman as monstrous because it enables a more rigorous examination of what is being passed from mother to daughter.

DESIRADA

If Condé foregrounds a combination of the first-person point of view so often associated with autobiography and the shifts between points of view that fiction allows to challenge readers' acceptance of structuring myths in *Windward Heights,* her notable turn away from this approach in *Desirada* differently orients the reader to her continued probing of truth and myth. Multiple points of view are still central to Condé's work, but in this novel these perspectives are, with a few notable exceptions, shared directly with the protagonist Marie-Noelle and not the reader. "A novel haunted by crossings—departures, relocations, detours, and returns—between the Caribbean, the U.S, and France," *Desirada*'s protagonist's search for the truth of her origins "is answered only in riddles, lies, and conflicting stories," but her journey ultimately "unveils an uncharted becoming, clearing the way for the pursuit of new potentialities" of personal mythmaking.[59] Whereas her search for her identity by seeking out that of her father through discussions with several people fails, she eventually follows her mother's lead in embracing her difference and monstrosity—an embrace that ultimately leads her to break with the extractions affixed to imposed monstrosity and craft a story of self.

One of the results of Condé's turning the multiple perspectives away from a first-person encounter with the reader and toward the protagonist is that the reader is now directed to focus more intently on the protagonist's forced grappling with the fictions she encounters. In this way, Condé can tell a story about how deeply entrenched notions of Black female monstrosity are and how deeply implicated each person, including the protagonist, is in reinforcing the organizing principles that keep this notion active. Marie-Noelle is first introduced to the idea of Black female monstrosity via her earliest caretaker, Ranélise. Ranélise is the first to teach Marie-Noelle the limits of the Black mother by using her own mother, Reynalda, as the monstrous example. Both in Guadeloupe and in France, Reynalda was judged "an eccentric, sullen girl who had not been content with her daily lot." Because she has attempted to commit suicide following an unwanted pregnancy, Reynalda is an enigma to women like Ranélise, who, unable to have children, reasons that "if every girl who paraded around an unwanted bun in the oven did the same the earth would soon be emptied." Reynalda's pregnant body and

acts of refusal become valuable to Ranélise, a woman who struggles with her own childlessness and what it means for her personal mythology. Whether Reynalda remains with Ranélise and Marie-Noelle or departs for France, her act of birthing her daughter and prior to this being saved from drowning mean that Ranélise can extract from Reynalda to enhance her own heroic self-fashioning. When Reynalda leaves, Ranélise casts her as "a deranged individual who had done nothing less than abandon her defenseless infant on this earth," and by questioning Reynalda's fitness for mothering, she attempts to build a case for her own.[60]

Ranélise not only teaches Marie-Noelle that her mother is monstrous, but she also coerces her into complying with her place as the monstrous body from which others' stories are crafted. Under Ranélise's tutelage, Marie-Noelle learns to perform within the frame early on, and she associates the success or failure of these performances with warmth or coldness: "Every time they talked of her maman Marie-Noelle sensed a feeling of danger. It was as if an icy wind blew stealthily over her shoulders and she might catch pleurisy. She quickly tried to change the subject, showing off her latest composition or asking to recite a lesson."[61] In this way, Marie-Noelle comes to associate love and mothering with the warm inclusion she enjoys while under Ranélise's care, a warmth that is correlated to familiarity and performing one's role while remaining in place.

In probing others for the identity of her father, Marie-Noelle instead is returned again and again to her mother via her interlocutors' disgust, pity, and fear, and this return constitutes an education on the behavior expected from the Black female body. As she moves beyond the path intended for her, from her refusals to adequately perform gratitude to her failure to perform happiness in her despised role as caretaker, Reynalda leaves a trail of disgust, pity, and fear in her wake. Through this range of responses, Condé probes the true source of this monstrosity while making clear that whether women stay in their predetermined places or abscond, the monstrosity projected onto the Black female body is inescapable. After interviewing her mother's first employers in France, an experience that Reynalda recalled as humiliating, Marie-Noelle considers how

> the Paris Reynalda landed in at the end of the fifties was not the Paris of today, the capital of color, the second generation.... It was the white Paris of the "*Y a bon, Banania!*" poster. The red tarboosh and the "Yes, massa" smile were spread shamelessly over every wall in the Metro. On the trains

and buses a circle of empty seats set apart the black woman of the wrong color. Small children pointed at her as she huddled in her corner, whereas grown-ups casually voiced their comments out loud.[62]

Layering a consideration of gender atop Frantz Fanon's epidermal schema, Marie-Noelle realizes that the Paris that her mother arrived in demanded that the myth of Black monstrosity remain ever present and regularly confirmed to maintain the distinction of White innocence, charity, generosity, and motherhood, all attributed ultimately to the mother country. Here, beyond illustrating the pervasiveness of myths of Black female monstrosity, Condé also comments on the limitations of crafting migratory subjectivity in moving between former colony and colonizing mother country. Unlike the author's and the protagonist Marie-Noelle's eventual move to the United States, where both enter an unfamiliar (if still upholding *partus sequitur ventrem*) space in which they too become somewhat strange to their advantage, Reynalda's movement to France simply constitutes a move to the center of the culture that generated the monstrous frames imposed upon her body in the first place.

Marie-Noelle ponders how "women who have gone through Reynalda's experience change from victim to tormentor. They turn into those woody stunted trees in the savanna, nothing but trunk and bare branches, giving neither blossom nor fruit."[63] Herself indoctrinated with an understanding of care that aligns with "the notion that woman is constructed as living the gift or donation of her*self* to the fulfillment of all others' desires and needs—i.e., to making everyone else happy," Marie-Noelle has difficulty viewing her mother as an exception.[64] However, although Reynalda is a central site of monstrosity in the novel, she is the only one that does not impose performance demands on her daughter. Although her removal by the woman who, according to Ranélise, was "giving herself airs in France" was jarring for a young Marie-Noelle, Reynalda performs a series of refusals that will later provide a strong model for similar breaks from extractive framing for her daughter.

Reynalda provides a model of the power of migratory subjectivity for her daughter, and she demonstrates the power of the pen. Marie-Noelle is initially exposed to the latter while under the spell of Ranélise's inculcation, and she therefore views it as further confirmation of her mother's monstrosity. When Marie-Noelle arrives at her mother's home in France, she finds that rather than "concern[ing] herself with things that

are a woman's lot around the house," Reynalda spends copious amounts of time in her office attending to her thoughts and writing. Her intellectual labor is respected in her home, with her partner Ludovic performing the domestic labor. The young Marie-Noelle does not see anything of value in the model her mother provides. Although she recognizes her mother's generosity with money, Reynalda's inability to perform the limited scripts of warm motherhood that Marie-Noelle is used to seeing makes Reynalda "not like one of those monsters whose revolting crimes you read about in the tabloids. She was worse." Despite her early critiques of her mother, Marie-Noelle walks in and exceeds her mother's steps. Like Condé, she moves to the United States. With the assistance of a Black American woman academic—whose presence in the novel illustrates both the tensions born of difference and the coalitions formed between US-born Black women and Afro-Caribbean migrant women—Marie-Noelle earns her doctorate, joins the professorate, and becomes a writer. Following her visit with Ludovic, her final attempt to determine her father's identity, Marie-Noelle shares her monstrosity theory. Ludovic refuses to discuss it and points out that Reynalda has provided a blueprint for her—an alternative way of moving through the world and crafting a life. Marie-Noelle notes, "He didn't realize that I had ended up liking this identity, real or imaginary. In some way or other my monstrosity makes me unique. Thanks to it I have no nationality, no country, and no language.... It also provides an explanation to everything surrounding my life. I can understand and accept that there never was any room in my life for a certain kind of happiness. My path is traced elsewhere." To not seek alignment with nationality, country, or language—all powerful barriers for Condé in both her life and her fiction—means to refuse extractive demands and to open sites of emergence for telling the story of herself. Lucid in observing everyone around her grasping at and entangled in certain narrative webs of longing, she stands at "the beginning of [her] recovery."[65]

JAMAICA KINCAID

Jamaica Kincaid informs Patricia T. O'Conner that although she finds herself and her voice in the United States, she is clear that this voice was "formed somewhere else"—the West Indies—a location that looms large

in her oeuvre.⁶⁶ Like Condé, however, Kincaid finds distance from her natal Antigua necessary if she is to craft her subjectivity, or at least dissect the myth of self she has inherited. As Lizabeth Paravisini-Gebert notes, Kincaid understands that her writing is intimately connected with her mother. Kincaid shares that her mother "wrote [her] life" and dictated it to her, serving "as the 'fertile soil' that roots her writing."⁶⁷ However, as Kincaid makes clear in both her interviews and her writing, this connection is a complicated one that is at times domineering and perhaps leads in part to Kincaid's disconnection from her family for nearly twenty years upon her arrival in the United States.

Kincaid's migration enables her to locate and recognize her writerly voice. For Kincaid, who was sent to the United States at sixteen to work as an au pair (or a servant, according to Kincaid), this was an encounter with an unfamiliar South (insofar as the United States writ large is representative of a South in terms of where the Black woman is located hierarchically). Boyce Davies reminds us that one of the potentials of migratory subjectivities is the locating of "home in its many transgressive and disjunctive experiences."⁶⁸ In 2002, Kincaid tells Kay Bonetti that one of the benefits of her move to the United States was the space it opened: "I do not think that I would have been allowed this act of self-invention. . . . If I'd gone to England, I could only have been concerned with the color of my skin. . . . I was not used to American racial attitudes, so whenever they were directed at me I did not recognize them, and if I didn't recognize them they were meaningless." Whereas a British colonial education means that Kincaid is acutely aware of her monstrous location in that hierarchy, her lack of familiarity with the US system means that new imaginative vistas are open to her. Once Kincaid establishes her identity as a writer, she sets to work using her craft to "understand how I got to be the person I am."⁶⁹ In the United States, Kincaid crafts an autofictional subjectivity.

Like Condé, Kincaid skillfully melds autobiography and fiction in her novels, a practice boldly signaled by the title *The Autobiography of My Mother*. This novel marks a significant shift in Kincaid's exploration of possession and self-fashioning. Whereas her early short stories and novels feature the struggle for autonomy between mother and daughter, with and following *The Autobiography* the author now experiments with this relationship, which is marked by a movement between mother/daughter separation at the time of childbirth and mothers being available to their daughters. However, whereas Condé borrows from both genres to leverage

the possibilities for experimentation with narrative point of view and disrupts the myths affixing monstrosity to Black women, Kincaid focuses on time and authorial dislocation. The next section analyzes how, in *The Autobiography of My Mother* and then in *See Now Then*, Kincaid differently models the collapsing of time either to reject mythological inheritances thick with the residue of history or to access a past that is vital to recentering in oneself and reclaiming the power of migratory subjectivity.

THE AUTOBIOGRAPHY OF MY MOTHER

Like Condé, Kincaid uses autobiography's first-person narrative point of view to center Black women's perspectives. However, as suggested in the novel's title, the story we receive is not simply the protagonist's own. Breaking from autobiography's conventional chronological unfolding, *The Autobiography of My Mother* features Xuela's highly introspective recounting of her mother's and her unborn children's lives alongside her own from the sole vantage point of her own seventy years. This autofictional collapsing of past and future into her immediate moment is aligned with Xuela's mantra that "the present is always the moment for which I live."[70] Xuela's mother died at the moment she was born, which means that the protagonist has a clean slate from which to craft the story of herself. Thus, unlike the author's, Xuela's life has not been narrated to her by her mother. Instead of seeking out the past or others with the goal of connecting with her mother, Xuela is satisfied with the occasional appearances her mother makes in her dreams. In fact, as a child, Xuela has a precocious understanding of the workings of history and mythological inheritances, and in an act of rejecting both and their demands upon her, she works to dwell solely in the present.

Melding the narrative conventions of autobiography with the ability to manipulate time that fiction provides, Kincaid's *Autobiography of My Mother* models the potentials that rejecting pasts and inheritances hold for breaking with monstrous framing and the myths that undergird it and for telling a story of the self. Kincaid grants Xuela—who in turn rather unconventionally endows herself—with the authority that autobiography imparts. Refusing to occupy the space of mammy, Nanny,

or anything in between, Xuela is instead continually drawn to what she variably calls blankness, darkness, blackness, the abyss, or the unknown.[71] She rejects any notion of an inheritance that would have her accept or pass on myths that will keep her or her offspring entangled in legacies of *partus sequitur ventrem*. In refusing inheritances that demand that she physically and/or narratively reproduce, Xuela embraces the clean slate that her disconnection from her mother leaves behind. She constantly chooses to move toward the abyss, a space that can be read as empty or as a nonhistory, but that can also be understood as a space of potential from which she may craft her own autofictional subjectivity based on her own observations and experiences. The darkness of her abyss also provides an opaque space that allows cover for the maintenance of her "secrets" and "ability to determine events."[72] Both in terms of readerly dependence due to her narrative positioning and within the world of the novel itself, Xuela's collapse of past and future timelines into the present means that what is passed on will be determined solely by her desire.

Although *The Autobiography* presents a multigenerational severing of mother-to-daughter transmission, Xuela receives her mother's raced and gendered identity. As she explains, her mother bequeaths her the Kalinago people's legacy of defeat and extermination.[73] This legacy is intermixed with the Africans' legacy of defeat and survival that she receives via her paternal grandmother. She also carries her mother's name, but Xuela questions the value of a name that is "at once her history recapitulated and abbreviated," a name that in part was passed to her mother by the nun who found her outside the gates of the convent: This nun represented havoc in the lives of the "vanishing people" that her mother was from and helped to ensure that her mother lived life with a foreclosed imagination and with the demand that she "be a quiet, shy, long-suffering, unquestioning, modest, wishing-to-die-soon person."[74] Xuela inherits a Kalinago heritage from her mother and a Scottish and African lineage from her father, but because of her position as "a woman and a poor one," she, like her mother, stands poised to take on a racialized position of Blackness and thus the legacies of *partus sequitur ventrem* that are related to multilayered cycles of demanded extraction.[75] In Xuela's father Alfred Richardson, the myths that organize the hierarchical order of the island and filiation via religion, education, and economics converge. Alfred, in whom "the Scots-man and the African people met," provides the novel's primary example of the

man of color who benefits from a monstrosity imposed on women. An ambitious, power-hungry, and cruel government official, Alfred is easily inconvenienced by women in his quest for an ever-stronger economic status, even as they support his climb.[76] Prior to marrying Xuela's mother and before Xuela's own birth, Alfred impregnates a number of women whom he doesn't marry, and the children number among the so-called illegitimate that he doesn't claim.

And yet Alfred, like other men in the novel, is concerned with having someone to pass on his amassed wealth and his mythology (a narrative of heroism, specifically), which may in part explain his eventual marriage to Xuela's mother, and after her death, to Xuela's unnamed stepmother. Although Xuela cannot inherit material goods because, as she frequently reminds readers, she is not a man, she inherits the expectation that she will transmit the myths that support systems of power. By sending Xuela to school, attempting to cultivate in Xuela an appreciation of all he's amassed, and becoming questionably immersed in the church, Alfred implores Xuela to embrace and reproduce system-supporting narratives while ignoring the truth of her own observations. Instead, these experiences inform her understanding of her father as "proof that the meeting of White, African, and Kalinago peoples characteristic of Creole societies had resulted in profoundly disturbing racial and class hierarchies." Alfred represents a "collusion with the oppressor" that at moments differs dramatically from "the unconditional love and care that Xuela imagines her dead mother would have lavished on her."[77]

Xuela refuses her father's demands that she act as a vessel for his mythology, just as she refuses the use of her body for othermothers' crafting of their own myths. This includes teachers who have internalized stories of their own monstrosity and caretakers such as Lise LaBatte, who desires a baby. With LaBatte, for whom she develops an unusual fondness, Xuela encounters the limitations of friendship. Lise, inculcated with the mythology of Black female fertility and superabundance, cannot see past the reproductive potentials of Xuela's body. When impregnated by Lise's husband Jack, Xuela turns toward the abyss and proceeds to birth herself. In her steadfast refusal to allow anyone to possess her, her offspring, or her narrative, Xuela makes "the life that was just beginning in me, not dead, just not to be at all." Upon learning that she is pregnant, Xuela recognizes that she "was standing in a black hole. The other alternative was another black hole, this

other black hole was one I did not know; I chose the one I did not know." She flees to the house of a woman named Sange-Sange, who guides Xuela to an actual small hole in a dirt floor where she spends eight days emptying her uterus. This scene marks Xuela's most pronounced refusal—a refusal to allow any life issuing from her body to be "refined and turned into something worldly, something to which a value could be assigned."[78]

What follows is a deep descent into opacity for Xuela. As she drops into a probing of her past, she outwardly performs an ungendering. Here, covered in a man's underwear, pants, and shirt, with cut hair and a wrapped head, Xuela spends eight hours a day as an androgenous worker digging holes. While performing a deep liminality, Xuela ruminates on "sifting" her past. Under the cover of an ambiguous outward appearance and a withdrawal from all conversation, Xuela engages in intense introspection that results in a deepening embrace of herself and her ordering of reality. Instead of seeking her mother's or father's faces to find her own reflected back, she seeks what has become a deeply affirming reflection in her own image, noting that "my own face was a comfort to me, my own body was a comfort to me, and no matter how swept away I would become by anyone or anything, in the end I allowed nothing to replace my own being in my own mind." Through this period of deep reorientation, which she describes as an emptying and then a refilling, Xuela radically shifts her relationship to herself and makes permanent her refusal of the demands of *partus sequitur ventrem*. She emerges from this introspective period with a grounding in the present, an ever-changing moment in which she remains guided by her own observations. Her voice and perspective in each moment that follows are intertwined with and informed by those of her imagined mother and children, representing a collective autofictional subjectivity. With her collapsed orientation, Xuela, and by extension her mother and her offspring, are "capable of casting a light on the past such that in [her] defeat lies the seed of [her] great victory, in [her] defeat lies the beginning of [her] great revenge," honoring her recognition that her "impulse is to the good," with her good being "serv[ing] herself." Although Xuela determines that she will never be a mother, she clarifies that this is not the same as bearing children and that she would "bear them in abundance."[79] Although her description of the children, each living only one day, and her acts of destroying them may appear macabre, these actions must be considered alongside her determination to avoid

the commodification of anything issuing from her. In her bearing of and relations with her children, who issue from her head, armpits, and legs, Xuela is strange alongside the predetermined mothering narratives available to her, and this rebellious mothering breaks the chain of transmission. Her imagined children's brief lives ensure that Xuela will not pass on the monstrosity of the victors or the monstrous, static positioning of the vanquished.[80] Xuela's abyss enables her to recognize the limits imposed on Black women, and this dark space allows her to create her own autofictional narratives to populate the pages of her life that "had no writing on them," proving that her mother's absence is not haunting as many critics suggest, but instead a generative new beginning.[81]

SEE NOW THEN

In *See Now Then*, Kincaid continues to intersperse elements of autobiography with fiction, such as when she aligns her own more recent life events with those of Mrs. Sweet, the novel's protagonist. Like several of Kincaid's characters, Mrs. Sweet has much in common with the author: She too is from the Caribbean, had a difficult relationship with her mother, is a writer, and ends up in Vermont in an interracial marriage with children.[82] However, perhaps most compelling is the way that Kincaid continues to incorporate a play with time that is more consistent with fiction into a work that also takes advantage of the authority that autobiography confers, allowing her to once again center a Black woman's perspective and the process that she undertakes to maintain it. Partially relocating to California in the years following her divorce, Kincaid notes that she sees "mountains and deserts that used to be underwater [and has] had the chance to rethink the notion of time," and this shift in focus is reflected in the structure of *See Now Then*.[83] Mrs. Sweet, like Kincaid, recognizes that with time what can be seen or perceived shifts, and thus she finds a value in the past that Xuela does not. Kincaid presents Mrs. Sweet's story as one that constantly toggles between past and present, prompting reflection on how time and the constant demands barraging the Black woman's body relate to subjectivity.

If the book is understood as a chronicle of Mrs. Sweet's negotiations with the past and present, the saccharine opening, contrasted almost immediately with her rumination on a neighbor's death, foreshadows

how fraught these negotiations will soon become. Mrs. Sweet's tense existence in the United States makes clear Kincaid's own awareness of how the United States operates hierarchically as an extended South for all Black women. Although she earlier notes that she benefits from her movement to an unfamiliar South, Kincaid's portrayal of the connection between Mrs. Sweet's mother (a Black Caribbean woman) and husband (an American man strongly aligned with European values and tastes) illustrates a growing concern with connections between colonial scenes of subjection and their afterlives in the United States. Unlike Xuela, Mrs. Sweet is dealing with the immense difficulties of navigating a space that sometimes presents similar and other times unfamiliar cultural organizing principles that have implications for her own understanding of the workings of monstrosity. These markers of monstrosity coalesce upon Mrs. Sweet's body; her mother, Mr. Sweet, and even her children via her husband's influence understand her only in an extractive relation.

Mr. Sweet has shifted from using his wife's body to tell a certain story of his youth to using her body as a place upon which to rest his failures. When he first meets his wife, Mr. Sweet is taken by her physical traits: her legs that "were so long, she could wrap them around me twice and still they did not touch the ground," and her lips that "were like a child's drawing of the earth before creation, a symbol of chaos, the thing not yet knowing its true form." By the opening of the novel, Mr. Sweet has embraced the idea that his wife is "from another world, a world of goods—people included—that came on ships." He understands himself to be a "poor unfortunate man" whose wife "block[ed] his progress in the world, for it was her presence in his life that kept him from being who he really was." He not only uses Mrs. Sweet as an excuse for his failures, but by actively separating their daughter from Mrs. Sweet and telling their son that she is unlovable and "strange," "smells of the past," and is "very primitive" and "mentally backward" with tastes and philosophies that differ from his own, he ensures that they, too, view her as monstrous. In her movement between the past and present, Kincaid illustrates the thickly interwoven layers of monstrosity that Mrs. Sweet navigates, including those she receives from "the amniotic fluid" in which she "lived when she was a child" or her "ancient landscape," her mother. Her mother, whose beauty is for her connected with a monstrous sexuality that she is ashamed of, has imparted the impression that her daughter was disposable to her. When her mother falls in love and has three boys with one of the men in her life, this occurrence takes on a

particularly gendered cast. But even prior to this act, Mrs. Sweet receives tough love from her mother, who teaches her to "plunge ahead or buck up," the "cliched words of the victorious" that in hindsight Mrs. Sweet connects with her learning to power through, not just confrontations with "the large girls and larger than anything boys" that frightened her in childhood, but also demands that she perform an impossible perfection with others' acceptance being the evidence of achievement.[84] It is with her mother that Mrs. Sweet learns to crave validation, making her vulnerable to the extractive demands that she will later face.

Although Kincaid borrows from autobiography to primarily center her protagonist's point of view, she does so in a fashion that is a great deal more intense than in her presentation of Xuela. In *See Now Then*, her meandering, sometimes perspective-shifting, stream-of-consciousness narrative style draws an intense focus to the workings of Mrs. Sweet's mind, and thus to her effort to remain in control of her own subjectivity. The interspersed shifts in perspective are experienced as intrusions, making plain the labor required for Mrs. Sweet to maintain such control. Mrs. Sweet's movement between past and present and the impact that these events have on Mrs. Sweet similarly highlight the intensity of the extractive demands that she fields, giving the perception that the constant onslaught she must navigate is not simply demands from Mrs. Sweet's husband in real time, but the perception that at any moment a past memory can similarly disturb Mrs. Sweet's grasp of her own consciousness.

Through the act of writing in a small room adjacent to her family's kitchen, Mrs. Sweet crafts a time-traveling portal that helps her avoid enclosure and stasis. In her movement between the past and present, Mrs. Sweet collapses time by weaving autobiography and invention to reconnect with what she calls "the sacred heart of her own life." She is reminded through her returns to her past, for example, that "if I had been left to myself I would have been perfect: there was not a thing about me that I found wanting, not my thoughts, not my physical appearance." Returning to her uncompromised self via writing requires that she rigorously reconstruct and examine both her past and present simultaneously, in part because, as she comes to realize, she needs to locate the small, fleeting event that, occurring "when you are most unable to make its malignancy benign, when you are most unable to shrug it off," is dangerous because it "can be seen by random people, and that small event makes

you vulnerable to the deep and casual desires of these people." Along with her own past, Mrs. Sweet probes broader Africana southern pasts that provide deeper context for Black women's exploitation. In this room Mrs. Sweet is able to "commune with the vast world that began in 1492" and, ever visible in her dark eyes to those that encounter her, access the truth of "scenes of turbulence, upheavals, murders, betrayals, on foot, on land, and on the seas where . . . people were transported to places on the earth's surface that they had never heard of or even imagined, and murderer and murdered, betrayer and betrayed, the source of the turbulence, the instigator of the upheavals, were all mixed up."[85] In this way, while Kincaid reminds her readers where the true monstrosity lies, Mrs. Sweet works through layers of imposed myths to arrive at the truth of her humanity.

In the room off the kitchen, Mrs. Sweet is reminded of the power of her "own creative narration" and "individual creation." Pondering her experience in learning to read and write, she is not able to recall learning the alphabet, but, echoing what a younger Mr. Sweet perceived in her physicality and was drawn to, she now recognizes that "those letters formed into words and that the words themselves leapt up to meet my eyes and that my eyes then fed them to my lips and so between the darkness of my impenetrable eyes and my lips that are the shape of chaos before the tyranny of order is imposed on them is where I find myself, my true self and from that I write." Here, Mrs. Sweet is clear that to express or write is to engage in a creative act from a position of autonomy, whereas reading can provide an opening to inculcation into others' worldviews. The room off the kitchen becomes, for this reason, a source of distress for her husband and children, who demand that she remain positioned for extraction. Additionally, Mrs. Sweet's access to the power of the pen enrages Mr. Sweet, "who everyone, anyone, in the whole world knew . . . was the true heir of the position of sitting at the desk and contemplating the blank mound of sheets of paper." In daring to write herself, she is supplanting his inheritance: the prerogative to craft his mythology of the world upon her monstrous body.[86]

The key to understanding Mrs. Sweet's movement beyond monstrosity and toward emergence on her own terms is arguably in her and Kincaid's shared attention to time, landscape, and life cycle. Unlike her husband, Mrs. Sweet understands and delights in the rhythms of trees, for example, and "the cycle of budding and leafing out and becoming themselves for a season and then their growth dimming and eventually coming to a temporary

pause, growing dormant and resting and then budding forth again." Pushed by her family to the precipice of the silencing abyss where she can no longer hear herself, Mrs. Sweet takes a hard look at her life—"the remains of it, the facts of it, the summation of it, the finality of it, the good-bye for now and see you later maybe of it, the end in the beginning of it"—and weeps. And then she enters her space off the kitchen, finds that "her childhood and her youth and middle age, all of her was intact and complete," and "the misery that resulted from that wound, eventually becom[es] its own salve," helping her realize that "a world and this world that she had made out of her own horror was full of interest and was even attractive." Mrs. Sweet, following the pattern of the trees, "died and died," but she found herself intact upon each return, "and in this way she lived for a long time."[87]

Kara Walker explains that her Venus, the "crowning figure aloft" her *Fons Americanus*, transmutes the amniotic fluid that is the Atlantic into nourishing "mother's milk and lifeblood."[88] In Rinaldo Walcott's estimation, this is not the case. He cites Wynter in arguing that what is needed is "'a deciphering practice,' in which a conscious rewriting of the human and a challenge of the 'cultural imaginary of our present order' are central to what aesthetics can and might do."[89] As evinced by a study of their life writing and fiction, Maryse Condé and Jamaica Kincaid meet this mandate. Inspired by their own unfamiliar encounters across Souths, Condé's and Kincaid's reconfiguring of expressive forms aided by tools from autobiography and fiction allows them to rigorously decipher for their protagonists and audiences the workings of truth and myth in relation to the long-held notion of Black women's monstrosity. Lodged in the position of monstrosity, Black women simultaneously carry and are banned from the potentials of the amniotic fluids that Walker imagines issuing from the hole of the brave. In their textual performances of autofictional subjectivity, Condé and Kincaid model new paradigms that provide paths toward the transmutation of this flow. In their embrace and presentation of monstrosity not as a site of extraction but instead as a confounding deviation from an order long taken for granted, both writers provide textual innovations that allow new stories of Black Caribbean womanhood to emerge.

CONCLUSION

ON MUCK HORIZONS

> *To Janie's strange eyes, everything in the Everglades [muck] was big and new. Big Lake Okechobee, big beans, big cane, big weeds, big everything. . . . Ground so rich that everything went wild. . . . People wild too.*
>
> —ZORA NEALE HURSTON, *THEIR EYES WERE WATCHING GOD*

What is a southern horizon? Where is it located, and what is its function? Zora Neale Hurston begins to probe at the seams of these inquiries in *Their Eyes Were Watching God*. She opens the novel with the following meditation: "Ships at a distance have every man's wish on board. For some they come in with the tide. For others they sail forever on the horizon, never out of sight, never landing until the Watcher turns his eyes away in resignation, his dreams mocked to death by Time. That is the life of men." For less fortunate men, dreams and wishes—hopes for futures—are affixed to ships, which are in turn affixed to the horizon—a meeting of sea and sky. And they taunt. Hurston continues: "Now, women forget all those things they don't want to remember and remember everything they don't want to forget. The dream is the truth. Then they act and do things accordingly."[1] At the opening of the novel, Hurston's women don't have the luxury of wishes. They don't gaze upon waters and dream into futures. Ships are not capacious enough to

play host to their hopes, even tauntingly. For Hurston, there is no horizon for women.

But Hurston's meditation on horizon is not done. The end of the novel finds her protagonist Janie newly home from a journey on which she has transmuted her relationship to southern landscape, seascape, and expression. Returning from the strange muck space, which for Janie is the Everglades where "everything . . . was big and new" and "wild," she becomes part of emergent expression and it a part of her. Seated on her porch, Janie is ready to share her story. As she satisfies "that oldest human longing—self revelation," she enters into a catalytic exchange with her friend Pheoby that will expand her imaginative horizon. As the book concludes, the reader learns that after retreating to her bedroom in peaceful satisfaction, Janie "pulled in her horizon like a great fishnet. Pulled it from around the waist of the world and draped it over her shoulder. So much of life in its meshes! She called in her soul to come and see."[2] By the novel's end, Janie has not only located horizon for herself but has also transmuted its definition: She locates the horizon not at the visible boundary of earth and sky, but rather in a meeting of southern water and land. She has returned home in possession of her "muck" horizon and sits and gazes not upon a hope or a dream but upon a life lived and expressed on transmuted terms.

Janie's muck horizon represents a transmuted relationship with the "perpetua[l] . . . state of hereditary rudeness and darkness" that Alexander Crummell argues is the lot of the Black woman of the South, a designation that becomes part of the stubborn afterlives of slavery. As Patricia Yaeger writes, for Janie "the muck initiates a spatial economy in which the vertical mobility of the first half of the novel is exchanged for the adventure of the horizon."[3] The muck is by no means an idyllic space free of social or political tension. Patricia Stuelke explains, for example, that in later works, Hurston presents the muck as an index of "the particular role that the 'strange moods and appetites' of white femininity play in linking the 'expansion of white life' to racial capitalism's extractive settler colonial and imperialist projects."[4] However, Janie's "exuberance on the muck," and her intentional "delight in defilement, suggests there may be unexplored, unimagined ways of inhabiting social space."[5] Instead of confirming that Black women exist outside the expressive economy of

the contemporary moment, Janie's muck horizon explodes this perceptual boundary and enables her to locate possibility in the new mental, visual, and expressive expanse she has accessed.

When Indigo, Ntozake Shange's protagonist with "the South in her" (in *Sassafrass, Cypress and Indigo*), later accesses the muck horizon, she does so having inherited Janie's lesson that her relationship with the South is not one of darkness and degradation but one of creative emergence. No longer a relationship that denotes stasis, the South is now "in" her, a tool for creative, expressive, and physical mobility, and as such her "lover was the horizon in any direction."[6] Indigo proclaims that she's "got earth blood, filled up with the Geechees long gone, and the sea," and that she thus embodies the muck horizon and is able to recognize the gifts bequeathed to her through both her material and spiritual lineages, including her relationship to Blue Sunday—a formerly enslaved-cum-mythological patron saint of Black laboring women who wish for freedom for their children. Blue Sunday's domain is the sea. Following her beloved Aunt Haydee, Indigo takes up residence close by on a barrier island and begins to ease the journey for babies moving from womb to earth; she fiddles in tandem with Aunt Haydee's midwifery and Blue Sunday's magic. Like Janie, Indigo realizes her fullest vision and expression through the Africana southern muck horizon. Both Janie's and Indigo's journeys are emblematic of the thesis on creative emergence guiding this manuscript.

Taken collectively in the context of the poetics of transmutation that *The Souths in Her* outlines and with folk hero Janie as a guide, the muck horizon represents the emergence of frameworks whose potentialities exceed the more dominant ones born of the womb abyss moment. For Lovalerie King, in the context of *Their Eyes*, the horizon is a metaphor for possibility and for exploring life to the fullest.[7] To King's definition I add expressing to the fullest. The poetics crafted by twentieth-century Black women that emerges from these sites features ongoing renewals of organizing principles governing form, theory, and what the Black female body means, as well as cycles of emergent expressive modes that are necessarily unique to the individual artist. Notably, it is in the muck that Janie grabs the reins of the Black southern horizon—not Nanny's or Jody's, or not even Tea Cake's, but her own.

FROM A POLITICS OF RESPECTABILITY TO THE MUCK HORIZON

Several variables may be attributed to Black women artists' altered relationships with Black Souths following the generation of Black women writers who published in the opening decades of the twentieth century. Whereas artists such as Alice Dunbar Nelson may not have enjoyed access to the capacious frames that Hurston and Dunham craft in the late 1930s, the latter create with the benefit of having inherited a Black women's expressive tradition in which artists engaged multiple genres. As Brenda Marie Osbey suggests, writers such as Dunbar Nelson may have experienced a paucity of immediate Black women writers as models.[8] Although this lack may have posed a challenge for Dunbar Nelson's generation, their search for a method of voicing—even if constrained by limiting expressive frames—resulted in a generative inheritance for those coming behind. What they bequeathed amounted to an expressive promiscuity, an inheritance heartily accepted by each of the artists included in this study. The artists who followed Alice Dunbar Nelson and others of her generation also began with a knowledge of what didn't work for their foremothers, including for some their faith in a politics of respectability and its failure to ensure inclusion and recognition in prevalent literary, artistic, and intellectual structures. With the failures of the past recognized, each of the artists featured in this study leverages this knowledge to build future possibilities. For the writers and choreographers centered in *The Souths in Her*, this inheritance becomes particularly pronounced in their encounters with defamiliarizing Africana Souths. Indeed, these moments of encounter are key moments of a shift—the moments when a poetics of transmutation is catalyzed and Black women's relationships with Souths cross from those thrust upon them that code them as primitive and primed for extraction, to the Souths that become a crucial part of each artist's recentering of their relationships with audiences, their expression, and themselves.

If by the 1920s we can characterize nineteenth- and early-twentieth-century Black women's expression as partly a trying on of different expressive modes, then from the vantage point of the 2020s it becomes clear that the muck horizon is a defining feature of Black women's poetics of transmutation in the twentieth and early twenty-first centuries. Beyond

geographical meetings of water and land, the muck speaks to mud, dirt, and to productive cycling—to decayed matter containing high mineral content—to reuse and rebirth. The horizon suggests boundaries and limits not only to what we can physically see but also to mental vision, perception, attitudes, and ways of thinking.[9] On a metaphorical register, the muck horizon is what flowers from individual grapplings within and across strange Souths. It represents imaginary and expressive expansion beyond the creative and cultural organizing principles that cast the Black female as static and beholden to "hereditary darkness and rudeness." As such, the muck horizon as a lens makes clear the ways that Black Souths operate as both origin point and ever-shifting horizon.

The muck horizon helps us understand and situate strange Souths not as locations restricted to land but instead as spaces that often require negotiations with the meeting of land and water.[10] It guides us to recognize that probing this nexus, not unlike probing the Black female moving body and the word, is also central to disrupting and reconfiguring the creative and cultural organizing principles that move from the aquatic Middle Passage to the terra firma of the plantation. As *The Souths in Her* has illustrated, Hurston and Shange, Dunham, Condé, and Kincaid have all leveraged the opportunity to reorient emergence in strange or unfamiliar sites across the Africana South. As a result, they have catalyzed shifts in the ways we communicate, preserve, and think about Black women's insights. This book has sought to tell a story about the role that movement and Souths have played in Black women artists' work of shifting the signification of Black female from stasis and site of extraction that exists outside of time to co-contributor and co-imagineer of Black futures. Collectively, the texts and performances examined here have suggested a disruption and reconfiguration of creative and cultural organizing principles that speak, not to what we commonly recognize as issuing forth from womb abyss, but to muck horizon emergence.

Through this book's examination of twentieth- and early-twenty-first-century Black women's redefined relationships to Souths, I join a tradition of Black feminist thinkers who demand that our inquiries are guided by the question "Who are we not hearing from?" It is a call to continue listening for voices and insights and methods of relation that have been silenced, to recognize the creative power in what has been submerged, and in so doing to continue to expand, via an enhanced archive and repertoire, the

horizons of who we imaginatively collaborate with. To focus on one set of Black women's routes to expressive innovation unavoidably highlights other expressions that remain submerged. While I ambitiously aimed to expose the reach of the silencing autopoietic frames and their shifting permutations informed by the most dominant principles that emerged from the womb abyss moment, coverage of the impact of these frames is necessarily limited by their prevalence. This work was also limited by what for me was an equally urgent goal to tell the story of how Black women's movement across Africana Souths aided them in transmuting the frames. In examining—via a focus on location and exchange—one set of artists' performances and artistic output evincing movement beyond it, I center fusions occurring across a number of Souths. While these fusions are initiated in part by women whose individual names may not yet be identified, pointing toward these key moments begins a process of attribution across the Africana world. Rather than continuing to silence and extract, this process will allow for a more accurate hearing or encounter with Africana southern women's articulation. That the artists featured in this work have inspired a deeper questioning of who is and is not being heard and the roles that Souths play is evinced in the ensuing priorities of twenty-first-century writers and artists.

If twentieth-century transmutations inspired by strange Souths are understood as yielding the muck horizon, then by the 2020s Black women and nonbinary artists are beginning to explicitly ask who we are not hearing from or incorporating into our theoretical and creative frameworks at this site of emergence. In the folklorist Michelle Lanier's 2020 essay on Black women and southern memory, she recalls being enchanted as a child by Daufuskie Island—"the meeting place of land and water":

> I became mesmerized by the marshes at sunset, grasses emerging at low tide, golden, sometimes wind-bent, sometimes erect in the humidity. If it had been permitted, I would have stood barefoot, calf-deep in the muck, searching for pearls in the oyster beds. . . . I yearned for gills to breathe at the bottom of this murky, brown coast. I yearned to find something, a message, a marble, a button, a bead, from the ones who didn't make it. The trees too were my sanctuary. There seemed to be stories in their understory, memory in the moss, ground truth in the loam, hidden worlds in the branches I'd climb.[11]

The artists that *The Souths in Her* gathers into conversation, and their various arrivals (whether physical like a young Lanier or cerebral) at recognizing the power of unfamiliar, strange Souths, begin the work of transforming the Black expressive archive and repertoire. By doing so, they lay a new foundation for twenty-first-century visual artists such as Allison Janae Hamilton, choreographers such as Urban Bush Women, and writers such as Lanier and Akwaeke Emezi, who each uniquely probe the seams of the muck horizon, Souths, and poetics in their work. In this final section of *The Souths in Her*, I briefly consider three new works that begin from and linger at sites of muck horizon emergence, each making evident the continued disruptive and generative potentials of strange Souths as their respective artists extend the poetics of transmutation to meet contemporary challenges.

TWENTY-FIRST-CENTURY TRANSMUTATION: ALLISON JANAE HAMILTON'S *FLORIDAWATER*

Allison Janae Hamilton's 2019 photographic work *Floridawater II* makes muck horizon emergence visual. Included in her "Floridawater" series, the image centers a Black female in a white dress who is mostly submerged in the Wacissa River—part of the Wakulla springshed that includes swamps or wetlands. The woman is in shallow waters, floating just above the line where water meets land, and this image is repeated in inverse at the top of the frame as the water's surface reflects her back on herself. Although her body is under water, it is dynamic. Her dress floats up gently, and bubbles trail behind her fingers. Hers is not a frantic movement but rather a controlled, expressive one. This corporeal expressivity is made more remarkable by the fact that her head rests above water and thus beyond the frame of the photograph, speaking to an emergence—the muck horizon rests just beneath her feet. This iceberg effect raises the question of whether what is above mirrors what is beneath, or if one or the other is being reserved or held in careful preservation—and against what?

Hamilton conceives of her visual exploration of Souths as part of "a long thought experiment to see what would happen if we put landscape at the center of the way we understand ourselves and the way we

understand all of the good, the bad, and the ugly that is happening in our history . . . through to the contemporary moment." The South that Hamilton encounters is one that is most intimate; it is home. Indeed, to locate a strange South in a twenty-first century saturated with the Internet and thus with easy access to the sounds and images of elsewhere is a more challenging task than that faced by Hurston or even Shange. Like her contemporaries working across a number of expressive fields, Hamilton locates a different register of the strange through her search for the unfamiliar. She locates the unfamiliar in part through the muck horizon, where "murkiness and depth push back against clarity," especially given water's "mercurial and inconsistent and uncontrollable" qualities.[12] Water is protective and healing, and it is also deadly and terrifying. Similar tensions characterize twentieth-century encounters with strange Souths, and they persist in Hamilton's probing.

A significant part of Hamilton's method for discerning what or who is not being heard is her exploration of "apparition like" haints and ghosts: "caretakers or custodians" over land and seascapes that have "different habits" and "different kinds of ways that they repeat" things.[13] These "fleeting," "swimming," "running" characters are often identified by the masks they wear in her photographs. Hamilton's representation of these figures prompts us to recognize the silenced histories and modes of relation that, if we listen, look, and otherwise sense differently enough, productively complicate the creative and cultural organizing principles that we take for granted. In this way Hamilton's photographs tell a layered story of the beings that exceed the corporeal and meet at the muck horizon, and they prompt us to consider what they offer to a collective worldbuilding project.

When Joan Morgan asks Hamilton about the title *Floridawater*, the artist reveals the Africana southern scope of the project. As Morgan notes, central to several religious traditions and ceremonies throughout the diaspora, Florida Water is a cleanser and a purifier, and "it's used to draw the sweet things in and repel the negative things out."[14] Hamilton responds by sharing that she has relatedly encountered the perception that the Black US South that figures in her work is somehow disconnected from the broader Black diaspora. The visual representation of her subject's encounter with the muck horizon speaks perhaps to the artist's discernment of and underlying desire to make clear not only Africana southern religious

and ceremonial connections, but also submarine links that are similar to those highlighted by Alexander. After all, her character (Is she a masked haint? A woman? We cannot see her head) floats in waters that are not separated from the broader diaspora, but that eventually flow into the Gulf of Mexico and then meet the Atlantic at the Straits of Florida and also into the Caribbean Sea via the Yucatan Channel. Hamilton's muck horizon helps to disrupt the terms of not only Black women's relation with the water and sea but also, more broadly, their erased perspectives and denied positioning as experts of environmental matters. Whether haint or physically embodied, her central character floats in easy relationship with the meeting of land and water.

TWENTY-FIRST-CENTURY TRANSMUTATION: *HAINT BLU* AND URBAN BUSH WOMEN'S HOLE IN THE BOTTOM OF THE SEA

As the show *Haint Blu* opens in Miami and then later in Harlem, Mame Diarra Speis, the coartistic director of the company, rushes by the audience, demanding, "What do you remember? Who's calling you? Can you hear me?" A rehearsal video for the New Orleans installation foregrounds the gestures and utterances of the company members Roobi Gaskins and Kentoria Earle layered atop the laughter and singing of the vocalist Grace Galu Kalambay. As time passes, we note a convergence, a crossing of paths, between the vocal and dancing storytellers. Gaskins's large, swooping exhales seemingly prompt Earle to ask, "How long have you been holding your breath?" and then Kalambay erupts into ecstatic laughter. Alongside movements alternatively smooth, like underwater movement, and then frantic, Earle demands, "What's not being said?" as Kalambay sings of shallow waters. Recalling Shange's lesson that a woman with the moon in her mouth knows her power, Earle asks, "Are those pearls in your eyes, moon in your mouth?" Not long thereafter, Kalambay begins her rendition of the folk song "Hole in the Bottom of the Sea." As the Harlem show comes to a close, Courtney J. Cook shouts, "Don't look down, keep moving, press on to higher ground," while Speis, in a bathtub, is aided by two performers in birthing—an emergence and crossing of horizon.

FIGURE. 5.1 Mame Diarra Samantha Speis, Urban Bush Women's *Haint Blu*.
Source: © Bee Lively Photography, 2023.

The hole in the bottom of the sea is central to the Brooklyn-based performance company Urban Bush Women's (UBW) *Haint Blu*, a show that provides an embodied look into the movements, histories, and stories of our elders and ancestors and that reflects on what has been lost—particularly in the mass exodus from the South known as the Great Migration—and on recovering and reconfiguring tools to meet our current exigencies.[15] Broadly, the show provides space for embodied interrogations into the movements, histories, and stories of our Black women contemporaries, elders, and ancestors, and it urges a collective exhuming of things lost in the movement away from southern landscapes and practices. The nature of this recovery is built into the creative process: As company members move from city to city, they enter into site-specific immersion with community partners and local histories, and what results is an exchange between community, audience, and performers. In this way, *Haint Blu* enables us to preserve, reflect on, exchange, and expand upon often long-silenced wisdom and insights that, collectively taken,

hold promise for forming seeds of new cosmologies and a counterarchive from which we may engage to recall, remember, or craft anew solutions to pressing contemporary problems. The show's title is a reference to the color that Gullah and Geechee people of the southeastern United States painted the exterior surfaces of their dwellings to confuse malevolent spirits into thinking they are gazing into water or sky and to thus keep them from entering their homes. As the title of the show suggests, *Haint Blu* is attentive to the tensions inherent in inviting pasts in—and provides space for safe passage between past, present, and future.

The hole in the bottom of the sea is the site of muck horizon emergence that UBW probes from Buffalo to Harlem to Miami to Martha's Vineyard to enact this work. As Chanon Judson shared with me, the song entered the show's repertoire via her own personal memories of her grandfather teaching the song to her.[16] As she and fellow company members moved deeper into the work, it became an important vehicle for recovering and voicing submerged Black women's insights. The song represents one of the ways that Judson had to personally "go back and find the South inside herself and her lineage," information that she realized she had been partially disconnected from due to migration and time. Relatedly, *Haint Blu*, "a work that encourages people to journey, to ask questions, and to be curious about their lineage and the untapped potential for collective healing," is also about forging connections to ancestral Africana southern relations with land and water and determining what has been left behind.[17] *Haint Blu* as the muck horizon is as much about the meeting of the present and the past as it is about the earth and water converging at the hole at the bottom of the sea. Exceeding child's play, the song becomes a compass to submerged expression as the dancers, vocalists, and storytellers initiate collective movements that map routes to recovering what is no longer known or heard.

The arrival at the muck horizon that is the hole at the bottom of the sea evolved as the company moved from city to city and often found themselves at the confluence of water and land. One site of origin was a community lab in Buffalo in 2019, where the company worked alongside artists from other institutions and from which many of the songs and movements that are now part of the work emerged. Recognizing Buffalo as a "very southern northern city" in relation to the wave of southern migrants (including her own grandparents) and their lasting cultural

and expressive impact, Judson shares, for example, that Courtney Cook's song featuring the line "don't look down, keep moving, press on to higher ground" was inspired by Harriet Tubman's prior movement through the bridges and landscapes of the city and neighboring Niagara Falls. In Miami and New Orleans, the company and their local partners explored how each community navigated water with rising sea levels and how their huge migrant population, each bringing its own ways of being in relation with land and sea, impacted their unique approach. Like Hamilton, each community recognized water's role as both "life sustainer and imminent danger," and this tension was taken up inside the project.[18]

The company's understanding of the potentials and tensions inherent in the bottom of the sea as the muck horizon is informed by several legends. Included among these is the Wampanoag's explanation of the formation of Martha's Vineyard. As Judson shared, one of the culture's giants and gods foresaw colonization centuries in advance and created space for people to exist safely away from the mainland. They had the option of either coming to the island or going underwater and becoming whales or dolphins, with whales and dolphins now understood to be part of their ancestry. Judson shared that the company's understanding of the bottom of the sea was also informed by a Bantu legend that centers the movement of women to the bottom of the sea, representative of both a drowning and a rewombing. When the women were ready, they were birthed from the sea and became organizers and leaders of their communities. The company also considered the writings of Afrofuturist authors who liken the sea to space, and so for them the bottom of the sea became infinite and similar to black holes. These legends and the history of the Middle Passage mean that for Urban Bush Women the bottom of the sea represents fertile creativity and also a space of destruction. They consider, for example, the captured Africans who were thrown overboard, who leapt to the depths themselves, or, as in the Ibo Landing legend, who rejected the life that lay ahead on the plantation and turned and walked into the sea. Thus the company imagines the sea in a range of registers: "ridden with bones and blood, and full of a community of whale and however-creatured folks of Black ancestry at the bottom of the sea," as a space of loneliness where neither "boat nor land" can be seen (akin to Glissant's abyss) and a space where "grief [becomes] a tool for restoration."[19] This range, influencing the impact of the movements of whales, dolphins, and fish on the

movement vocabulary that emerges from the show, for example, becomes a touchstone in the work.

Haint Blu marks a major shift in the company's leadership. Metaphorically, the muck horizon from which the show springs also marks the site from which the new artistic directors Chanon Judson and Mame Diarra Speis begin to define new multidisciplinary expressive territory, presenting hints of their own new poetics. With *Haint Blu*, the company that Judson describes as "a body of thinkers and makers that push form" extends ways of saying and listening that, as McIntyre did with her 1986 staging of Janie's story, move between text and stage and artist and audience in a manner that signals the ongoing existence of a collective project and preservation praxis through which Black women make more inclusive the Black expressive archive and repertoire. This expressive extension is apt because it reflects the priorities of the founder Jawole Willa Jo Zollar's vision—a vision that was, in turn, built directly upon and extended Dianne McIntyre's poetics of transmutation, as Zollar studied with McIntyre at Sounds in Motion. Thus *Haint Blu* provides a direct movement from the Africana southern-forged twentieth-century poetics of transmutation that this book outlines to the twenty-first-century muck horizon from which today's artists begin.

TWENTY-FIRST-CENTURY TRANSMUTATION: AKWAEKI EMEZI'S EMBODIED, SPIRITUAL, AND SWAMP MUCK HORIZON

Akwaeki Emezi teaches us that masks are also for the living—for humans and embodied deities—and the author straddles both worlds by exploring the muck horizon within their body and on the haint blue porch at their "godhouse in the swamp." For Emezi, these two sites of emergence facilitate cycles of rebirth. Their epistolatory memoir *Dear Senthuran* chronicles these regenerations that the author calls "a loop, a cycle that includes a constant death, selves that are dying and being replaced, skins slipping on and off." Emezi describes their muck horizon emergence as happening on both a personal and planetary scale: "A new planet was forming, land masses were breaking up to the surface, seas were boiling forth," but

they "cannot tell if I am the one traversing the planet or if I am the planet myself, volcanoes erupting in my right shoulder, extinction happening along my thighs." It is Emezi who is constantly unfamiliar, and it is within Emezi that transmutations are taking place. The memoir comprises letters written to friends, family, and fellow artists, but most notably to Emezi themself. As the Nigerian Tamil nonbinary transgender *ogbanji* notes, "I had to remind myself that, before I started writing letters to anyone, I was writing letters to myself; all of these are letters to myself." These letters serve as markers of memory that outlast the upheavals caused by cycles of regeneration, death, and transformation. As a friend informs the author, "you write when you are most fragile, because you're changing from one form to another."[20] *Dear Senthuran* chronicles these changes along with the author's probing of the emergencies and insufficient organizing principles that threaten to continue silencing the insights of both Black nonbinary writers and unfamiliar Africana southern ontologies in the twenty-first century.

The memoir opens with Emezi's recollection of standing in the turquoise waters of the Black Sea—a stance they've held for two hours, "none of it ma[king them] feel as if [they] w[ere] anywhere." They are exhausted with what they refer to as a nomadic feeling of homelessness, and note that "the state of my body matches that of my mind—floating, tripped, and suspended amid clouds, crashing down into borders, lonely. . . . I have stopped fighting detachment and started learning how to sink into it instead." In the United States, where Emezi continues to contend with a sense of being spatially unmoored, they also become ensnared in the dominant frames shaped for interpreting bodies perceived to be Black and female. Their struggles both in the academy and publishing industry illustrate the persistence and reach of the dominant organizing principles born of the womb abyss. For example, Emezi is met with the shock of unfamiliar expressive expectations while enrolled in their MFA program. In a workshop seminar, Emezi is surprised to find resonance between their own exploration and thinking on selfhood and that of Vladimir Nabokov. They arrive to the workshop ready to discuss their own and Nabokov's work only to find that their colleagues of color have shown up empty-handed. There is a worshipful air in the room: Her colleagues of color "were so intimidated by his brilliance that they'd chosen not to present their own writing." Encountering this silence, Emezi finds themself

"besieged with anxieties" and questions: "What if I wasn't allowed to do what I was doing? What if it didn't get published? What if the gatekeepers read it and saw it as arrogant, me stepping out of place, writing about metaphysical selves as if I had the creative freedom of a white writer in this industry? I knew the world saw me as a Black writer, as an African woman even though I wasn't a woman, and I'd read enough about racism in publishing to worry about how it would play out in real time against me." And yet, recognizing the (if somewhat unfamiliar) expressive afterlives of the slave trade at play, Emezi finds that they "couldn't blame the other writers of color in [their] workshop for swallowing their work instead of presenting it. They were hearing the same message, broadcast by the limited range of stories made available to us, a message that seemed to tell us which of these stories would be allowed through the gates and which would be held back. . . . 'There's a script for people like you; stick to it.'" Although in the United States the author finds themself and the limits of their expression organized and predetermined based on old codes dictating what the Black female body means and can say, this is not the only space where Emezi is forced to deal with the residue of the transatlantic trade. Identifying as an embodied god and ogbanje, a divine spirit in Igbo cosmology that is born to a human mother, Emezi faces criticism from Nigerians for daring to name themself. As the author explains, "People want to be the ones drawing the lines, building the boxes, making the names. Maybe because stories live inside all those structures, and if you're the one controlling the stories, then you're the one in power." In the hands of others, the act of "naming becomes a weapon and what you are becomes a shame, a sentence, a tie around your neck with fire." As the author argues, another familiar legacy of colonialism, the severance or "estrange[ment] from the indigenous Black realities that might make some sense of it all," makes more difficult their embrace and naming of their reality, one that falls beyond broadly accepted limits.[21]

In the memoir, Emezi prominently identifies two things that they locate in the United States as a strange South that enables a transmuted relationship to expression and excavation of self as the muck horizon. One of these is the words of Toni Morrison. Acknowledging that their relationship to Morrison is different from those of Black Americans, Emezi's transmuted relationship to self and writing is catalyzed by a VHS tape in which Morrison shares that she "stood at the border, stood at the edge,

and claimed it as central . . . claimed it as central and let the rest of the world move over to where I was." Speaking to the elderspirit of Morrison, Emezi expresses gratitude because these words empower them to navigate the literary world and their embodiment with a degree of (fraught) confidence. On their first novel and emergence as an author, Emezi writes:

> Everyone thought I was a woman. I could be great. They thought my book [*Freshwater*] was a metaphor for mental illness. . . . *I could be great.* . . . I listened to her, that elderspirit, to you. I wrote an essay disclosing that I wasn't a woman, that I wasn't even human, explaining some of what an ogbanje is. When the press for *Freshwater* began, I made NPR acknowledge my multiplicity of self on air, made the press use plural pronouns, centered Igbo ontology as a valid reality made unreal only by colonialism. . . . Let the world move over, you said, and I obeyed.

Because of the sureness and steadiness in Morrison's own voice, Emezi was moved to "she[d] all these faces I thought I had to wear to survive," deepen into themselves and their center, and challenge the terms with which they were encouraged to represent their ontological and embodied realities, which meant placing their creative success at risk.[22]

While Morrison's words encourage Emezi to locate center, their voice, and thus their home in the ever-emerging muck and planetary landscape that is themself, the author's acquisition and cultivation of a property in the swamplands of Louisiana become a material artefact of their center. In a letter to new storytellers, Emezi writes that "there is no unfolding of a self without the space to do it in, without the safety that my career as a writer has given me," and they speak in like terms about Shiny the godhouse.[23] Emezi delights in the home: They have dedicated an Instagram page to it, enlarging its followers' imaginations through the photographs detailing its vibrantly limewashed walls, the paintings and sculptures created by Black visual artists covering its walls and surfaces, and the abundant and color-saturated yield of their yard turned garden that they've named Emmeline. While a reminder at times of their loneliness, the home allows Emezi to "see *myself*, not the version of me" stored in others' eyes, and they craft what for them is "more than a house, it's an entire dimension" to their specifications "without human anxieties, fears, or limitations." For Emezi, Shiny the godhouse "is the place I will write the rest of my books,

make the rest of my money, and find a quieter type of freedom," and it stands as a testament to their belief in the muck horizon emergence that is themself, their insights, and their expression shaped from their center.[24]

POETICS BEYOND THE WOMB ABYSS

Following Hurston's earliest writings contesting the linking of Souths, hereditary stasis and primitivity, and Black women by nearly a century, the work of contemporary artists such as Hamilton, Urban Bush Women, and Akwaeki Emezi illustrates the continued impact of their and subsequent artists' reclamation of Souths. If a twentieth-century Black women's poetics of transmutation was about stretching the capacity to express their insights by disrupting and reconfiguring cultural and creative organizing principles, with the interdisciplinary nature of the artists demonstrating that this poetics necessarily transcends singular forms, twenty-first-century artists have embarked on a project of recovery. While the twentieth- and early-twenty-first-century poetics of transmutation allows these artists to begin from sites of muck horizon emergence, thinking and imagining from this site mean that, perhaps even more than their foremothers, they are deeply informed by both their perceptions of what's possible and what continues to obstruct a full consideration and incorporation of the insights of Black female embodied people. Contemporary artists recognize the value of their forebears' insights, the extent to which their project remains an unfinished one, and the implications their knowledge ways hold for navigating their own contemporary emergencies.

Although this book focuses on a select group of Black women artists, it is important to acknowledge the diversity of experiences, expressions, and even Souths that exists beyond the scope of this study. *The Souths in Her* centers a particular genealogy, but it also gestures toward vast and varied landscapes—some of which are taken up by the contemporary artists I discuss in this conclusion. Hamilton, for example, begins with an intimate understanding of Africana southern women's long-held roles as environmental stewards and activists, and also of the ways these women are silenced and have their voices manipulated in the service of national politics. This work is powerful because it pushes against what can be

imagined about Black women and the natural world more broadly. As she reveals, we must continue to question how Black women's expression of their insights and expertise on these urgent issues can be best communicated in a manner that evades extraction and erasure. Urban Bush Women's initial impetus for creating *Haint Blu* was their recognition of the depletion and exhaustion of front-line cultural workers. Theirs is a concern of physical, mental, and spiritual wellness. They move within and through Africana Souths in an attempt to recover the methodologies and intelligence both in our ancestors and as it is embedded in and has grown up differently in contemporary provision plots. They ask: How do we gather and synthesize this intelligence while also honoring and providing a platform for the members of communities that are helping us along with this work? Emezi asks us to continue to push beyond binary thinking, whether on the level of gender or of the human versus the divine. Emezi challenges us to confront a number of difficult truths about how we need to continue to break the habitual ways we see ourselves, and they say that this effort may best be done in collectives. They write, "As I get bigger and accumulate more power, I have trouble seeing myself. I still play small, out of habit and comfort. Remind me of what I am, please. I will remind you of what you are too: something magnificent, someone who makes the world bow under her hands, who pulls history out from shadows and makes people look at the hard things. And we will keep doing this for each other, world in and world out. We all we got." Emezi asks what is possible if we move beyond caring about the ways others enframe and see us and instead work to free ourselves from caring about what we even think about ourselves. This, they suggest, could lead to "making unleashed work," creating and expressing without censorship, translation, "not worrying if it fits form," just writing because the story is one's truth. Emezi also warns younger creatives about the continued threat of extraction, of those who seek to "settl[e] you into a brilliant stillness. They deeply value your mind, but as a resource, as a glittering mine," a challenge that endures. Perhaps most compelling, however, is a question that Emezi asks explicitly and the other artists implicitly through their work, the question that most forcefully distinguishes their project from that of their predecessors: Despite our enduring "desires to be seen and to see ourselves," they wonder if "this reflection of known things" is enough.[25] I have sought to illustrate how the ways of being that emerged

from the womb abyss Middle Passage moment crafted according to Black women's sensibilities have been silenced or submerged in repetitive fashion; instead, the Black female has been positioned as a site upon which others craft their identities and subjectivities, not as an equal to create in partnership with. However, from reclaiming the scream to trying numerous forms to transmuting formal terms to recouping the submerged and silenced, Africana Souths have proven to be not anchors, but tools in the quest for expression. Whether absorbed in childhood, taken in through the clinging rich yet ever-regenerating soil of the muck, received through spiritual inhabitation, or imbued through sonic vibrations, the encounter with unfamiliar Black Souths has meant an alignment of two forces that, formerly in the periphery, align in a center. Individually, this has meant the emergence of a singular expression that disrupts creative and organizing principles that insist on extracting from the Black female and what her body means the stories that empires, colonial powers, and all who exist even minimally higher on a contemporary chain of being concoct of themselves. But Black women have always recognized that the stakes for breaking form are high. Those who have been longest forced to inhabit the womb abyss know that imagination and possibility are intimately linked. And as their poetics of transmutation illustrates—a poetics that exceeds the womb abyss—every perspective and insight is necessary for imaginative work. Real possibility lies beyond recursively reinforced creative, cultural, expressive, and ontological frames, and in wandering through, dwelling in, and vibrating with the strange South, Black women artists continue to expand the horizon of what is possible.

ACKNOWLEDGMENTS

The process of creating a book is far from a solo venture. I have found it to instead be a journey characterized by an exchange that has catalyzed, challenged, shifted, buoyed, encouraged, shaped, and conducted this book toward its eventual form. Put differently, *The Souths in Her* exists because of the transformative possibility of collaboration that Saidiya Hartman teaches us is the work of the chorus. To echo Sarah M. Broom, I, too, come with the chorus, and I am honored to be surrounded by such generous company.

My thinking on this book began at Emory University, where I benefited from the careful, exacting, and encouraging guidance of Valérie Loichot. The intellectual largesse of my committee members Mark Sanders and Dianne Stewart shaped the serious approach I now take to mentoring. Formative seminars and conversations with Lawrence Jackson, Barbara Ladd, Ben Reiss, Carol Anderson, Kimberly Wallace-Sanders, Laura Otis, Pellom McDaniels, and Randall Burkett have influenced and will continue to influence my approach to Africana expression well into the future. With the support of the Rose MARBL Alice Walker fellowship, I had the honor of working with Valerie Boyd for several years. I will always cherish the time we spent with Alice Walker's journals and our weekly meals over which we discussed our recent findings. Valerie, your lessons on the care that we must bring to Black women's archives will forever affect the ways that I approach my research. Thank you. And to Walker: Thank you for

having the foresight to keep such a complete record of your trials, triumphs, and insights. I am sure that many years will pass before I begin to properly grasp the impact that transcribing your journals has had upon my scholarship.

I am also grateful to have had teachers and mentors beyond the institutions that I've been affiliated with. Among these is the generous Herman Beavers, who reminds me to care for myself, my family, and my work simultaneously. His advice—to move toward the difficult arguments, where the "good stuff" lives—emboldened me to take the courageous intellectual leaps that pushed this project forward. Salamishah Tillet served as an important healing presence when we both lost Valerie Boyd and, despite being one of the busiest people I know, always reminds me that she is but a text away. Roberto Strongman, thank you for sharing chapters of your manuscript before its publication. Your ideas on transcorporeality have informed my understanding of Black women's encounters with unfamiliar Souths, and you have also proved to be a long-term supporter of my ideas. Thanks, Ras Michael Brown, for the warm welcome to Southern Illinois, and thanks also for your ongoing support. Barbara McCaskill and Paulla Ebron, I've enjoyed the privilege of your mentorship since my early days as a graduate student, and I continue to look forward to our conversations.

Ebony Coletu and Koritha Mitchell, thank you for modeling methods of gracefully existing in the academy. Ebony, I remain grateful for the lessons you provided for advocating for the resources that my research and thinking demand. Koritha, thank you for the powerful words of wisdom you so generously share that always arrive right on time.

I have had the great fortune of landing among exceptionally brilliant and munificent colleagues. I thank colleagues in the English department at California State University, Northridge (CSUN) for warmly welcoming me into the fold as a new junior faculty member. The English department at the University at Buffalo (UB) has proved the ideal environment for *The Souths in Her* to take shape. Huge thanks to my fellow traveler and writing partner Miriam Thaggert, who has read several drafts of my manuscript with great care. I am also grateful to think and work among Kristen Moore, David Alff, Rachel Ablow, Ruth Mack, Kyla Wazana Tompkins, Mishuana Goeman, Collie Fulford, Carrie Bramen, David Schmid, Cris Miller, Jim Holstun, Stacy Hubbard, Trina Hyun, Damien

Keane, Carine Mardorossian, Jason Maxwell, Elizabeth Mazzolini, Tanya Shilina-Conte, Rinaldo Walcott, Bill Solomon, Tony O'Rourke, Christine Varnado, Camilo Trumper, Dalia Muller, Noemi Waight, the late Tyrone Williams, and so many others. A special shout-out is owed to Judith Goldman, whose suggestion to insert a single "s" into my book's title set into motion a monumental clarification of my project. Thank you all for your camaraderie and support and for making UB a dynamic space of intellectual exchange. It is my sincere hope that my dazzling students are aware of the impact that their questions and insights have had upon this project. This is true of all the students I've had the honor of interacting with, including the participants in my Gullah/Geechee Renaissance courses at CSUN and UB; students in my Black Writers and the Archive seminar; the graduate students Janice Robinson, Dana Venerable, BreAnna Rice, Taylor Coleman, Alice Hall, and Luke Folk; and the research assistants Cole Turner and Taylor Coleman.

I wish to acknowledge the invaluable support of a junior faculty leave, a Dr. Nuala McGann Drescher Leave Award, and a UB OVPRED Humanities Institute Faculty Publication Support Award from the UB Humanities Institute (a unit within the College of Arts and Sciences) and the UB Office of the Vice President for Research and Economic Development. Additionally, the Julian Park Publication Fund (College of Arts and Sciences, University at Buffalo) provided timely funding to cover the book's production costs.

I have had the ongoing privilege of sharpening my thinking within several writing communities. Soyica Diggs Colbert, Rinaldo Walcott, Riché Richardson, Mishauna Goeman, Miriam Thaggert, and Sharon Beckford-Foster graciously read an early draft of *The Souths in Her* with care, and they helped expand my vision of the project's possibilities. The Dark Room: Race and Visual Culture Studies Seminar—the community that Kimberly Juanita Brown built—is breathtaking. I remain humbled to have been invited to join such a dynamic space of intellectual and creative exchange. In addition to Kimberly, K. Melchor Quick Hall and Sandy Alexandre are among the many chorus members in this space that have an impact the ways that I think and move.

Thanks to Despina Stratigakos, Jacqueline Hollins, and Jodi Valenti-Protas for supporting the writing community that I created with my cofacilitator, Miriam Thaggert. Thank you to the dedicated members that

showed up weekly and made the community a reality, and much gratitude to Noemi Waight and Camilo Trumper for keeping the community alive. Gwendolyn Baxley is among this number, and, Gwen, your summer writing retreat provided the perfect space for revising and bringing this project to completion—thank you. Michelle Boyd, Inkwell is also something to behold, and I'll be back just as soon as possible. Much gratitude also to Patricia Matthew (who generously invited me into her home away from home), AnneMarie Mingo, Camila Alvarez, Preeti Sharma, Christina León, H. Rakes, Akua Gyamerah, Joycelyn Moody, Maya Corneille and Isadora Trejo (words cannot begin to express the gravity of our lockdown-era sessions), Collie Fulford, Elizabeth Mazzolini, Ariel Nereson, Jocelyn Moody, and Bethany Swiezy. Each of you has created space for the kinds of collaborative thinking and writing (and in some cases healing) that made showing up for each step of this work a joy.

Great friends have also been an important part of the ensemble that buoyed this work. Sumita Chakraborty (the bacon to my eggs—or the other way around?) and Rose Gerazime, Rise-n-Dine will always live on in our hearts. In Buffalo, I had the great fortune of being part of several brunch and dinner crews. Shout-out to dear friends Denetra, Noelle, Terry Ann, Dierdre, and Tyra and the 'alley crew,' who ensure we gather often. Thanks also to Denetra and Linwood, Tyra and Kelvin, Noelle and Chris, Christine and Tony, Kristen and Craig, Nava and Jeremy, and Rachel and Ruth, who have so often invited my family into their homes for good food and camaraderie.

This book would not exist in its current form without the invaluable assistance I received from a number of archivists and librarians, including Ed Kirtz, research and outreach specialist at Robert S. Cox Special Collections and University Archives Research Center, UMass Amherst Libraries; DeLisa Minor Harris, director of library services at Fisk University; Matthew Forzalski, university archivist at Morris Library at Southern Illinois University; Martha Tenney, associate director at Barnard Archives and Special Collections; and Kathleen Shoemaker, reference coordinator at Stuart A. Rose Library at Emory University.

This project has benefited from the support of various fellowships and organizations. Among these are the Institute for Citizens and Scholars, which awarded me with the (formerly Woodrow Wilson) Career Enhancement Fellowship; the IRAAS Summer Teachers and Scholars

Institute; and an NEH Summer Institute fellowship hosted by the Georgia Historical Society. This support opened portals at key stages of my research that allowed for new questions and relationships to emerge.

I would also like to acknowledge colleagues' generous engagement with my ideas at conferences and conventions, including those hosted by the MLA, NWSA, MELUS, ASWAD, and MSA, and the thought-provoking questions and feedback shared following the presentation of portions of my research at Penn State, Dartmouth, the University of South Carolina, Adelphi University, and the College of Charleston. Similarly, the brilliant insights of the editors Cathy Hannabach, Shirley Carrie-Hartman, Laura Portwood-Stacer, and Meghan Drury pushed me to more fully meet this book's potential. Much gratitude to my editor, Philip Leventhal; Emily Elizabeth Simon; and the team at Columbia University Press and the editorial board of the Black Lives in the Diaspora series for patiently helping me navigate the unfamiliar waters of book publishing. Thanks are also owed to my anonymous reviewers and to Dawn Durante for taking the time to provide the gracious yet challenging feedback that strengthened this book.

An article that appeared in *Meridians: Feminism, Race, Transnationalism* 18, no. 1 reflects early ideas that appear in chapter 4. Portions of the *Meridians* article appear in chapter 4 by permission of Duke University Press. I would also like to thank the following people and places for granting permission to use images: Allison Janae Hamilton and Marianne Boesky Gallery, Ja'Tovia Gary, Robert S. Cox Special Collections and University Archives Research Center at UMass Amherst Libraries, John Hope and Aurelia E. Franklin Library Special Collections at Fisk University, Dianne McIntyre, Johan Elbers, Bibliothèque numérique Manioc, Kara Walker and Sikkema Jenkins & Co. and Sprüth Magers and Tate Images (Matt Greenwood), and Bee Lively Photography.

I learned the importance of ensemble from my dance and theater families, the most formative of these being Living Word / the African American Repertory Theatre of Virginia—a direct descendant of Ernie McClintock's BAM-era Jazz Actor Theater. McClintock's jazz acting method, accessed by way of Derome Scott Smith, provided a means for melding multiple modes of storytelling (choreography and acting). Later, through AMMA: An Experiment in Movement and Sound, I was grateful to join into a choral formation that probed the nexus of academic and creative expression with Rose Gerazime, Lauren Highsmith, Tamika Fields,

and Malcolm Tariq. I have most recently been invited to continue this work as dramaturg alongside the brilliant artists of Ujima Theater Company, Inc., 2nd Generation Theatre Company, Naila Ansari, and Ansari-Saxon Productions. Thank you for inviting me to participate in the kinds of co-creative experiments that undergird so much of my thinking and scholarship. Relatedly, I'd like to thank Chanon Judson and Dianne McIntyre for generously giving of your time to discuss your own performance families and practices in interviews that have greatly enriched this project.

Last but far from least, I must acknowledge the nurture, love, and support that I've received from family—those Earthside and in ancestral realms, biological and chosen—that makes this work possible. Aunt Gert, thank you for showing me how wonderful language and story could be. To my late grandparents Laura and Fred, your love continues to reach and envelope me. To Grandma Thelma, your encouraging desire to read this book has kept my pen (and typing fingers) afloat. A hearty thank you is owed to my grandfather James for the annual summer vacations that instilled curiosity and a lifelong desire to encounter and join into meaningful conversation with the unfamiliar. Mom, thank you for the gift of impeccable musical taste. Dad, thanks for instilling the gift of courage and for demonstrating how to fully inhabit a life. I'm grateful to my bonus family: my stepmother, Anita; my in-laws; and my chosen family (hi, Keia! hi, Maya!) for meals, homes away from home, and unceasing encouragement. Thanks for my siblings for being amazing inspiring human beings and for always getting the jokes, and thanks to my nieces for sharing their brilliant light. BJ, thank you for your ongoing companionship, witness, and love and for being my constant discussion partner (no days off!). You helped me rigorously sharpen the ideas that appear in this book. Thanks for always lending a listening ear and a thought or two.

Janie, my dear one, this book is dedicated to you. May this book help remind you of the myriad layers of your marvelous and ever-shifting inheritances as you craft expressive innovations that only you can dream up. Your song is an indispensable, deeply loved, gorgeous contribution to a vast, multigenerational chorus.

NOTES

INTRODUCTION: ON EMERGENCE: SOUNDING BEYOND THE WOMB ABYSS

1. Many sources list 1927 as the painting's creation date, but Dunbar Nelson discusses it in March 1926 in the *Pittsburgh Courier*. Valerie Harris, currently at work on a Waring biography, locates the creation date in 1925. In *South to America: A Journey Below the Mason-Dixon to Understand the Soul of a Nation* (HarperCollins, 2022), Imani Perry writes: "in this country's history, *Black* and *White* have never been mere adjectives, and *Indigenous*, a global term, is specific in this nation. These are identity categories that were made by law, custom, policies, protest, economic relations, and perhaps most potently, culture." Like Perry, I capitalize *Black* and *White*, categories that were "made together," in recognition of their "strangely symbiotic, opposing yet intimate" relationship (xi).
2. Alice Dunbar Nelson, Scrapbook No. 4, "From a Woman's Point of View/Une Femme Dit," *Pittsburgh Courier*, January 2, 1926–September 18, 1926; box 12, folder 235, MSS 0113, Alice Dunbar Nelson Papers, University of Delaware Library, Newark, DE, https://udspace.udel.edu/handle/19716/28940, 36.
3. Alexander Crummell and Daniel Murray Pamphlet Collection, *The Black Woman of the South: Her Neglects and Her Needs* (Woman's Home Missionary Society of the Methodist Episcopal Church, 1883).
4. Dunbar Nelson, Scrapbook No. 4, 36.
5. Zora Neale Hurston, "How It Feels to Be Colored Me," *World Tomorrow*, May 1928; repr. in Hurston: *Folklore, Memoirs, and Other Writings*, ed. Cheryl Wall (Library of America, 1995), 826–29. "But I am not tragically colored. There is no great sorrow dammed up in my soul, nor lurking behind my eyes" (827).
6. Ntozake Shange, interview by Jane Pauley, "Shange: 'Sassafrass, Cypress and Indigo,'" *Today*, NBCUniversal Media, September 14, 1982.

7. I acknowledge the contentious history of the noun "woman" for Black people throughout the Africana world. Black feminist scholars such as Hortense Spillers remind us that during the Middle Passage "one is neither female, nor male, as both subjects are taken into account as *quantities*." This ungendering was reinforced within the plantation economy, and the boundaries around the category "woman" continue to be policed today. However, it is also the case, as Omise'eke Natasha Tinsley writes, that the word carries a legacy of resistance. I join Spillers, Tinsley, and Mecca Jamilah Sullivan, among others, in using the terms "woman" and "women" to "include a range of genders and identities, including nonbinary, trans, and other genders aligned with self-articulated visions of black womanhood. 'Women' means all those who have identified as women, often alongside other gender identifications." See Hortense Spillers, *Black, White, and in Color: Essays on American Literature and Culture* (University of Chicago Press, 2003), 215; Omise'eke Natasha Tinsley, *Thiefing Sugar: Eroticism Between Women in Caribbean Literature* (Duke University Press, 2010), 9, 14, 10; and Mecca Jamilah Sullivan, *The Poetics of Difference: Queer Feminist Forms in the African Diaspora* (University of Illinois Press, 2021), 11.
8. Oxford English Dictionary, s.v. "Poetics (*n*)," accessed December 2023.
9. Aimee Meredith Cox, *Shapeshifters: Black Girls and the Choreography of Citizenship*, (Duke University Press, 2015), 28.
10. Saidiya Hartman, *Lose Your Mother: A Journey Along the Atlantic Slave Route* (Farrar, Straus and Giroux, 2007), 110; Édouard Glissant, *Poetics of Relation*, trans. Betsy Wing (University of Michigan Press, 1997), 6.
11. Christina Sharpe, *In the Wake: On Blackness and Being* (Duke University Press, 2016), 27.
12. Glissant, *Poetics of Relation*, 6. Glissant identifies the three abysses as the belly of the boat (a womb abyss that "dissolves you, precipitates you into a nonworld from which you cry out"), the depths of the sea into which Africans were tossed overboard to lighten the boat, and the projection of "a reverse image of all that had been left behind," accessible only in the increasingly threadbare memory or imagination (6–7).
13. Glissant, *Poetics of Relation*, 7, 8.
14. Cilas Kemedjio, "Rape of Bodies, Rape of Souls: From the Surgeon to the Psychiatrist, from the Slave Trade to the Slavery of Comfort in the Work of Edouard Glissant," *Research in African Literatures* 25, no. 2 (1994): 59.
15. Glissant, *Poetics of Relation*, 7; John E. Drabinski, *Glissant and the Middle Passage* (University of Minnesota Press, 2019), 3.
16. Sharpe, *In the Wake*, 28–29. While acknowledging the ungendering of African women that, as Hortense Spillers argues, occurs during the Middle Passage, a gendered and heterosexual understanding of hierarchy and power developed simultaneously and traveled to the plantation, further cementing the positioning of Black women as property. In *Thiefing Sugar*, Tinsley reads the extension of this positioning, for example, in Glissant's discussion of enslaved men's "hidden sexual encounters . . . as male slaves grab and penetrate females while both move through the cane." Here, the phallus becomes "a redeployed machete that simultaneously steals the master's property and subjugates the penetrated partner to create a fleeting sense of power," leaving the female "immobilized by 'sexual indifference'" and Martinican males without desire to pleasure or be a woman.

In this example, the woman as site of degradation, property, and potential for the formation of others' subjectivity is reinforced, and any space for female pleasure or eroticism, as Tinsley points out, is "choked out" (177–78).

17. Sharpe, *In the Wake*, 74.
18. I find a number of Glissant's arguments compelling, including his central tenet that the post–Middle Passage identities that Black people forge in the Americas via relations that are in any way liberating are best understood as rhizomatic rather than rooted. He contends in *Poetics of Relation*, for example, that root identity is built on Western creation myths, claims to filiation, and thus to legitimacy and entitlement to possession of land and territory and is the source of the violent creation of the other. He instead focuses on errantry: an ever-changing identity that is "produced in the chaotic network of Relation and not in the hidden violence of filiation," one that is not mired in entitlement and that "does not think of a land as a territory from which to project toward other territories but as a place where one gives-on-and-with rather than grasps" (143–44). It is from this process of relation, Glissant argues, that individual and community move beyond folklore and toward forming a culture with a transcended collective consciousness. It is in this ongoing process of relation, criticism, and transcendence that some measure of a subjugated community's voices rises.
19. Drabinski, *Glissant and the Middle Passage*, 48–49. Commenting on gendered language in Glissant's work, Drabinski notes that he suspects that Glissant's stance on the paternal is linked to Walcott's association of the paternal with the proper name and its link between past and present. He reads Glissant's engagement of the maternal as not a "carriage of or container for pain," and instead finds Glissant's representation of the mother "fecund under melancholic conditions."
20. David Luis-Brown, *Waves of Decolonization: Discourses of Race and Hemispheric Citizenship in Cuba, Mexico, and the United States* (Duke University Press, 2008), 54.
21. Robert E. Park, "The Conflict and Fusion of Cultures with Special Reference to the Negro," *Journal of Negro History* 4, no. 2 (1919): 130.
22. Michelle Ann Stephens, *Black Empire: The Masculine Global Imaginary of Caribbean Intellectuals in the United States, 1914–1962* (Duke University Press, 2005), 41.
23. Alain Locke, "The New Negro" (1925), repr. in *The New Negro: Voices of the Harlem Renaissance*, ed. Alain Locke (Simon and Schuster, 1992), 6.
24. Joanna Dee Das, *Katherine Dunham: Dance and the African Diaspora* (Oxford University Press, 2017), 31–32.
25. As Samantha Pinto observes, "Following the radical extension of the African American canon to include 'lost' authors such as Nella Larson and Jessie Fauset, and the vibrant vein of the black feminist thought of Hazel Carby, Patricia Hill Collins, and Valerie Smith," Gilroy's is a "nineteenth- and early twentieth century-centered critique that left out women altogether in its focus on the ship as chronotype—a sexless, ineffable Middle Passage on one route and the possibilities of free black masculine labor on the other." However, as Pinto further explains, "the critical intervention that endures beyond this lack, for this project, is Gilroy's focus on the potential of black art and cultural expression to make 'race' strange and unfamiliar," an intervention that finds resonance in *The Souths*

in Her. See Pinto's *Difficult Diasporas: The Transnational Feminist Aesthetic of the Black Atlantic* (New York University Press, 2013), 6.

26. Joan Anim-Addo, "Gendering Creolisation: Creolising Affect," *Feminist Review* 104 (2013): 21; Shona Jackson, *Creole Indigeneity: Between Myth and Nation in the Caribbean* (University of Minnesota Press, 2012), 31; Richard Price, "Créolisation, Creolization, and Créolité," *Small Axe: A Journal of Criticism* 21, no. 1 (2017): 211–19. Richard Price highlights the distinction between creolization with a "z"—an analytical tool that has historically been "the balliwick of anthropologists and historians"—and creolisation with an "s"—"the domain of poets and novelists" (219). For the purposes of this study, I find both (separate and combined) inadequate for gaining an understanding of the movement of Black women artists from being narratively tethered to plantation pasts to a new poetics that has at its ever-shifting center new relationships with Souths.

27. Anne Garland Mahler, *From the Tricontinental to the Global South: Race, Radicalism, and Transnational Solidarity* (Duke University Press, 2018), 3–5. As Mahler argues, tricontinentalism, which for her is more akin to the concept of the Global South, differs from postcolonial theory in that it includes in its subjectivity the subaltern, oppressed people located within imperial nations. She explains further that this "particularly applies to African Americans in the U.S. South" because in tricontinentalist thought and discourse, Black movements for liberation emerging from the Jim Crow South come to symbolize the tricontinental's "global struggle" (35).

28. Farah Jasmine Griffin, *Who Set You Flowin? The African-American Migration Narrative* (Oxford University Press, 1995), provides a robust account of the impact of the Great Migration on African American cultural production, and more recently, Imani Perry, *South to America: A Journey Below the Mason-Dixon Line* (HarperCollins, 2022), discusses how international institutions such as historically Black colleges and universities (HBCUs) (which she refers to as "HBCU Souths") also represent networks of Black life that constitute "a Southern thing, even if it's not always precisely happening in the South" (91).

29. Deborah McDowell, "Afterword," in *Recovering the Black Female Body: Self-Representations of African American Women*, ed. Michael Bennett and Vanessa D. Dickerson (Rutgers University Press, 2001), 312.

30. Mahler, *From the Tricontinental to the Global South*, 11. Black women artists are met with what Mahler calls a "metonymic color politics." Centering a recurring representation of a Black male freedom fighter through numerous liberation movements, this discourse issues silencing and extractive demands for Black women artists and threatens to govern their expression throughout this expansive South.

31. Riché Richardson, *Emancipation's Daughters: Reimagining Black Femininity and the National Body* (Duke University Press, 2021), 33, 182. Richardson's Africana South could be categorized as one of the recent developments in southern studies that, as LaMonda Horton-Stallings notes, challenges "essentialist ideas of 'the South.' Some of the essentialisms being challenged include agrarianism, Christian-centricity, singular public/political identity linked with the Confederacy, racial binary of Black/white, and genteel men and women." Other recent developments in southern studies include "incorporating the lives of the many non-Europeans who formed the majority population as they reshape

the history of the Southeast." See LaMonda Horton-Stallings, *A Dirty South Manifesto* (University of California Press, 2020), 2.

32. Paul Gilroy, *The Black Atlantic: Modernity and Double Consciousness* (Harvard University Press, 1993), 17.
33. Katherine McKittrick and Clyde Woods, "No One Knows the Mysteries at the Bottom of the Ocean," in *Black Geographies and the Politics of Place*, ed. Katherine McKittrick and Clyde Woods (Between the Lines, 2007), 3–4.
34. M. Jacqui Alexander, *Pedagogies of Crossing: Meditations on Feminism, Sexual Politics, Memory, and the Sacred* (Duke University Press, 2005), 265.
35. McKittrick and Woods, "No One Knows the Mysteries," 3–4.
36. Alexander, *Pedagogies of Crossing*, 259.
37. Alexander, *Pedagogies of Crossing*, 261.
38. Marina Magloire, *We Pursue Our Magic: A Spiritual History of Black Feminism* (University of North Carolina Press, 2023), 159.
39. McKittrick and Woods, "No One Knows the Mysteries," 4, 5; Alexander, *Pedagogies of Crossing*, 4.
40. Walter Mignolo, "What Does It Mean to Be Human?," in *Sylvia Wynter: On Being Human as Praxis*, ed. Katherine McKittrick (Duke University Press, 2015), 107.
41. Sylvia Wynter and Katherine McKittrick, "Unparalleled Catastrophe for Our Species?," in *Sylvia Wynter: On Being Human as Praxis*, 68.
42. For further reading on the sonic implications of Douglass's representation of Aunt Hester's audible pain, see Saidiya Hartman, *Scenes of Subjection: Terror, Slavery, and Self-Making in Nineteenth-Century America* (Oxford University Press, 1997); Fred Moten, *In the Break: The Aesthetics of the Black Radical Tradition* (University of Minnesota Press, 2003); Meina Yates-Richard, "'What Is Your Mother's Name?' Maternal Disavowal and Reverberating Aesthetic of Black Women's Pain in Black Nationalist Literature," *American Literature* 88, no. 3 (2016): 477–507; Daphne Brooks, *Liner Notes for the Revolution: The Intellectual Life of Black Feminist Sound* (Harvard University Press, 2021); and Jayna Brown, "Black Sonic Refusal," in *The Female Voice in the Twentieth Century: Material, Symbolic and Aesthetic Dimensions*, ed. Serena Facci and Michela Garda (Routledge, 2021).
43. Ifeoma Kiddoe Nwankwo, *Black Cosmopolitanism: Racial Consciousness and Transnational Identity in the Nineteenth-Century America*s (University of Pennsylvania Press, 2014), 27.
44. Édouard Glissant, *Caribbean Discourse* (University of Virginia Press, 1989), 122–23. As per Glissant, "To move from the oral to the written is to immobilize the body, to take control (to possess it). The creature deprived of his body cannot attain the immobility where writing takes shape. He keeps moving; it can only scream."
45. Glissant, *Caribbean Discourse*, 123, 133, 122.
46. Farah Jasmine Griffin, "When Malindy Sings," in *Uptown Conversation: The New Jazz Studies*, ed. Robert O'Meally, Brent Hayes Edwards, and Farah Jasmine Griffin (Columbia University Press, 2004), 110–13.
47. Tinsley, *Thiefing Sugar*, 35, 7.
48. Carole Boyce Davies, "From Masquerade to *Maskarade*: Caribbean Cultural Resistance and Rehumanizing Project," in *Sylvia Wynter: On Being Human as Praxis*, 212, 213.

49. Sylvia Wynter, "Novel and History, Plot and Plantation," *Savacou*, no. 5 (June 1971): 100.
50. Rinaldo Walcott, "The Problem of the Human: Black Ontologies and 'the Coloniality of Our Being,'" in *Postcoloniality—Decoloniality—Black Critique: Joints and Fissures*, ed. Sabine Broeck and Carsten Junker (Campus Verlag, 2014), 95.
51. Alice Walker, *In Search of Our Mothers' Gardens: Womanist Prose* (Harcourt Brace Jovanovich, 1983), 240.
52. Here, I refer to Nadine George-Graves's concept of "diasporic spidering." For more, see "Diasporic Spidering: Constructing Contemporary Black Identities," in *Black Performance Theory*, ed. Thomas F. DeFrantz and Anita Gonzalez (Duke University Press, 2014), 37.
53. Soyica Diggs Colbert, *Black Movements: Performance and Cultural Politics* (Rutgers University Press, 2017), 6, 21.
54. Ntozake Shange, "my pen is a machete," in *lost in language & sound: or how i found my way to the arts* (St. Martin's, 2011), 19.
55. Daphne Brooks, *Bodies in Dissent: Spectacular Performances of Race and Freedom 1850–1910* (Duke University Press, 2006), 8.
56. Meredith Cox, *Shapeshifters*, 29.
57. Shange, *lost in language & sound*, 58.
58. Zora Neale Hurston, "Characteristics of Negro Expression," in *Hurston: Folklore, Memoirs, and Other Writings*, ed. Cheryl Wall (Library of America, 1995), 836; originally published in *Negro: An Anthology*, ed. Nancy Cunard (Hours Press, 1934).
59. Walker, *In Search of*, 235.

1. ON AUTHORITATIVE WANDERING: HURSTON AND DUNHAM

1. Ja'Tovia Gary, *An Ecstatic Experience*, directed, edited, and animated by Ja'Tovia Gary (2015; single channel, 6 minutes). For the quote in this chapter's epigraph, see "Katherine Dunham on the 'Pole Through the Body' in Dunham Technique," Library of Congress video, 2002, www.loc.gov/item/ihas.200003848/. Marjorie Jones interviewed Fannie Moore in Asheville, North Carolina, on September 21, 1937. As Saidiya Hartman notes in *Scenes of Subjection*, use of the WPA interviews raises "a host of problems regarding the construction of voice, the terms in which agency is identified, the dominance of the pastoral in representing slavery, the political imperatives that shaped the construction of national memory, the ability of those interviewed to recall what had happened sixty years earlier, the use of white interviewers who were sometimes the sons and daughters of former owners in gathering the testimony, and so on. The transcription of black voice by mostly white interviewers through the grotesque representation of what they imagined as black speech, the questions that shaped those interviews, and the artifice of direct reported speech when, in fact, these interviews were paraphrased non-verbatim accounts make quite tentative all claims about representing the intentionality or consciousness of those interviewed, despite appearances that would encourage us to believe that we have gained access to the voice of the subaltern and located the true history after all." See Hartman, *Scenes of Subjection: Terror, Slavery, and Self-Making in Nineteenth-Century America* (Oxford University Press, 1997), 13–14.

1. ON AUTHORITATIVE WANDERING 215

2. The most immediate frame that Gary encounters is that of Ossie Davis, whose treatment of Moore's narrative is brought to life by Dee for the "Slavery" segment of the 1965 miniseries *History of the Negro People* (National Educational Television). The next frame available to Gary and readers is that created by the WPA interviewer Marjorie Jones, a White woman, and any subsequent editors that have shaped the interview with Fannie Moore into what is available in print. The next is the daughter Fannie Moore's presentation of her mother.
3. As I discuss in this book's introduction and again in chapter 3 in detail, the Black woman's scream has long been extracted for others' use. In this instance, instead of confirming the supremacy of her enslavers, Moore reclaims her voice and uses it to sing.
4. *Federal Writers' Project: Slave Narrative Project*, Vol. 11, North Carolina, Part 2 (Jackson-Yellerday, 1936). Manuscript/Mixed Material. Retrieved from the Library of Congress, www.loc.gov/item/mesn112/, 4.
5. *The Souths in Her* recognizes the *womb abyss*, born of the transatlantic slave trade and enjoying robust afterlives, as both lived condition and metaphor. It operates as a common thread connecting a broad array of theoretical approaches to Black expression that inform the narrative grounding of Black women to silencing, extractive Souths. Africans' emergence from the violent sites of enclosure referred to as "holds"—from the warehouses of Cape Coast Castle to what Glissant calls the "belly of the boat"— was understood as a kind of birth of modernity and Blackness. See Saidiya Hartman, *Lose Your Mother: A Journey Along the Atlantic Slave Route* (Farrar, Straus and Giroux, 2007); Édouard Glissant, *Caribbean Discourse* (University of Virginia Press, 1989); and Christina Sharpe, *In the Wake: On Blackness and Being* (Duke University Press, 2016). This womb or belly into which Africans descended and were "dissolved" becomes "the unconscious memory of the abyss" that serves "as the alluvium" for the forging of new relation, or shared knowledge, from which new Afro-Creole cultures are born (Glissant, *Caribbean Discourse*). Gary's presentation of Fannie Moore's narrative is itself framed—it is preceded by a montage of scenes depicting Black religious life in what appears to be the US South, and it is followed by insurrection footage from the contemporary Baltimore uprising and from Assata Shakur's interview in Gil Noble's *Like It Is* TV series. Gary's framing inserts Rachel's narrative into a long visual lineage of both anti-Black violence and Black transcendence of the frames that this violence supports. Even with the remove, Rachel's new ability to discern possibilities and an alternative reality that exceeds the frame in which she as a Black enslaved woman is conceived to exist remains strikingly compelling and in dialogue with the continuing impact of the afterlives of slavery.
6. Sharpe, *In the Wake*, 29.
7. Gary follows Christina Sharpe's notion of "refusal" as discussed in *In the Wake*; Ja'Tovia Gary, "A Care Ethic," Art, Design & Architecture Museum at UCSB, July 26, 2018, YouTube, https://www.youtube.com/watch?v=GZwVuvU-4Qg.
8. Audra Simpson, *Mohawk Interruptus: Political Life Across the Borders of Settler States* (Duke University Press, 2014), 177, 178.
9. Both Hurston and Dunham, although in the minority, worked with the WPA projects, helping to diversify the approaches and perspectives that shaped the work.
10. Joanna Dee Das, *Katherine Dunham: Dance and the African Diaspora* (Oxford University Press, 2017), 30.

11. David Luis-Brown, *Waves of Decolonization: Discourses of Race and Hemispheric Citizenship in Cuba, Mexico, and the United States* (Duke University Press, 2008), 54.
12. "Characteristics of Negro Expression," published in 1934, features Hurston's early theorizing on Black performance. Zora Neale Hurston, "Characteristics of Negro Expression," in *Negro: An Anthology*, ed. Nancy Cunard (Hours Press, 1934), repr. in *Hurston: Folklore, Memoirs, and Other Writings*, ed. Cheryl Wall (Library of America, 1995).
13. Imani Owens, *Turn the World Upside Down: Empire and Unruly Forms of Black Folk Culture in the U.S. and Caribbean* (Columbia University Press, 2023), 63.
14. Glissant, *Caribbean Discourse*, 207–8.
15. Marina Magloire, *We Pursue Our Magic: A Spiritual History of Black Feminism* (University of North Carolina Press, 2023), 3.
16. Melville Herskovits to Erich von Hornbostel, June 10, 1927; Hornbostel, E. M. von, 1927–1940, folder 28, box 9; Melville J. Herskovits (1895–1963) Papers, 35/6, Northwestern University Archives.
17. Sylvia Wynter and Katherine McKittrick, "Unparalleled Catastrophe for Our Species?," in *Sylvia Wynter: On Being Human as Praxis*, ed. Katherine McKittrick (Duke University Press, 2015), 34, 49.
18. Roberto Strongman, *Queering Black Atlantic Religions: Transcorporeality in Candomblé, Santería, and Vodou* (Duke University Press, 2019), 2. Strongman defines transcorporeality as "the distinctly Afro-diasporic cultural representation of the human psyche as multiple, removable, and external to the body that functions as its receptacle."
19. Hurston, "Characteristics of Negro Expression," in *Hurston: Folklore*, 827, 908.
20. Lindsey Stewart, *The Politics of Black Joy: Zora Neale Hurston and Neo-Abolitionism* (Northwestern University Press, 2021), 8.
21. Hurston, *Hurston: Folklore*, 906.
22. Stewart, *The Politics of Black Joy*, 17.
23. Hurston, *Hurston: Folklore*, 953, 952.
24. Valerie Boyd, *Wrapped in Rainbows: The Life of Zora Neale Hurston* (Simon and Schuster, 2004), 38–39.
25. Hurston, *Hurston: Folklore*, 599; Boyd, *Wrapped in Rainbows*, 30.
26. Hurston, *Hurston: Folklore*, 605.
27. Hurston, *Hurston: Folklore*, 10; Stewart, *The Politics of Black Joy*, 75.
28. Hurston, *Hurston: Folklore*, 618.
29. Boyd, *Wrapped in Rainbows*, 57. As Hurston ends the first paragraph of a chapter in her memoir dedicated partly to her recollections of the years in which she finds herself, to use her words, "homeless and uncared for," she notes that "people can be slave ships in shoes." This observation has a particular resonance for the experiences of Black women and girls given the limiting frames that hold many captive in the 1910s. Much of what occurs during this period remains lost to history, but we know that Zora was "shifted from house to house of relatives and friends and found comfort nowhere" (*Hurston: Folklore*, 635). The hungers that Hurston inherits from her father—for "education, excitement and adventure. . . . A big life" (Boyd, *Wrapped in Rainbows*, 59)—prove challenging to satisfy for a Black teenager with no financial support. Like many Black girls

and women at the time, Hurston lived the afterlives of the plantation-based narrative enclosures: She worked in several households as a maid, where she was forced to navigate undesired sexual advances.

30. Boyd, *Wrapped in Rainbows*, 70.
31. Imani Perry, *South to America: A Journey Below the Mason-Dixon Line* (HarperCollins, 2022), 91–92.
32. In Baltimore and then Washington, D.C., Hurston encounters scenes that would have reminded her of the Souths she'd traversed prior to her time with the troupe—for better and for worse. While supporting herself by waitressing, she is groped, propositioned, and reminded of the old scripts on Black women's sexuality.
33. Ayesha K. Hardison, "Crossing the Threshold," *African American Review* 46, no. 2 (2013): 222.
34. As Perry notes (*South to America*, 90), "HBCSs . . . were and are international institutions. Black young adults from all over the colonized world traveled to the United States to study at Black colleges."
35. In addition, while at Howard she may have witnessed Locke's rumored misogynistic behavior toward women students—behavior that limited their access to opportunities.
36. Although both works satirize the notion of the Race Champion as the voice of Black America and the establisher of the race's agenda, they may also be understood as Hurston's early commentary on the imagined international reach of gendered limitations that emerge from the frames that Race Champions set forth. Or perhaps they reveal how these frames affect her own literary imaginary.
37. Alice Gambrell, *Women Intellectuals, Modernism, and Difference: Transatlantic Culture 1919–1945* (Cambridge University Press, 1997), 100.
38. In fact, 1934 is a signal year for locating Hurston's positions on the debates of her day. Free of Mason's contract, she weighs in on a number of issues in several essays. In "You Don't Know Us Negroes," for example (Hurston aligns with the infrequently represented southern New Negro perspective on the literature of the Southern Renaissance; see *You Don't Know Us Negroes and Other Essays* (Albert and Charles Boni, 1925; repr. Amistad, 2022). While several prominent northern critics celebrate the representations of Black people featured in this work, Hurston critiques writers such as Julia Peterkin, joining southern-based New Negro writers such as James Waldo Ivy and Thomas Lewis Dabney who similarly view the celebration as a bit naïve; see Claudrena N. Harold, *New Negro Politics in the Jim Crow South* (University of Georgia Press, 2016). In both "Characteristics" (1934) and *Mules and Men* (Lippincott, 1935), Hurston foregrounds her contention that Black southern folklore "is not a thing of the past" but indeed is "still in the making," both by stating it boldly and by allowing her informants (such as the storyteller George Thomas) to speak it directly to readers. In this way, she contradicts Franz Boas's foreword to *Mules*, where he explains that the book "draws the reader into the orbit of loss and value that animates the collectionist project." See Brian Carr and Tova Cooper, "Zora Neale Hurston and Modernism at the Critical Limit," *Modern Fiction Studies* 48, no. 2 (Summer 2002): 295–96. See also Zora Neale Hurston, *Jonah's Gourd Vine: A Novel* (HarperPerennial, 1934).

39. Mary Helen Washington, foreword to *Their Eyes Were Watching God* (Perennial Classics, 1998), xv.
40. Autumn Womack, *The Matter of Black Living* (Chicago University Press, 2022), 208, 184.
41. Hurston begins her study of Haitian-influenced transcorporeal religion in New Orleans, which she understands to be the "hoodoo capital of America," with "great names in rites that vie with those of Hayti in deeds that keep alive the powers of Africa" (*Mules and Men*, 176). As Hurston explains in "Hoodoo in America," New Orleanian Hoodoo and Haitian Vodou are intimately linked—a link that extends back to the Haitian Revolution; see Zora Neale Hurston, "Hoodoo in America," *Journal of American Folklore* 44, no. 174 (1931): 317–417.
42. Hurston, *Tell My Horse*, in *Hurston: Folklore*, 284. Originally published by Lippincott, 1938.
43. Hurston, *Tell My Horse*, 298, 289.
44. Owens, *Turn the World Upside Down*, 90.
45. Hurston, *Tell My Horse*, 479.
46. Hurston, *Hurston: Folklore*, 376.
47. Owens, *Turn the World Upside Down*, 91.
48. Magloire, *We Pursue Our Magic*, 3.
49. Katherine Dunham, *Island Possessed* (University of Chicago Press, 1994), 61.
50. Hurston, *Tell My Horse*, 376.
51. Daphne Lamothe, *Inventing the New Negro: Narrative, Culture, and Ethnography* (University of Pennsylvania Press, 2008), 147–48.
52. Lamothe, *Inventing the New Negro*, 143–44, 148. As Lamothe writes, responses to the text's dissonance range from aversion in the case of Hazel Carby's charge of Hurston's ethnographic imperialism, to Ishmael Reed's "selective listening" in which he focuses almost exclusively on "the narrative's contributions to scholarship on Vodou and New World Black cultures" to "the imposition of 'sonic' uniformity," with an example being "Rachel Stein and Kevin Meehan's tracing of Hurston's feminist politics as a unifying theme throughout the text's disparate parts."
53. Lamothe, *Inventing the New Negro*, 147–48.
54. Strongman, *Queering Black Atlantic Religions*, 3.
55. Owens, *Turn the World Upside Down*, 66. As Owens notes, this law was passed "even as Vodou-inspired folkloric forms were ushered onto the national stage as symbols of Haitian identity," illustrating Édouard Glissant's warnings about folklorization.
56. Hurston spends a great deal of time probing Black religious practices in the US South, and in her writings she increasingly focuses on how they intersect with Black womanhood. While *Mules and Men* reveals that Hurston is deeply impressed by figures such as the Hoodoo doctor Kitty Brown and Mother Catherine, their performances of religious worship and ritual meet their limits as portals to Black women's full inclusion into mythmaking. The Hoodoo that Hurston presents in *Mules* operates within a frame in which, as Alice Gambrell notes in *Women Intellectuals, Modernism, and Difference*, it "more often than not . . . reinforce[s] extremely conventional erotic plots," and it "restores order" rather than raising questions thorough its adherence to a "tightly circumscribed

domestic ideal" (122). Hurston also encounters gender-based domestic ideals during her international fieldwork, but her engagement with Haitian Vodou provides an encounter with a cosmology strange enough to pierce the frames governing her gendered imagination and shift her into her fullest space of storytelling authority, as is partly evident in the shift in her ethnographic author's voice.

57. Hurston, *Hurston: Folklore*, 208, 700.
58. Édouard Glissant, *Poetics of Relation*, trans. Betsy Wing (University of Michigan Press, 1997), 189–90.
59. Hurston, *Hurston: Folklore*, 711; Barbara Ladd, *Resisting History: Gender, Modernity, and Authorship in William Faulkner, Zora Neale Hurston, and Eudora Welty* (Louisiana State University Press, 2012), 111.
60. Carla Kaplan, *Zora Neale Hurston: A Life in Letters* (Doubleday, 2002), 389–40.
61. In a letter to Henry Allen Moe dated August 26, 1937, Hurston informs Moe that she plans on writing two books using her Haitian material: "one for anthro. And one for the way *I* want to write it." See Kaplan, *Zora Neale Hurston*, 404. This extends my observation on Hurston's embrace of opacity. Dixie on her tongue perhaps continues at play. Like the informants who "sit" something outside their door for outsiders to toy with, the author plans a version written for anthropologists while protecting the ability to write a version more compelling for her away from the consumptive dictates she must meet. Yet, even if the version ultimately published is the one she planned for anthropologists, a shift can still be discerned between *Mules* and *Tell My Horse*. *Mules* is also a book for anthropology, and though innovative, she takes great pains to explain and authenticate it in a way less evident in *Tell My Horse*.
62. Hurston, *Hurston: Folklore*, 9, 411–12.
63. Katherine Dunham, *A Touch of Innocence* (Harcourt Brace Jovanovich, 1959), 177–79, 197, 49–50, 179, 178–79.
64. Dunham *A Touch of Innocence*, 210. Dunham writes that during this period she develops "a great interest in imagining the interior lives of people" and that she begins to think of her oppressions in terms of abyss: "if all of life and all relationships were like the Dunhams', then she had been born into an ice age or into a black abyss with only more blackness beyond each door which was opened at so much effort and cost."
65. For more on Dunham's early views on the potentials of Black dance and the dance world's stereotyped ideas on Black dancers, see Das's discussion on Dunham's Rosenwald application and Rosenwald committee members' response in *Katherine Dunham*, 32–33. See also David F. Garcia, *Listening for Africa: Freedom, Modernity, and the Logic of Black Music's African Origins* (Duke University Press, 2017), 176.
66. Das, *Katherine Dunham*, 23.
67. Valerie Linson, "Interview of Carmencita Romero by Valerie Linson," Hatch Billops Collection, New York, 1999, 157.
68. Frederick L. Orme, "The Negro in the Dance, as Katherine Dunham Sees Him," in *Kaiso! Writings by and About Katherine Dunham*, ed. VèVè A. Clark and Sara E. Johnson (University of Wisconsin Press, 2005), 192.
69. Susan Manning, "Watching Dunham's Dances, 1937–1945," in *Kaiso!*, 259.

70. John Martin, "The Dance: Dunham," *New York Times*, November 17, 1946, 81.
71. David F. Garcia, *Listening for Africa: Freedom, Modernity, and the Logic of Black Music's African Origins* (Duke University Press, 2017), 191.
72. Das, *Katherine Dunham*, 24, 55. From Robert Redfield, ca. 1939, Rosenwald Fund Application, box 409, folder 10, Julius Rosenwald Papers, Special Collections, Fisk University Franklin Library, Nashville, Tennessee. For more on Redfield, see Q. E. Castañeda, "Stocking's Historiography of Influence: The 'Story of Boas,' Gamio and Redfield at the Cross-'Road to Light,'" *Critique of Anthropology* 23, no. 3 (2003): 235–63.
73. Dunham, *Island Possessed*, 4.
74. Sascha Morrell, "'There Is No Female Word for Busha in These Parts': Zora Neale Hurston, Katherine Dunham and Women's Experience in 1930s Haiti and Jamaica," *Australian Humanities Review* 64 (2019): 169–70. As Morrell notes, both Hurston and Dunham are guilty of contradicting their stances on women's subjection in their invasive uses of the camera lens: "Hurston notes she 'had permission of Dr. Léon to take some pictures,' but Felix-Mentor herself could not and clearly did not consent. It seems the crime contains its own punishment, however, for the 'dreadful' revelation 'was too much to endure for long.'" Still, it did not stop her from publishing the now-famous "zombie" snapshot in *Tell My Horse* for her North American audience to gape at. In *Island Possessed*, Dunham likewise describes photographing her female "zombies" without consent. Although aware that her camera could be obtrusive (see Dunham, *Island Possessed*, 210, 218), she planned ahead to "take a photograph or two if I were clever" on visiting 'ti Couzin's compound, asking her companion Fred Alsop to "cover for me if I could find an occasion to photograph the wives." She was successful in obtaining this surreptitious souvenir of domestic oppression, she reports, "and somewhere in my archives is a photograph of a lone woman with others behind her in ghostly attendance."
75. Das, *Katherine Dunham*, 46–47.
76. Dunham, *Island Possessed*, 61.
77. Katherine Dunham, *Dances of Haiti* (Center for Afro-American Studies, University of California, 1983), 73.
78. Gambrell, *Women Intellectuals*, 104–5.
79. Dunham, *Island Possessed*, 127, 108. During the last step of the *lave-tête*, when the initiates leave the houngfor and join the community gathered outside, Dunham "thought of the imminent entrance of the gods, wondered what sort of spectacle I would make of myself if by chance possessed, what would be thought of me if I weren't. Then I decided to let happen what would, not to fear my divinity but not to seek him falsely. Each hypocritical move or act is not only immediately discerned but severely frowned on by the priests of the vadun" (127).
80. Dunham, *Island Possessed*, 129; Dunham, *Dances of Haiti*, 62, 61.
81. Dunham, *Island Possessed*, 135.
82. Dunham, *Island Possessed*, 136. Damballa makes his appearance immediately following the performance of the yonvalou, and it is in Dunham's description of this moment that her movement into trance and possession appears to be confirmed. A man possessed by the loa slides up to Dunham, and despite attempting to leave the vicinity, she becomes

included in a ritual sacrifice of a chicken to Damballa. She shares, "In the tumult of drumming, singing, and exulting I found a way to push through the crowd to Doc and Cécile. I have never fainted in my entire life, that I know of, but I have no memory of leaving the houngfor, of kneeling before my baptized drums, of saluting my co-initiates and the two mambos and La place, then being violently sick to my stomach at Cécile's place before going to bed between her cool, white, pink-embroidered hope-chest sheets. This is the way doc tells it, or told it to me the next day." Here, Dunham's complete lack of recall suggests that she experiences trance possession.

83. Das, *Katherine Dunham*, 52–53. Although Dunham began conceiving the ballet in Haiti, *Christophe* was never staged. As Das notes, Dunham considered collaborating with Paul Robeson and "spent three years developing the project, even sending a detailed outline to Langston Hughes in 1938, but ultimately she faced insurmountable difficulties."
84. Das, *Katherine Dunham*, 28.
85. *Kaiso!*, 117, 100.
86. Stephanie L. Batiste, *Darkening Mirrors: Imperial Representation in Depression-Era African American Performance* (Duke University Press, 2011), 190.
87. VèVè A. Clark, "Performing the Memory of Difference in Afro-Caribbean Dance: Katherine Dunham's Choreography, 1938–1987," in *Kaiso!*, 195.
88. Katherine Dunham, "Dunham the Woman," in *Kaiso!*, 224–25.
89. As Dunham explains in her 1951 program notes, she is deeply connected to the racial violence occurring in the United States. Although, as she notes, the commentary presented is not occurring in all of America or even all of the South, and although she has "not smelled the smell of burning flesh, and ha[s] never seen a black body swaying from a southern tree," these violent scenes have a direct impact on her spirit and personal experience. "Southland," Series 3, Subseries 1, box 49, folder 7, Katherine Dunham Papers, Special Collections Research Center, Southern Illinois University Carbondale, 1–2.
90. Dunham's success with *Tropics* and "Le Jazz Hot!" opens the door both to a robust touring schedule and to encounters with national and international racism. As Dunham endures encounters with segregation, she confronts the perpetrators. In 1944, wearing a Colored Only sign pinned to her backside, she informs a segregated house at Memorial Auditorium in Louisville, Kentucky, that she will not return to perform there until Black people can freely choose seats anywhere in the theater. These encounters are not limited to the US South: Local Boston newspapers banded together to campaign against her *Tropical Review* show, also in 1944, and were successful in having her "Rites de Passage"—a section that Ramsay Burt considers the most serious piece in the review—"censored for being 'outrageously objectionable.'" See Ramsay Burt, "Katherine Dunham's Floating Island of Negritude," in *Rethinking Dance History*, ed. Alexandra Carter et al. (Routledge, 2013), 97. And when Dunham is refused a room at Hotel Esplanada in Brazil in 1950 because of her race, she is met with a situation common to Black Brazilians at the time. Using her stature as a US performer to draw attention to the situation, Dunham threatens the hotel with a lawsuit, and this threat prompts the passing of the Afonso Arinos Law making racial discrimination in public accommodations illegal. In these instances, Dunham turns the Black woman moving-body-as-primitive-spectacle trope on its head.

For more, see the website for the Missouri Historical Society "Katherine Dunham's Living Legacy" exhibit (and Dunham's interview with Jacob's Pillow) at https://mohistory.org/legacy-exhibits/KatherineDunham/global_activist.htm; and Jerry Dávila, "Defining and Denouncing Racial Discrimination in Brazil: The Debate Surrounding the Katherine Dunham Case," presentation as part of *The Politics of Race, Art, and Performance in 20th-Century Latin America*, American Historical Association, Session 264, January 7, 2017, https://aha.confex.com/aha/2017/webprogram/Paper20947.html. See also Julia L. Foulkes, "Ambassadors with Hips: Katherine Dunham, Pearl Primus, and the Allure of Africa in the Black Arts Movement," in *Impossible to Hold: Women and Culture in the 1960s*, ed. Avital Bloch and Lauri Umansky (New York University Press, 2005).

2. ON DYNAMIC SUGGESTION: HURSTON AND McINTYRE

1. Notably, Dianne McIntyre choreographed this scene for the film adaptation of *Beloved* in 1998.
2. Toni Morrison, *Beloved* (Vintage, 2004), 161, 102.
3. Zora Neale Hurston, *Their Eyes Were Watching God*, in *Zora Neale Hurston: Novels and Stories*, ed. Cheryl Wall (Library of America, 1995), 186–187.
4. Patricia J. Saunders, "Fugitive Dreams of Diaspora: Conversations with Saidiya Hartman," *Anthurium: A Caribbean Studies Journal* 6, no. 1 (2008): 5.
5. Zora Neale Hurston, "Characteristics of Negro Expression," in *Hurston: Folklore, Memoirs, and Other Writings*, ed. Cheryl Wall (Library of America, 1995), 836. Originally published in *Negro: An Anthology*, ed. Nancy Cunard (Hours Press, 1934).
6. Édouard Glissant, "Theatre, Consciousness of the People," *Acoma*, no. 2 (1971): 41–59.
7. Édouard Glissant, *Caribbean Discourse* (University of Virginia Press, 1989), 204.
8. Hurston, "Characteristics of Negro Expression," 836.
9. Glissant, *Caribbean Discourse*, 217. Glissant writes that "such a theater . . . offers an internal capacity to challenge and refute."
10. Mary Helen Washington, foreword to *Their Eyes Were Watching God* (Perennial Classics, 1998), xv.
11. Achille Mbembe, "The Power of the Archive and Its Limits," in *Refiguring the Archive*, ed. Carolyn Hamilton et al. (Kluwer Academic, 2002), 20.
12. Mbembe, "The Power of the Archive," 19; Saidiya Hartman, *Lose Your Mother: A Journey Along the Atlantic Slave Route* (Farrar, Straus and Giroux, 2007), 17.
13. Diana Taylor, *The Archive and the Repertoire* (Duke University Press, 2003), 28.
14. In *The Archive and the Repertoire*, Diana Taylor notes that the repertoire, which enacts embodied memory, includes "performances, gestures, orality, movement, dance, singing—in short, all those acts usually thought of as ephemeral, nonreproducible knowledge," while the archive is composed of "supposedly enduring materials"; it "exists as documents, maps, literary texts, letters, archaeological remains, bones, videos, films, CDs, all those items supposedly resistant to change," 20, 19.
15. Quoted in Saunders, "Fugitive Dreams," 5.

16. Richard Schechner, *Between Theater and Anthropology* (University of Pennsylvania Press, 1985), 25, 22, 23.
17. Rebecca Schneider, "Performance Remains" in *Perform, Repeat, Record: Live Art in History*, ed. Amelia Jones and Adrian Heathfield (Intellect, 2012), 138; Peggy Phelan, *Unmarked: The Politics of Performance* (Routledge, 1993), 146. Phelan argues: "Performance's only life is in the present. Performance cannot be saved, recorded, documented, or otherwise participate in the circulation of representations *of* representations. . . . Performance's being . . . becomes itself through disappearance," 146.
18. Dorota Sajewska and Dorota Sosnowska, "Blackness as Medium: Body in Contemporary Theatre Practice and Theory," *Theatralia* 19, no. 2 (2016): 92.
19. Taylor, *The Archive and the Repertoire*, 16.
20. Soyica Diggs Colbert, *Black Movements: Performance and Cultural Politics* (Rutgers University Press, 2017), 4.
21. Soyica Diggs Colbert, *The African American Theatrical Body: Reception, Performance, and the Stage* (Cambridge University Press, 2011), 36.
22. Taylor, *The Archive and the Repertoire*, 36; Diggs Colbert, *The African American Theatrical Body*, 4.
23. Hurston to Langston Hughes, April 12, 1928, in Carla Kaplan, *Zora Neale Hurston: A Life in Letters* (Doubleday, 2002), 116.
24. Shirley Moody-Turner, *Black Folklore and the Politics of Racial Representation* (University Press of Mississippi, 2013), 24.
25. Hurston to Langston Hughes, April 12, 1928, in Kaplan, *Zora Neale Hurston*, 116.
26. Hurston to Alain Locke, in Kaplan, *Zora Neale Hurston*, 56. Though no evidence has surfaced suggesting that the theater company she references came to fruition, in 1925 Hurston informs Locke that "a new (I suppose it ought to be written in capitals) New Negro play company is about to be born with your humble servant as Chief mid-wife," 56.
27. Thomas F. DeFrantz and Anita Gonzalez, eds., *Black Performance Theory* (Duke University Press, 2014), 2.
28. Deborah Plant, *Every Tub Must Sit on Its Own Bottom: The Politics and Philosophy of Zora Neale Hurston* (University of Illinois Press, 1995), 73.
29. Valerie Boyd, *Wrapped in Rainbows: The Life of Zora Neale Hurston* (Simon and Schuster, 2004), 117.
30. Boyd, *Wrapped in Rainbows*, 118; Kaplan, *Zora Neale Hurston*, 87.
31. Jean Lee Cole and Charles Mitchell, eds., *Zora Neale Hurston: Collected Plays* (Rutgers University Press, 2008), xviii.
32. W. E. B. Du Bois, "Krigwa Players Little Negro Theatre: The Story of a Little Theatre Movement," *Crisis* 32, no. 3 (1926): 134–36, 134.
33. W. E. B. Du Bois, "The Colored Audience," *Crisis* 12, no. 5 (1916): 217.
34. Hurston to Langston Hughes, April 12, 1928, in Kaplan, *Zora Neale Hurston*, 116.
35. Zora Neale Hurston, *Dust Tracks on a Road*, in *Hurston: Folklore*, 714.
36. Boyd, *Wrapped in Rainbows*, 228, 230.
37. Mbembe, "The Power of the Archive," 19–21.
38. Hurston to Hughes, April 12, 1928, in Kaplan, *Zora Neale Hurston*, 115.

224 2. ON DYNAMIC SUGGESTION

39. In May of 1928, Hurston writes to Locke critiquing the "misinformed" work of Howard W. Odum and Gary B. Johnson in their 1926 publication *The Negro and His Songs*. She issues similar complaints in several letters. See Kaplan, *Zora Neale Hurston*, 118.
40. Hurston to Locke, May 10, 1928, in Kaplan, *Zora Neale Hurston*, 120.
41. Hurston to Hughes, April 12, 1928, in Kaplan, *Zora Neale Hurston*, 116.
42. Hurston to Hughes, July 10, 1928, in Kaplan, *Zora Neale Hurston*, 121–22.
43. Hurston to Hughes, April 12, 1928, in Kaplan, *Zora Neale Hurston*, 116.
44. In addition to her frustrations discussed here, it is also important to note Hurston's illegibility as a choreographer. As Aimee Meredith Cox notes in *Shapeshifters*, "Hurston's positionally as a Black woman in that time and the collaborative nature of her engagement with the dancers meant that her creative work contradicted the assumed under lying masculinist and racist under pinnings of notions of who a choreographer could be. Within the dichotomies of authorship versus collaboration, choreography versus improvisation, creative artistry versus natural expression, and the known versus the unknown, Hurston's work was perceived to be in alignment with the latter aspect of each binary. Because of this, her creative labor and artistic innovation were denied." Aimee Meredith Cox, *Shapeshifters: Black Girls and the Choreography of Citizenship* (Duke University Press, 2015), 248.
45. DeFrantz and Gonzalez, *Black Performance Theory*, 2.
46. Hurston, "Characteristics," 843, 841, 845.
47. DeFrantz and Gonzalez, *Black Performance Theory*, 2.
48. Édouard Glissant, "Theater, Consciousness of the People," in *Caribbean Discourse* (University of Virginia Press, 1989), 196–97.
49. Hurston "Characteristics," 835–37, 845, 843.
50. Hurston "Characteristics," 844, 835.
51. Kaplan, *Zora Neale Hurston*, 116.
52. Diggs Colbert, *The African American Theatrical Body*, 4.
53. Stetson Kennedy et al., "Halimuhfack," recorded on sound disc in Jacksonville, Florida, 1939, https://www.loc.gov/item/flwpa000014/.
54. Diggs Colbert, *The African American Theatrical Body*, 4.
55. Hurston, "Characteristics," 831; DeFrantz and Gonzalez, *Black Performance*, 10.
56. DeFrantz and Gonzalez, *Black Performance*, 10.
57. Hurston, "Characteristics," 830.
58. Hurston, *Their Eyes Were Watching God*, 186.
59. Hurston, *Their Were Watching God*, 280, 284, 294.
60. Hurston, *Their Eyes Were Watching God*, 175, 179, 332. In what is arguably her most sustained meditation on gender-related issues, Hurston opens *Their Eyes* with a statement that immediately suggests differences in the approach to memory, desire, and lived experiences. Although she initially presents these ideas in terms of men and women, it quickly becomes clear that these differences also illustrate responses to race- and class-based oppression and powerlessness. Taken this way, the ships at a distance that taunt men and women's selective remembering are all responses to very real oppression. This oppression robs the men and women of their humanity during the working day, making them "tongueless, earless, eyeless conveniences" for others. As their response to the

recently returned Janie illustrates, this daily ongoing violent subjection makes them susceptible to feeling a false power in the absence of those representing the power structure. They bond in envious judgment over someone who has openly rejected the hierarchy that keeps their humanity thus confined. Janie tells Pheoby: "Ah don't mean to bother wid tellin' 'em nothin', Pheoby. Tain't worth de trouble. You can tell 'em what Ah say if you wants to. Dat's just de same as me 'cause mah tongue is in mah friend's mouf."

61. Taylor, *The Archive and the Repertoire*, 15.
62. Hurston, *Their Eyes Were Watching God*, 175, 177.
63. Carla Kaplan, *The Erotics of Talk: Women's Writing and Feminist Paradigms* (Oxford University Press, 1993), 115.
64. Washington, foreword to *Their Eyes* (1998), xiii–xiv.
65. Kaplan, *The Erotics of Talk*, 107, 180, 332.
66. For more on the novel's publication history, see Neal A. Lester, *Understanding Zora Neale Hurston's* Their Eyes Were Watching God: *A Student Casebook to Issues, Sources, and Historical Documents* (Greenwood, 1999.); Washington, foreword to *Their Eyes* (1998), xi.
67. Ann duCille, "The Mark of Zora: Reading Between the Lines of Legend and Legacy," *Scholar and Feminist Online* 3, no. 2 (2005): 3.
68. Washington, foreword to *Their Eyes* (1998), xiv, xi–xii.
69. Kaplan, *The Erotics of Talk*, 116.
70. Isabel Wilkerson, *The Warmth of Other Suns: The Epic Story of America's Great Migration* (Vintage Penguin Random House, 2010), 260.
71. Author's interview with Dianne McIntyre, Skype, February 9, 2022.
72. McIntyre interview. In 2002, while in D.C. working with Arena Stage on Hurston's *Polk County*, McIntyre was invited to listen to and view recordings of Hurston housed in the Library of Congress. As McIntyre recalls, it was eye opening to see and hear Hurston. The choreographer found Hurston's sound particularly surprising, as it was "familiar," laid-back, and "not what you'd think from her writing or what we read about her."
73. Veta Goler, "'Moves on Top of Blues': Dianne McIntyre's Blues Aesthetic," in *Dancing Many Drums: Excavations in African American Dance*, ed. Thomas F. Defrantz (University of Wisconsin Press, 2001), 207.
74. Susan Leigh Foster, "Muscle/Memories: How Germaine Acogny and Diane McIntyre Put Their Feet Down," in *Rhythms of the Afro-Atlantic World*, ed. Mamadou Diouf and Ifeoma C. K. Nwankwo (University of Michigan Press, 2013), 129–30.
75. Marcia Siegel, *SoHo Weekly News*, 1976, 25; Danielle Goldman, "Sound Gestures: Posing Questions for Music and Dance," *Women and Performance* 17, no. 2 (2007): 123–24.
76. Goldman, "Sound Gestures," 123–24.
77. McIntyre interview.
78. In *Culture-Bearing Women: The Black Women Renaissance and Cultural Nationalism* (De Gruyter, 2019), Izabella Penier discusses "two apparently parallel phenomena taking place at the end of the 20th century: the Black Women's Renaissance . . . of the United States and the 'literary blossoming' . . . of Caribbean female fiction." As she explains, these expressive movements "came to fruition in the aftermath of the civil rights and feminist struggles of black people in the US and across the entire postcolonial world" (1).

79. Toni Morrison, "The Site of Memory," in *The Source of Self-Regard: Selected Essays, Speeches, and Meditations* (Knopf, 2019), 237.
80. McIntyre interview.
81. William J. Harris, "How You Sound: Amiri Baraka Writes Free Jazz," in *Uptown Conversation: The New Jazz Studies*, ed. Robert G. O'Meally et al. (Columbia University Press, 2004), 312–13. As McIntyre shares in an interview published in *Time Out New York* in 2012, "I really had planned that I would go to New York and then come back to the Midwest and start my own company. What happened though was that I became so connected with music, which at that time was called new jazz or avant-garde jazz or new music, free jazz. It had a feeling of that time in the Black Arts Movement. Many of us artists who were black, in whatever our particular field, we had a consciousness about what our work was saying for the moving forward of the consciousness about our race and our place in the society. That was in the air, and this music said that to me." See "Dianne McIntyre Talks About Her Love Affair with Modern Dance," *Time Out New York*, August 19, 2012, www.timeout.com/newyork/dance/dianne-mcintyre-talks-about-her-love-affair-with-modern-dance.
82. Goldman, "Sound Gestures," 126.
83. "Dianne McIntyre Talks."
84. Goldman, "Sound Gestures."
85. Dianne McIntyre et al., "Street Dance Activism Global Dance Meditation for Black Liberation Radical Embodied Dialogue August 19, 2020, Recorded over Zoom," *Dance Research Journal* 53, no. 2 (2021): 154.
86. McIntyre interview.
87. Goldman, "Sound Gestures," 127–28.
88. As Goler notes, McIntyre is regarded as a "'musician's dancer' by her musician colleagues because of her musical sensitivity and knowledge. Goler, "'Moves on Top of Blues,'" 209.
89. Alex Abramovich, "Face to Face with Olu Dara (Unabridged): Highlights from Issue 34: Jazz," *Stopsmiling*, March 14, 2008, www.stopsmilingonline.com/story_detail.php?id=1003.
90. Hurston, *Their Eyes Were Watching God*, 332; Tracie Morris, "Olu Dara," *Bomb* 62 (Winter 1998), https://bombmagazine.org/articles/1998/01/01/olu-dara/.
91. McIntyre interview; Daniel Cooper, "Olu Dara," *Oxford American*, 21/22 (Summer 1998), https://oxfordamerican.org/magazine/issue-21-22-summer-1998/olu-dara.
92. Morris, "Olu Dara."
93. Cooper, "Olu Dara."
94. Morris, "Olu Dara."
95. Claudia La Rocco, "Telling Stories in Many Shades of Delta Blue," *New York Times*, May 25, 2008, www.nytimes.com/2008/05/25/arts/dance/25laro.html. Here, the former McIntyre student Jawole Willa Jo Zollar explains why McIntyre has not "received as much acclaim as other dance artists who were experimenting in New York during the 1970s, despite her singularity as a black woman honing a distinct choreographic voice." Zollar and Claudia La Rocco recognize the role that race and McIntyre's approach as "a storyteller at a time when cool abstraction was de rigueur for experimenters" played in this predicament.
96. Goler, "'Moves on Top of Blues,'" 206.

97. Taylor, *The Archive and the Repertoire*, 29, 20–21, 33.
98. This texture resembles the chorus, as Saidiya Hartman may say, or, following Diana Taylor, the expansive, collectively crafted dynamic scenario. See Saidiya Hartman, *Wayward Lives, Beautiful Experiments: Intimate Histories of Social Upheaval* (Norton, 2019), 347–48; Taylor, *The Archive and the Repertoire*, 16–17.
99. Henry Louis Gates, *The Signifying Monkey: A Theory of Afro-American Literary Criticism* (Oxford University Press, 1988), 203.
100. McIntyre interview.
101. Taylor, *The Archive and the Repertoire*, 32.

3. ON UNINCORPORABLE STRANGE SOUND: CONDÉ AND SHANGE

1. Harmony Holiday, "Abbey Lincoln's Scream: Poetic Improvisation as a Way of Life," *Poetry Foundation* (blog), October 26, 2016, 1, https://www.poetryfoundation.org/featured-blogger/76012/abbey-lincolns-scream-poetic-improvisation-as-a-way-of-life.
2. Holiday, "Abbey Lincoln's Scream," 4–5.
3. Danielle Goldman, "Sound Gestures: Posing Questions for Music and Dance," *Women and Performance* 17, no. 2 (2007): 130.
4. Abbey Lincoln interviewed by Charlie Rose, June 10, 1993, https://charlierose.com/videos/14990; Goldman, "Sound Gestures," 129, 133.
5. Holiday, "Abbey Lincoln's Scream," 2.
6. Goldman, "Sound Gestures," 133.
7. Ntozake Shange, *lost in language & sound: or how i found my way to the arts* (St. Martin's, 2011), 15, 36, 30, 29.
8. Édouard Glissant, *Poetics of Relation*, trans. Betsy Wing (University of Michigan Press, 1997), 6. Glissant identifies the three abysses as the belly of the boat (a womb abyss that "dissolves you, precipitates you into a nonworld from which you cry out"), the depths of the sea into which Africans were tossed overboard to lighten the boat, and the projection of "a reverse image of all that had been left behind," accessible only in the increasingly threadbare memory or imagination (6–7). This book defines the womb abyss as a silencing, autopoietic frame that inscribes Black women with a primitivity based on the Middle Passage and the plantation. This frame positions Black women for silencing and extraction.
9. Farah Jasmine Griffin, "When Malindy Sings," in *Uptown Conversation: The New Jazz Studies*, ed. Robert O'Meally, Brent Hayes Edwards, and Farah Jasmine Griffin (Columbia University Press, 2004), 110–11. Additionally, as Deborah McDowell reminds us, "as autobiography, the slave narratives are primarily expressions of male subjectivity, and, as history, they are narratives of his-story." Deborah McDowell, "Witnessing Slavery after Freedom—*Dessa Rose*," in *Slavery and the Literary Imagination*, ed. Deborah E. McDowell and Arnold Rampersad (Johns Hopkins University Press, 1989), 146.
10. Jayna Brown, "Black Sonic Refusal," in *The Female Voice in the Twentieth Century: Material, Symbolic and Aesthetic Dimensions*, ed. Serena Facci and Michela Garda (Routledge, 2021), 103. For further reading on the sonic implications of Douglass's representation of

Aunt Hester's audible pain, see Saidiya Hartman, *Scenes of Subjection: Terror, Slavery, and Self-Making in Nineteenth-Century America* (Oxford University Press, 1997); Fred Moten, *In the Break: The Aesthetics of the Black Radical Tradition* (University of Minnesota Press, 2003); Meina Yates-Richard, "'What Is Your Mother's Name?' Maternal Disavowal and Reverberating Aesthetic of Black Women's Pain in Black Nationalist Literature," *American Literature* 88, no. 3 (2016): 477–507; and Daphne Brooks, *Liner Notes for the Revolution: The Intellectual Life of Black Feminist Sound* (Harvard University Press, 2021). For more on the national and international contemporary expectations of Black women's sonic production (and the ways that Black women disrupt or resist these expectations), see Shana Redmond, *Anthem: Social Movements and the Sound of Solidarity in the African Diaspora* (New York University Press, 2014); and Griffin, "When Malindy Sings." Griffin focuses particularly on how southern Black women's sound is used.

11. As Griffin explains, "There is the emphasis on the meaning conveyed in the sound and on the sound as more representative of the people's condition than words in a book. And yet the only access we have to the sound is his [Douglass's] written effort to describe it." See Griffin, "When Malindy Sings," 110.
12. Yates-Richard, "'What Is Your Mother's Name?,'" 482.
13. Roland Barthes, *The Grain of the Voice: Interviews 1962–1980*, ed. and trans. Linda Coverdale (Northwestern University Press, 2009), 181, 188. I agree with Jayna Brown's observation that uncritically applying Barthes's grain as a prelanguage utterance to an analysis of Black sound "would capitulate a racial politics that relegates black personhood to a pre-civilised status." See Brown, "Black Sonic Refusal," 108. My analysis of the grain here follows her suggestion that Black subjects' relationship to sound and language be considered "as not pre-linguistic expression, but as *anti*-linguistic," a stance taken up in Condé and Shange's desire to break language.
14. Moten, *In the Break*, 53.
15. Kamau Brathwaite, "History of the Voice," in *Roots* (University of Michigan Press, 1993), 271, 273.
16. Abbey Lincoln, "NEA Jazz Master," interview by Sally Plaxon, *Smithsonian Online Virtual Archives*, December 17–18, 1996, 31, https://mads.si.edu/mads/id/NMAH-AC0808_Lincoln_Abbey_Transcript.
17. Maryse Condé, "Order, Disorder, Freedom, and the West Indian Writer," *Yale French Studies* 83, no. 2 (1993): 122. The journals *La Trouée* (political) and *La Revue Indigène* (literary) both emerged from the Haitian Indigenisme Movement, which was largely a rejection of the United States's occupation and its impact.
18. Aimé Césaire, *Return to My Native Land*, trans. Emile Snyder (Présence Africaine, 1968); Aimé Césaire, *The Collected Poetry*, trans. Clayton Eshelman and Annette Smith (University of California Press, 1982), 61.
19. Condé, "Order, Disorder," 125.
20. Michelle Wright, "The Problem of Return in the African Diaspora," in *Physics of Blackness: Beyond the Middle Passage Epistemology* (University of Minnesota Press, 2015), 92.
21. For more on the implications of these stubborn classifications in both colonial-era and contemporary visual art, see Alissandra Cummins and Allison Thompson, "The

Unnamed Body: Encountering, Commodifying, and Codifying the Image of the Black Female," *Nka: Journal of Contemporary African Art* 38–39 (2016): 110–20.
22. Wright, *Physics of Blackness*, 92.
23. Brooks, *Liner Notes*, 31. In "A Great Rhetorician of Erotic Figures," part of *The Grain of the Voice*, Roland Barthes notes that in order for an author to create a language, they "must take semantic units and establish a combinative, a syntax," and this "system of units of figures" should be represented by their entire oeuvre (256).
24. Unlike Aunt Hester's heavily mediated scream (which we rely on Douglass to experience), Fred Moten suggests that Billie Holiday's "grained" voice is able to resist, despite efforts to repress it. He writes that through her grained sound and the echo it continues to send out, "she resists such [literary] interpretation, is constantly reversing and interrupting such analytic situations, offering and taking back that mastery, finally reaching radically around it," thereby resisting attempts to "domesticate or explain" or even make "strange" her grained voice. See Moten, *In the Break*, 104. Because her sound has been so deeply located within herself and issues from her body, these efforts to domesticate or co-opt her sound fail, and "the violence she does to words when singing is duplicated in her writing" (105). My notion of the "strange" sound that Condé and Shange develop is partially indebted to Moten's thinking, and in part it speaks to the centuries-long history of the Black voice being marked as strange or peculiar by European and White American observers; see Griffin, "When Malindy Sings," and Eileen Southern, *The Music of Black Americans: A History*, 3rd ed. (Norton, 1997). I argue that authors such as Condé and Shange find power in cultivating their own strange sounds as opposed to guarding against estrangement as a result of them.
25. Brathwaite, "History of the Voice," 261–62.
26. Regina Bradley, "Sounding the South/Souf," *Southern Cultures* 27, no. 4 (2021): 8–9; Brathwaite, "History of the Voice," 266.
27. Brooks, *Liner Notes*, 4. In *Caribbean Discourse*, Édouard Glissant discusses how noise, or what could also be considered strange sound, enabled enslaved Africans to maintain opacity in their communications: "From the outset (that is from the moment Creole is forged as a medium of communication between slave and master), the spoken imposes on the slave its particular syntax. For Caribbean man, the word is first and foremost sound. Noise is essential to speech. . . . Since speech was forbidden, slaves camouflaged the word under the provocative intensity of the scream. . . . This is how the dispossessed man organized his speech by weaving it into the apparently meaningless texture of extreme noise." Édouard Glissant, *Caribbean Discourse* (University of Virginia Press, 1989), 123–24.
28. Emily S. Apter and Maryse Condé, "Crossover Texts/Creole Tongues: A Conversation with Maryse Condé," *Public Culture* 13, no. 1 (2001): 95.
29. Condé, "Order, Disorder," 125.
30. Sékou Touré mentions this "no place" in his speech "The Political Leader as the Representative of a Culture" given at the 2nd Congress of Black Writers and Artists Rome, Italy, March–April 1959, and published as Sékou Touré, *The Political Leader Considered as the Presentative of a Culture* (Jihad, 1975). Cited in Condé, "Order, Disorder," 125, 123, 127, 128.
31. Condé, "Order, Disorder," 130–34, 143, 134.

32. Maryse Condé, *What Is Africa to Me? Fragments of a True-to-Life Autobiography*, trans. Richard Philcox (Seagull, 2016), 6.
33. Condé, *What is Africa to Me?*, 9, 8.
34. Tsitsi Jaji, *Africa in Stereo: Modernism, Music, and Pan-African Solidarity* (Oxford University Press, 2014), 73, 75, 78. Translation by Jaji.
35. Condé, *What Is Africa to Me?*, 192. While traversing the streets near the port of Marseille shortly before she and her son Denis depart for Bingerville, Ivory Coast, a pregnant Condé is buoyed by the feeling that geography places her "in touch with the writers of the Négritude movement."
36. Condé, *What Is Africa to Me?*, 27.
37. Francoise Pfaff, *Conversations with Maryse Condé* (University of Nebraska Press, 1996), 112. In her discussion with Pfaff, Condé notes: "Césaire and Senghor have not followed the same path. On the one hand, Senghor went back to Senegal and became president. His approach to Negritudé boiled down to dividing the world between French and African people. On the other hand, Césaire has never considered Negritudé from an ideological standpoint. For him Negritudé is a literary and poetic movement." Condé, *What Is Africa to Me?*, 27.
38. Condé, *What Is Africa to Me?*, 280, 51, 55, 35, 30.
39. Although the griot is often assumed to be male, critics such as Chiji Akoma and Chinosole argue convincingly that Condé's fiction can be read as a subversive modern extension of the tradition that provides room for voice and subjectivity for her female characters. See Chiji Akoma, "Griot with Attitude: Maryse Condé's *The Last of the African Kings* and New World Narrative Order," *Research in African Literatures* 38, no. 3 (2007): 114; and Chinosole, "Maryse Condé as Contemporary Griot in Segu," *Callaloo* 18, no. 3 (1995): 593–601.
40. Jaji, *Africa in Stereo*, 79. Translation by Jaji.
41. Here I refer to Tsitsi Jaji's translation of "Joal" from French, 80–81.
42. Condé, *What Is Africa to Me?*, 70–71, 67, 112, 92–94, 55.
43. Condé, *What Is Africa to Me?*, 55. It is notable that Condé does not comment on the patriarchal domination that the griot represents. Her silence on this topic may be a result of the tension arising around her privilege in encountering a strange South—perhaps this does not become immediately (or prominently at any point) apparent. Or perhaps more likely, it is the case that for Condé, the danger that silencing aesthetic rules pose is more pressing.
44. Condé, *What Is Africa to Me?*, 66.
45. Condé, *What Is Africa to Me?*, 209. During the same period that she begins to attract and reach audiences with her "strange" voice, her relationship shifts at the Institute of Languages—where she now recognizes her classes as an integral part of the "forum of ideas" that would later become a hallmark of the program. During this period, she composes an anthology for her students that includes the work of Césaire, Senghor, Pascal, Saint-John Perse, Rimbaud, Fanon, and the Bible. This anthology also represents a notable shift, as it represents Condé's new role as a framer of discussion, not a loyal follower or rejected interlocutor. It is also in this moment that she recalls receiving the first declaration of appreciation for her voice and ideas.

46. Condé, *What Is Africa to Me?*, 231.
47. Maryse Condé, *Heremakhonon: A Novel*, trans. Richard Philcox (Three Continents, 1982), 11, 65.
48. Pfaff, *Conversations with Maryse Condé*, 41. As Condé explains to Francoise Pfaff, "I used the character of Marilisse, whom I found in history. She was a Negro slave who lived with a White man and bore his children. Through her, I wanted to stress simultaneously Veronica's wish to be liberated and her submission." For Emily Sahakian, "the Marlisse and the Chestnut are examples of what sociologist Patricia Hill Collins has called the 'controlling images' of black womanhood—clichés of black women's roles and sexuality that originated under slavery and continue to regulate black female bodies to reinforce the status quo." See Emily Sahakian, *Staging Creolization: Women's Theater and Performance in the French Caribbean* (University of Virginia Press, 2017), 24.
49. Pfaff, *Conversations with Maryse Condé*, 41, 234.
50. Laurie Corbin, "The Voicing of Desire: The Quest for History in 'Heremakhonon' and 'The Women of Tijucopapo,'" *Callaloo* 35, no. 2 (2012): 426; Curdella Forbes, "Between Plot and Plantation, Trespass and Transgression: Caribbean Migratory Disobedience in Fiction and Internet Traffic," *Small Axe: A Caribbean Journal of Criticism* 16, no. 2 (2012): 35. For more, see Francois Lionnet, "Happiness Deferred: Maryse Condé's *Heremakhonon* and the Failure of Emancipation," in *Autobiographical Voices: Race, Gender, Self-Portraiture* (Cornell University Press, 1989), 23–42; Eva Sansavior, "Just a Case of Mistaken Ancestors? Dramatizing Modernisms in Maryse Condé's *Heremakhonon*," *Paragraph* 37, no. 2 (2014): 221–34; and H. Adlai Murdoch, "Divided Desire: Biculturality and the Representation of Identity in *En attendant le bonheur*," *Callaloo* 18, no. 3 (1995): 579–92.
51. Kevin Quashie, *The Sovereignty of Quiet: Beyond Resistance in Black Culture* (Rutgers University Press, 2012), 76–77.
52. Apter and Condé, "Crossover Texts/Creole Tongues," 96.
53. Shange, *lost in language & sound*, 19, 3, 52.
54. Quashie, *The Sovereignty of Quiet*, 159n11.
55. Ricky Vincent, *Party Music: The Inside Story of the Black Panthers' Band and How Black Power Transformed Soul Music* (Lawrence Hill, 2013), 15–16.
56. John Bracey, Sonia Sanchez, and James Smethurst, eds., *SOS—Calling All Black People: A Black Arts Movement Reader* (University of Massachusetts Press), 3–4, 2–3.
57. Shange, *lost in language & sound*, 57.
58. Ntozake Shange, *nappy edges* (St. Martin's, 1978), 22.
59. Amiri Baraka and Larry Neal, eds., *Black Fire: An Anthology of Afro-American Writing* (Black Classic, 2007), 647.
60. For more on approaches to the development of a Black interior during this period, see Margo Natalie Crawford, *Black Post-Blackness: The Black Arts Movement and Twenty-First-Century Aesthetics* (University of Illinois Press, 2017).
61. Cheryl Clarke, *"After Mecca": Women Poets and the Black Arts Movement* (Rutgers University Press, 2005), 18, 179.
62. Crawford, *Black Post-Blackness*, 186.

63. Shange, *nappy edges*, 21. For Larry Neal, "feeling one's history in a particular way" and the ability of a leader to interpret the emotional history of a people and "express the emotional realities of a given historical epoch" determine whether or not Black America will be united or separated. Describing Black Power, Larry Neal states, "Black Power is . . . a synthesis of all the nationalistic ideas embedded within the double-consciousness of Black America. But it has no one *specific* meaning. It is rather a kind of feeling—a kind of emotional response to one's history." On contemporary Black writing, he notes that it has "turned its attention inward to the internal problems of the group. The problem of living in a racist society . . . can not be dealt with until certain political, social and spiritual truths are understood by the oppressed themselves—inwardly understood." See Baraka and Neal, *Black Fire*, 639, 646, 647. In Shange's "wow . . . yr just like a man!" (1977—reprinted in *nappy edges*, 13), she elaborates on the plight of women poets—what they are expected to give up, what they are allowed to discuss—in order to be accepted by men as artists: "& this guy well he liked this woman's work/ cuz it waznt 'personal'/ I mean a man can get personal in his work when he talks politics or bout his dad/ but women start alla this foolishness bout their bodies & blood & kids & what's really goin on at home/ we & that aint poetry/."

64. Ntozake Shange, *for colored girls who have considered suicide, when the rainbow is enuf: a choreopoem* (Scribner Poetry, 1997), 4.

65. David Savran, *The Playwright's Voice: American Dramatists on Memory, Writing, and the Politics of Culture* (Theatre Communications Group, 1999), 194–95. As many scholars have noted, by 1971 both the Black Panther Party and the Young Lords Party had publicly taken positions on women's equality, but the Young Lords had more prominently spoken out on gay, lesbian, and transgender equality. In featuring the African American founding member and Minister of Finance Denise Oliver on the cover of the *Tricontinental Bulletin*, the Young Lords had also challenged the hold of the masculine metonym on a transnational stage; see Anne Garland Mahler, *From the Tricontinental to the Global South: Race, Radicalism, and Transnational Solidarity* (Duke University Press, 2018), 131. As GerShun Avilez highlights, Huey Newton publishes a letter in the *Black Panther* newsletter in 1970 about women's liberation and gay liberation that "recognizes that homosexual activists and black activists might have a common purpose or political goal . . . an important step in political discourse toward the public acknowledgment of subjects who identify with both groups. Ostensibly, this letter indicates a new way of thinking in Black power." See GerShun Avilez, "Queering the Black Arts Movement," Oxford African American Studies Center, May 31, 2019.

66. As Rinaldo Walcott notes, "The story of Africa is a complex one for 'New World' Black people who make use of Africa and also 'make Africa' in numerous ways." See Rinaldo Walcott, *The Long Emancipation: Moving Toward Black Freedom* (Duke University Press, 2021), 30. There is nuance among Black Arts artists regarding "Africa." Larry Neal, in his afterword for the anthology *Black Fire*, for example, argues that to center a focus on "some glorious African past" is not the goal, but neither is an acceptance of "a truncated Negro history which cuts us off completely from our African ancestry," as he views this as an acceptance of "the very racist assumptions which we abhor. Rather, we want to

comprehend history totally, and understand the manifold ways in which contemporary problems are affected by it." Baraka and Neal, *Black Fire*, 639.
67. Baraka and Neal, *Black Fire*, 33.
68. Clarke, "After Mecca," 81.
69. James Smethurst, *The Black Arts Movement: Literary Nationalism in the 1960s and 1970s* (University of North Carolina Press, 2005), 82, 79.
70. Shange, *lost in language & sound*, 122. Here, Shange is more aligned with Huey Newton and what he identifies as a difference between the Panthers and cultural nationalists in 1970: "Cultural nationalists [are] concerned with returning to the old African culture and thereby regaining their identity and freedom. . . . The BPP . . . realizes that we have to have an identity. We have to realize our black heritage in order to give us strength to move on and progress. But as far as returning to the old African culture, it's unnecessary and it's not advantageous in many respects." (see Vincent, *Party Music*, 190–91). As Shange tells Thulani Davis in 2014, "When it came time for the black nationalists to talk about going to the Motherland, they all wanted to go to Africa. And I was concerned about the other black people who had been here 500 years, who had the same or similar experiences to me. And I wanted to know about them. Because that's who I came from. And there were millions of us who had more in common than I had in common with the millions of people who had been left in Africa. No disrespect to them, but I came from a 500-year-old tradition that I felt I had to honor." See Ntozake Shange, "Ntozake Shange in Conversation with Thulani Davis," in *The Worlds of Ntozake Shange* (Class Visit, 1, New York, April 17, 2014). See also *If I Can Cook/ you Know God Can* (Boston: Beacon, 1999), 2 and throughout.
71. Savran, *The Playwright's Voice*, 193. As an undergraduate student, Shange finds herself enamored by the "movement" and "cadence" of the Last Poets; this enchantment perhaps also leads to her work with the Young Lords Party because key members straddled the two groups.
72. Ntozake Shange, *Sing a Black Girl's Song: The Unpublished Work of Ntozake Shange*, ed. Imani Perry (Legacy Lit/Hatchette Book Group, 2023), 49–52, 45–48, 80.
73. For example, in her discussion with Savran, Shange recalls being asked to open for a political act (who was in turn opening for the play *Free Angela* near the University of Southern California campus); Savran, *The Playwright's Voice*, 194.
74. Benjamin Lord, "Ed Bereal Speaks," *Contemporary Art Review Los Angeles*, July 7, 2016, https://contemporaryartreview.la/ed-bereal-speaks/.
75. Savran, *The Playwright's Voice*, 194.
76. Nina Sun Eidsheim, *The Race of Sound: Listening, Timbre, and Vocality* (Duke University Press, 2019), 9, 11–12.
77. Savran, *The Playwright's Voice*, 194.
78. Savran, *The Playwright's Voice*, 194–95. For more on the expectations around political sound that Shange inherits, see Maurice Wallace, *King's Vibrato: Modernism, Blackness, and the Sonic Life of Martin Luther King, Jr.* (Duke University Press, 2022).
79. Savran, *The Playwright's Voice*, 194–95.
80. Crawford, *Black Post-Blackness*, 143.

81. In 1973 Shange becomes a founding member of the Nuyorican Poets Café.
82. Here, Noel focuses on canons, academic institutions, and presses as well as incorporation into national bodies. He also notes how poets slip between being intentionally and forcefully incorporated, how this slippage overlaps with questions of assimilation, and how the poets simultaneously resist it—primarily through sound (languages and music) and form.
83. Larry Neal, "The Black Arts Movement," *The Drama Review: TDR* 12, no. 4 (1968): 31.
84. Vincent, *Party Music*, 15–16.
85. Smethurst, *The Black Arts Movement*, 286.
86. Shange, *lost in language & sound*, 7. As Cheryl Clarke notes, "The visibility gains of the Women's Liberation Movement were not lost on black women writers within the circle of the Black Arts Movement as they began to distance themselves from its dictates. Though they openly claimed to share an equitable power relationship with black men, black women—activists, academics, and artists alike—began to identify with feminists on issues of hierarchy, division of labor, role proscriptions, and recognition for the work they were doing 'within the circle' and in the Movement(s)." See Clarke, *"After Mecca,"* 84.
87. Shange, *lost in language & sound*, 7.
88. Serena Anderlini, "Drama or Performance Art? An Interview with Ntozake Shange," *Journal of Dramatic Theory and Criticism* 6, no. 1 (1991): 89.
89. Anderlini, "Drama or Performance Art?," 89. Although Shange often refers to herself as a third world writer, she maintains a nuanced position on her identification with Africa. As Ania Spyra notes, "Shange cites third worldism as an important precursor to her political thought and describes herself as a third world writer. . . . But whereas third worldism imagines a tri-continental community based on the commonality of oppression among the Fanonian 'wretched of the earth,' Shange's application of the term is often limited to the Americas. While she remains committed to various issues on the African continent, she does not see herself as 'conversant in those cultures'. . . . apart from her adopted Zulu name and some geographical names that appear in her poetry, Africa does not play as important a role in her poetics as do the Americas. Africa acts rather as a trace of origin, not a reality of the New World." Ania Spyra, "Ntozake Shange's Multilingual Poetics of Relation," *Contemporary Literature* 54, no. 4 (2013): 796.
90. Shange, *nappy edges*, 21, 22.
91. Urayoán Noel, *In Visible Movement: Nuyorican Poetry from the Sixties to Slam* (University of Iowa Press, 2014), 115.
92. Shange, *lost in language & sound*, 89.
93. Although this was not her first dance experience in the Bay Area—Shange participated in a three-week dance intensive at Lone Mountain College years before—the poet recalls this particular experience as being especially formative. Ntozake Shange, *Dance We Do: A Poet Explores Black Dance* (Beacon, 2020), 2.
94. Shange, *lost in language & sound*, 8–9, 58, 52.
95. Shange, *lost in language & sound*, 56, 9. In her essay "why i had to dance," Shange again acknowledges the connection between movement, language, and her sound, noting, "i realized that i wrote differently and more forcefully after class/ that the movements

propelled the language and/or the language propelled the dance/ it is possible to start a phrase with a word and end with a gesture."
96. Shange, *lost in language & sound*, 8.
97. Shange, *nappy edges*, 21.
98. Dianne McIntyre's work, discussed in chapter 2, serves as an important nexus point between the work of Shange and Hurston. Although the work I discuss in this chapter predates McIntyre's extending of Janie's narrative in her *Their Eyes* choreopoem, McIntyre is an important teacher and collaborator of Shange. McIntyre will play a key role in the development of Shange's choreopoem *for colored girls*, and the two will continue working together throughout Shange's career.
99. Shange, *for colored girls*, 4, 45, 11.
100. Vanessa K. Valdés, "'There Is No Incongruence Here': Hispanic Notes in the Works of Ntozake Shange," *CLA Journal* 53, no. 2 (2009): 133.
101. Noel, *In Visible Movement*, 89, 103.
102. Shange, *for colored girls*, 11, 12, 4.
103. Jeremy M. Glick, "The Pleasure of Writing at Last a Language as One Hears It," *The Caribbean Commons: Caribbean Studies in the Northeast US*, March 26, 2012. https://caribbean.commons.gc.cuny.edu/2012/03/26/the-pleasure-of-writing-at-last-a-language-as-one-hears-it/.

4. ON AUTOFICTIONAL SUBJECTIVITY: CONDÉ AND KINCAID

1. Kara Walker, "Fons Americanus," in Kara Walker et al., *Kara Walker: fons Americanus*, ed. Clara Kim (Tate, 2019), 58.
2. Valérie Loichot, *Orphan Narratives: The Postplantation Literature of Faulkner, Glissant, Morrison, and Saint-John Perse* (University of Virginia Press, 2007), 17.
3. Walker, "Fons Americanus," 17.
4. In the past Walker anticipated such behavior and incorporated it to extend her critique. For example, at the installation of *A Subtlety or the Marvelous Sugar Baby* (2014), visitors were encouraged to post pictures (many mocking and objectifying) to #karawalkerdomino. Walker also had a film crew capture a range of audience responses. This footage became the subject of *An Audience* (2014).
5. Zadie Smith, "Kara Walker: What Do We Want History to Do to Us?," in Walker et al., *Kara Walker: fons Americanus*, 33.
6. Christina Sharpe, *Monstrous Intimacies* (Duke University Press, 2010), 160–61.
7. Jamaica Kincaid, *See Now Then: A Novel* (Farrar, Straus and Giroux, 2013), 19.
8. Sharpe, *Monstrous Intimacies*, 167. Christina Sharpe cites Manthia Diawara's thoughts as they appear in "The Blackface Stereotype," in *David Levinthal—Blackface*, ed. Manthia Diawara (Arena, 1999), 7–17.
9. Sharpe, *Monstrous Intimacies*, 168. As Sharpe explains, it is important to acknowledge the difference between the breast of the mammy (Black) and of the mother (White). She reminds us that the enslaved woman or wet nurse is "denied the rights and privileges of

both womanhood and motherhood. Such naming would grant her a legal status as well as "a 'feminization' that enslavement kept at bay.... Nonetheless the mammy performs a—often *the*—maternal function in the white household."

10. Kimberly Juanita Brown, *The Repeating Body: Slavery's Visual Resonance in the Contemporary* (Duke University Press, 2015), 72–73.
11. Patrick Chamoiseau et al., "Créolité Bites," *Transition*, no. 74 (1997): 154.
12. Katherine McKittrick, ed., *Sylvia Wynter: On Being Human as Praxis* (Duke University Press, 2015), 26, 34.
13. Hortense Spillers, *Black, White, and in Color: Essays on American Literature and Culture* (University of Chicago Press, 2003), 227.
14. *Partus sequitur ventrem*, or the demand that what is brought forth follows the womb, was instituted in 1672 in Antigua and in 1680 in Guadeloupe. For more, see Christopher Tomlins, *Freedom Bound: Law, Labor, and Civic Identity in Colonizing English America, 1580–1865* (Cambridge University Press, 2010); and Jessica Marie Johnson's post "Sex, Blood, and Belonging in the Early Republic," *Black Perspectives*, August 12, 2016, https://www.aaihs.org/sex-blood-and-belonging-in-the-early-republic/. For more on how the contemporary residue of this doctrine continues to haunt Black mothers, see Jennifer C. Nash, *Birthing Black Mothers* (Duke University Press, 2021).
15. As Glissant writes, "In your poetic vision, a boat has no belly a boat does not swallow up, does not devour; a boat is steered by open skies. Yet, the belly of this boat dissolves you, precipitates you into a nonworld from which you cry out. This boat is a womb, a womb abyss. It generates the clamor of your protests; it also produces all the coming unanimity. Although you are alone in this suffering, you share in the unknown with others whom you have yet to know. This boat is your womb, a matrix, and yet it expels you. This boat: pregnant with as many dead as living under sentence of death." See Édouard Glissant, *Poetics of Relation*, trans. Betsy Wing (University of Michigan Press, 1997), 6.
16. Katherine McKittrick, *Demonic Grounds: Black Women and the Cartographies of Struggle* (Minnesota University Press, 2006), 82.
17. For more in-depth discussion on the ways that liberation discourse reinforces the silencing of Black women, see Carole Boyce Davies, *Black Women, Writing and Identity: Migrations of the Subject* (Routledge, 1994); Alys Weinbaum, *The Afterlife of Reproductive Slavery: Biocapitalism and Black Feminism's Philosophy of History* (Duke University Press, 2019); and Meina Yates-Richard, "'What Is Your Mother's Name?' Maternal Disavowal and the Reverberating Aesthetic of Black Women's Pain in Black Nationalist Literature," *American Literature* 88, no. 3 (2016): 477–507.
18. Yates-Richard, "'What Is Your Mother's Name?,'" 480. Yates-Richard explains maternal disavowal: "Maternal acts become abrogated in nationalistic texts by black men who enact their own metaphorical rebirthings through proxy wombs and black women's songs or sounds of pain. These men then claim subjective autonomy and the authority to represent the black community, thereby erasing the presence of black women."
19. Yates-Richard, "'What Is Your Mother's Name?,'" 478.
20. Fred Moten, quoted in Yates-Richard, "'What Is Your Mother's Name?,'" 485.

21. Maryse Condé, "Order, Disorder, Freedom, and the West Indian Writer," *Yale French Studies* 83, no. 2 (1993): 133. Both Condé and the Antiguan author Jamaica Kincaid also address their relationships with their fathers in their fiction.
22. Jamaica Kincaid, *The Autobiography of My Mother* (Farrar, Straus and Giroux, 1996), 181.
23. My use of the term "othermother" or "(other)mother" draws on the work of Patricia Hill Collins and Stephanie Y. Mitchem and aligns with that of Simone A. James Alexander, *Mother Imagery in the Novels of Afro-Caribbean Women* (University of Missouri Press, 2001); Alexander explains that her "usage of the term *mother* encompasses mother as biological and as 'other.' The 'othermother' . . . is the substitute mother who takes on and takes over the nurturing role from the biological in times of need or crisis." I find James Alexander's nuancing crucial, as she explains that this 'other'ness also refers to ways that the biological mother becomes an enemy to her daughter, "particularly when she appears to advocate colonial habits and mannerisms" (James Alexander, *Mother Imagery*, 7). This problem also surfaces in the nonbiological othermothering relationships, which may not prove to be sites of nurture and support for reasons like those that James Alexander highlights. See also Carol Boyce Davies, "Mothering and Healing in Recent Black Women's Fiction," *SAGE: A Scholarly Journal on Black Women* 2, no. 1 (1985): 41–43.
24. In Philip's "Dis Place," a group of women called the "mothers" frequently intervene to warn their presumed daughters against becoming "wajanks, jackabats, spoats, and hos (whores)," inadvertently encoding their daughters with fear and silence. Philip suggests that the Jamette poet—charged with the labels the mothers hurl—is in fact admirable in her refusal of such narratives. Kincaid's mother-figure issues similar warnings in "Girl," instructing the girl on how to cook, clean, interact with men, and other matters of proper comportment to avoid being seen as the "slut you are so bent on becoming." See M. NourbeSe Philip, "Dis Place: The Space Between," in *Feminist Measures*, ed. Lyn Keller and Cristanne Miller (University of Michigan Press, 1994); and Jamaica Kincaid, "Girl," *New Yorker*, June 19, 1978.
25. Selwyn R. Cudjoe, "Jamaica Kincaid and the Modernist Project: An Interview," *Callaloo*, no. 39 (1989): 408.
26. Bénédicte Boisseron, *Creole Renegades: Rhetoric of Betrayal and Guilt in the Caribbean Diaspora* (University Press of Florida, 2014), 1–2.
27. Maryse Condé, *The Journey of a Caribbean Writer* (Seagull, 2014), 149; Boisseron, *Creole Renegades*, 3–4.
28. Boisseron. *Creole Renegades*, 4, 8.
29. Boyce Davies, *Black Women, Writing and Identity*, 25; Boisseron, *Creole Renegades*, 21. Here, it important to recognize both Carole Boyce Davies's argument that "critical thinkers have been slow to acknowledge that, in the latter half of [the twentieth] century, it is the United States of America which is the colonial power, not Europe as a generation of writers had alleged," and Boisseron's that for writers of the second generation, America is "first and foremost an ideology, the ideology of the third continent, neither Africa nor Europe, but the place where one can attempt to stay out of a postcolonial polarity."
30. In 1989, for example, while discussing her novel *La vie Scélérate*, Condé tells VèVè Clark that independence activists have openly complained, "She belongs to us, and look at

the way she has portrayed our cause in her novel." VèVè A. Clark and Cecile Daheny. "'I Have Made Peace With My Island': An Interview with Maryse Condé," *Callaloo*, no. 38 (Winter, 1989), 107. As noted in chapter 3, both Patrick Chamoiseau and Raphaël Confiant address her critique of Créolité, and in doing so they draw an insider/outsider line: They note that she "doesn't have the same command of Creole" or "Creole imaginary." The grafting of Condé to the West presents an implicit argument that because of her physical and ideological distance from Antillean Créolité, she simply cannot comprehend their discourse. See Chamoiseau et al., "Créolité Bites," 150.

31. Boisseron, *Creole Renegades*, 9.
32. Lizabeth Paravisini-Gebert, *Jamaica Kincaid: A Critical Companion* (Greenwood, 1999), 27. See also J. Brooks Bouson, *Jamaica Kincaid: Writing Memory, Writing Back to the Mother* (SUNY Press, 2005).
33. Boyce Davies, *Black Women, Writing and Identity*, 36.
34. Boyce Davies, *Black Women, Writing and Identity*. Boyce Davies explains her formulation of migratory subjectivity: "The subject here is Black women as it is Black women's writing in their many meanings. Migrations of the subject refers to the many locations of Black women's writing, but also to the Black female subject refusing to be subjugated. Black female subjectivity then can be conceived not primarily in terms of domination, subordination or 'subalternization,' but in terms of slipperiness, elsewhereness. Migratory subjects suggests that Black women's writing . . . exists in myriad places and times, constantly eluding the terms of the discussion," 36. "Autobiographical subjectivity of Black women," she explains, "is one of the ways in which speech is articulated and geography redefined," 21.
35. Boyce Davies, *Black Women, Writing and Identity*, 21.
36. Spillers, *Black, White, and in Color*, 229. Mecca Jamilah Sullivan provides an important discussion on the Caribbean-descended author Audre Lorde's creation of "biomythography," "a composite genre to accommodate her understanding of herself and her social experience"; see Mecca Jamilah Sullivan, *The Poetics of Difference: Queer Feminist Forms in the African Diaspora* (University of Illinois Press, 2021), 24.
37. Kavita Ashana Singh, "Conversation and Tea with Maryse Condé," *Journal of West Indian Literature* 31, no. 1 (2022): 61, 162.
38. Maryse Condé, *What Is Africa to Me?* (Seagull, 2017), 80.
39. Singh, "Conversation and Tea," 157. According to Condé, "My father worshipped [the French language] like you worship a woman. My mother . . . considered it the magic key that opened every door to social success." See Condé, *The Journey of a Caribbean Writer*, 34.
40. Singh, "Conversation and Tea," 158.
41. Chamoiseau et al., "Créolité Bites," 150.
42. Condé, *What Is Africa to Me?*, 80.
43. Maryse Condé, "Maryse Condé's First Encounter with Frantz Fanon's 'Black Skin, White Masks,'" *frieze*, issue 215, October 7, 2020, https://www.frieze.com/article/maryse-condes-first-encounter-frantz-fanons-black-skin-white-masks.
44. Condé, *What Is Africa to Me?*, 11; Condé, "Maryse Condé's First Encounter."

4. ON AUTOFICTIONAL SUBJECTIVITY 239

45. Condé, *What Is Africa to Me?*, 12.
46. Condé, *What Is Africa to Me?*, 12. Condé explains to Singh the negative reaction that she receives from Dominique's family due to her finally coming out and revealing that she believes "that man never married me because I was Black and he was a mulatto." See Singh, "Conversation and Tea," 163.
47. Condé, *What Is Africa to Me?*, 12.
48. Condé, *The Journey of a Caribbean Writer*, 61–62.
49. Eliana Văgălău, "'A part le bonheur, il n'y a rien d'essentiel' 1: The Transnational Narrative Model in Maryse Condé's Desirada," in *Transnational Africana Women's Fictions*, ed. Cheryl Sterling (Routledge, 2022), 223.
50. Maryse Condé, *Windward Heights*, trans. Richard Philcox (Faber and Faber, 1998), 44, 42, 58–59.
51. In *Windward Heights*, the condition of *partus sequitur ventrem* is not solely relegated to African-descended women. As Carine Mardorossian notes, Condé complicates key elements of Creolite and creolization with her model of relation by "represent[ing] a world where the dominant ideology does not repress the truth of miscegenation but reappropriates it in service of its own imperialist agenda." See Mardorossian, *Reclaiming Difference: Caribbean Women Rewrite Postcolonialism* (University of Virginia Press, 2005), 37. Alys Eve Weinbaum asserts that "laborers who engage in reproductive labor are racialized by their labor, and their racialization (via their labor) used as the pretext to further extract labor and products," providing a useful lens for deciphering the power structure in Condé's novel. See Weinbaum, *The Afterlife of Reproductive Slavery*, 9.
52. Alexander Crummell and Daniel Murray Pamphlet Collection, *The Black Woman of the South: Her Neglects and Her Needs* (Woman's Home Missionary Society of the Methodist Episcopal Church, 1883), 2–3.
53. Condé, *Windward Heights*, 279, 37, 89, 67, 74.
54. Notably, through her inclusion of Sanjita's (and her daughter Etiennise's) autofictional stories, Condé reveals the central role that servant-class Indian women play in the creolization and subversive recording of women's experience in the Caribbean. By including these characters, Condé challenges a reading put forth by Supriya Nair that discusses Kamau Brathwaite's valorization of African or Black elements in "authentic" creolization, and his assertion that "the borrowed 'great tradition' of the Indian subcontinent was an impediment to the creolization process, since the migrant Indian laborers ignored their 'authentic' folk traditions." See Supriya Nair, *Pathologies of Paradise* (University of Virginia Press, 2013), 242.
55. Condé, *Windward Heights*, 120.
56. Yates-Richard, "'What Is Your Mother's Name?,'" 478.
57. Condé, *Windward Heights*, 124, 123, 121, 120.
58. Loichot, *Orphan Narratives*, 140.
59. Văgălău, "'A part le bonheur,'" 219.
60. Maryse Condé, *Desirada*, trans. Richard Philcox (Soho, 2001), 11, 15.
61. Condé, *Desirada*, 11.
62. Condé, *Desirada*, 151.

63. Boyce Davies, *Black Women, Writing and Identity*, 28.
64. Condé, *Desirada*, 29, 30, 259, 260.
65. Patricia T. O'Conner, "My Mother Wrote My Life," *New York Times Book Review*, April 7, 1985, 6.
66. Paravisini-Gebert, *Jamaica Kincaid*, 27; O'Conner, "My Mother Wrote My Life," 6.
67. Boyce Davies, *Black Women, Writing and Identity*, 115.
68. Jamaica Kincaid and Kay Bonetti, "Interview with Jamaica Kincaid," *Missouri Review*, June 1, 2002, https://missourireview.com/article/interview-with-jamaica-kincaid/.
69. Kincaid, *The Autobiography*, 205.
70. Published in her short story collection *At the Bottom of the River* (1983), Kincaid's "Blackness" provides a nuanced meditation on this concept. Diane Simmons in *Jamaica Kincaid* (Macmillan, 1994), 90–91, likens the author's presentation of the unknown in the short story to its treatment in *Annie John*. She understands both as "progressing from the denial of loss and the limbo of separation seen in the earlier pieces to a crisis of acceptance. . . . the advent of 'blackness' . . . signals not only erasure and silence but also renewal, the possibility of rebirth, and . . . the dawning of a new sense of identity, the feel of one's name 'filling up' one's mouth." I understand Kincaid's concept of Blackness or the unknown as one of possibility and contradiction. In either case, it is a space free of imposed boundaries or meanings.
71. Xuela observes the disadvantages that her stepsister, a devotee to dominant ordering narratives, receives by being born in the middle of the day: "It was too bright a time of day to be born; to be born at such a time could only mean that you would be robbed of all your secrets, your ability to determine events. No room could be made dark enough to protect you from a brutality so spare, so voluptuous: life itself. The time of day when a son was born did not matter at all. Any time of day a son is born is the right time" (*The Autobiography*, 107).
72. Although Kincaid's protagonist refers to the people Indigenous to the island now recognized as Dominica as Carib in the novel, I use Kalinago in this study in recognition of Dominica passing an act in 2015 that officially recognizes the negative connotations and painful history that the use of the name Carib evokes.
73. Kincaid, *The Autobiography*, 16, 79–80, 199.
74. Kincaid, *The Autobiography*, 18. For more on the relationship between narrative reproduction and reproductive labor, see Weinbaum, *The Afterlife of Reproductive Slavery*.
75. Kincaid, *The Autobiography*, 185, 181.
76. Paravisini-Gebert, *Jamaica Kincaid*, 153, 159.
77. Kincaid, *The Autobiography*, 91, 82, 91.
78. Kincaid, *The Autobiography*, 99, 102, 100, 216.
79. Kincaid, *The Autobiography*, 97.
80. Xuela's illegible mothering echoes that of Kincaid's mother in the short story "Blackness." As Diane Simmons observes, unlike the mothering voice in "Girl," "Kincaid invented a mother who will allow identity to develop. . . . the mother fashioned here, another of Kincaid's othermothers, neither molds nor chastises, but grasps and celebrates, both the immense energy and the unfettered, contradictory nature of the daughter, this spirit that she has 'summoned . . . into a fleeting existence.'" See Simmons, *Jamaica Kincaid*, 51.

81. Kincaid, *The Autobiography*, 214.
82. As Daryl Cumber Dance notes, "Kincaid does not mention race, but Mrs. Sweet's focus on Mr Sweet's blue-blood and aristocratic family and background . . . contrasted with his emphasis on Mrs Sweet's third-world, backwater origins (he constantly reminds her that she came on a banana boat) reflects the same ambivalence about race that may be seen in several Kincaid writings and interviews." See Dance, "'I Married My Mother': Jamaica Kincaid's *See Now Then*," *Journal of West Indian Literature* 23, nos. 1–2 (2015): 15n18.
83. Leigh Haber, "10 Questions for Author Jamaica Kincaid: Fiercely Original Author Jamaica Kincaid on Her First Novel in a Decade," Oprah.com, March 2013, https://www.oprah.com/entertainment/jamaica-kincaid-interview-see-now-then.
84. Kincaid, *See Now Then*, 13, 11, 160, 10, 159, 82, 44, 175, 92
85. Kincaid, *See Now Then*, 166, 153–54, 145, 19
86. Kincaid, *See Now Then*, 29–30, 20
87. Kincaid, *See Now Then*, 174, 173, 18, 21, 180.
88. Walker, "Fons Americanus," 58.
89. Rinaldo Walcott, "The Black Aquatic," *liquid blackness: journal of aesthetics and black studies* 5, no. 1 (2021): 68.

CONCLUSION: ON MUCK HORIZONS

1. Zora Neale Hurston, *Hurston: Novels and Stories* (Library of America, 1995), 175.
2. Hurston, *Hurston: Novels & Stories*, 280, 180, 333.
3. Patricia Yaeger, *Dirt and Desire: Reconstructing Southern Women's Writing, 1930–1990* (University of Chicago Press, 2000), 298n2.
4. Patricia Stuelke, "'Sympathy with the Swamp': Reading Hurston in the Trumpocene," *Scholar and Feminist Online* 16, no. 2 (2020).
5. Yaeger, *Dirt and Desire*, 298n2.
6. Ntozake Shange, *Sassafrass, Cypress and Indigo* (Picador, 1982), 4.
7. Lovalerie King, *The Cambridge Introduction to Zora Neale Hurston* (Cambridge University Press, 2008), 53.
8. Tara T. Green, Brenda Marie Osbey, and Corey Walker, "Conversations in Black Studies: 'Love, Activism, and the Respectable Life of Alice Dunbar-Nelson,'" YouTube video, April 2022, https://www.youtube.com/watch?v=_jqynpDJKng.
9. "Horizon, N., Sense 1.a." Oxford English Dictionary, March 2024, https://doi.org/10.1093/OED/1041281698. "Horizon, N., Sense 2.b." Oxford English Dictionary, March 2024, https://doi.org/10.1093/OED/9391668631.
10. In introducing and deploying the muck horizon as an interpretive tool for grappling with meetings of Africana southern land and sea, I join into conversation with and am indebted to the following works: Tiffany Lethabo King, *The Black Shoals: Offshore Formations of Black and Native Studies* (Duke University Press, 2019); Mecca Jamilah Sullivan, *The Poetics of Difference: Queer Feminist Forms in the African Diaspora* (University of Illinois Press, 2021); M. Jacqui Alexander, *Pedagogies of Crossing: Meditations on Feminism, Sexual Politics, Memory, and the Sacred* (Duke University Press, 2005); Michelle

Lanier, "Rooted: Black Women, Southern Memory, and Womanist Cartographies," *Southern Cultures* 26, no. 2 (2020); and lastly Bettina Judd, *Feelin: Creative Practice, Pleasure, and Black Feminist Thought* (Northwestern University Press, 2023), who teaches us that Black woman have long known land and waters. Judd's presentation of "feelin" as a paradigm for creative practice, pleasure, and Black feminist thought returns us to the promise of Mati relational structures, which are also "forever connected to/shaped by/in processes of becoming through what was lost through racial injury—made metaphor by the Atlantic Ocean's abyss" (14). As Omise'eke Natasha Tinsley explains, the Suriname word *mati* is derived from the Dutch *maat* or mate, and that the term means "'mate' as in 'shipmate': she who survived forced transport and enslavement with me." For more, see Tinsley, *Thiefing Sugar*, Duke University Press, 2010, 7.

11. Lanier, "Rooted," 16–17.
12. Allison Janae Hamilton and Dr. Joan Morgan, "At the Table: A Conversation with Allison Janae Hamilton and Joan Morgan," Creativetime, December 17, 2020, https://creativetime.org/waters-lower-register-ajh-conversation/.
13. Hamilton and Morgan, "At the Table."
14. Hamilton and Morgan, "At the Table."
15. "Haint Blu is an embodied look into familial lines and the movements, histories and stories of our elders and ancestors. It reflects on what has been lost across generations and what can be recovered." @Ubwdance, *Instagram*, April 17, 2024, https://www.instagram.com/p/C54Wht2PZML/.
16. Chanon Judson, personal interview, January 17, 2024.
17. "'HAINT BLU' calls us to be inside a place where we can access our histories and full creative power," says the UBW co-artistic director Mame Diarra Speis. "We are presenting a work that encourages people to journey, to ask questions, and to be curious about their lineage and the untapped potential for collective healing." @Ubwdance, *Instagram*, June 7, 2023, https://www.instagram.com/p/CtNZ2h4L3El/?img_index=1.
18. Judson personal interview.
19. Judson, personal interview.
20. Akwaeki Emezi, *Dear Senthuran* (Riverhead, 2021), 226–27
21. Emezi, *Dear Senthuran*, 1, 2, 49, 57, 154, 77, 78–79.
22. Emezi, *Dear Senthuran*, 80, 21.
23. Emezi, *Dear Senthuran*, 112. Emezi writes that they couldn't initially share their home with their family due to their family's inability to view it and by extension them through more dynamic frames. As a result, they would "cur[l] up on the marble floor of my master closet and so[b] from exhaustion and sadness that I was doing this alone."
24. Emezi, *Dear Senthuran*, 106
25. Emezi, *Dear Senthuran*, 75, 61, 83, 49.

BIBLIOGRAPHY

Abramovich, Alex. "Face to Face with Olu Dara (Unabridged): Highlights from Issue 34: *Jazz*." *Stopsmiling*, March 14, 2008. https://stopsmilingonline.com/story_detail.php.

Akoma, Chiji. "Griot with Attitude: Condé's *The Last of the African Kings* and New World Narrative Order." *Research in African Literatures* 38, no. 3 (2007): 112–21.

Alexander, M. Jacqui. *Pedagogies of Crossing: Meditations on Feminism, Sexual Politics, Memory, and the Sacred.* Duke University Press, 2005.

Anderlini, Serena. "Drama or Performance Art? An Interview with Ntozake Shange." *Journal of Dramatic Theory and Criticism* 6, no. 1 (1991): 85–97.

Anim-Addo, Joan. "Gendering Creolisation: Creolising Affect." *Feminist Review* 104 (2013): 5–23.

Apter, Emily S., and Maryse Condé. "Crossover Texts/Creole Tongues: A Conversation with Maryse Condé." *Public Culture* 13, no. 1 (2001): 89–96.

Avilez, GerShun. "Queering the Black Arts Movement." Oxford African American Studies Center, May 31, 2019. https://doi.org/10.1093/acref/9780195301731.013.78531.

Baraka, Amiri, and Larry Neal, eds. *Black Fire: An Anthology of Afro-American Writing.* Black Classic, 2007.

Barthes, Roland. *The Grain of the Voice: Interviews 1962–1980.* Ed. and trans. Linda Coverdale. Northwestern University Press, 2009.

Batiste, Stephanie L. *Darkening Mirrors: Imperial Representation in Depression-Era African American Performance.* Duke University Press, 2011.

Boisseron, Bénédicte. *Creole Renegades: Rhetoric of Betrayal and Guilt in the Caribbean Diaspora.* University Press of Florida, 2014.

Bouson, J. Brooks. *Jamaica Kincaid: Writing Memory, Writing Back to the Mother.* SUNY Press, 2005.

Boyce Davies, Carole. *Black Women, Writing and Identity: Migrations of the Subject.* Routledge, 1994.

Boyce Davies, Carole. "Mothering and Healing in Recent Black Women's Fiction." *SAGE: A Scholarly Journal on Black Women* 2, no. 1 (1985): 41–43.

Boyd, Valerie. *Wrapped in Rainbows: The Life of Zora Neale Hurston*. Simon and Schuster, 2004.

Bracey, John, Sonia Sanchez, and James Smethurst, eds. *SOS—Calling All Black People: A Black Arts Movement Reader*. University of Massachusetts Press, 2014.

Bradley, Regina. "Sounding the South/Souf." *Southern Cultures* 27, no. 4 (2021): 6–11.

Brathwaite, Kamau. *Roots*. University of Michigan Press, 1993.

Brooks, Daphne. *Bodies in Dissent: Spectacular Performances of Race and Freedom 1950–1910*. Duke University Press, 2006.

Brooks, Daphne. *Liner Notes for the Revolution: The Intellectual Life of Black Feminist Sound*. Harvard University Press, 2021.

Brown, Jayna. "Black Sonic Refusal." In *The Female Voice in the Twentieth Century: Material, Symbolic and Aesthetic Dimensions*, ed. Serena Facci and Michela Garda. Routledge, 2021.

Brown, Kimberly Juanita. *The Repeating Body: Slavery's Visual Resonance in the Contemporary*. Duke University Press, 2015.

Burt, Ramsay. "Katherine Dunham's Floating Island of Negritude." In *Rethinking Dance History*, ed. Alexandra Carter. Routledge, 2013.

Carr, Brian, and Tova Cooper. "Zora Neale Hurston and Modernism at the Critical Limit." *Modern Fiction Studies* 48, no. 2 (2002): 285–313.

Césaire, Aimé. *Return to My Native Land*. Trans. Emile Snyder. Présence Africaine, 1968.

Césaire, Aimé. *The Collected Poetry*. Trans. Clayton Eshelman and Annette Smith. University of California Press, 1982.

Chamoiseau, Patrick, et al. "Créolité Bites." *Transition*, no. 74 (1997): 124–61.

Chinosole. "Maryse Condé as Contemporary Griot in Segu." *Callaloo* 18, no. 3 (1995): 593–601.

Clarke, Cheryl. *"After Mecca": Women Poets and the Black Arts Movement*. Rutgers University Press, 2005.

Cole, Jean Lee, and Charles Mitchell, eds. *Zora Neale Hurston: Collected Plays*. Rutgers University Press, 2008.

Condé, Maryse. *Desirada*. Trans. Richard Philcox. Soho, 2001.

Condé, Maryse. *Heremakhonon: A Novel*. Trans. Richard Philcox. Three Continents, 1982.

Condé, Maryse. *The Journey of a Caribbean Writer*. Seagull, 2014.

Condé, Maryse. "Order, Disorder, Freedom, and the West Indian Writer." *Yale French Studies* 83, no. 2 (1993): 121–35.

Condé, Maryse. *What Is Africa to Me? Fragments of a True-to-Life Autobiography*. Trans. Richard Philcox. Seagull, 2016.

Condé, Maryse. *Windward Heights*. Trans. Richard Philcox. Faber and Faber, 1998.

Cooper, Daniel. "Olu Dara." *Oxford American*, 21/22 (1998). https://oxfordamerican.org/magazine/issue-21-22-summer-1998/olu-dara.

Corbin, Laurie. "The Voicing of Desire: The Quest for History in 'Heremakhonon' and 'The Women of Tijucopapo.'" *Callaloo* 35, no. 2 (2012): 425–41.

Cox, Aimee Meredith. *Shapeshifters: Black Girls and the Choreography of Citizenship*. Duke University Press, 2015.

Crawford, Margo Natalie. *Black Post-Blackness: The Black Arts Movement and Twenty-First-Century Aesthetics*. University of Illinois Press, 2017.
Crummell, Alexander, and Daniel Murray Pamphlet Collection. *The Black Woman of the South: Her Neglects and Her Needs*. Woman's Home Missionary Society of the Methodist Episcopal Church, 1883.
Cudjoe, Selwyn R. "Jamaica Kincaid and the Modernist Project: An Interview." *Callaloo*, no. 39 (1989): 396–411.
Cummins, Alissandra, and Allison Thompson. "The Unnamed Body: Encountering, Commodifying, and Codifying the Image of the Black Female." *Nka: Journal of Contemporary African Art* 38–39 (2016): 110–20.
Dance, Daryl Cumber. "'I Married My Mother': Jamaica Kincaid's *See Now Then*." *Journal of West Indian Literature* 23, nos. 1–2 (2015): 8–18.
Das, Joanna Dee. *Katherine Dunham: Dance and the African Diaspora*. Oxford University Press, 2017.
Defrantz, Thomas F., ed. *Dancing Many Drums: Excavations in African American Dance*. University of Wisconsin Press, 2001.
Diawara, Manthia, ed. *David Levinthal—Blackface*. Arena, 1999.
Diggs Colbert, Soyica. *The African American Theatrical Body: Reception, Performance, and the Stage*. Cambridge University Press, 2011.
Diggs Colbert, Soyica. *Black Movements: Performance and Cultural Politics*. Rutgers University Press, 2017.
Drabinski, John E. *Glissant and the Middle Passage*. University of Minnesota Press, 2019.
Du Bois, W. E. B. "The Colored Audience." *Crisis* 12, no. 5 (1916).
Du Bois, W. E. B. "Krigwa Players Little Negro Theatre: The Story of a Little Theatre Movement." *Crisis* 32, no. 3 (1926).
DuCille, Ann. "The Mark of Zora: Reading Between the Lines of Legend and Legacy." *Scholar and Feminist Online* 3, no. 2 (2005).
Dunbar Nelson, Alice. Scrapbook No. 4, "From a Woman's Point of View/Une Femme Dit." *Pittsburgh Courier*, January 2, 1926–September 18, 1926.
Dunham, Katherine. *Dances of Haiti*. Center for Afro-American Studies, University of California, 1983.
Dunham, Katherine. *Island Possessed*. University of Chicago Press, 1994.
Dunham, Katherine. *A Touch of Innocence*. Harcourt, Brace, 1959.
Eidsheim, Nina Sun. *The Race of Sound: Listening, Timbre, and Vocality*. Duke University Press, 2019.
Emezi, Akwaeki. *Dear Senthuran*. Riverhead, 2021.
Forbes, Curdella. "Between Plot and Plantation, Trespass and Transgression: Caribbean Migratory Disobedience in Fiction and Internet Traffic." *Small Axe: A Caribbean Journal of Criticism* 16, no. 2 (2012): 23–42.
Foster, Susan Leigh. "Muscle/Memories: How Germaine Acogny and Diane McIntyre Put Their Feet Down." In *Rhythms of the Afro-Atlantic World*, ed. Mamadou Diouf and Ifeoma C. K. Nwankwo. University of Michigan Press, 2013.

Foulkes, Julia L. "Ambassadors with Hips: Katherine Dunham, Pearl Primus, and the Allure of Africa in the Black Arts Movement." In *Impossible to Hold: Women and Culture in the 1960s*, ed. Avital Block and Lauri Umansky. New York University Press, 2005.

Gambrell, Alice. *Women Intellectuals, Modernism, and Difference: Transatlantic Culture 1919–1945*. Cambridge University Press, 1997.

Garcia, David F. *Listening for Africa: Freedom, Modernity, and the Logic of Black Music's African Origins*. Duke University Press, 2017.

Gary, Ja'Tovia. "A Care Ethic." Art, Design & Architecture Museum at UCSB, July 26, 2018. YouTube. https://www.youtube.com/watch?v=GZwVuvU-4Qg.

Gates, Henry Louis. *The Signifying Monkey: A Theory of Afro-American Literary Criticism*. Oxford University Press, 1988.

George-Graves, Nadine. "Diasporic Spidering: Constructing Contemporary Black Identities." In *Black Performance Theory*, ed. Thomas F. DeFrantz and Anita Gonzalez. Duke University Press, 2014.

Gilroy, Paul. *The Black Atlantic: Modernity and Double Consciousness*. Harvard University Press, 1993.

Glick, Jeremy M. "The Pleasure of Writing at Last a Language as One Hears It." *The Caribbean Commons: Caribbean Studies in the Northeast US*, March 26, 2012. https://caribbean.commons.gc.cuny.edu/2012/03/26/the-pleasure-of-writing-at-last-a-language-as-one-hears-it/.

Glissant, Édouard. *Poetics of Relation*. Trans. Betsy Wing. University of Michigan Press, 1997.

Glissant, Édouard. *Caribbean Discourse*. University of Virginia Press, 1989.

Goldman, Danielle. "Sound Gestures: Posing Questions for Music and Dance." *Women and Performance: A Journal of Feminist Theory* 17, no. 2 (2007): 123–38.

Goler, Vita. " 'Moves on Top of Blues': Dianne McIntyre's Blues Aesthetic." In *Dancing Many Drums: Excavations in African American Dance*, ed. Thomas F. Defrantz. University of Wisconsin Press, 2001.

Green, Tara T., Brenda Marie Osbey, and Corey Walker. "Conversations in Black Studies: 'Love, Activism, and the Respectable Life of Alice Dunbar-Nelson.' " YouTube video, April 2022. https://www.youtube.com/watch?v=_jqynpDJKng.

Griffin, Farah Jasmine. "When Malindy Sings." In *Uptown Conversation: The New Jazz Studies*, ed. Robert O'Meally, Brent Hayes Edwards, and Farah Jasmine Griffin. Columbia University Press, 2004.

Griffin, Farah Jasmine. *Who Set You Flowin? The African-American Migration Narrative*. Oxford University Press, 1995.

Haber, Leigh. "10 Questions for Author Jamaica Kincaid: Fiercely Original Author Jamaica Kincaid on Her First Novel in a Decade." Oprah.com, March 2013. https://www.oprah.com/entertainment/jamaica-kincaid-interview-see-now-then.

Hardison, Ayesha K. "Crossing the Threshold." *African American Review* 46, no. 2 (2013): 217–35.

Harris, William J. "How You Sound: Amiri Baraka Writes Free Jazz." In *Uptown Conversation: The New Jazz Studies*, ed. Robert G. O' Meally et al. Columbia University Press, 2004.

Hartman, Saidiya. *Lose Your Mother: A Journey Along the Atlantic Slave Route*. Farrar, Straus and Giroux, 2007.

Hartman, Saidiya. *Scenes of Subjection: Terror, Slavery, and Self-Making in Nineteenth-Century America*. Oxford University Press, 1997.
Hartman, Saidiya. *Wayward Lives, Beautiful Experiments: Intimate Histories of Social Upheaval*. Norton, 2019.
Holiday, Harmony. "Abbey Lincoln's Scream: Poetic Improvisation as a Way of Life." *Poetry Foundation* (blog), October 26, 2016. https://www.poetryfoundation.org/featured-blogger/76012/abbey-lincolns-scream-poetic-improvisation-as-a-way-of-life.
Horton-Stallings, LaMonda. *A Dirty South Manifesto*. University of California Press, 2020.
Hurston, Zora Neale. "Characteristics of Negro Expression." In *Negro: An Anthology*, ed. Nancy Cunard. Hours Press, 1934. Reprinted in *Hurston: Folklore, Memoirs, and Other Writings*, ed. Cheryl Wall. Library of America, 1995.
Hurston, Zora Neale. "How It Feels to Be Colored Me." *World Tomorrow*, May 1928. Reprinted in *Hurston: Folklore, Memoirs, and Other Writings*. Library of America, 1995.
Hurston, Zora Neale. *Their Eyes Were Watching God*. Lippincott, 1937.
Jackson, Shona. *Creole Indigeneity: Between Myth and Nation in the Caribbean*. University of Minnesota Press, 2012.
Jaji, Tsitsi. *Africa in Stereo: Modernism, Music, and Pan-African Solidarity*. Oxford University Press, 2014.
James Alexander, Simone A. *Mother Imagery in the Novels of Afro-Caribbean Women*. University of Missouri Press, 2001.
Johnson, Jessica Marie. "Sex, Blood, and Belonging in the Early Republic." *Black Perspectives*, August 12, 2016. https://www.aaihs.org/sex-blood-and-belonging-in-the-early-republic/.
Judd, Bettina. *Feelin: Creative Practice, Pleasure, and Black Feminist Thought*. Northwestern University Press, 2023.
Kaplan, Carla. *The Erotics of Talk: Women's Writing and Feminist Paradigms*. Oxford University Press, 1993.
Kaplan, Carla. *Zora Neale Hurston: A Life in Letters*. Doubleday, 2002.
Kemedjio, Cilas. "Rape of Bodies, Rape of Souls: From the Surgeon to the Psychiatrist, from the Slave Trade to the Slavery of Comfort in the Work of Edouard Glissant." *Research in African Literatures* 25, no. 2 (1994): 51–79.
Kincaid, Jamaica. *At the Bottom of the River*. Farrar, Straus and Giroux, 1983.
Kincaid, Jamaica. *The Autobiography of My Mother*. Farrar, Straus and Giroux, 1996.
Kincaid, Jamaica. "Girl." *New Yorker*, June 19, 1978.
Kincaid, Jamaica. *See Now Then: A Novel*. Farrar, Straus and Giroux, 2013.
King, Lovalerie. *The Cambridge Introduction to Zora Neale Hurston*. Cambridge University Press, 2008.
Lamothe, Daphne. *Inventing the New Negro: Narrative, Culture, and Ethnography*. University of Pennsylvania Press, 2008.
Lanier, Michelle. "Rooted: Black Women, Southern Memory, and Womanist Cartographies." *Southern Cultures* 26, no. 2 (2020): 12–31.
La Rocco, Claudia. "Telling Stories in Many Shades of Delta Blue." *New York Times*, May 25, 2008. www.nytimes.com/2008/05/25/arts/dance/25laro.html.

Lincoln, Abbey. "NEA Jazz Master." Interview by Sally Plaxon. *Smithsonian Online Digital Archives*. December 17–18, 1996, 31. https://americanhistory.si.edu/sites/default/files/file-uploader/Abbey-Lincoln-Transcription-2020.pdf.

Linson, Valerie. "Interview of Carmencita Romero by Valerie Linson." Hatch Billops Collection, New York, 1999.

Lionnet, Francois. *Autobiographical Voices: Race, Gender, Self-Portraiture*. Cornell University Press, 1989.

Locke, Alain. "The New Negro" (1925). Reprinted in *The New Negro: Voices of the Harlem Renaissance*, ed. Alain Locke. Simon and Schuster, 1992.

Loichot, Valérie. *Orphan Narratives: The Postplantation Literature of Faulkner, Glissant, Morrison, and Saint-John Perse*. University of Virginia Press, 2007.

Lord, Benjamin. "Ed Bereal Speaks." *Contemporary Art Review Los Angeles*, July 7, 2016. https://contemporaryartreview.la/ed-bereal-speaks.

Luis-Brown, David. *Waves of Decolonization: Discourses of Race and Hemispheric Citizenship in Cuba, Mexico, and the United States*. Duke University Press, 2008.

Magloire, Marina. *We Pursue Our Magic: A Spiritual History of Black Feminism*. University of North Carolina Press, 2023.

Mahler, Anne Garland. *From the Tricontinental to the Global South: Race, Radicalism, and Transnational Solidarity*. Duke University Press, 2018.

Manning, Susan. "Watching Dunham's Dances, 1937–1945." In *Kaiso! Writings by and About Katherine Dunham*, ed. VèVè A. Clark and Sara E. Johnson. University of Wisconsin Press, 2005.

Mardorossian, Carine. *Reclaiming Difference: Caribbean Women Rewrite Postcolonialism*. University of Virginia Press, 2005.

Martin, John. "The Dance: Dunham." *New York Times*, November 17, 1946.

Mbembe, Achille. "The Power of the Archive and Its Limits." In *Refiguring the Archive*, ed. Carolyn Hamilton et al. Kluwer Academic, 2002.

McDowell, Deborah. "Afrerword." In *Recovering the Black Female Body: Self-Representations by African American Women*, ed. Michael Bennett and Vanessa D. Dickerson. Rutgers University Press, 2001.

McIntyre, Dianne. "Dianne McIntyre Talks About Her Love Affair with Modern Dance." *Time Out New York*, August 19, 2012. https://www.timeout.com/newyork/dance/dianne-mcintyre-talks-about-her-love-affair-with-modern-dance.

McIntyre, Dianne, et al. "Street Dance Activism Global Dance Meditation for Black Liberation Radical Embodied Dialogue August 19, 2020, Recorded over Zoom." *Dance Research Journal* 53, no. 2 (2021): 143–60.

McKittrick, Katherine. *Demonic Grounds: Black Women and the Cartographies of Struggle*. Minnesota University Press, 2006.

McKittrick, Katherine, ed. *Sylvia Wynter: On Being Human as Praxis*. Duke University Press, 2015.

McKittrick, Katherine, and Clyde Woods. "No One Knows the Mysteries at the Bottom of the Ocean." In *Black Geographies and the Politics of Place*, ed. Katherine McKittrick and Clyde Woods. Between the Lines, 2007.

Mignolo, Walter. "What Does It Mean to Be Human?" In *Sylvia Wynter: On Being Human as Praxis*, ed. Katherine McKittrick. Duke University Press, 2015.

Moody-Turner, Shirley. *Black Folklore and the Politics of Racial Representation*. University Press of Mississippi, 2013.

Morrell, Sascha. "'There Is No Female Word for Busha in These Parts': Zora Neale Hurston, Katherine Dunham and Women's Experience in 1930s Haiti and Jamaica." *Australian Humanities Review* 64 (2019): 158–76.

Morris, Tracie. "Olu Dara." *Bomb* 62 (Winter 1998). https://bombmagazine.org/articles/1998/01/01/olu-dara/.

Morrison, Toni. *Beloved*. Knopf, 1987.

Morrison, Toni. "The Site of Memory." In *The Source of Self-Regard: Selected Essays, Speeches, and Meditations*. Knopf, 2019.

Moten, Fred. *In the Break: The Aesthetics of the Black Radical Tradition*. University of Minnesota Press, 2003.

Murdoch, H. Adlai. "Divided Desire: Biculturality and the Representation of Identity in *En attendant le bonheur*." *Callaloo* 18, no. 3 (1995): 579–92.

Nair, Supriya. *Pathologies of Paradise*. University of Virginia Press, 2013.

Nash, Jennifer C. *Birthing Black Mothers*. Duke University Press, 2021.

Neal, Larry. "The Black Arts Movement." *The Drama Review: TDR* 12, no. 4 (1968): 29–39.

Noel, Urayoán. *In Visible Movement: Nuyorican Poetry from the Sixties to Slam*. University of Iowa Press, 2014.

Nwankwo, Ifeoma Kiddoe. *Black Cosmopolitanism: Racial Consciousness and Transnational Identity in the Nineteenth-Century America*s. University of Pennsylvania Press, 2014.

Orme, Frederick L. "The Negro in the Dance, as Katherine Dunham Sees Him." In *Kaiso! Writings by and About Katherine Dunham*, ed. VèVè A. Clark and Sara E. Johnson. University of Wisconsin Press, 2005.

Owens, Imani. *Turn the World Upside Down: Empire and Unruly Forms of Black Folk Culture in the U.S. and Caribbean*. Columbia University Press, 2023.

Paravisini-Gebert, Lizabeth. *Jamaica Kincaid: A Critical Companion*. Greenwood, 1999.

Park, Robert E. "The Conflict and Fusion of Cultures with Special Reference to the Negro." *Journal of Negro History* 4, no. 2 (1919): 111–133.

Penier, Izabella. *Culture-Bearing Women: The Black Women Renaissance and Cultural Nationalism*. De Gruyter, 2019.

Perry, Imani. *South to America: A Journey Below the Mason-Dixon Line*. HarperCollins, 2022.

Pfaff, Francoise. *Conversations with Maryse Condé*. University of Nebraska Press, 1996.

Phelan, Peggy. *Unmarked: The Politics of Performance*. Routledge, 1993.

Plant, Deborah. *Every Tub Must Sit on Its Own Bottom: The Politics and Philosophy of Zora Neale Hurston*. University of Illinois Press, 1995.

Price, Richard. "Créolisation, Creolization, and Créolité." *Small Axe: A Journal of Criticism* 21, no. 1 (2017): 211–19.

Quashie, Kevin. *The Sovereignty of Quiet: Beyond Resistance in Black Culture*. Rutgers University Press, 2012.

Richardson, Riché. *Emancipation's Daughters: Reimagining Black Femininity and the National Body*. Duke University Press, 2021.
Sahakian, Emily. *Staging Creolization: Women's Theater and Performance from the French Caribbean*. University of Virginia Press, 2017.
Sajewska, Dorota, and Dorota Sosnowska. "Blackness as Medium: Body in Contemporary Theatre Practice and Theory." *Theatralia* 19, no. 2 (2016): 91–102.
Sansavior, Eva. "Just a Case of Mistaken Ancestors? Dramatizing Modernisms in Maryse Condé's *Heremakhonon*." *Paragraph* 37, no. 2 (2014): 221–34.
Saunders, Patricia J. "Fugitive Dreams of Diaspora: Conversations with Saidiya Hartman." *Anthurium: A Caribbean Studies Journal* 6, no. 1 (2008).
Savran, David. *The Playwright's Voice: American Dramatists on Memory, Writing, and the Politics of Culture*. Theatre Communications Group, 1999.
Schneider, Rebecca. "Performance Remains." In *Perform, Repeat, Record: Live Art in History*, ed. Amelia Jones and Adrian Heathfield. Intellect, 2012.
Shange, Ntozake. *Dance We Do: A Poet Explores Black Dance*. Beacon, 2020.
Shange, Ntozake. *for colored girls who have considered suicide, when the rainbow is enuf: a choreopoem*. Scribner Poetry, 1997.
Shange, Ntozake. *If I Can Cook/ you Know God Can*. Boston: Beacon, 1999.
Shange, Ntozake. *lost in language & sound: or how i found my way to the arts*. St Martin's, 2011.
Shange, Ntozake. *nappy edges*. St. Martin's, 1978.
Shange, Ntozake. *Sassafrass, Cypress and Indigo*. Picador, 1982.
Shange, Ntozake. "Shange: 'Sassafrass, Cypress and Indigo.'" Interview by Jane Pauley, *Today Show*, NBC Universal Media. September 14, 1982.
Shange, Ntozake. *Sing a Black Girl's Song: The Unpublished Work of Ntozake Shange*, ed. Imani Perry. Legacy Lit/Hatchette Book Group, 2023.
Sharpe, Christina. *In the Wake: On Blackness and Being*. Duke University Press, 2016.
Sharpe, Christina. *Monstrous Intimacies*. Duke University Press, 2010.
Simmons, Diane. *Jamaica Kincaid*. Macmillan, 1994.
Simpson, Audra. *Mohawk Interruptus: Political Life Across the Borders of Settler States*. Duke University Press, 2014.
Singh, Kavita Ashana. "Conversation and Tea with Maryse Condé," *Journal of West Indian Literature* 31, no. 1 (2022): 154–67.
Smethurst, James. *The Black Arts Movement: Literary Nationalism in the 1960s and 1970s*. University of North Carolina Press, 2005.
Spillers, Hortense. *Black, White, and in Color: Essays on American Literature and Culture*. University of Chicago Press, 2003.
Spyra, Ania. "Ntozake Shange's Multilingual Poetics of Relation." *Contemporary Literature* 54, no. 4 (2013): 785–809.
Stephens, Michelle Ann. *Black Empire: The Masculine Global Imaginary of Caribbean Intellectuals in the United States, 1914–1962*. Duke University Press, 2005.
Stewart, Lindsey. *The Politics of Black Joy: Zora Neale Hurston and Neo-Abolitionism*. Northwestern University Press, 2021.
Strongman, Roberto. *Queering Black Atlantic Religions: Transcorporeality in Candomblé, Santería, and Vodou*. Duke University Press, 2019.

Stuelke, Patricia. "'Sympathy with the Swamp': Reading Hurston in the Trumpocene." *Scholar and Feminist Online* 16, no. 2 (2020).
Sullivan, Mecca Jamilah. *The Poetics of Difference: Queer Feminist Forms in the African Diaspora*. University of Illinois Press, 2021.
Taylor, Diana. *The Archive and the Repertoire*. Duke University Press, 2003.
Tinsley, Omise'eke Natasha. *Thiefing Sugar: Eroticism Between Women in Caribbean Literature*. Duke University Press, 2010.
Tomlins, Christopher. *Freedom Bound: Law, Labor, and Civic Identity in Colonizing English America, 1580–1865*. Cambridge University Press, 2010.
Văgălău, Eliana. "'A part le bonheur, il n'y a rien d'essentiel' 1: The Transnational Narrative Model in Maryse Condé's Desirada." In *Transnational Africana Women's Fictions*, ed. Cheryl Sterling. Routledge, 2022.
Valdés, Vanessa K. "'There Is No Incongruence Here': Hispanic Notes in the Works of Ntozake Shange." *CLA Journal* 53, no. 2 (2009): 131–44.
Vincent, Ricky. *Party Music: The Inside Story of the Black Panthers' Band and How Black Power Transformed Soul Music*. Lawrence Hill, 2013.
Walcott, Rinaldo. "The Black Aquatic." *liquid blackness: journal of aesthetics and black studies* 5, no. 1 (2021): 63–73.
Walcott, Rinaldo. "The Problem of the Human: Black Ontologies and 'the Coloniality of Our Being.'" In *Postcoloniality—Decoloniality—Black Critique: Joints and Fissures*, ed. Sabine Broeck and Carsten Junker. Campus Verlag, 2014.
Wallace, Maurice. *King's Vibrato: Modernism, Blackness, and the Sonic Life of Martin Luther King, Jr*. Duke University Press, 2022.
Walker, Alice. *In Search of Our Mothers' Gardens: Womanist Prose*. Harcourt Brace Jovanovich, 1983.
Walker, Kara. "Fons Americanus." In *Kara Walker, Fons Americanus*, ed. Clara Kim. Tate Modern, 2019.
Weinbaum, Alys. *The Afterlife of Reproductive Slavery: Biocapitalism and Black Feminism's Philosophy of History*. Duke University Press, 2019
Wilkerson, Isabel. *The Warmth of Other Suns: The Epic Story of America's Great Migration*. Vintage Penguin Random House, 2010.
Womack, Autumn. *The Matter of Black Living*. Chicago University Press, 2022.
Wright, Michelle. *Physics of Blackness: Beyond the Middle Passage Epistemology*. University of Minnesota Press, 2015.
Wynter, Sylvia. "Novel and History, Plot and Plantation," *Savacou*, no. 5, June 1971.
Wynter, Sylvia, and Katherine McKittrick. "Unparalleled Catastrophe for Our Species?" In *Sylvia Wynter: On Being Human as Praxis*, ed. Katherine McKittrick. Duke University Press, 2015.
Yaeger, Patricia. *Dirt and Desire: Reconstructing Southern Women's Writing, 1930–1990*. University of Chicago Press, 2000.
Yates-Richard, Meina. "'What Is Your Mother's Name?' Maternal Disavowal and Reverberating Aesthetic of Black Women's Pain in Black Nationalist Literature." *American Literature* 88, no. 3 (2016): 477–507.

INDEX

Bold page numbers refer to figures

abjection, 4–5, 8, 26–27, 125, 161, 166
absorption, 20, 67, 85, 94–96, 100, 103–4
Africana Souths, 5, 13–19, 22, 93, 112, 115, 120, 146, 150–52, 181, 185–88, 190–96, 199–201, 212n31, 241n10; and anthropology, 30, 33–34; and Black women, 31; definition, 12; in Dunham's work, 30–34, 56–57, 60–64; in Hurston's work, 30–36, 42, 44, 47–48, 64, 67; in Shange's work, 110, 131, 134, 139; and spirituality, 24, 28; and transmutation, 27–29
Afro-Creole cultures, 7, 45, 215n5
Akoma, Chiji, 230n39
Alexander, M. Jacqui, 13–14, 191
alluvium, 7–8, 15, 69, 215n5
Anderlini, Serena, 141
Angelou, Maya, 118
Anim-Addo, Joan, 11
anthropology, 64, 68, 71, 212n26; Boasian, 29, 52, 54; in Dunham's work, 19, 27–28, 30–34, 49, 52, 54–55, 60; in Hurston's work, 19, 27–34, 36, 39, 41, 45–47, 78, 219n61. *See also* ethnography
Antigua, 173, 236n14, 237n21

Antillanité, 113
Antilles, 117, 122, 153, 160, 237n30
archives, 26, 120, 187, 189, 195, 220n74; in Condé's work, 168; counter-, 193; and extraction, 6, 96; gendered, 65; in Hurston's work, 40, 64, 67–68, 70–71, 78–79, 82, 84–85, 87, 89–90, 92, 106; in McIntrye's work, 70–71, 94, 96, 99–102, 106; relation to repertoire, 19–20, 70–73, 222n14
autofictional subjectivities, 21–22, 147–82, 239n54
autopoiesis, 15, 18, 19, 28, 42, 56, 168, 188
Avilez, GerShun, 232n65

Bahamas, 40, 42, 45, 78, 92
ballet, 50–52, 56–57, 60–63, 221n83
Ballet Nègre, 52
Baraka, Amiri, 132–35, 145
Barnard College, 133–34, 137
Barnicle, Mary Elizabeth, 84
Barthes, Roland, 112, 228n13, 229n23
Batiste, Stephanie, 61–62
Bederman, Gail, 9

Bellevue College, 127
Bereal, Ed, 137–38
Bethune-Cookman College, 80
bios/mythoi, 33, 153–54
Black Arts Movement, 5, 132, 133, 135, 139, 226n81, 232n66, 234n86
Black Atlantic, 12–13, 156
Black feminism, 27, 32, 41, 187, 210n7, 211n25, 241n10
Black modernity, 8–9, 15–16, 81
Black mother, 21
Black nationalism, 11, 130, 132–33, 155, 232n63, 233n70, 236n18
Black Panther Party for Self-Defense, 129, 132–33, 135, 140, 232n65, 233n70
Black Power, 133, 232n63
Black radical traditions, 21, 140, 145
blues, 50, 60, 85, 95, 97–100, 106, 116
Boas, Franz, 29, 39–40, 43, 52, 54, 217n38
Bodacious Buggerilla, 137
body-archive, 72
Boisseron, Bénédicte, 156–57
Bonetti, Kay, 173
Bouson, Brooks, 157
Boyce Davies, Carol, 16, 21, 150, 154, 158, 237n29; on migratory subjectivity, 150, 173, 238n34; on the provision plot, 16
Bracey, John, 132
Bradley, Regina, 115–16
Brathwaite, Kamau, 112–16, 120, 239n54
Brazil, 62, 142; Afonso Arinos Law, 221n90
Brooks, Daphne, 18, 112, 114
Brown, Elaine, 140
Brown, James, 133, 138
Brown, Jayna, 112, 228n13
Brown, Kimberly Juanita, 152
Brown, Oscar, Jr.: *We Insist!*, 107–9
Brown, Sterling, 38, 120

California, 143, 178; Los Angeles, 137–40; Oakland, 132–33, 140–41; San Francisco Bay Area, 140–41
Capécia, Mayotte, 117, 160

Cape Coast Castle, 7, 215n5
Carby, Hazel, 211n25, 218n52
Carlos, Laurie, 144
Carnival, 53, 57, 62
Catholic Church, 40
Césaire, Aimé, 113, 117, 119, 153, 230n37, 230n45
Césaire, Suzanne, 10
Chamoiseau, Patrick, 117, 152–53, 237n30
Chicago School of sociology, 9
Chicano Arts Movement, 133
Chinosole, 230n39
Clark, Joe, 35–36, 38, 75
Clark, VèVè, 61, 237n30
Clarke, Cheryl, 135, 234n86
Cochran, Felix, 100
Cole, Jean Lee, 75
Collins, Patricia Hill, 211n25, 231n48
Colon, Willie, 144
colorism, 52
Condé, Maryse, 5, 10–11, 13–14, 20, 22, 113–14, 124–25, 131–32, 187, 228n13, 231n48, 237n21, 239n46, 239n54; and autofictional subjectivities, 150–74, 182; and Créolité, 237n30, 239n51; *Desirada*, 21, 150, 162, 169; and griot figure, 230n39, 230n43; *Heremakhonon*, 128–30, 159; and inheritance, 150–51, 164, 166; on language, 238n39; on Negritude, 230n37; "Order, Disorder, Freedom, and the West Indian Writer," 145, 155, 162, 164; and strangeness, 109–11, 115–23, 126–27, 146, 150, 158, 164–65, 171, 229n24, 230n43, 230n45; *What Is Africa to Me?*, 21, 118–19, 159; *Windward Heights*, 21, 150, 162–69, 239n51
Confiant, Raphaël, 117, 237n30
Congress of African Peoples, 145
Cook, Courtney J., 191, 194
Cooper, Daniel, 98
Copper, Anna Julia, 31
Cox, Aimee Meredith, 6, 18, 224n44
Crawford, Marho Natalie, 134
Créolité, 10, 113, 117, 153, 237n30

critical fabulation, 71
Crummell, Alexander, 1–2, 4, 12, 184
Cuba, 61–62, 131, 142, 163
Cunard, Nancy, 81

Dance, Daryl Cumber, 241n82
Dara, Olu, 97–100, 106
Das, Joanna Dee, 10, 53, 221n83
Davis, Chuck, 133
Davis, Ossie, 23, 215n2
Davis, Thulani, 233n70
Dee, Ruby, 23
DeFrantz, Thomas, 81
Derry, Annie Washington, 1–4
diasporic spidering, 214n52
Diawara, Manthia, 152
Diggs Colbert, Soyica, 72–73
Domenach, Jean-Marie, 160–61
double consciousness, 13
Douglass, Frederick, 15, 34, 112
Drabinski, John E., 211n19
Du Bois, W. E. B., 38–39, 41, 75–77, 79, 153, 156–57
duCille, Ann, 91
Dunbar, Paul Laurence, 120
Dunbar Nelson, Alice, 1–2, 4, 120, 186, 209n1
Dunham, Katherine, 5, 11–12, 22–23, 48, 50, 93–94, 186–87, 219n64, 219nn64–65, 221n89; and Africana Souths, 30–34, 56–57, 60–64; and anthropology, 19, 27–28, 30–34, 49, 52, 54–55, 60; *Christophe*, 56, 61–62, 221n83; Dunham Technique, 60, 63, 142; and Haiti, 13–14, 19, 28, 33, 51–56, 60–62, 221n83; *Island Possessed*, 220n74, 220n79, 220n82; *L'Ag'Ya*, 53–54, 60–63; "Minefield," 57; *The Negro Dance Evening*, 57, 60, 62–63; *Southland*, 63, 221n89; *Tropics*, 57–60, 221n90; work with WPA, 215n9
dynamic suggestion, 19–20, 65–106

Earle, Kentoria, 191
Eidsheim, Nina Sun, 138

emergence, 87, 142, 172, 181, 215n5; and autofictional subjectivity, 21, 150; and Black women, 17, 69–70, 108–9, 154, 159; and Middle Passage, 7–8, 15; and muck horizon, 184–91, 195–201; and transmutation, 19
Emezi, Akwaeki, 189; *Dear Senthuran*, 22, 195–200, 242n23
ethnography, 30, 40–41, 46, 67, 71, 218n56; ethnographic limit, 36. *See also* anthropology

Fanon, Frantz, 13, 44–45, 113, 153, 160–61, 171, 184, 230n45, 234n89
femininity, 44–45, 184
feminism, 7, 14, 218n52, 225n78, 234n86; Black, 27, 32, 41, 187, 210n7, 211n25, 241n10; Caribbean, 13; third world, 141
Florida, 38, 40–41, 74, 78, 80, 82, 84, 191; Eatonville, 35–36, 75, 87, 101, 103–4, 106
Fodéba, Keita, 124
folk culture, 19–20, 66–67, 95, 103, 185, 191, 218n55, 239n54; in Condé's work, 167; in Dunham's work, 27, 49, 57, 63–64; Glissant on, 19, 68–69, 75, 82, 87, 90, 211n18, 222n9; in Hurston's work, 20, 27–48, 63–64, 69–93, 106, 217n38; and masculinity, 69, 82, 90; in McIntyre's work, 99–101, 103, 106
folklorization, 30–31, 218n55
France, 119, 122, 159–60, 169–71, 230n37

Gambrell, Alice, 39, 54, 218n56
Garcia, David F., 51
Garvey, Marcus, 39
Gary, Ja'Tovia, 215n2, 215n5; *An Ecstatic Experience*, 23–27
Gaskins, Roobi, 191
Gates, Henry Louis, Jr., 9
Geertz, Clifford, 54
George-Graves, Nadine, 214
Georgia Sea Islands, 84
Ghana, 11, 118, 121, 128, 132
Ghana Broadcasting Corporation, 127

Gilpin Players, 80
Gilroy, Paul, 10, 12, 211n25
Glick, Jeremy, 145
Glissant, Édouard, 19, 74, 77, 104, 113, 117, 194; on the belly of the boat, 7, 210n12, 215n5, 227n8, 236n15; on folk culture and theater, 68–69, 75, 82, 87, 90, 211n18, 222n9; on folklorization, 30, 218n55; on gender, 211n19; on noise, 229n27; on opacity, 46; on root identity, 211n18; on the scream, 15, 213n44; on the womb abyss, 8, 17, 210n12, 227n8
Global South, 212n27
Goldman, Danielle, 93, 96, 109
Goler, Veta, 93, 99
Gonzalez, Anita, 81, 85
Goode Bryant, Linda, 100
Great Migration, 11, 31, 37, 49, 92, 97–98, 192, 212n28
Griffin, Farah Jasmine, 16, 111–12, 212n28
griot figure, 120, 123–27, 230n39
Guadeloupe, 128, 155, 160, 163, 166, 169, 236n14
Guinea, 11, 118, 123–27, 132, 145
Gullah Geechee cultures, 84, 193

Haiti, 57, 113, 131, 142, 161; in Dunham's work, 13–14, 19, 28, 51–56, 60–62, 221n83; in Hurston's work, 19, 28, 33, 42–48, 64, 87, 218n41, 218n52, 219n61; in McIntyre's work, 94; US occupation, 30, 43, 228n17
Haitian Indigenisme Movement, 228n17
Haitian Revolution, 56, 218n41
Haitian Vodou, 30, 33–34, 64, 94, 218n55, 218nn55–56; in Dunham's work, 13–14, 19, 28, 33, 52–56, 60–62; in Hurston's work, 13–14, 19, 28, 33, 42–48, 87, 218n41, 218n52; in McIntyre's work, 94
Hamilton, Allison Janae, 194, 199; *Floridawater II*, 22, 189–91
Harlem Renaissance, 29, 75
Harney, Stefano, 7
Harris, Valerie, 209n1
Harris, William J., 95
Hartman, Saidiya, 15, 65, 71, 112, 118, 214n1, 227n98
Hawkins, Coleman: *We Insist!*, 107–9
HBCU Souths, 38, 212n28
Hearn, Lafcadio, 57
hereditary darkness, 1, 4–7, 9, 17, 27, 71, 86, 165, 184, 187
Herskovits, Melville, 32, 39–40, 43, 52–54
Holiday, Billie, 229n24
Holiday, Harmony, 107–8
Horton-Stallings, LaMonda, 212n31
Howard University, 38, 74, 217n35
Hughes, Langston, 40, 43, 74, 79–80, 120, 221n83
Hurston, John, 36
Hurston, Zora Neale, 4–5, 11, 13, 19, 22, 97, 120, 143, 186–87, 190, 199, 216n29, 217n32, 218n52; "Characteristics of Negro Expression," 40–41, 67, 81–88, 102, 216n12, 217n38; as choreographer, 224n44; communications with Locke, 223n26, 224n39; "Drenched in Light," 39; *Dust Tracks on a Road*, 45; *The First One*, 75; folk culture engagement, 27–48, 63, 70–92; *The Great Day*, 78, 80; "Hoodoo in America," 218n41; "John Redding Goes to Sea," 38; *Jonah's Gourd Vine*, 40; *The Lilac Bush*, 75; and McIntyre's work, 20, 92–95, 99–106, 225n72, 235n98; *Mules and Men*, 36, 40, 44–46, 217n38, 218n56, 219n61; and New Negro theater, 74–78; *Polk County*, 225n72; on Race Champions, 217n36; *Tell My Horse*, 42–44, 46, 219n61, 220n74; *Their Eyes We Watching God*, 20, 66–69, 73, 86–92, 183–85, 224n60, 235n98; work with WPA, 215n9; "You Don't Know Us Negroes," 217n38

Igbo people, 22, 197–98
illegibility, 21, 42, 53, 64, 85, 114, 117, 121, 139, 240n80
Illinois, 60; Chicago, 48–49, 57, 93, 131

Indiana, 57, 60
Indigenismo, 9
Indigenization, 17
inheritance, 2, 6, 14, 26, 147, 154, 186; and African American drama, 72; in Condé's work, 150–51, 164, 166; hereditary darkness, 1, 4–7, 9, 17, 27, 71, 86, 165, 184, 187; in Hurston's work, 43, 216n29; in Kincaid's work, 150–51, 156, 173–76, 181; in McIntyre's work, 93, 97; monstrous, 21–22, 148, 157; in Shange's work, 185. See also *partus sequitur ventrem*
Institute of Languages, 230n45

Jaji, Tsitsi, 119–21
Jamaica, 42, 61–62, 94
James Alexander, Simone A., 237n23
jazz, 85, 119, 123, 131; free jazz, 95, 226n81; in McIntyre's work, 69, 95, 97–99, 108; in Shange's work, 134
Jim Crow, 10, 212n27
Johnson, Georgia Douglass, 38
Johnson, Guy, 80
Johnson, James Weldon, 38
Johnson, Jessica Marie, 154
Jones, Marjorie, 24, 28, 215n2
Judd, Bettina, 241n10
Judson, Chanon, 193–95
Just Above Midtown (JAM) gallery, 100

Kaba, Sékou, 123, 126
Kalambay, Grace Galu, 191
Kaplan, Carla, 89, 92
Karenga, Maulana, 132, 141
Kincaid, Jamaica, 5, 11, 13–14, 146, 153, 157–58, 172, 187, 237n21; *The Autobiography of My Mother*, 21–22, 150, 154–55, 173–78, 240n71, 240n72, 240nn71–72; "Blackness," 240n70, 240n80; "Girl," 156, 237n24, 240n80. *See Now Then*, 150–52, 174, 178–82, 241n82
King, Lovalerie, 185
King, Woody, 100

Kokomo, 57, 60
Kouyaté, Sory Kandia, 124
Krigwa Players, 75–77

Lacascade, Suzanne, 117
Lacrosil, Michèle, 117
Ladd, Barbara, 46
Lamothe, Daphne, 43–44, 218n52
Lanier, Michelle, 188–89
La Rocco, Claudia, 226n95
Laviera, Tato, 144
life writing, 5, 19, 21
Lincoln, Abbey, 113; "Triptych," 108–9, 115; *We Insist!*, 107–9
Little Theatre Movement, 75
Locke, Alain, 9–10, 38, 40–41, 74, 79, 120, 217n35, 223n26, 224n39
Loichot, Valérie, 168
Lomax, Alan, 84
Lorde, Audre, 238n36
Louisiana, 2, 44, 198; New Orleans, 5, 40, 131, 191, 194, 218n41
Luis-Brown, David, 10
Lycée Fénelon, 119, 160

Magloire, Marina, 14, 32, 43
Mahler, Anne Garland, 11, 212n27, 212n30
Malcolm X, 133, 138
mammy figure, 151–52, 162, 167, 174, 235n9
Mardorossian, Carine, 239n51
Maroons, 16, 61, 151–52
Martin, John, 51
Martinique, 14, 52–53, 57, 61, 63, 68, 160, 210n16
masculinity, 5, 21, 87, 109, 111, 131, 152, 155, 232n65; and Black Atlantic, 13, 211n25; and blues, 100; critiques of, 39; and folklore, 69, 82, 90; in Négritude, 129; racialized, 9–10; and slave narratives, 15; and sound, 138–40; and women's silence, 21
Mason, Charlotte Osgood, 29, 78–79, 217n38
Mason-Dixon Line, 66
Master Brotherhood, 95–96
mati, 16–18, 22, 241n10

Matthew, Victoria Earle, 37
Mbembe, Achille, 70
McDowell, Deborah, 11, 227n9
McIntyre, Dianne, 5, 11–13, 70–73, 195, 222n1, 225n72, 226n95; and jazz, 69, 95–99, 108, 226n81; *Life's Force*, 96; *Mississippi Talks, Ohio Walks*, 98; as musician's dancer, 226n88; *New Dance*, 108; *Sounds in Motion*, 96, 100, 195; *Their Eyes Were Watching God: An Adventure in Southern Blues*, 20, 67, 74, 91–95, 99–106, 235n98; "Triptych," 108–9, 115
McKay, Claude, 120
McKittrick, Katherine, 12–13
methodology of book, 6, 17–18
Middle Passage, 6, 13, 110, 115, 125, 160, 164–65, 187, 194; afterlives of, 63, 211n18; and Black women, 8, 15–16, 148, 155, 201, 227n8; as break, 14; and hereditary darkness, 4, 17; and mati, 22; as moment of emergence, 7, 63; and the scream, 108; ungendering in, 210n7, 210n16
Miller, May, 38
misogyny, 35, 42, 217n35
Mississippi, 93, 131; Natchez, 97–98
Mitchell, Charles, 75
Mock, Ed, 142
modern dance, 28, 93, 96, 99
Moe, Henry Allen, 46, 219n61
monstrosity, 45, 152, 154, 158–82; monstrous inheritance, 21–22, 148, 157
Moore, Fannie, 23–24, 26–28, 215n5, 215nn2–3
Moore, Rachel, 23–24, 26–27, 45, 48, 63–64, 215n5
Morgan, Joan, 190
Morgan Academy, 38
Morrell, Sascha, 220n74
Morris, Butch, 100
Morris, Tracie, 99
Morrison, Toni, 94, 197–98; *Beloved*, 65–66
Moten, Fred, 7, 15, 112, 229n24
mother's gardens, 17, 21–22
Moussokoro, 125

muck horizon, 17, 22, 183–201, 241n10
multilingualism, 116, 135–39, 145. *See also* translingualism
Murray, Albert, 99

NAACP: *Crisis*, 2
Nabokov, Vladimir, 196
Nair, Supriya, 239n54
Nanny of the Maroons, 151–53, 162, 174
Natchezippi Band, 97
National Black Power Conference, 133
National Urban League, 74
nation language, 112, 120
Neal, Larry, 132–33, 135, 232n63, 232n66
Negrismo, 9
Négritude, 5, 10, 113, 117–21, 129, 132, 135, 230n35
Negro World, 39
neo-abolitionism, 34
neo-Africanism, 132
New Jersey: Newark, 145; Trenton, 145
New Negro, 5, 9, 20, 29, 39, 51, 70, 74–75, 77, 79, 135, 217n38
New Orleanian Hoodoo, 40, 44–45, 218n41, 218n56
Newton, Huey, 232n65, 233n70
New World, 8, 16, 107, 111, 115, 166, 232n66, 234n89
New World Black Nation, 16, 111
New York City, 39, 82, 108; Condé in, 162; Harlem, 79, 137, 191; Hurston in, 39, 69, 75, 80; McIntyre in, 93, 95, 97, 226n81, 226n95; Shange in, 133, 135, 137, 140
Nigerians, 22, 107, 196–97
Nkrumah, Kwame, 118, 132
Noble, Gil, 215n5
Noel, Urayoán, 21, 139, 144, 234n82
no place (Touré), 117, 229n30
Nwankwo, Ifeoma Kiddoe, 15

Oakland Women's Press Collective, 141
O'Connor, Patricia T., 172
Odum, Howard, 80
Ohio, 66; Cleveland, 80

Okra Ochestra, 97
Olatunji, Michael Babatunde, 133; *We Insist!*, 107–9
Oliver, Denise, 232n65
opacity, 18, 44–46, 48, 177, 219n61, 229n27
Orme, Frederick L., 51
Osbey, Brenda Maria, 186
Osumare, Halifu, 142
othermothers, 156, 166, 176, 237n23, 240n80
Owens, Imani, 30, 42, 218n55

Page, Ruth: *La Guiablesse*, 57
pan-Africanism, 113, 119
Paravisini-Gebert, Lizabeth, 157, 173
Park, Robert E., 9
partus sequitur ventrem, 21, 152, 154–55, 157, 162, 164–65, 171, 175, 177, 236n14, 239n51
Pauley, Jane, 4
Penier, Izabella, 225n78
Pennsylvania, 2
People's National Theatre, 124, 127
performance knowledge, 71, 81
performance studies, 17
performative writing, 85
Perry, Imani, 38, 209n1, 212n28, 217n34
personal mythmaking, 37, 169–70
Pfaff, Françoise, 129
Phelan, Peggy, 72, 223n17
Philip, M. NourbeSe: "Dis Place," 147, 156, 237n24
Pinto, Samantha, 211n25
Plant, Deborah, 75
poetics of transmutation, definition, 5–6
polyphony, 18, 126, 130, 146, 164
possession, spiritual, 44–48, 55–56, 61–63, 220n79, 220n82
postcolonialism, 11, 109, 128, 155, 212n27, 225n78, 237n29
Potts, Lucy, 36–37
Price, Richard, 212n26
Primus, Pearl, 93
provision plot (Wynter), 16, 22, 36, 64, 112, 115, 120, 142, 200

Quashie, Kevin, 132
queerness, 7, 16, 232n65

Race Champions, 34, 217n36
racism, 26–27, 30, 32, 34, 49, 197, 221n90, 224n44, 232n63. *See also* Jim Crow
Radcliffe-Brown, A. R., 52
Reconstruction, 2
Redfield, Robert, 52
Reed, Ishmael, 218n52
Relation (Glissant), 8, 211n18, 215n5
religion. *See* spirituality
Renda, Mary, 30
repertoire, 68, 187, 189, 193, 195; in Hurston's work, 64, 67, 85–92; in McIntyre's work, 94, 99, 101–2, 106; relation to archives, 19–20, 70–73, 222n14
Richards, Sandra, 118
Richardson, Riché, 12, 212n31
Roach, Max: "Triptych," 108–9; *We Insist!*, 107–9
Robeson, Paul, 221n83
Rollins College, 80
Romero, Carmencita, 51
Roumain, Jacques, 113

Sajewska, Dorota, 72
Sanchez, Sonia, 132
Sartre, Jean-Paul, 113, 117
Savran, David, 137–39, 233n73
Sawyer, Raymond, 142
Schechner, Richard, 71–72, 81
Schneider, Rebecca, 72
Schuyler, George, 79
scream, 15, 24, 111, 113–16, 201, 213n44, 215n3, 229n24, 229n27; in Douglass's work, 112, 229n24; in *We Insist!*, 107–9
Sékou Touré, Ahmed, 113, 117–18, 126, 132, 229n30
self-nativising, 54
Seminole people, 92
semiotics, 7–8, 15, 17–18, 21, 138, 140
Senegal, 119, 142, 230n37; Dakar, 118, 120

Senghor, Léopold, 119–21, 132, 230n37; "Joal," 123, 230n41
sexual violence, 8, 16, 37, 66, 101, 166, 167, 216n29
Shakur, Assata, 215n5
Shameless Hussy Press, 141
Shange, Ntozake, 6, 11–13, 18, 22, 187, 190–91, 228n13, 233n71, 233n73, 234n93; "a history," 142; "Banjo," 137; on Black nationalism, 233n70; *for colored girls*, 134, 141–45, 235n98; "dark phases," 137; *lost in language & sound*, 21; "Mr. Wrong," 136; as Nuyorican Poets Café founding member, 234n81; *Sassafras, Cypress and Indigo*, 1, 4–5, 141, 185; on South in her, 4–5, 10, 185; and strange sound, 109–11, 113–16, 130, 131–46, 229n24; as third world writer, 234n89; "unrecovered losses/black theater traditions," 110; "why i had to dance," 234n95; "wow…yr just like a man!," 232n63
Sharpe, Christina, 7–8, 151–52, 215n7, 235nn8–9
Siegel, Marcia, 93
Simmons, Diane, 240n80
Simpson, Audra, 28, 36
Singh, Kavita, 159–60, 239n46
slave narratives, 15, 21, 23, 94, 110–11, 155, 227n9; WPA slave narrative project, 23, 28, 214n1, 215n2
slavery, 65, 68, 72, 112, 115, 120, 148, 151–52, 158, 229n27, 241n10; afterlives of, 2, 10, 26, 28, 56, 63, 157, 184, 197, 215n5, 216n29; antislavery activism, 9, 29, 34; and Black women, 1–2, 4–5, 7–8, 13–14, 16, 31, 111, 154–55, 184–85, 210n16, 215n3, 235n9; in Condé's work, 125, 163–64, 167–68, 231n48; in Dunham's work, 28; in Hurston's work, 28, 66, 86; and jazz, 95; in McIntyre's work, 100; and provision plot, 16–17; in Shange's work, 110–11; slave ship, 5, 7–8, 16, 154, 160, 168, 216n29; and spirituality, 24; WPA slave narrative project, 23, 28, 214n1, 215n2. *See also* slave narratives

Smethurst, James, 132, 135
Smith, Zadie, 151–52
Solder, Steve, 93
sonic extraction, 109
sonic Souths, 21, 115–16, 134, 137
Sonoma State College, 141
Sosnowska, Dorota, 72
South Carolina: Moore Plantation, 24
South Carolina Sea Islands, 94
southern folk culture. *See* folk culture
Southern Renaissance Literature Movement, 29, 217n38
"South in her," definition, 4–5
Souths, definition, 11–14
Speis, Mame Diarra, 191–92, *192*, 195, 242n17
Spillers, Hortense, 154, 158, 210n7, 210n16
spirituality, 24, 27, 31, 42–48, 60–63, 114, 126, 185, 200–201. *See also* Catholic Church; Haitian Vodou; New Orleanian Hoodoo; possession, spiritual
Spyra, Ania, 234n89
Stephens, Michelle A., 9
Stepto, Robert, 89
Stewart, Lindsey, 34
strangeness, 5, 14, 18, 80, 211n25; in Condé's work, 110–11, 115–23, 126–27, 146, 150, 158, 164–65, 171, 229n24, 230n43, 230n45; in Dunham's work, 53; in Hurston's work, 42, 86–92, 184, 218n56; in Kincaid's work, 150, 158, 178–79; in McIntyre's work, 92, 97, 99, 108–9; and muck horizon, 184, 187–90; in Shange's work, 110–11, 115–16, 130, 134–40, 144, 146, 229n24; strange sound, 20–21, 107–46, 229n24, 229n27; strange Souths, 6, 13, 16–17, 20, 22, 92, 99, 116, 150, 187–90, 197, 201, 230
Strongman, Roberto, 44, 216n18
Stuelke, Patricia, 184
subalternity, 11, 152, 212n27, 214n1, 238n34
Sullivan, Mecca Jamilah, 210n7, 238n36

talented tenth, 38, 75
Tamil people, 22, 196
Taylor, Cecil, 97

Taylor, Diana, 70, 72–73, 88, 101, 222n14, 227n98
Third World Communications, 141
Tinsley, Omise'eke Natasha, 16, 210n7, 210n16, 241n10
Touré, Sekou, 113, 132
transcorporeality, 34, 44, 54–56, 63–64, 216n18, 218n41
translingualism, 116, 143–45. *See also* multilingualism
transmutation, 6, 14, 16, 18–19, 21, 24, 27, 182, 185–86, 188–89, 196–201; in Condé's work, 111, 116–18, 146, 150, 158, 162; in Dunham's work, 56; in Hurston's work, 20, 68, 88, 90, 106, 184; in Kincaid's work, 150, 158; in McIntyre's work, 20, 68, 100, 106, 195; poetics of, definition, 5–6; in Shange's work, 111, 143, 146
tricontinentalism, 212n27
Tubman, Harriet, 194
Turbyfill, Mark, 51
Turner, Victor, 71, 81
Tuskegee Institute, 9

Umpierre, Maria, 141
unincorporability, 20–21, 107–46
University of Chicago, 52
University of Illinois Press, 91
Urban Bush Women (UBW), 189, 199; *Haint Blu*, 22, 191–95, 200, 242n15, 242n17

Valdés, Vanessa K., 144
ventriloquism, 34, 54, 103–6, 112
vertical synecdoche, 114
von Hornbostel, Erich, 32

Walcott, Derek, 8, 211n19
Walcott, Rinaldo, 17, 182, 232n66
Walker, Alice, 17, 22, 89, 107
Walker, Kara, 156; *Fons Americanus*, 147–49, *149*, 151–52, 182; *A Subtlety or the Marvelous Sugar Baby*, 235n4

Waring, Laura Wheeler, 1–3, *3*, 209n1
Washington, Booker T., 9
Washington, Mary Helen, 41, 69, 91
Weinbaum, Alys, 154, 239n51
West Africa, 14, 82, 109–11, 115, 117–19, 123, 128–29
West Indies, 57, 118, 129, 145, 160, 172
White Rose Mission, 37
Wilkerson, Isabel, 92
Williams, Shirley Ann, 91
Womack, Autumn, 40–41
womb, 65, 236n15; in Condé's work, 127, 150, 157, 163–65; in Kincaid's work, 150, 157, 175–76, 178; and maternal disavowal, 236n18; and *partus sequitur ventrum*, 154–57, 236n14; rewombing, 194; Sharpe on, 7–8. *See also* womb abyss
womb abyss, 4, 11, 26, 28, 73, 108, 110, 146, 185, 187–88, 201; and autopoiesis, 15; definition, 31, 215n5; in Dunham's work, 57, 64; in Emezi's work, 196; Glissant on, 8, 17, 194, 210n12, 227n8, 236n15; and hereditary darkness and rudeness, 6, 9, 17, 71; in Hurston's work, 36, 64, 67, 82, 86, 89, 101, 106; in McIntyre's work, 67, 69, 94–95, 101–2, 106; in Shange's work, 18
Woods, Clyde, 12–13
Works Progress Administration (WPA), 214n1; Chicago Federal Theater, 60; Federal Music Project, 84; Hurston and Dunham's work with, 215n9; slave narrative project, 23, 28, 214n1, 215n2
Wright, Michelle, 114, 122
Wynter, Sylvia, 15, 182; on bios/mythoi, 33, 153; on provision plot, 16–17, 22, 36, 64, 115, 120

Yates-Richard, Meina, 15, 112, 154–55, 236n18
Young Lords Party, 135–36, 139, 145, 232n65, 233n71

Zollar, Jawole Willa Jo, 195, 226n95

GPSR Authorized Representative: Easy Access System Europe, Mustamäe tee
50, 10621 Tallinn, Estonia, gpsr.requests@easproject.com

www.ingramcontent.com/pod-product-compliance
Lightning Source LLC
Chambersburg PA
CBHW022045290426
44109CB00014B/985